PLEASURES OF PARIS DAUMIER TO PICASSO

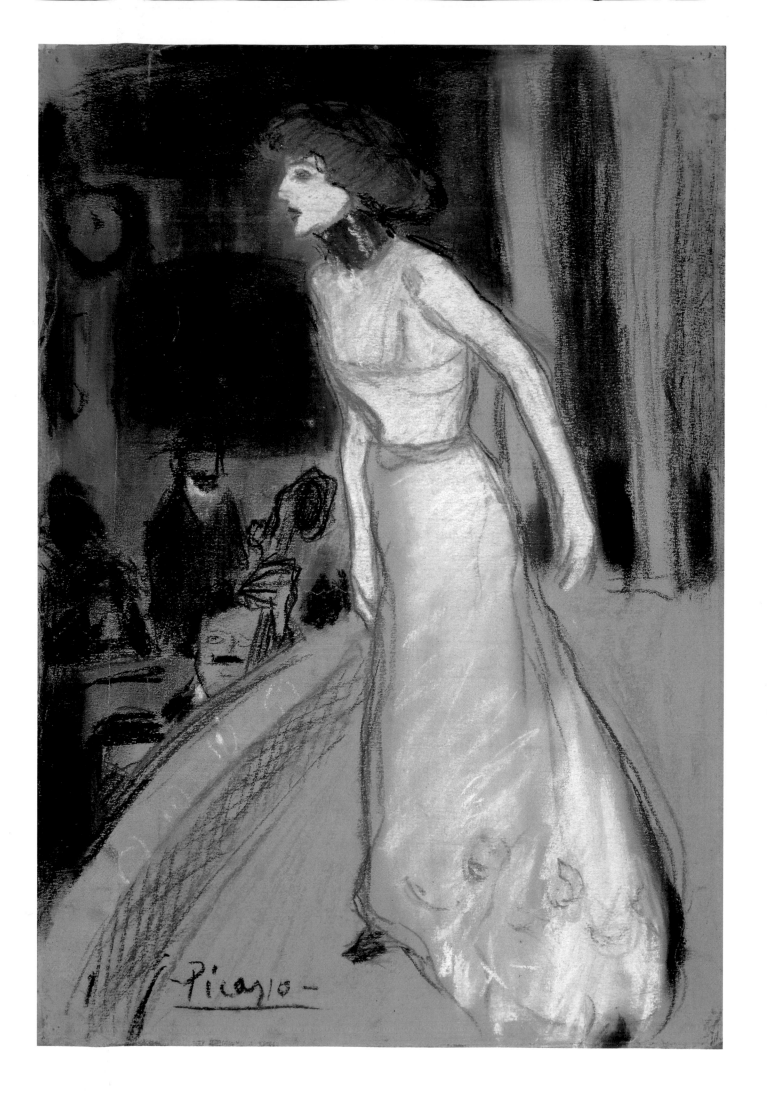

PLEASURES OF PARIS : DAUMIER TO PICASSO

Barbara Stern Shapiro with the assistance of Anne E. Havinga

Essays by Susanna Barrows, Phillip Dennis Cate, and Barbara K. Wheaton

Museum of Fine Arts, Boston

This exhibition was organized by the Museum of Fine Arts, Boston, and was made possible by the IBM Corporation.

Museum of Fine Arts, Boston
June 5 – September 1, 1991

IBM Gallery of Science and Art, New York
October 15 – December 28, 1991

Published in 1991 by the Museum of Fine Arts, Boston, in association with David R. Godine, Publisher, Inc., Boston. All rights reserved. No part of the contents of this book may be reproduced without the written permission of the publishers.

Copyright © 1991 by the Museum of Fine Arts, Boston, Massachusetts

Library of Congress Catalogue Card No. 91-72212

ISBN 0-87846-340-2 (paper)
ISBN 0-87923-919-0 (cloth)

Designed by Carl Zahn

Edited by Margaret Jupe

Typeset and printed by Acme Printing Co., Wilmington, Massachusetts

Bound by Acme Bookbinding Co., Charlestown, Massachusetts

The publishers wish to thank the lenders of works reproduced in this catalogue for kindly granting permissions and for providing photographs.

Front cover:
Pablo Picasso (1881-1973)
Jardin [de] Paris: Design for a Poster, *1901*
The Metropolitan Museum of Art, Gift of Raymonde
Paul, in memory of her brother, C. Michael Paul, 1982.
1982.179.17
(cat. 149)

Back cover:
Honoré Daumier (1808-1879)
Nadar Elevating Photography to the Height of Art
(Nadar élévant la Photographie à la hauteur de l'Art), 1862
Museum of Fine Arts, Boston, Bequest of W.G. Russell Allen,
1963.1998
(cat. 24)

Frontispiece:
Pablo Picasso (1881-1973)
On Stage (En scène), 1901
Albright-Knox Art Gallery, Bequest of A. Conger Goodyear.
66:9.16
(cat. 147)

Contents

Lenders to the Exhibition

Addison Gallery of American Art,
 Phillips Academy, Andover, Massachusetts

Albright-Knox Art Gallery, Buffalo, New York

Mr. and Mrs. Arthur G. Altschul

Matthew Braddock

Boston Public Library

The Brooklyn Museum

Fogg Art Museum, Harvard University,
 Cambridge, Massachusetts

Harvard Theatre Collection

The Alex Hillman Family Foundation

Jane Voorhees Zimmerli Art Museum, Rutgers,
 The State University of New Jersey

Josefowitz Collection

Melas Kyriazi Collection

The Metropolitan Museum of Art, New York

Museum of Art, Rhode Island School of Design

The Museum of Modern Art, New York

The Museum of Fine Arts,
 Springfield, Massachusetts

Collection of Mr. and Mrs. Jack Rennert,
 New York

Laurence Senelick Collection

William Kelly Simpson

Smith College Museum of Art,
 Northampton, Massachusetts

Sterling and Francine Clark Art Institute,
 Williamstown, Massachusetts

Mr. and Mrs. Eugene V. Thaw

Arthur and Charlotte Vershbow, Boston

Barbara and Ralph Voorhees

The Wenham Museum, Wenham, Massachusetts

Worcester Art Museum,
 Worcester, Massachusetts

Private Collections

Private Foundation

Foreword

This exhibition investigates what is generally considered a period of festivity and joy in the history of Europe: the second half of the nineteenth century in Paris, the "City of Light." With the increase of prosperity and leisure time, Parisians eagerly sought diversions, such as spending a day at the racetrack, lounging in a sidewalk café, attending the circus, or simply strolling along the boulevards. These pursuits became a source of inspiration for some of the greatest artists of the time, who left a record of what we have come to regard as a delightful, unpressured, even idyllic lifestyle. It cannot be denied that this notion of Paris is somewhat distorted; the surface gaiety and material comfort masked severe political oppression and social injustice. Although this exhibition illustrates to some extent the darker side of this glittering world, it does not attempt to explore the political or social issues; rather, it presents with beautiful and provocative works of art — paintings, sculpture, and works on paper, in new and insightful groupings — a visual documentation of some of the more pleasant aspects of Parisian life in the nineteenth century, beginning with the Second Empire, in 1852, and culminating just before the outbreak of World War I.

"Pleasures of Paris from Daumier to Picasso" was organized by Barbara Stern Shapiro, associate curator in the Department of Prints, Drawings, and Photographs at the Museum of Fine Arts, and a noted specialist in French graphic art of the nineteenth century. Mrs. Shapiro has selected works of the finest quality to present her view of this extraordinary period. To assemble this exhibition, she has drawn extensively from the rich and varied holdings of French art in the Museum and sought loans from collections in the Northeast. At least half the works in the show are from our collection, and these are augmented by superb objects from some thirty institutional and individual lenders. The result is a fascinating and instructive view of a great city and its pastimes.

We are grateful to the IBM Corporation for its generous support of this exhibition and catalogue, and we owe a special debt to Richard P. Berglund, director of cultural programs at IBM, for his interest in the project. The IBM Gallery of Science and Art, under the supervision of Cynthia J. Goodman and her successor, Robert M. Murdock, is the second venue for "Pleasures of Paris." The Museum of Fine Arts is extremely gratified to have worked closely with IBM in the realization of this exhibition, and we greatly appreciate the IBM Corporation's financial assistance.

ALAN SHESTACK
Director

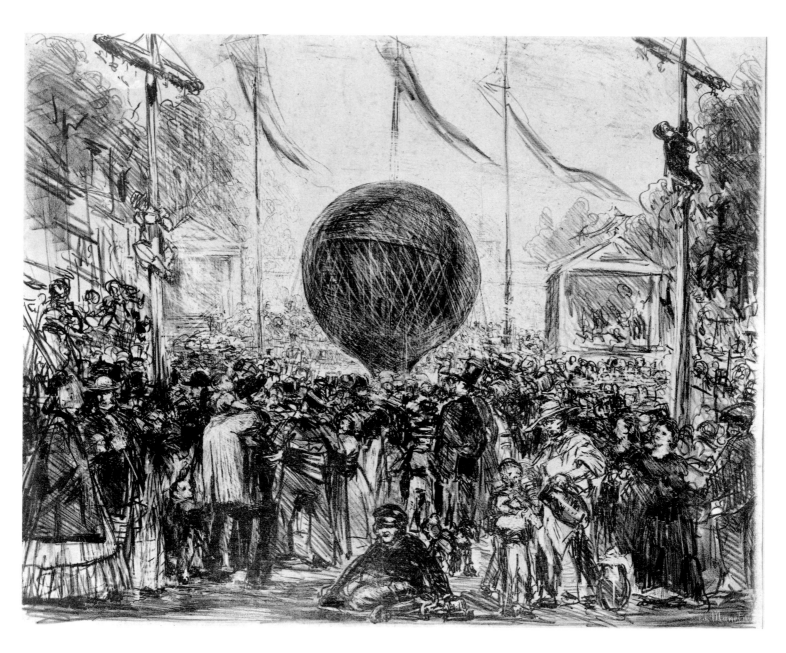

Édouard Manet
The Balloon
(Le ballon), 1862
Fogg Art Museum, Harvard University, Purchase
from the Program for Harvard College. M13,710
(cat. 39)

The balloon ascent depicted by Manet celebrated the
holiday on August 15, 1862 (the feast of the Assump-
tion), which was declared by Napoleon III as a national
fête. The event took place on the esplanade in front of the
Invalides, and it was still unusual and exciting enough
to attract a large crowd. Manet composed the scene from
sketches he made of friends, working-class people, ven-
dors, policemen, and a cripple in the foreground who
would hardly have been able to observe the festive event.
The small puppet theaters, the banners, the maypoles, as
well as archival records attest to the geographic location
for the ascent, which was an anticipated happening at
any public festival (Manet, 1983, pp. 133-136).

Preface and Acknowledgments

The exhibition "Pleasures of Paris" was first defined in conversations held in 1986 between Robert L. Herbert, professor of art history at Mount Holyoke College, and Peter C. Sutton, Mrs. Russell W. Baker Curator of European Paintings at the Museum of Fine Arts. At that time, a proposal was made to assemble works from collections throughout the world that would visually reflect Professor Herbert's interest in the social history of Impressionism. Although the concept seemed exciting, the logistics of acquiring loans for such an exhibition along with the complexities of insurance and shipping proved overwhelming.

When Alan Shestack became director of the Museum, he challenged the staff to devise exhibitions that would depend, for the most part, on the Museum's collections. In the light of this guideline, I revived the idea of a show that would focus on Parisian entertainments. At least half the works in this exhibition are drawn from the Museum's extensive and fine holdings of French art and are supplemented by splendid loans that were requested only from the Northeast of the United States. Thus, the well-known Impressionist paintings in distant collections that depict the pleasurable aspects of Paris were not included.

The topic of Paris and its many forms of recreation in the second half of the nineteenth century is vast, and this exhibition could have been organized in a number of ways. Owing to my interest in works on paper and my conviction that life in the French capital at that time was ultimately conveyed and chronicled through prints, posters, photographs, and journal illustrations, I relied to a great extent on images in these media to present the various themes. For the preparation of the catalogue, I regret that a lack of time did not permit me to personally consult sources in archives and libraries in Paris; I am indebted to the publications of Phillip Dennis Cate, Robert Herbert, and Charles Rearick for the depth and reliability of their information.

I am particularly grateful to Robert Herbert for his kind response to my restructuring of the earlier exhibition and for his suggestion that Susanna Barrows contribute an essay on cafés. She was joined by Dennis Cate and Barbara Wheaton, who have written, respectively, on the circus and the pleasures of the table, and their three essays have greatly enriched the catalogue. Peter Sutton agreed to rearrange the Museum's Impressionist and Post-Impressionist galleries to accommodate my requests for paintings and pastels from his department, some of which will travel to the IBM Gallery of Science and Art; he was also instrumental in obtaining a significant loan from a sister institution. Theodore E. Stebbins, Jr., John Moors Cabot Curator of American Paintings, graciously agreed to lend four paintings by Americans working in Paris, and Jeffrey H. Munger, acting curator of European Decorative Arts and Sculpture, kindly offered three Degas sculptures to the exhibition. I am indebted to Eric Zafran and Robert Boardingham of the European paintings department, who have been so supportive throughout this project; they have always been willing to make constructive suggestions, to bring works of art to my attention, and to share books from their personal libraries for research.

Clifford S. Ackley, curator of Prints, Drawings, and Photographs, encouraged me to pursue this project, which brings together so many of my interests; he has been helpful with comments and advice, as well as with the installation of the exhibition. Roy Perkinson, conservator of works on paper, restored fragile posters in the Museum's collection and acted as adviser on the condition of other works. Anne Havinga assisted in many aspects of the project, and Shelley Langdale ably managed the complex problems of assembling photographs. Stephanie Loeb Stepanek was most helpful in the preliminary organization of the exhibition. To the other members of the department go my profound thanks: Sue Reed, who essentially "covered" for me during this year; Annette Manick, who conserved a number of prints; Gail English, who prepared the works for exhibition; and Jessica Murray for her word-processing skills.

I extend my profound appreciation to the directors of the museums and private individuals for their generous loans to this exhibition. I am very grateful to the following colleagues who have discussed ideas with me and offered many thoughtful suggestions: Douglas Druick, Elizabeth Easton, Alicia Faxon, Trudy Hansen, Colta Ives, Steven Kern, David Kiehl, Cecily Langdale, Rebecca Nemser, Eleanor Panasevich, Melinda Rabb, Polly Sartori, Richard Thomson, Gary Tinterow, Margaret Weitz, and Michael Wentworth. To friends and colleagues in Paris go my special thanks for assisting me in the execution of the show that celebrates "their" city: Laurens and Yolande D'Albis, Anne Distel, Françoise Heilbrun, Mira Jacob, Henri Loyrette, and

especially Judith Pillsbury. Nicole Friedler and Victoire Taittinger Gardner were helpful with research problems.

Within the Museum, I am grateful to Alan Shestack and to Désirée Caldwell, exhibitions coordinator, for their enthusiastic support of the project from its inception; to Carl Zahn for his positive interest in the exhibition and his design of the accompanying catalogue; and to Margaret Jupe for her constantly thoughtful and sympathetic editing. Gilian Wohlauer was very supportive in many ways. Janice Sorkow and her staff efficiently organized and provided the photographs from lenders and this museum; Karen Lanzoni obtained many important inter-library loans; and Pat Loiko, associate registrar, deftly managed the intricacies of loans of works of art. Tom Wong and Judy Downes created an attractive and appropriate installation for the "Pleasures of Paris." My thanks go also to colleagues in the Museum, too numerous to list here, who helped with translations, conservation, and general advice. Lastly, a word of heartfelt appreciation to my husband for his invaluable support of my projects, his patience, and for his well-known good nature.

BARBARA STERN SHAPIRO

Paris, the Capital of the Nineteenth Century

The historian and social critic Walter Benjamin, in the working title of his last but unfinished book *Paris, the Capital of the Nineteenth Century*, succinctly characterized the reputation of the "city of light."[1] Although Benjamin was apparently describing Paris as the center of the universe of commodities and assets, he recognized that it was the most modern city in the world and "confirmed in its position as the capital of luxury and of fashion."[2]

The nation had survived the great Revolution of 1789, which brought about, among other extraordinary events, the dissolution of the monarchy and the breakdown of the aristocracy. Any efforts on the part of the politicians to restore the Old Regime met with strong opposition. From these conflicts rose the bourgeoisie, the class that would dominate the entire nineteenth century as the nation's most vital political and economic force; no longer would one's birthright automatically constitute power. The crises and agitations that ensued in the decades following the Revolution merely strengthened the resolve of the propertied classes; this determination coincided with the development of rules of conduct and ways of thought that opposed the ideals of a decaying nobility and the authority of the Church.[3] *La France bourgeoise*, as it has come to be known, encompassed the professionals, the industrialists, and any Frenchmen who possessed "a surplus of wealth, dedicated to cultured living, beyond the basic necessities."[4] Thus, the overriding goal of the predominating class was to enjoy a distinctive and moneyed style of life.

After the Revolution of 1848, which was essentially a class war, Louis Napoleon Bonaparte (nephew of Napoleon I) was enthusiastically elected president of the Second Republic, riding on a wave of nostalgia for the Napoleonic legend. Within a few years, he acquired absolute authority, and in 1852 he was formally proclaimed Emperor of the French, with the magic name of Napoleon III. The Second Empire was his creation, with his political imprint as the first modern dictator and with his social stamp, whereby festivities and the active pursuit of pleasure were the order of the day. These policies appealed to the wealthy, but in the end they masked years of corruption and popular discontent. Nonetheless, the overall prosperity of Louis Napoleon's reign strengthened the role of the bourgeoisie, which established solid financial foundations. This class, with its wide-ranging constituencies, developed its own tastes and turned its attention to the "Arts" as an acceptable form of recreation.[5] The *grands bourgeois* who attended the painting Salons and theaters were joined by the artisans and clerks who were directly beneath them in the social scale; members of the weakened aristocratic class, who would number half a million by 1900, moved closer to the bourgeoisie in their artistic preferences and in their new positions as art patrons. Meanwhile, the large number of well-to-do men who had inherited great wealth from family property holdings or who had made fortunes from real estate during the upheavals generated by the emperor's city planner, Baron Haussmann, became a dominant force in society.

The combination of wealth and power with an appreciation of the "Fine Arts" gave the period its special distinction. When the Second Empire ended pathetically in September 1870 with the surrender of the French army under Napoleon III to the Prussians at Sedan, eighteen extravagant years, noted for a devotion to elegance and gaiety, had left their indelible mark on French social life. However, this signaled the last time in France that a monarch and his court would be able to impose a national lifestyle.

Two days after the fall of the Second Empire, the Third Republic was declared, and Adolphe Thiers, a statesman and historian, was named its first president. The Prussian army surrounded and besieged Paris, and by January 1871 its citizens surrendered after unendurable fighting and famine. The German Empire gained Alsace and Lorraine along with huge reparations — grievous losses that have caused permanent repercussions. In March, the Paris Commune followed, cutting the city off from the rest of the country and pitting the French against each other. A revolutionary municipal group, or "Commune," seeking to suppress any ideas of a new monarchy, fought a violent battle against the forces of the National Assembly at Versailles, who triumphed after a wretched two months. The Communards, in final desperation, tore down the Vendôme column and burned a number of public buildings, including the palace at the Tuileries. Financially, however, France recovered quickly, and despite the plundering in 1871, it became the banker of Europe for the next twenty years.[6]

Even though the Third Republic was essentially only a fragile balance of factions, and the country was beset by political, social, and economic upheavals, Paris retained its prominence

Fig. 1. Édouard Manet, *Music in the Tuileries*, 1862. Oil on canvas. National Gallery, London

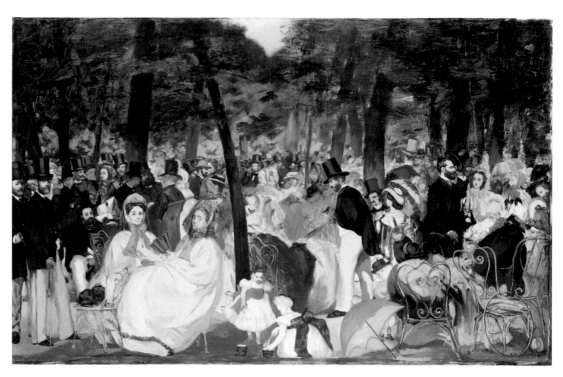

as a modern center for recreation. Forms of entertainment that were firmly established under the regime of the Second Empire were maintained and enhanced during the Third Republic. In 1876 Henry James wrote about the "amazing elasticity of France. Beaten and humiliated on a scale without precedent, despoiled, dishonored, bled to death financially . . . Paris is today in outward aspect as radiant, as prosperous . . . as if her sky had never known a cloud.[7] Notable writers and artists, particularly the Impressionists, who acted as witnesses to this period, have left a legacy that illuminates this world of pleasure, which reached its peak in the 1890s and continued until the Great War of 1914. Some artists and illustrators such as Daumier and, in later years, Théophile Steinlen and Félix Vallotton, assumed responsibility for satirizing the activities of the various political factions that were tolerated by the government: the monarchists and militarists of the right who were descendants of the Second Empire, as well as the socialists and anarchists of the left who were concerned with the problems of the oppressed and the economically exploited. Journals, prints, and posters focused on this political turmoil and interpreted the social issues for the general public.

The evocative terms *la belle époque, fin de siècle*, "the banquet years" refer to a significant and influential part of French history that one could

propose began around the close of the Universal Exposition of 1878. This impressive fair proved to the world that Paris had not only survived the demise of the Second Empire and the struggles of the Commune but had also regained its wealth and power. The Fourteenth of July 1880 could also be claimed as the opening of the *belle époque*, when Bastille Day was first officially observed as a national holiday in France.[8] Large sectors of the population gathered to participate in the dancing and to admire the government-sponsored firework displays and the tricolor flags, attesting to the general indulgence in pleasures throughout the city and country. Some historians believe that this initiated an era of greater consumption of alcohol as a social pastime and a greater searching for amusements. (Others have suggested that methods of documentation became more accurate.)

By 1880 the Impressionist artists had already launched four group exhibitions, in 1874, 1876, 1877, and 1879, and were preparing for a fifth. They had lived through the new planning of Paris under Louis Napoleon and Haussmann and had accommodated themselves to the multitude of changes as they formulated and established their careers. Works by Monet and Renoir during this period frequently emphasized the animation of the cityscape with strong patterns of light and shadow. Even much earlier, Manet had been

12

painting and exhibiting pictures that were con-sciously linked to contemporary subjects. In *Music in the Tuileries* of 1862 (fig. 1), the artist used innovative pictorial forms and brushwork to show a suitably fashionable occasion as exemplified in his own life, suggested by the daily five-o'clock concerts. Manet's keen powers of observation have been inextricably linked to the poetic writings and perceptions of Charles Baudelaire, whose essay "The Painter of Modern Life" was published in 1863.[9]

The role of the artist as observer, or *flâneur*, was clearly recognized by Baudelaire and the modern painters of the day. The *flâneur* was defined as the purposeful male stroller; a writer or illustrator who looked about with the acute eye of a detective, sizing up persons and events with a clinical detachment; an ambulatory naturalist.[10] To varying degrees all the artists were *flâneurs*, from Manet and Degas to artists such as Jean Béraud and Jean-François Raffaëlli, who were committed to recording a "transitory bit of modern life" but did not embrace the Impressionists' techniques or pictorial style (see cat. 4, 45). Béraud was not as objective in his observations as the Impressionists; rather, he provided detailed information about the contemporary urban scene, including subtle depictions of the "universal" *flâneur* (cat. 5). This male personage, who lived his life on the boulevards, was a member of the upper class; he resembled his peers in gesture, pose, and dress, but his finely tuned skills as connoisseur, conversationalist, and — in Baudelaire's words — as "passionate spectator" distinguished him from his confreres. Significantly, he preferred a civilized setting and was untroubled by the deprivations of others. He was a unique Parisian type and a phenomenon of his time and place.

An exceptional depiction of Paris at leisure is Renoir's painting *Ball at the Moulin de la Galette* (fig. 2), which was shown at the third Impressionist exhibition in 1877.[11] Renoir chose as his subject a Sunday afternoon outing at the open-air dance hall in Montmartre. Young men and women of the working class with limited free time enjoy the agreeable setting; only an occasional top-hatted figure, possibly of an upper-class gentleman, can be detected. The spacious garden, the gas candelabra hanging from a trellised roof, and the green outdoor framework, partly visible, clarify the physical surroundings. In describing the painting in 1893, the art critic Gustave Geffroy

placed it in the context of pleasurable entertainments in Paris: "*Ball at the Moulin de la Galette* is one of the most successful products of direct observation . . . it expresses the intoxication of dancing, the noise, the sunshine and the dust of a dance in the open air, the excitement on the faces and the casual poses, the rhythmic swirl of the dresses . . . a burst of passion, a sudden sadness, a quick flare-up, pleasure and fatigue."[12]

By 1881 the controversial government-sanctioned Salon exhibitions had given way to those organized by artist-run professional associations. At this time, Manet made preliminary sketches for his *A Bar at the Folies-Bergère* (fig. 3), which was shown at the Salon of 1882. It describes a major music hall whose history began in 1869 during the Second Empire and brings to life a spectacular form of entertainment that gave the city its reputation as the center of an ever increasing pace of recreation. (An illustration of a seating plan announced that the Folies-Bergère provided "a variety of spectacles — Operettas — Ballets — English pantomimes — Acrobats — Gymnasts — Eccentricities of every kind.")[13] Even though the Folies-Bergère charged an admission fee, it drew its large audience — in 1879 almost 500,000 people — from the growing bourgeois public and the tourists, as well as from the affluent. Contemporary novelists and guidebook writers have recorded the interior of this impressive hall with its promenades, balconies, several bars, performance stages, reserved boxes, mirrors, and electric chandeliers that cast a fine white light. "The soul of Paris is concentrated and inhaled in this soft, perfumed atmosphere. . . . The eye is enchanted, the ear charmed, and you are captivated, dazzled by it all."[14] Selected features of the music hall were visually immortalized by Manet, who assembled them into this remarkable painting, while acknowledging the complex yet ambiguous role of the barmaid, who gazes impassively at the viewer.

The decade closed with the Universal Exposition of 1889, when even the French writers ran out of superlatives. In size and attendance, the fair was colossal; from one end to the other of the more than two hundred acres, there was a merging of mechanical progress with architectural and artistic invention, all officially and enthusiastically supported by the government. The construction of the iron-framed, thousand-foot Eiffel Tower forever changed building specifications, and the immense Galerie des Machines, covering

Fig 2. Pierre Auguste Renoir, *Ball at the Moulin de la Galette*, 1876. Oil on canvas. Musée d'Orsay, Paris

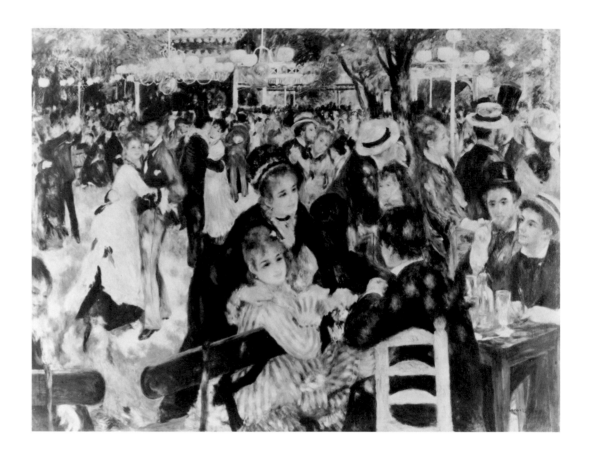

Fig. 3. Édouard Manet, *A Bar at the Folies-Bergère*, 1881-1882. Oil on canvas. Courtauld Institute Galleries, London, Courtauld Gift

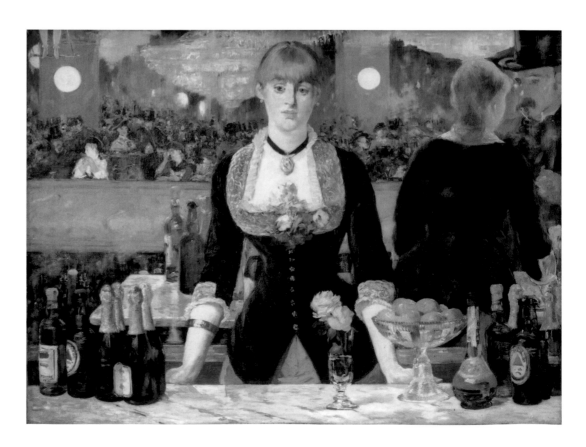

some fifteen acres, brought together nearly sixteen thousand machines that demonstrated the profound results of the Industrial Revolution and left observers engulfed with a sense of anxiety and "wearisome proportions." Nevertheless, the public fascination with spectacle and festival drew millions of Parisians, provincial visitors, and foreign tourists to an unforgettable experience of pleasure and celebration.

The 1880s also witnessed four more Impressionist shows, including the eighth and final exhibition of the group, which took place in 1886. It was held on the Boulevard des Italiens above the fashionable restaurant Maison Dorée and across the street from the equally popular and stylish Café Tortoni. Shortly before the exhibition opened, a proposal was made to install electric lights, evidence of the rapid changes that were taking place in the 1880s.[15] Although attendance was small, the numerous critical reviews called attention to the Impressionists' space as well as to the nearby art dealers' galleries, Durand-Ruel and Georges Petit, and to the simultaneously held and competitive Salon exhibition installed at the Palais de l'Industrie.

Politically, the 1890s were overshadowed by scandals and corruption, especially by the failure of the Panama Canal venture, which had gone bankrupt as the result of widespread government dishonesty and mismanagement. The disenchantment felt by antagonistic factions — monarchists, Bonapartists, aristocrats, French Catholics, and republicans, alike — coupled with an extreme form of nationalism created the climate for the Dreyfus Affair. It began in the autumn of 1894 when a Jewish army captain, Alfred Dreyfus, was unjustly accused and found guilty of treason. When Émile Zola published his letter "J'Accuse" in January 1898 denouncing the government and the military, the Affair exploded and rocked the nation for many years. All the latent oppositions and prejudices, including virulent anti-Semitism, divided France, and every professional group was split over the Affair.

Writers, painters, sculptors, and illustrators took sides in the case. Pissarro, Monet, Signac, Cassatt, and Vuillard were Dreyfusards against Degas, Renoir, and Cézanne, who were strongly anti-Semitic and anti-Dreyfusards.[16] Yet, curiously, none of their paintings from these years reflect the extraordinary strife that was raging about them. Other artists such as Steinlen, Ibels, and Vallotton were drawn into the dispute and fre-

quently conveyed biting social messages in journals and newspapers. They often went further by designing posters and broadsides to advertise these publications. Owing to the proliferation of artistic journals, the introduction of new photo-printing processes, and the passing of the 1881 Freedom of the Press law, which greatly reduced censorship, illustrators, unlike painters, were able to make bold use of the popular imagery both for and against Dreyfus as the case unfolded. The great number of political images and words manipulated and interpreted the Affair in the media. The pardon of Dreyfus in 1899 and his eventual reinstatement as a captain in 1906 finally brought to an end the controversy that had so profoundly affected the national life of France.

Given the decade's tensions and conflicts, which included scattered anarchist uprisings and bombings — nearly a dozen bombings took place between 1892 and 1894 — it is difficult to believe that the government forged ahead, after another eleven-year interval, with a colossal extravaganza in 1900. The Eiffel Tower was surrounded by pavilions exhibiting fine arts and domestic designs, and even a military division was installed in an amusement park. Nearly fifty million visitors traveled over the immense acreage, seduced by new and enticing commercial products. Proportionately, the amusements and special festivities were expanded beyond the scope of the 1889 fair, and a brilliant light show sponsored by the Palace of Electricity demonstrated new horizons to the public. Loie Fuller, the American dancer who became a Parisian star (cat. 166), had her own small building where "she danced through beams of electric light colored by moving cellophane filters."[17] Other inventions, such as an electrically powered sidewalk that moved people through the fair, anticipated the impact that these technological breakthroughs would have on everyday life in the future. Not only were there commercial advancements in electricity, but after 1900 the music halls, cafés-concerts, and other centers of recreation showed off spectacular lighting installations. In many middle-class homes, however, candles and oil lamps were used well into the twentieth century.

Artists continued with enthusiasm to find modern motifs and subjects in Paris. The cafés, music halls, racetracks, and boulevards were always important to Degas, Seurat, Van Gogh, and Toulouse-Lautrec, and the lively visual aspects of the city also absorbed Bonnard and Vuillard. Picas-

so, who first visited the capital in late 1900, was inspired by Lautrec and favored the circuses and itinerant performers. As the century drew to a close, Paris, with a population of nearly three million, was still at play, producing spectacles and encouraging every possibility that would turn daily experiences into delightful amusements. This brilliant city suffered its injustices, its poverty, and its crime, yet when one thinks of it in the second half of the nineteenth century, the image that is retained is one of "graces and joys." It was a unique period of intoxication and excitement that could not be sustained and appropriately drew to a close with the first World War. We owe a debt to the astonishingly productive painters, printmakers, photographers, and illustrators who recorded this intense and legendary aspect of French life and who made Paris in this celebrated period the unrivaled world center for the arts.

Notes

1. See Dean MacCannell, *The Tourist: A New Theory of the Leisure Class* (New York, 1976), p. 60 and note 6. See also Walter Benjamin, *Charles Baudelaire: A Lyric Poet in the Era of High Capitalism*, trans. Harry Zohn, 2nd ed., paperback (London, 1985), pp. 155-176.

2. Benjamin, *Baudelaire*, p. 166.

3. Theodore Zeldin, *France 1848-1945: Ambition and Love*, paperback (Oxford, 1979), p. 11.

4. Ibid., p. 15.

5. Philadelphia Museum of Art, *The Second Empire 1852-1870: Art in France under Napoleon III*, exhib. cat. (1978), p. 13.

6. Jean Roman, *Paris, fin de siècle*, trans. James Emmons (New York, 1960), p. 8.

7. Henry James, *Parisian Sketches: Letters to the* New York Tribune, *1875-1876* (New York, 1957), p. 40.

8. Charles Rearick, *Pleasures of the Belle Epoque: Entertainment and Festivity in Turn-of-the-Century France* (New Haven, 1985), p. 3.

9. For Manet as observer, see Robert L. Herbert, *Impressionism: Art, Leisure, and Parisian Society* (New Haven, 1988), chap. 2, especially pp. 37-39.

10. Ibid., pp. 33-34.

11. Given the geographic restraints of the exhibition, according to which works would be borrowed only in the Northeast of the United States, this painting by Renoir and similar superb depictions of Parisian leisure were not requested.

12. Quoted in John House and Anne Distel, *Renoir*, exhib. cat. (London, 1985), p. 212. For another point of view see also Herbert, *Impressionism*, pp. 136-139, who discusses Renoir's awareness of social truths but his need to sublimate this to his idealistic illusions.

13. See Juliet Wilson Bareau, "The Hidden Face of Manet," *The Burlington Magazine*, special issue (exhib. cat.), 1986, p. 78.

14. Ibid, p. 77.

15. Charles Moffett et al., *The New Painting: Impressionism 1874-1886*, exhib. cat. (San Francisco: The Fine Arts Museums, 1986), pp. 13 and 427.

16. For an important analysis of art and the Affair, see Norman L. Kleeblatt, ed., *The Dreyfus Affair: Art, Truth, and Justice*, exhib. cat. (Berkeley, 1987), which includes a number of essays and illustrations.

17. Miriam R. Levin, *When the Eiffel Tower Was New*, exhib. cat. (South Hadley, Mass.: Mount Holyoke College, 1988), p. 36.

Nineteenth-Century Cafés: Arenas of Everyday Life

Susanna Barrows

However diverse their observations, no commentator on nineteenth-century Paris could overlook its most characteristic fixture: the café. Other nations, to be sure, had their share and panoply of drinking establishments, but by common consensus, none replicated the ambience of the French café. Morand may have pushed truth to hyperbole when he claimed, in 1855, that the café was "one of the great elements of Parisian life, and 30,000 individuals would hang themselves on Sunday night if they were closed, as in London."[1] But his fantasy suggests a fundamental observation: the café was the primary theater of everyday life in nineteenth-century France. The scenarios, of course, were as diverse as the locales themselves, but all bore witness to the changing cultures of drink, politics, and distraction.

Until the nineteenth century, drink was a luxury for the well-to-do. While the richest of France's notables could indulge in the practice of daily drinking, the mass of the French population turned to liquor only on rare and largely ceremonial occasions, on feast days such as Mardi Gras, festivals of saints, marriages, and the like. The traditions associated with drink varied no less than costumes, dialects, or diet; France itself was a patchwork wrought of local custom, linked by a common thread: most of its people lived on the margins of poverty.

But on those rare days of general drinking, drunkenness was the general rule. Countless songs and poems beloved by the common people, popular illustrations depicting Mardi Gras, and ample reminiscences recorded by the police bear witness to the ubiquity of inebriation during the "fat days" of the Ancien Régime.[2] Drunkenness, even to the point of vomiting or losing consciousness, received almost no popular censure. In a world where spirits in any form were dear, the ability to consume a great deal on a single outing represented to poor people a badge of prestige and a display of well-being. Middle-class reformers, as late as the 1860s, were mystified by the sight of Parisian workers returning to the city on a Sunday evening ("the whole family was walking along perfectly sober until they saw the *octroi* — the tax barriers — then they started to sing, wobble, and shout"). Local police knew better; they could interpret the behavioral shift with insight ("These people were showing off to their neighbors").

Beginning in the 1830s, as industry and transport began to change the nature and volume of French production, as roads, waterways, and railroads pierced the countryside, the wine trade and the distillation of hard liquors revolutionized French drinking practices. Industrial liquors, distilled from beets, sugar, grains, or potatoes, became one of the fastest-growing industries in the North of France and gradually lowered the price of spirits to the level of ordinary people's budgets. Improvements in French transport allowed producers of wine and spirits to move their products from one corner of the country to another; Paris was one of the first beneficiaries of this expansion. Cheap prices for alcohol, widespread and rapid distribution, and persuasive advertising broke down many of the particularities associated with local patterns and rhythms of drink.

By midcentury, the price of wine, liquor, and beer had dropped dramatically and now fell within the budgets of all who were not wholly destitute. Within forty years, drinking passed from the realm of the exceptional into the everyday. At a very modest price, it offered laborers an antidote to the cold, a substitute for filling one's stomach, and a means for alleviating hunger. Because food and fuel prices remained relatively high and wages relatively stable, alcohol became the sector of working-class budgets that expanded the most rapidly between 1840 and 1900. Surveying working-class life in the 1860s, the Catholic sociologist Paul Leroy-Beaulieu was forced to admit that, at least in urban areas, cafés had become the "cathedrals of the poor," secular churches offering comfort, rituals, and solace to the dispossessed. Cathedrals, indeed, but with this difference: the host being distributed was the gift of Bacchus, not of Christ. And that gift was richly given; alcoholic consumption tripled between 1840 and 1870, and the variety of alcoholic beverages expanded accordingly.

Nature's harsh hand further transformed the new world of drink. In the late 1870s phylloxera struck French vineyards. Throughout the country, worried winegrowers watched grapes wither on the vines, and the national consequences were disastrous. Over ten percent of the French population faced personal ruin, while the ordinary drinker was forced to choose between an expensive and usually unpalatable wine and a substitute alcoholic beverage: beer, absinthe (first popularized by French soldiers returning from Algeria in the 1830s), Vermouth, Byrrh, rum, or eau-de-vie.

Fig. 1. Honoré Daumier, *The Muse of the Brasserie*, 1864. Lithograph. Museum of Fine Arts, Boston

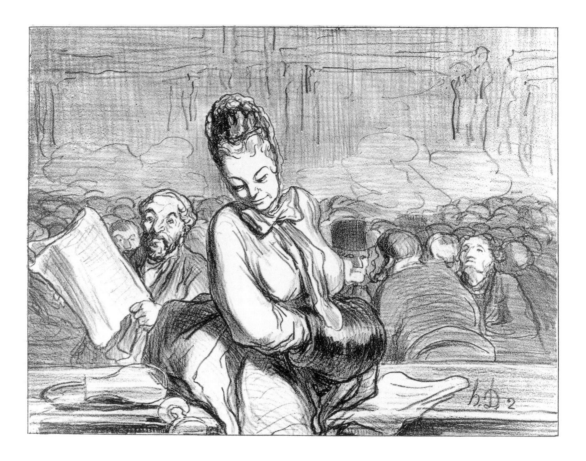

Thanks to the implantation of vines from California and to the French government's decision to encourage the massive implantation of vineyards in Algeria, wine reappeared on the tables and counters of both Paris and the provinces by the 1890s. But the new habits of alcoholic consumption were not easily sloughed off; millions of French citizens simply added wine to their already ample intake of aperitifs, *digestifs*, cider, and beer. By the turn of the century, France, the nation whose international prestige had been slipping since the fall of Napoleon, found itself unsurpassed in at least one respect: she had the highest per capita consumption of alcohol.

This alcoholization of the French did not pass unnoticed by reformers, social critics, scientists, and governmental authorities. Doctors, scientists, and a handful of public servants had long been alarmed by the troublesome increase in drinking, but widespread awareness of the problems associated with excessive drink came late to France. In 1852 the Swedish physician Magnus Huss coined the word "alcoholism"; his treatise was translated and awarded a prize by the French Académie de Médecine, then dismissed as if it had concerned

subtropical bacilli wholly unknown to France. "There may be a good many drunkards in France, but happily there are no alcoholics." Twice during the reign of Louis Napoleon, the French legislature discussed the possibility of instituting a law against public drunkenness, only to reject such legislation as interfering with the liberty of the liquor trade. In 1875, the *Grand dictionnaire universel du XIXe siècle* could still reassure its readers that "in our country, although drunkenness is not unknown, it is far from having a character as repellent and as nefarious as in England and America."[3]

Denial of the existence of French "alcoholism" was one way to skirt the problem; elaborate distinctions drawn between "healthy" and "dangerous" forms of alcohol was another. Throughout the century, the French medical and scientific community argued that wine and, to a lesser degree, beer and cider, were "hygienic" drinks — good for one's liver, an aid to digestion, a stimulant for work, a necessity for nursing mothers, a cure for "flatulent appetites." Distilled beverages, especially the industrial alcohols produced in the North, were seen as the culprits that accounted

for the rising statistics of alcoholism. But the statistical exposés and medical lectures did little to curb a national predilection for drink; as the nineteenth century drew to a close, the French drank more alcohol than any other nation.

Much of the revolution in drinking was a public spectacle, visible in any one of a dozen types of drinking establishments all legally subsumed under the category *débit de boisson*. Compared with other nations, the French have always consumed a remarkably high percentage of their alcohol outside the confines of the household. As early as the seventeenth century, notables and sturdy bourgeois took their libations in the dignified surroundings of the café. Urban dwellers of the simpler sort, artisans and skilled laborers, found refreshment at less elaborate *débits*, at wine shops, at taverns, or at cabarets, which were concentrated in working-class faubourgs. But the most popular *débits* — *the goguettes* and *guinguettes* (suburban and rustic cafés) — lay outside the city limits, because liquor consumed there was not subject to urban surtaxes and hence slightly cheaper. These institutions did almost all their business on holidays, Sundays (the day for family drinking), and Mondays (the day reserved for male workers honoring "Saint Lundi"). Some, like the Californie, served at least five thousand clients a day rough wine and robust cuisine.

By whatever name, cafés were closely monitored by the government, which required each proprietor to be licensed by local authorities. By the 1830s a special arm of the law, the *police des débits de boisson*, watched over the drinking establishments of many cities and large towns. In the countryside, local minions of the law, the *garde champêtre* and the mayors, exercised similar functions. Municipal regulations controlled the hours of commerce (especially the closing times of 10 or 11 p.m. in cities, 9 p.m. in rural areas), forbade the sale of drinks during holy offices, and counseled proprietors not to permit the singing of political songs or the recitation of subversive ballads. In 1835, some 283,000 cafes were sprinkled throughout France. Their distribution was uneven; large cities like Paris or Lyon boasted most of the elite cafés; areas just outside the octrois catered to the popular classes, while the rural *auberges* offered drink to local residents, food and lodging to the traveler.

In a world set into rapid motion, cafés came to fill a cluster of diverse and basic needs. Almost all of them served food, since urban laborers had neither the time nor the means of transport to take their meals at home. No less important, they assuaged thirst. Until the late nineteenth century, potable water was a scarce commodity in the urban landscape. While Baron Haussmann's rebuilding of the city's water supply in the 1850s and 1860s had improved the quality of Parisian tap water, public drinking fountains supplying spring water were virtually unknown before the British philanthropist Richard Wallace gave them to the capital a decade later. In most working-class neighborhoods there was an average of only one fountain for every fifteen hundred residents.[4] With some justice, French workers regarded water skeptically as dangerous and a potential carrier of disease. To be labeled a *buveur d'eau* by fellow workers was to be triply insulted: as someone who was destitute, unmanly, and short-sighted. Working for long hours at heavy tasks, often sweltering in shops, factories, or alongside dusty construction sites, laborers relied on their cafés to furnish the very staff of life: food and drink.

The great waves of nineteenth-century migrants within France came to regard the café as the only fixed point in an unfamiliar universe. Often illiterate, and ill-equipped to navigate about strange towns and bewildering cities, newcomers, especially those speaking in dialects, learned quickly to make a map of their surroundings whose major landmarks were cafés. The very names given to many of these establishments — the Golden Lion, the Grapes, the White Sheep being among the most popular — were announced with iconographic signs affixed to their exteriors. These icons allowed rural migrants to be reunited with their fellow villagers within hours of their arrival in cities hundreds of miles away.[5] And they returned there often, to converse in their mother tongues, to reenact rituals in part transplanted from their villages, in part wrought out of the conditions of their urban labors.

Cafés constituted, in fact, the placement bureaus for both day and seasonal workers. In Paris, masons clustered in the *débits* adjacent to the Hôtel de Ville, metalworkers gathered in the side streets around the Place de la Bastille, while woodworkers and furnituremakers awaited employment in cabarets dotting the Faubourg St. Antoine. Each of these trades had a customary claim to the specific locales of drink and to the variegated rituals that linked work to the consumption of alcohol. When a new mechanic was

hired in the working-class district of Belleville, the newcomer was obliged to furnish a *quand-es?*, the ritual buying of rounds of drinks for all the shop's veteran laborers. Parisian moving-men and painters gathered several times each morning for their own special coffee break, white wine, which even today is described as a *café des déménageurs*.[6]

Beyond providing the basic necessities, cafés offered workers specialized networks for obtaining housing and financial credit. Migrants tramping to towns and larger cities found crowded but cheap quarters above rural *auberges*. It was far from unusual to see urban cafés in working-class neighborhoods function also as boarding houses or as informal housing bureaus for would-be lodgers. In between pay days, café regulars often asked their proprietors for an *ardoise*, a charge account or small loan to tide them over to their next payment, which often took place at the counters of the same cafés. Independent shopkeepers and skilled artisans regularly retired to their local *débit* to seal business arrangements with a *verre* (a glass), since sharing a drink constituted a ritual contract, the customary French equivalent to the English gentleman's handshake.

However arduous the rhythms of labor in the nineteenth century, migrant workers still had time on their hands — evenings, holidays, Sundays, and in some parts of France, Mondays. Lodged in dreary, crowded quarters, urban workers could find in cafés the amenities that their domestic surroundings lacked: heat, light, and distraction. Most had been raised in family circles that valued sociability over privacy; once installed in the city, they turned quite naturally to the café for their new sense of community. There they could smoke; if literate, read newspapers or pamphlets, if illiterate, be read to; there they could digest and editorialize on the events of the day, or keep in touch — by word of mouth or the rare letter — with their families in the countryside. As news centers, singing and gambling societies, employment centers, housing bureaus, essential half-way spaces between public and private, branches of the village grafted on the city, as reading rooms and libraries, cafés by the 1850s offered to all but the utterly indigent a modicum of decency and the good life. "Here," wrote the popular novelist Jules Vallès, "One can have all the luxuries of a millionaire for a few sous."[7]

Indeed, the expenditures of workers in such modest pleasure palaces elicited the concern of social reformers and writers on the social question as early as the 1840s. Armand Audiganne, René Villerme, and Leroy-Beaulieu decried the improvidence of the laboring classes, who appeared all too willing to squander a week's wages in a single evening. Surveys of the budgets of artisans in Paris and other urban areas suggested that increased wages quickly passed into the hands of the tavern keepers, and that the laboring classes would never emulate the thrifty habits of the bourgeoisie. The Parisian Chamber of Commerce estimated that in 1848 a construction worker spent more of his earnings on alcohol than on lodging for his family. But their calls for prudence and sobriety found few echoes in popular practice.

Even more than improvidence, French governments feared the dangerous political activities that transpired within the confines of cafés. Until 1880 all French regimes, be they monarchical, imperial, or republican, rightly viewed the cabaret, the *goguette*, the *auberge*, and the café as the prime places for political organization, for the transmission of news and dangerous ideas, and for the mobilization of strikes and popular protest. To the novelist Honoré de Balzac, they were the "parliaments of the people"; to the politician Leon Gambetta, "the salons of democracy." Following each of France's waves of revolution in the nineteenth century (after 1830, 1848-1851, and 1871), "the strictest surveillance" of cafés was ordered by governments eager to dismantle forms of working-class and radical social organization. The very militance of the French working classes produced its nemesis: a vast bureaucracy intent on recording their every move. Its legacy to twentieth-century scholars: perhaps the richest set of documents on all aspects of café culture for any country in the nineteenth century.

As cafés grew in number, so did the anxieties of the men of order. By 1851, as Napoleon III installed a more sophisticated machinery of political repression in order to dismantle the Second Republic, he immediately singled out the café for special surveillance. On December 29, he issued orders that held a sword of Damocles over every drinking establishment in the land. He gave prefects the discretionary power to close down any cabaret, *auberge*, or café. Napoleon's motives were frankly political; he held cabarets, especially those in the countryside, responsible for

"disorders," the rise of secret societies, and what he called the "progress of despicable passions." Under the twin pretexts of politics and immorality, any existing café could be closed by prefectoral fiat, any new ones refused licenses to open. Within three years, the number of such subversive forums had been cut from 350,000 to 291,000.[8]

As lunchrooms, watering holes, and centers for political mobilization, cafés were multipurpose institutions, closely patterned after the needs of the common citizen. But to enumerate these diverse functions is not to bring them back to life. Like X-rays of a loved one, such a catalogue of utility records a structure that, though real, appears lifeless, almost unrecognizable to subject and viewer alike. Cafés were not simply "useful" as clearing stations for people on the move; they were the very houses of popular culture, the primary arenas of ritual, and the central stages for social drama. The participants were the regulars, men who assembled at regular hours, greeted each other with handshakes and secret nicknames, exchanged ritual gifts in the form of rounds, and often occupied for decades the same place at the same table or counter. The cafés were ideal settings for the symbolic reversals of status and the creation of mock hierarchies.[9]

As highly specialized institutions, almost all cafés depended upon a steady clientele, a particular set of activities (*boules*, billiards, music, card-playing, dances, or — that cheapest and most dangerous activity — *rixes* [brawls], which have been described as "the duels of the poor").[10] No less ordered were their rhythms of commerce. Workingmen in cities could be seen fortifying themselves at five in the morning on their way to work, at noon sharing an aperitif, after lunch savoring a *digestif*, and at five in the evening honoring the "hour of absinthe." Each of these bands of regulars was a ceremonious circle; each had its particular paroles. By the 1880s the densely textured working-class slang and patois had become so extensive that no less than a dozen dictionaries of French argot found their way into publication. If workers' own reminiscences are to be believed, café discussions represented the most eloquent moments in the discourse of ordinary people. Here were retold the events of the day, in dramatic, playful, musical, or poetic form. Here laborers could grumble against harsh foremen, deliver sarcastic gibes against kings, presidents, or emperors; here they could comment on the peccadilloes of nobles, offer scathing pastiches of priests, local bores, tax collectors, meddlesome neighbors, or haughty moralizers. The rich reshaping of daily experience into café discourse allowed every man to be something of a Homer, every day to become a chapter in the epic drama of an otherwise unremarkable life.

Often underdogs, victims in the world of labor, café habitués did more than bring the mighty low. By their very choice of nicknames, they could appropriate for themselves the symbols of power and authority. Anyone who has worked in nineteenth-century archives has been amused by the colorful adoption of aliases that supplement the legal names of individuals interrogated by the police. Like the wearing of a mask, these nicknames served as disguises to the prying outside world of public order — the world that required each laborer to carry a *livret* (labor passport) — but were easily recognizable to members of one's particular circle. The verbal equivalent to the disguises adopted in times of Carnaval, these humorous sobriquets often pointed to a mocking or reversal of social hierarchies. Although most attempts to translate slang are doomed to failure, let me hazard a few examples. Common nicknames in the 1860s included Emperor of the Drunkards, King of the Pigs, Savior of the World, President of the World in 1860, Mohammed of the Bars, Le Grand Louis, the Curé, or the Pope of the Cabaret. Other nicknames evoked masks directly: witness Messieurs Herring-Head, Woodcock, Wig Face, Baldy the Terrible, Steel-Head. Still others suggested awesome alcoholic capacities: Wooden-Stein, Corkscrew, Son of Fatso, and Celery Foot. Many cafés even found their space baptized in telling ways. Places boasting more than one room often named the more public space the "Chamber,"[11] and the back room, reserved for the inner circle, the "Senate." Larger establishments with three rooms differentiated them by reference to one of the three estates of the Ancien Régime.

In relatively tranquil times, these symbolic reversals of power were hardly more threatening to the social and political order than the ritual inversions of Mardi Gras.[12] But during periods of revolutionary protest or times of severe government repression, the nature of café rituals could move from innocuous satire to subversion, from critique to popular assaults on the regime. In the past ten years, social historians of mid-nineteenth-century France have richly documented the centrality of the café as the primary point of political mobilization during the Second Republic (1848-1851).

During the massive insurrection that followed the coup of Louis Napoleon in December 1851, café owners were among the ringleaders of the rebellion, and nearly sixty thousand were shut down for alleged subversive political activities between 1852 and 1855.[13] New laws against sedition made any critique of the regime a crime, be it the singing of the Marseillaise, the insulting of local notables, the public complaints against unpopular wars or the high cost of bread.

Especially in the 1850s, Louis Napoleon's system of repression was both sophisticated and severe. No less than 26,884 citizens were arrested as dangerous to the regime; some 9,581 were eventually deported to Algeria or other French penal colonies. But despite these draconian measures, he could not wholly eradicate radical critiques of his regime. Of 528 trials for "seditious speeches" recorded by the emperor's courts in the 1850s, 377 mentioned the locale in which the offensive language had been voiced. The majority of these verbal assaults transpired in cafés, *auberges*, and hotels.[14] The seditious speech acts themselves offer a colorful and richly textured picture of the manner in which citizens chose to voice their disaffection in a period of massive repression. The language itself was "rough": "Napoleon is an ass-hole, a *con*"; "I would like to rub his face with shit"; "The Empress Eugenie is a whore." Rejecting the bureaucratic and "proper" language of the regime, Napoleon's critics willfully intertwined political commentary, obscenity, the popular language of the marketplace, and the patois of their regions. Using icons and images to reinforce their sentiments, dissident Frenchmen spat on images of the emperor, insulted coins and statues that bore his likeness. How much had alcohol in fact loosened the tongues of these critics? When brought to trial, at least 150 of them claimed that they had been drunk at the time of the speech. But their defense of inebriation should not be taken at face value, since drunkenness was commonly accepted as a mitigating factor that lightened their sentences.

During the so-called liberal phase of the Second Empire (the decade of the 1860s), the statutes against sedition and the power of prefects to close cafés remained intact, but the regime became far more tolerant in practice. By 1870, on the eve of the Franco-Prussian war, the number of cafés throughout France had reached some 360,000 — far more than during the Second Republic. Governmental surveillance of French drinking establishments now focused on a broader range of café activities than politics alone — licentiousness and drunken comportment found their way into dossiers on "dangerous" *débits*. But the regime that had tried to eradicate political activity decided that the rights of Frenchmen to besot themselves or to frequent prostitutes were apparently inalienable.

Then came the Franco-Prussian War and the Commune. Reactivating the existing machinery of repression, the head of the French government, Adolphe Thiers, urged a thorough purge of all cafés whose proprietors or clientele had sympathized with the Commune or who dared voice criticism of the new, and largely monarchical, regime. The close surveillance was quickly extended to all aspects of café culture. In November 1872, the Minister of the Interior lashed out at those "veritable schools of depravation," the cafés-concerts. Prefects were instructed to "repress energetically" any establishment that permitted "obscene songs, smutty sketches, and all other items which might compromise morals or the public order."[15] The following year the National Assembly saw fit to declare public drunkenness a crime and to equate obscenity, immorality, and vice with revolution. A new hegemony over the nonpolitical activities of citizens became the order of the day. Forms of café sociability that had been tolerated during the Second Empire — the right to intoxicate oneself, to employ waitresses, to install a piano, or to sing slightly off-color ditties — were now declared illegal and, indeed, associated with political subversion. Such a conflation of politics and morals signaled a new phase of state control over the citizen and social space. The new restrictions on cafés now presumed to enforce not simply political but, in effect, a total control over one's public comportment.[16]

Both the law against public drunkenness and the purge of cafés were regarded by France's workers, republicans, and men and women of the Left as class conspiracies, as secular arms of political repression. The Societé Française de Tempérance, established immediately after the Commune, railed repeatedly against the ravages of alcoholism among French workers in both the city and the countryside and sponsored competitions for the moral reform of the "dangerous" classes, but not one of their articles conceded that alcoholism was a disease that could cross class lines. Until the mid-nineties, the subject of alcoholism

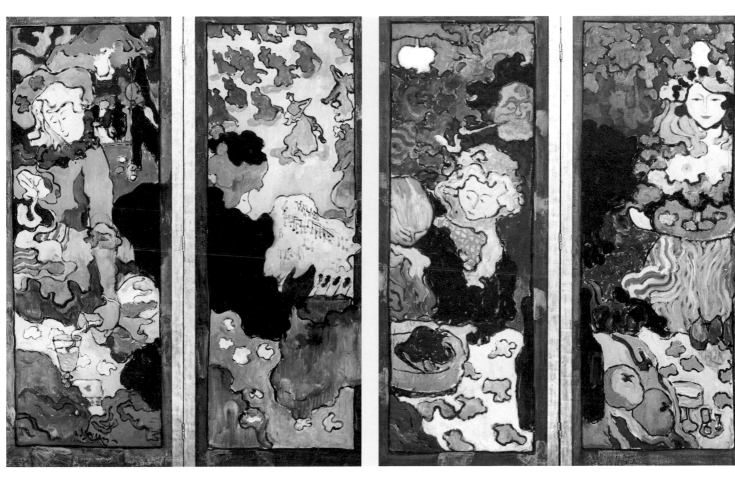

Fig. 2. Armand Seguin, *The Delights of Life*, 1892-1893. Oil on
canvas with painted and gilded frame. Private Collection

remained a broken dialogue. Moral reformers of
the bourgeoisie lectured workers on the scourge
of alcoholism; workers and socialists turned a
deaf ear to both the reformers' rhetoric and their
research documenting the rising consumption of
alcohol throughout the land.[17]

The conflation of politics, immorality, and
drink was never more sharply delineated than
during the 1870s. When the "pope" of the moral
order, Marshal MacMahon, assumed the presi-
dency of the Republic in May 1873, the repres-
sion of the cafés grew to draconian proportions.
MacMahon's prefects were told to establish a
more severe curfew on all drinking establish-
ments (8 or 9 o'clock in the countryside, 10 or 11
in most cities), to scrutinize all those employing
waitresses, and to shut down many of them as a
"moral lesson." Any rumor of left-wing sympa-
thies, any hint of unseemly or familiar behavior
could trigger a departmental sweep of the cafés.
When a detailed survey of the *brasseries à femmes*

in Lyon reported that the "eccentrically" clothed
women addressed their clients with the familiar
tu or permitted an occasional squeeze of the
waist, all such establishments were outlawed.
Anonymous letters denouncing particular *débi-
tants* as "radicals" or morally suspect were suffi-
cient grounds for prosecution and closing, even
when the local gendarmes could find no evidence
of illegal activity.

The worst was yet to come. After the *coup de
seize mai* in 1877, the Ministry of the Interior tel-
egraphed all prefects to remind them that cafés
could not allow the reading out loud of newspa-
pers, professions of political opinion, political
discussions; nor could they display electoral pos-
ters, leaflets, or ballots. The prefects themselves
were encouraged to use any pretext, however min-
imal, to shut down a representative sample of the
débits.[18] Of the 2,200 cafés closed that year, not
one was cited as a café sympathetic to the anti-
republican head of state, Marshal MacMahon.

Despite his repressive measures, MacMahon's moral order did not destroy the political culture of the cafés. In Paris, where the police preferred eavesdropping upon popular sentiment to wholesale closing of the cafés, daily reports underscored the political preoccupations of workers' grumbling in their local haunts. "You must frequent the workshops and the cafés where they gather in little groups to have an exact idea of the sentiments of the mass toward the president," confided one spy. And those sentiments were expressed in the rough pejoratives of common speech. MacMahon was derided as a a drunkard, a "shit," a pig, a coward, and presumably worse, since many reports prudishly claimed they preferred not to reproduce the exact language.[19]

When the republicans finally secured the reins of state in 1879, they took swift action against an abuse of the prefectoral powers over the café. Within a year, the new regime passed a law guaranteeing the freedom of political expression in all cafés. As the charismatic republican leader Leon Gambetta had maintained, cafés were the "salons of democracy," and as such, they deserved their own "constitution." Under the new law of 1880, prefects could no longer close any establishment for reasons of "public security"; local authorities were given responsibility for monitoring brawls, clandestine prostitution, and other "offensive" disturbances. Thus, by the closing decades of the nineteenth century, the great fear of politics disappeared from the culture of the café; in its fading shadow grew the great fear of sexual license.

After 1880 the lifting of restrictions on cafés triggered an immediate increase in their number. Within five years of the passing of the law, 50,000 additional such establishments sprang up across the land; by the turn of the century, France claimed 435,000 (twice the number of cafés today) — one for every eighty inhabitants, man, woman, and child. Paris alone had nearly 30,000 cafés in 1895, which were densely but unevenly dotted across the city's neighborhoods. Near the Bourse (Stock Exchange) or Les Halles, there was an average of one café for every inhabitant, while in the wealthiest parts of Paris around the École Militaire or in the exclusive sixteenth *arrondissment*, cafés catered to an average of 150 residents. As the century drew to a close, many streets — especially those in popular neighborhoods and branching off the new boulevards — were saturated with cafés, with one such establishment for every two buildings.

Free commerce meant fierce competition. First in Paris, and eventually throughout France, musicians were hired to perform in cafés; dance floors were installed, façades were painted, outside terraces were added, billiard tables purchased, and the interiors revamped with the addition of large mirrors, elaborate counters, and ornate lighting fixtures. In the 1890s, café proprietors rushed to be the first in their neighborhood to offer telephone services or moving pictures to their customers. By the early twentieth century, even working-class cafés appeared to have become *embourgeoisés*.

Other café proprietors harnessed Eros to the fortunes of their commerce. The late nineteenth century witnessed the spectacular rise of the *brasseries à femmes*, *débits* where waitresses proffered food and drink to their male customers: soldiers, single workers, students, bachelors of various social classes, and travelers. While Honoré Daumier could draw attention in Gallic fashion to the fulsome curves of the new "muse of the brasserie" in the 1860s (fig. 1), anxious authorities took a less benign view: they tended to equate these *brasseries* with dens of debauchery, their waitresses with common prostitutes. Laboring under grim conditions, the *serveuses* rarely received a daily wage. In cities like Paris, many apparently paid three to five francs a day for the right to work. Venus in the *belle époque* was becoming the handmaiden of a commercialized Bacchus.

Once more, Paris set the tone for a national eroticization of drink. By the late 1880s, literally hundreds of cafés offered their customers libations tendered by nubile young women in exotic attire. Disturbed by the proliferation of these *brasseries à femmes*, Paris's prefect of police ordered his forces to raid all such establishments to ascertain exactly how many customers could be found in *flagrante delicto*. And so between 11 p.m. and 1 a.m. on the night of May 5-6, 1887, Parisian police rushed into forty-eight brasseries with the most notorious reputations. Places like the Devil's Angels employed waitresses who wore "very short skirts, Tyrolian hats, and, in between, heart-shaped blouses which make no pretence of covering their bare arms," thus allowing all to "see the rise of their breasts." At the Tonkin Brasserie customers could gaze upon a "bit of leg," beautified with "flesh-colored stockings," which the oriental costumes of the eight waitresses displayed. But their decorum retained lit-

tle of the famed "oriental reticence"; these waitresses, the report noted, "drink, sing, smoke, and sit on the banquettes."

The Tonkin was no anomaly; almost every brasserie visited by the police could boast of an exotic or unusual motif for its decor and costume. Some proprietors dressed their waitresses as nursemaids, others as fetching *paysannes* who could be seen milking a cow inside the brasserie every night at ten. At the Brasserie du Divorce, the *serveuses*, wearing the robes of a divorce judge, plied drinks to their bemused customers; the satiric name of this establishment capitalized upon the reinstitutionalization of divorce in 1884 and the fantasies of its married customers for an immediate, if illusory, sexual license. Although several other brasseries could boast of women dressed in male attire — in Scotsmen's kilts or sailor's suits, the most popular guises were those drawn from France's colonial empire, from Algeria, Tonkin, or Morocco. Thus, even Venus in the *belle époque* was draped in the clothes of empire.

As the police tried to document the erotic transgressions supposedly enacted in these brasseries, they scrutinized decor as closely as décolletage. Although the five waitresses at the Sorcerer's Den were not dressed in troublesome costume, the walls suggested "smut," since they were adorned with murals of nude women. And of all the capital's brasseries, the most upsetting decor was found inside the Auberge Saint-Denis. Here the walls of the ground floor and the basement were adorned with suggestive murals of amorous cats; as the police put it, "the murals are provocative on the ground floor, obscene" in the underbelly of the establishment.[20] But despite the enticements of the feline pornography, no customers were found engaging in any sexual activity in any of the raided brasseries.

The police were not the only contemporaries to scrutinize this new world of drink. In 1884 Auguste Carel, an otherwise unremarkable *homme de lettres*, published a short volume devoted to the "pernicious" popularity of the *brasseries à femmes*. Carel scarcely concealed his nostalgia for the watering holes of the early nineteenth century and for the old-fashioned orthodox brothels. "There at least, the merchandise is delivered for cash; and besides, these houses are subject to sanitary regulations which the *brasseries à femmes* escape."[21]

Carel's picture of the culture of the *brasseries à femmes* suggests a well-developed commerce in sex and alcohol. The *filles* themselves constituted a highly mobile work force, who moved from one brasserie to the next but rarely crossed from one bank of Paris to the other. Paid almost nothing in wages, the *filles* were reimbursed for the drinks ordered by their customers and for those which the girls had the customers order for them, either "legitimate" libations or glasses of water tinted to simulate bitters or *chartreuses*. Although some of the *filles* adopted "harmonious" sobriquets, most of their names were intentionally ridiculous, inverting or denying the panoply of classic sexual charms: Blanche the Dead Head, Nini-Cadaver, Irma the Skeleton, Titine the Deaf, Maria White Nipples. There was every variety of name beginning with "Ni" and even a Napoleon. Advertising was hardly subtle; "in the best neighborhoods, the exteriors [are] painted in the loudest colors and the gaudy signs are designed to attract the eyes of the passerby." Commercial advantage was sought even from the provinces; brasseries were often named after a region of France, and the waitresses sported racy versions of the local costumes of Arles, Toulouse, Metz, Strasbourg, or Rennes. And if costumes and street façade were not sufficient to lure a curious clientele, fliers were circulated in the street to likely pedestrians.[22]

By 1893 the French painter Armand Seguin chose to evoke the array of eroticized pleasures of such Parisian cafés in his screen *The Delights of Life* (fig. 2). To the venerable amenities of drink, food, and smoking were added many of the novel attractions of the *fin-de-siècle* café: gaslight, music, billiards, dancing, and, above all, the allure of sexual pleasure. In such a milieu, politics had quite literally disappeared. For Seguin and for many others, the political culture of Parisian cafés had receded in the public eye; now they were increasingly linked to the classic trilogy of "wine, women, and song." Appealing to the millions of tourists who crowded into the capital each year, cafés loomed large in the imagination of rakes who defined sin as "something you do abroad." But for the ordinary Parisian, the café was more than a liminal space for the occasional transgressive outing. To the migrant, the bachelor, and the clerk, the café was not a way station but a way of life. Its history, as Willy warned, is as large and as rich as the history of France.[23]

Notes

1. A. Morand, *La vie de Paris* (Paris, 1855), p. 8.

2. See, for instance, Alain Faure, *Paris Carême-prenant: Du Carnaval à Paris au XIX siècle* (Paris, 1978).

3. Pierre Larousse, *Grand dictionnaire universel du XIXe siècle*, vol. 14 (Paris, 1875), p. 1579, col. 4, under *tempérance*.

4. Lenard R. Berlanstein, *The Working People of Paris, 1871-1914* (Baltimore, 1984), pp. 57-59.

5. The Carnavalet Museum in Paris has a fine collection of many of these signs.

6. Denis Poulot, *Le sublime* (Paris, 1870), p. 141.

7. Jules Vallès, *Le tableau de Paris* (Paris, 1971), p. 297. (Originally published in 1932, the book contains journal articles by Vallès that had appeared in 1882-1883.)

8. See Susanna Barrows, "After the Commune: Alcoholism, Temperance, and Literature in the Early Third Republic," in *Consciousness and Class Experience in Nineteenth-Century Europe*, ed. John M. Merriman (London and New York, 1979), pp. 205-218.

9. Victor Turner, *Drama, Fields, and Metaphors* (Ithaca, N.Y., 1971).

10. Maurice Agulhon, *La république au village* (Paris, 1970), p. 205.

11. Poulot, *Le sublime*, pp. 144-146, 159.

12. See Natalie Zemon Davis's splendid treatment of rituals in her *Society and Culture in Early Modern France* (Stanford, Calif., 1975), pp. 97-123.

13. In addition to Agulhon, *La république au village*, see John M. Merriman, *Agony of the Republic* (New Haven, Conn., 1978); and Ted W. Margadant, *French Peasants in Revolt: The Insurrection of 1851* (Princeton, N.J., 1979).

14. Archives Nationales, Paris, BB 30 411-412.

15. Archives Nationales, Paris, F7 12705-06.

16. See Barrows, "After the Commune."

17. Ibid.

18. See Susanna Barrows, "Parliaments of the People: The Political Culture of Cafes in the Early Third Republic," in *Drinking: Behavior and Belief in Modern History*, ed. Susanna Barrows and Robin Room (Berkeley, 1991); and AD Haute Vienne, 4 M 154, October 4, 1877.

19. APP, BA, 407.

20. APP, DB 173.

21. Auguste Carel, *Les brasseries à femmes de Paris* (Paris, 1884), p. 26.

22. See in the Bibliothèque Historique de la Ville de Paris the numerous examples of fliers circulated on the streets of Paris that touted the attractions of cafés, cabarets, and brasseries.

23. Quoted in *Cafés, bistrots et compagnie*, exhib. cat. (Paris: Centre Georges Pompidou, 1977), p. 6. Willy (Henry Gauthier-Villars) was a critic, entrepreneur, and habitué of cafés. He is perhaps best remembered today as the first husband of the writer Colette.

The Pleasures of Parisian Tables

Barbara K. Wheaton

In the Second Empire, the pleasures of the table were a serious business for producers and consumers alike; the elaboration of forms that characterized higher art forms was also in full bloom in culinary enterprises. Meals were made up of preparations as intricately composed as any architectural interior or crinoline ball gown.

La grande cuisine, the most expensive and prestigious style of French cooking in the nineteenth century, had originated in the style of cookery championed by Antonin Carême in the first third of the century. The people who cooked these meals were skilled but ill-paid, and in the kitchens of luxury restaurants and wealthy private establishments the staff was usually all male. Young boys began their apprenticeship before they were ten, performing much of the kitchen drudgery while gradually learning useful skills. They would go on to specialize in sauce-making, roasting, or frying and so forth; if they were especially able, they could rise to head entire kitchens, or, like the renowned Auguste Escoffier, the operations of international catering establishments. Women cooks were less esteemed. "Good female cooks," a turn-of-the-century writer observed, "are not rare, in our days, although one must often regret the reasons of economy which, in some households, had led them to be substituted for chefs — false economies, provoked by the indelicacies of some unscrupulous cooks, the basest minority, let us hasten to say."[1]

Classic French cuisine rests on a foundation of basic mixtures, such as stocks, sauces, mixtures of herbs, vegetables, or meats for flavorings, which were used to enhance and vary the fish and shellfish, meats, poultry, and game that were the central foods in the typical menu. Until the end of the century, when the style began to change, these foods were served in exceedingly complex presentations (see fig. 1). A poached fish might be raised up on a firm, inedible platform of compressed cooked rice, then decorated with truffles and flower shapes cut from vegetables, and glazed with aspic; it might then be impaled with ornamental skewers stuck full of whole truffles and cocks' combs and surrounded by individual aspics filled with forcemeats and decorated with yet more cut-out patterns. By comparison, the salmon with cucumber scales that languishes on our late twentieth-century buffet table is a pathetic shadow of a great tradition. But those classic French preparations were so time-consuming, were structurally so complex, and required ingre-

Fig. 1. A presentation of lobster. Engraving from Urbain Dubois, *La cuisine artistique* (Paris, 1872), vol. 2, pl. 83.

dients of such solidity that they can rarely have been as delicious as they appeared. Ingredients were arranged in ornate patterns, set on armatures of wood or wire, and on mounds and platforms of cold suet, compacted rice or mashed potato. Only the diner who understood how these affairs were composed recognized the parts of a dish that were intended to be eaten — it was the skewers with truffles and shrimp thrust into a poached carp, the foie-gras-stuffed quail in an eggshell, the tartlets of puff pastry filled with creamy tidbits ornamented with disks of truffles and flower shapes cut out of carrot or leek leaves. Considering how heavily the food had been worked, the best of it seems to have been remarkably good; the worst must have tasted rather tired, especially after it had served as part of a visual display for several hours without refrigeration.

This gastronomic carnival came to an abrupt halt when the Prussians besieged Paris in the autumn of 1870. As the weeks passed, the entire population grew hungry enough to eat anything they could get. Despite the efforts that had been made to stock the city with flocks of sheep, herds of cattle, tons of grain, and other staple foods, supplies began to run out after a few weeks. Canning techniques, invented at the beginning of the century by the Parisian confectioner Appert, though still expensive and unreliable, provided some meats, vegetables, and especially sardines,

but by November supplies were scarce. At the end of the month the ever stylish Edmond de Goncourt wrote in his journal: "the salt meat that the government has delivered cannot be unsalted and is inedible. I have been reduced to killing one of my little chickens myself, with a Japanese sword."[2] By the end of December people were desperate.

Remarkable efforts were made to maintain the patterns of normal meals even then. Among the many people who subsequently wrote about their experiences in Paris during the siege, Nathan Shepard, a British traveler who had been stranded there, described his ordeal with more humor than most. Whether it was the skill of the cooks, or the sauce of hunger, he still found some pleasure in his meals. In late November he dined on "soup from horse-meat . . . mince of rat . . . shoulder of dog with tomato sauce . . . jugged cat with mushrooms . . . roast donkey and potatoes . . . rat, peas, and celery . . . mice on toast . . . [and] plum-pudding." "It would be difficult to take a restaurant meal now in Paris," he observed, "without being served with at least one of the above-named animals. The bland market-man tells you it is an otter, or a rare species of hare, or an extraordinarily small and odd kind of sheep; but still you go away with the suspicion that you have seen, and will presently eat, a cat in disguise."[3] In Shepard's judgment, rats were far from being bad to eat and were not indigestible: "You may cook the rat in all sorts of ways; but rat pâté is a delicacy!" Despite his comments on the edibility of the rat, however, Shepard confessed that to his taste, cat was "far superior."[4] Restaurateurs struggled to find substitutes for their traditional ingredients. One discovered the uses of donkey, finding in the flesh "a very pleasant hint of hazelnut," while he used the fat in place of butter.[5]

When Paris began to recover from the siege and from the destruction wrought during the Commune in the spring of 1871, citizens and visitors alike turned to the pleasures of the table with a renewed intensity. The extent to which they could indulge in these pleasures was determined by their class, sex, and purse. For working people in the last third of the nineteenth century, gastronomic treats were rare exceptions in a daily life that was severely limited by their incomes. A work week lasting at least six and a half days allowed for little indulgence of any kind. Pleasures were often financed by visits to the pawnshop.

The cheapest treats were the street foods that survive today: hot chestnuts in winter, ices in summer, and waffles all year round. They also served as tidbits for people of the more prosperous classes and as treats for all children. A cheap meal in a commonplace restaurant or a snack from a street vendor was as much culinary indulgence as they could pay for.

When the middle class dined out, it favored the hearty meals served in brasseries and neighborhood bistros, such as sauerkraut, sausages, and pot-au-feu. Families could dine economically; for each child they paid only the cost of a *couvert* (utensils, plate, and napkin), and they either gave the child part of an adult portion or paid half-price for a smaller portion. Inexpensive meals could also be had in the creameries, which, in fact, served simple cooked dishes such as steak and chops in addition to the dairy foods that were their specialties.[6] The creameries were especially abundant in the Latin Quarter, but virtually every neighborhood had its own restaurants, brasseries, and cafés with their individual clienteles. These establishments supplemented the cramped living spaces of their customers, at the same time that they allowed them to meet acquaintances without having them intrude on their well-guarded privacy. It is not surprising, then, that the gastronomic pleasures of all but the wealthiest classes changed little between the wars, being made up of the simplest materials, preparations, and presentations.

On the other hand, the most luxurious food, available to the fortunate few who could afford it, was, as mentioned earlier, elaborate. Because affluent, fashionable people competed in the race to be first in taking up the newest trends, their demands for novelty fired the development of innovation, in food as in the fine and decorative arts and elsewhere. Ingredients, flavor combinations, and presentations all changed with the decades on the tables of the finest restaurants, clubs, and private houses. Wealthy men ate anywhere they pleased; they took "le five o'clock" (tea) in the secluded milieu of aristocratic ladies, went slumming in the *gargotes* (greasy spoons) of the poor, and dined with their friends in the private rooms of the best restaurants (with or without purchased female companionship) and in their private clubs.

Artists, writers, intellectuals, foreign visitors, and all the respectable people of Paris visited the Palais de l'Industrie, where the Salon, the annual exhibition of art by contemporary artists, took

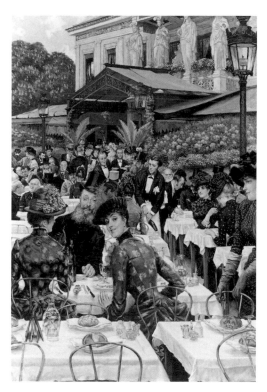

Fig. 2. J.J.J. Tissot, *The Artists' Wives*, 1885. Oil on canvas. The Chrysler Museum, Norfolk, Virginia, Gift of Walter P. Chrysler, Jr., and Grandy Fund, Landmark Communications Fund and "An Affair to Remember, 1982

place every May.[7] There was a restaurant at the Salon itself where the well-to-do refreshed themselves in a relatively luxurious section. Substantial meals, such as "poulet chasseur, filets mignons, sauce béarnaise," were offered by waiters hoping to enlarge their tips; diners could also settle for slightly more modest delicacies like braised beef, eggs with asparagus tips, and galantines.[8]

Those in a hurry or more economically inclined "escaped by going to one of the little tables in that gloomy corner of the Salon restaurant where there was no napkin to be unfolded, no radishes and butter to lead to indiscretion, and nothing more elaborate was served than a sandwich or a brioche, a cup of coffee" or a glass of wine.[9] It was crowded, and one dined less well; "the place was stifling, packed with people. . . . Out of the murky depths of the great dark cavern there rose a stream of little marble tables and a boiling tide of chairs, all tightly packed and hopelessly entangled, which filled the cave itself and flooded into the garden and the daylight provided by the thick glass roof. . . . The lunch was anything but good: the trout was sodden, the roast beef over-cooked, the asparagus tasted of wet rag."[10]

Other visitors to the Salon dined nearby. Ledoyen, on the Champs-Élysées, close to the Palais de l'Industrie, was a favorite fine-weather rendez-vous. Dating back to the First Empire, this restaurant had been lavishly redecorated in the Second, with paintings by Louise Abbéma.[11] For some years Edmond de Goncourt lunched there each spring on the day the Salon opened, with the Charpentier, Zola, and Daudet households.[12] It was built in the form of a pavilion, containing the kitchens and some private dining rooms. Around this core was a glassed-in area that provided shelter in bad weather, but the garden, with its fountains playing and horse chestnuts in flower, was the preferred place to eat. "Flowering creepers and grape vines are trained up the supports of the shelter, and fuchsias and other flowers give a plenitude of colour. In front of the little house is a gravel space, which is enclosed either by a privet hedge or by shrubs in green tubs. Trees large or small give shade to the enclosure, and the white-clothed tables are dotted here and there."[13] Henry James took a more measured view of the Champs-Élysées restaurants: "You may dine . . . at a table spread under the trees, beside an ivied wall, and almost believe you are in the country. This illusion, imperfect as it is, is a luxury and must be paid for accordingly; the dinner is not so good as at a restaurant on the boulevard, and is considerably dearer, and there is after all not much difference in sitting with one's feet in dusty gravel or on a sanded floor. But the whole situation is more idyllic" (see fig. 2).[14]

Among the popular fair-weather outings available to Parisians were the picturesque outdoor eating places at Sceaux, where one could dine, like the shipwrecked family in the popular novel *The Swiss Family Robinson*, in tree houses. In midcentury an enterprising tavern keeper had the idea of serving meals "on a platform amidst the foliage of the big chestnut trees at Sceaux-Robinson, [where one could] pull up to his aerie the basket, containing cold fowl and bottle of red wine and a yard of bread, by a rope."[15] It became so popular that his competitors opened similar establishments, and Sceaux became Sceaux-Robinson in honor of the fictional family. The village served as the point of origin for travels on donkeyback to the neighboring woods and hamlets. On a July evening in 1900 the Union of Pastrycooks,

Ice-cream Makers and Confectioners went there for their annual banquet. They chose the original establishment, the Maison Gueusquin, which dated from 1860, and according to the account of the event, the food and service were "all that could be wished" among the ancient trees with their three-storied platforms.[16]

There were other rural dining places. "There is a little restaurant on the Isle de la Jatte," another English food critic wrote, "which acquired a reputation for good breakfasts when the island was a favourite ground for duelists to settle affairs of honour."[17] The Bois de Boulogne was a popular resort for all classes in the earlier part of this period, but as the decades passed, a series of elegant — and expensive — restaurants replaced some of the more popular cafés. A carriage ride to the Pavillon d'Armenonville, especially on the day of the Grand Prix, was an ideal way for a gentleman to display simultaneously his taste in horses, mistresses, and the pleasures of the table.

Men who prided themselves on their discernment in matters of the table preferred to do their serious dining in the absence of women, or at least in the absence of respectable women. As Châtillon-Plessis put it, "Men's meals are more favorable to the intelligent appreciation of dishes, the company of a charming woman being disastrous, because of the absorbing duty which politeness requires." He went on to say that the only exception is a woman who is greedy enough herself "which constitutes a double charm, and all the more appetizing — the inconvenience is less, and may even disappear. But in any case, whoever may be in his vicinity, a gourmand does not have the right to be in love while he eats."[18] Women saw it differently. Baroness Staffe, a contemporary of Châtillon-Plessis, described gourmandise as "a defect harmful to beauty, to health, to moral dignity; this defect that, in some families, unbalances the budget."[19]

Among the cafés, Tortoni had a particularly distinguished history. Opened in 1798 on a fashionable corner of the Boulevard des Italiens, it continued in business there until 1895. The three steps outside its doors were considered to be one of the best places for Paris dandies to be seen. In its early years the statesman Talleyrand played billiards in an upstairs room, and it was a favorite haunt of literary people who lived nearby and came to the café for breakfast each morning.[20] The food served at Tortoni was of excellent quality, though expensive.[21] When the café closed, an admirer wrote: "It nailed up its door last summer because its customers had grown so few. It was long renowned, especially under the Second Empire, for its ices, and for the witty fraternity of journalists, litterateurs, and artists who haunted its historic perron of three steps, and its gilded little rooms. . . . The proprietor retires with no reproaches to fate. He defended butter against oleomargarine, beef consommé against Liebig's Extract [bouillon cubes], early fruits against preserved, wine against beer, cognac against rectified alcohol, but the contest had become hopeless."[22]

There must have been hundreds, if not thousands, of formal and informal dining clubs. Some of the larger dining clubs grew out of shared origins in the provinces; groups from Provence (La Cigale), Burgundy (unimaginatively, Les Bourguignons), and Normandy (La Pomme), for example, gathered to celebrate hometown holidays, to meet with hometown politicians, and presumably to eat their local dishes.[23] Women's clubs were in short supply, but one such was the Dîner des Rieuses, a group of actresses that met monthly at Durand's restaurant. The bylaw forbidding members to speak of men during dinner, upon the penalty of a fine, appears to have succeeded in keeping the treasury on a solid footing.[24] The great fashion house of Worth gave an annual gala dinner-dance for women only on Saint Catherine's Day, November 25 (Saint Catherine is the tutelary saint of unmarried women), for the hundred permanent female employees who formed the core of the organization. They were offered a fine meal, "irrigated copiously with champagne," followed by a dance that is said to have become boisterous as the night progressed.[25]

Most men's dining clubs were small, and some were exclusive. Edmond de Goncourt belonged to several such groups. The most brilliant of these was probably the Société des Cinq, whose other four members were the novelists Flaubert, Zola, Turgenev, and Alphonse Daudet. They met sometimes at the Café Riche, sometimes in a cheaper establishment, and often at the Daudets', spicing their wide-ranging conversations with such epicurean southern fare as a dish of bouillabaisse and a thrush pâté from Corsica.[26] More formal groups met fortnightly or monthly in private rooms at restaurants. The Goncourt brothers attended the Dîners de Magny, which met monthly at that restaurant in the Latin Quarter. The club survived for decades, changing its emphasis from literary

to political over time. Magny was reputed to have the best *pieds de mouton à la poulette* (sheep's trotters in a cream sauce based on white stock) in Paris. Twice weekly he himself made the restaurant's special *petite marmite*, with chicken and beef, served on a toasted crust of bread.[27] Magny told the Goncourt brothers that only his love for his art prevented him from imitating his colleagues in using cheap butter and earning thereby an additional 4,000 francs a year.[28] The restaurant's cellar was "small but good," and the atmosphere was friendly.[29] Later, the club moved its meetings to the Brébant restaurant, whose proprietor was Magny's brother-in-law.[30] Brébant had a more charitable nature than some; he gave surplus food to hungry beggars each morning at the restaurant door. The English journalist George Augustus Sala described the scene as it appeared in 1878: "At least a hundred forlorn-looking creatures, men and women, young and old, and mere children, are standing *en queue* two and two against the wall which skirts the kitchens of the great restaurant. Eight o'clock in the morning is the time when M. Brébant gives away soup, made from all sorts of yesterday's leavings, to the poor; and his poverty-stricken guests may either sup their pottage on the spot or take it home with them in the cans or the pipkins which they have brought."[31]

Most restaurants were less generous than Brébant. Their leftovers were collected in carts at daybreak and taken to Les Halles, to be assembled, or merely tumbled together into portions, and laid out for sale on newspapers. Sala asked his readers to imagine a pile consisting of

> the tail of a fried sole, two ribs of a jugged hare, a spoonful of haricot beans, a scrap of filet, a cut pear, a handful of salad, a slice of tomato, and a dab of jelly. It is the microcosm of a good dinner, abating the soup. The pile constitutes a portion, and is to be bought for five sous.... But there are loftier luxuries to be had.... Yonder are the magnificent relics of a *demie-selle de pré salé* [half a saddle of salt-marsh mutton], the remains of a sole à la Normande, the ruins of a *buisson d'écrevisses* [bouquet of crayfish], half a dozen smelts, the backbone of a pheasant, and, upon my word, some truffles; yes, positively truffles. It is true that they are mingled with bits of cheese and beetroot, with a dash of *meringue à la crème*, and a suspicion of *sauce Robert*. All this is gathered together on a front page of the *Pays*.[32]

Sala remarked that it was the finest restaurants that sold off their leavings; the cheapest establishments had few, because their diners were so hungry. This may have been an optimistic view; James McCabe, visiting the same place in 1869, saw "wretched food," eaten by people who were "tattered, ragged, squalid, blear-eyed, weak from long fasting, and dirty beyond expression."[33] The alternative for these miserable people was establishments like La Nouvelle Californie, "where all manner of broken-down men [dine] amid *chiffoniers* [ragpickers] and other unsavoury company."[34] Philanthropists and others made sporadic efforts to assuage hunger with *soupes économiques* (public soup kitchens) at which cheap food was sold at subsidized prices.

Working people had some reasonable alternatives. In 1867 a butcher by the name of Duval opened the first of what was to become a chain of very successful cheap restaurants, the Bouillons Duval, serving meals of boiled and roasted meats in modest but clean surroundings — "big places for small purses."[35] One key to Duval's success was his firm grasp of money-tracking. Diners ordered from a bill of fare on which prices were marked: "As the waiter brings [the food] to you, he checks it on the bill of fare with his pencil. Upon finishing your meal, you hand the bill to a woman sitting at a second counter near the door. She adds up the amount, stamps the bill and receives your money. Then giving the bill back to you, she requests you to leave it with the man in charge of the door as you go out. In this way a system of perfect checks is maintained, and M. Duval's employees find it impossible to swindle him."[36] Visited by people of all classes, the Bouillons Duval were particularly favored by parsimonious British and American travelers in search of plain meat and potatoes. The author of a guide to the Exposition of 1867 wrote enthusiastically of "Duval (immortal in the annals of the Boeuf Gras)," in whose establishments "the Briton who may yearn for the plain meats of his native land, will find good fare and cheap. . . . For a franc and a half he may satisfy the inner man with solid, plainly-cooked, roast or boiled."[37] Visitors were particularly struck by the respectable waitresses in their uniforms of blue dresses, white caps and aprons.

The restaurant and catering industries had indeed solved the problem of feeding large numbers of people, and the government was quick to make use of their skills to influence public opinion. As

early as the Exposition of 1867 the government staged a banquet for some five thousand mayors from all over France, and another took place in the Palais de l'Industrie in 1888. The apogee of French political dining was undoubtedly the banquet for 22,695 municipal dignitaries held on September 22, 1900, to celebrate the anniversary of the Republic.[38] Catered by the distinguished firm of Potel et Chabot, it was served in tents in the Tuileries.[39] It moved a pastrycooks' journal to poetry (or at least verse); evidently mere prose did not suffice. "I would need the language of Homer!" the writer exclaimed, describing with military metaphor the squadrons of cooks, assistants, and equipment needed to serve the "numerous army, which, under the armor of its dinner napkins, marched bravely to the assault on the aspics."[40] Elated stragglers from that army, still hungry, erupted into Maxim's restaurant afterwards, foraging for dessert. A maître d'hôtel later recalled that the deportment of "these rustic and municipal magistrates" caused an uproar among the regular clientele.[41]

Luxury restaurants were lavishly decorated in the most up-to-date styles, glistening with marble and mirrors and enriched with paintings, ornate furniture, and spotless linen, although sanded wood or tile floors were standard. By the end of the 1890s, the Art Nouveau interior had become the hallmark of stylish restaurants; the best-known survivor from this period is Maxim's. SEM's lithograph (fig. 3 [cat. 154]) evokes the sophisticated energy and animation of the place. The food served was opulent and substantial; the menu featured salmon, foie gras, creamy sauces, truffles, ox-marrow, and rich desserts. Château-Lafitte was poured from magnums (double bottles) and champagne from jeroboams (equivalent to four ordinary bottles). At least one waiter kept a notebook with the names, descriptions, and availability of fashionable women.[42]

Until the turn of the century it was unusual for the better restaurants to put prices on their menus, so that the diner in an unfamiliar restaurant had sometimes to wait in a state of increasing nervousness to discover how much money he was spending for his dinner.[43] The only way to avoid such anxiety was to order the entire meal in advance. Some restaurants offered private rooms that could be engaged for small numbers of people. Clubs like the ones that the Goncourts belonged to would meet in them, but they were also used as places of assignation. The celebrated

cabinets particuliers at Lapérouse still have mirrors "scratched by the diamonds of happy ladies."[44]

On the whole, respectable women dined in restaurants at midday with gentlemen; disreputable women dined in the evening, often in the same restaurants and sometimes with the same gentlemen, although demi-mondaines were not welcome everywhere. A respectable woman did not eat in a restaurant of any importance without a male escort. Women of the bourgeoisie and of the upper class were severely restricted as to where they could go. Unmarried young ladies never went out alone. In some cases even after they were married they did so rarely or not at all. Ladies were not, however, without their amusements. Tearooms and pastry shops were favored destinations. An English visitor in the 1890s described the Parisian version of teatime: "French tea, very thin and very weak [was] taken with plenty of sugar and often no milk, and . . . each cup and saucer [was served] on a dainty napkin which one placed in one's lap, and used to put biscuits on, or 'petits fours' — tiny sweet cakes. Sometimes in the summer there were 'sirops' as well or instead. Many callers did not take tea at all. And it was not necessary either to serve it to every one or to stay until it was served. It was brought in at the proper hour of five o'clock, hence its French name 'le five o'clock,' and its verb, 'five o'clocker,' meaning to take tea."[45]

Cooking demonstrations also provided a seemly destination for women. As in other cities — New York, Boston, Amsterdam, and London among them — the cooking school enjoyed a vogue in the last decades of the century. Auguste Colombié's school in Paris attracted women of all ages — even grandes dames, he boasted — to his cooking demonstrations at which he cooked entire meals. They were specifically directed to the more prosperous class; among his books were the Manuel des éléments culinaires à l'usage des jeunes filles and its sequel, the Traité pratique de cuisine bourgeoise. Colombié stressed simple, honest cooking and up-to-date equipment. To the protests of nervous souls who were alarmed by his use of the new gas range he replied that it was especially useful to housewives of modest means, "too often deprived, alas! of hot and restorative meals, lacking the time to get another combustible burning to prepare their lunches and that of their children before returning harassed to the workshop."[46]

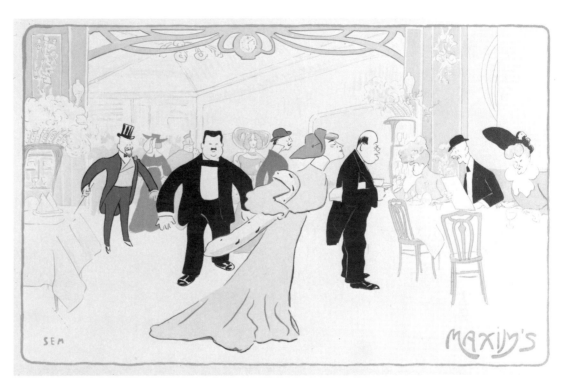

Fig. 3 (cat. 154). SEM (Georges Goursat), *Maxim's*, ca. 1900.
Color lithograph. Sterling and Francine Clark Art Institute, Williamstown, Massachusetts, Gift of Mrs. F. Hamilton Palmataire

There were many delights for children. In mild weather they could eat thin Breton crêpes or hearty Belgian waffles in the parks or ices in the Jardin d'Acclimatation, at the northern edge of the Bois de Boulogne. Herds of goats were led about the city to be milked at the door for children and invalids, or, most genteel of all, the children were taken to drink warm, freshly drawn milk at a little farm in the Pré Catalan, in the center of the Bois.[47] They were joined there by ladies who hoped to benefit their complexions. Soon, however, this pleasant meadow was taken over by a restaurateur who opened a more stylish establishment. There were special foods for holidays; April Fools' Day was (and is) celebrated with chocolate *poissons d'avril*. Children of all classes enjoyed *pain d'épice*, the heavy, sticky, honey-sweetened gingerbread that was sold at the Foire au Pain d'Épice during the fortnight beginning on Easter Monday, as well as at New Year's, and at other times by street vendors.

More than just a food market, the Foire au Pain d'Épice was a carnival too, with sideshows, performers, and games for the gullible, where vendors sold toys and cheap knickknacks of all kinds.[48] Sala described it as having "two distinct

and rigidly-adhered-to sides — the side of Business and the side of Tomfoolery."[49] On the side of tomfoolery he found sideshows, displays of gymnastics and weight-lifting, and shooting galleries, along with the usual low-life people who frequented them. On the business side was an "enormous quantity of gingerbread exposed for sale, either in solid lumps weighing a kilogramme each, or in the forms — such forms! — of horses, camels, donkeys, and human beings, either plain or garnished with almonds." As to the quality of the article, Sala was "tolerably well satisfied."[50] Two or three decades later a less enthusiastic English visitor described *pain d'épice* as "a mild and not very appetizing form of gingerbread cake."[51] The ham fair at Easter was a similar attraction. It had to compete with all the specialty stores selling luxuries for the Easter feast. (See Louis Anquetin's painting of a *charcuterie* (pork butcher's shop) in Place de Clichy; fig. 4.)

Change came chiefly from the prosperous end of the social ladder. A general taste for modern improvements included those which affected eating. One gastronomic writer stated firmly that "the art of the table is enriched daily by an infinity of original inventions, which come especially

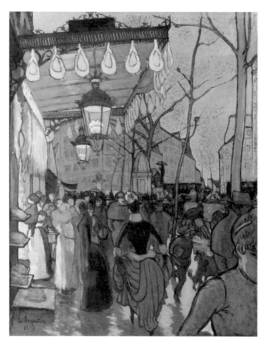

Fig. 4. Louis Anquetin, *La Place Clichy*, 1887. Oil on canvas. Wadsworth Atheneum, Hartford, Ella Gallup Sumner and Mary Catlin Sumner Collection (Photo Joseph Szaszfai)

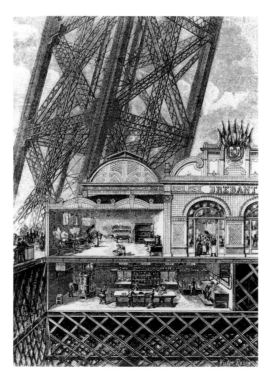

Fig. 5. Restaurant Brébant in the Eiffel Tower. Engraving from Châtillon-Plessis, *La vie à table* (Paris, 1894), p. 39. (The Schlesinger Library, Radcliffe College)

from industry. To keep ourselves up-to-date with this special movement, so useful, so indispensable to life everywhere, and in particular to Parisian life, constitutes at once a duty and a pleasure.[52]

Gustave Eiffel, himself a gastronome, saw to it that his tower, erected for the Universal Exposition of 1889, was supplied with fine restaurants, with modern kitchens, although gastronomic pleasures had to compete with the structure itself. A Russian restaurant supplied the caviar that Eiffel loved, and a restaurant of Alsace-Lorraine the sauerkraut.[53] Brébant, mentioned earlier, opened a branch of his restaurant on the first level of the tower, incongruously decorating it in an eighteenth-century style (see fig. 5). Eiffel had the satisfaction of welcoming his dining club at Brébant for a ten-course dinner featuring turbot, saddle of lamb, and for dessert an elaborate frozen construction. In July 1889 Edmond de Goncourt, faithful patron of Brébant that he was, visited the tower restaurant with the Charpentiers, the Zolas, and others, but he had far more to say about his reactions to the tower than about the food. Ascending in the elevator, he compared his sensations to seasickness; descending (they elected to walk), he said he felt like an ant walking down an iron cable mooring an ocean liner to its pier.[54]

The foods served at the great Universal Expositions gave the general public an opportunity to savor many different national cuisines. It could not be expected that in an age of nationalism people would become internationalists by experiencing the diversity of human characteristics, but there does seem to have been a genuine interest in the varied possibilities of the world's kitchens.

Edmond de Goncourt, a discerning critic of food as well as of the arts, described his reactions to an authentic Japanese meal that was served at the Charpentiers'. He did not exactly enjoy the food, which included: "little fish tartlets, white and green fish aspics, and also a dish of which they seem to be very fond: little rolls of rice in a leaf of grilled seaweed, rather like a piece of *boudin blanc* in a wrapping of *boudin noir* [i.e., *sushi*]. However, he quickly (and accurately) grasped its essential character: "One feels in these things a very civilized cuisine, very careful of the juices and essences of the ingredients, and whose products give one's taste buds a crowd of little, delicate, complex, fleeting sensations. These are dishes that have the character and for-

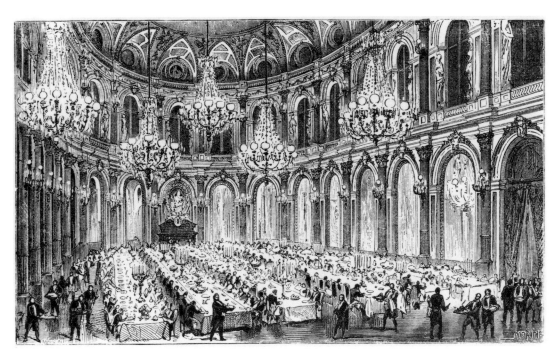

Fig. 6. Dining room at the Grand Hotel, Paris. Engraving from
Paris: Guide par les principaux écrivains et artistes de la France
(Paris, 1867), vol. 2, facing p. 1554. (Widener Library, Harvard
University)

mat of our hors d'oeuvres. However, we can only
be poor judges of this style of cookery, since fat
is the base of European cuisine, and the lean ele-
ment is the base of Japanese cuisine."[55]

As at the Universal Expositions, so at the res-
taurants of Paris, diners found cosmopolitan fare.
Nathaniel Newnham-Davis, a food critic, spoke
with enthusiasm of Italian, Spanish, Austrian,
Hungarian, and Czech restaurants; he also re-
ferred to several that catered especially to English
or to American tastes, unkindly summarizing the
food at the latter as "dry hash and corn cakes."[56]
As early as the 1860s hungry Americans could do
well at Madame Busque's establishment near the
Place de la Madeleine, "a pleasant little oasis in
the great desert of Paris" where she sold pump-
kin, mince, and apple pies to homesick Yankees,
as well as gingerbread and doughnuts, "all look-
ing particularly nice and tempting."[57] An attempt
to establish an American soda fountain did not
succeed, apparently because the proprietor, ex-
pecting the sippers of sodas to drink up and move
on promptly, offered no place in which to linger
in comfort.[58]

Street markets, seasonal fairs, and food shops
displayed an endless still life of foodstuffs that
gave pleasure to those who could afford to buy

them and even to those who could only gaze at
them. Luxury food stores such as Potel et Chabot
had admiring spectators gathered around their
windows at every hour. The great market known
as Les Halles, built in 1851-1854, was still new
and resplendent; Parisians and tourists alike en-
joyed the displays of fresh meats, fish, poultry,
dairy goods, and produce. A wholesale market in
the early hours, Les Halles opened for retail sales
later in the day. Those who worked there — and
bon vivants at the end of pleasure-filled nights —
greeted the dawn with the bowls of onion soup
laced with melted cheese whose popularity has
outlasted the buildings themselves.

In the world of gastronomic high fashion, as in
other aspects of creative Paris, important changes
took place between 1870 and 1914. In *la grande
cuisine* the trend was toward simplicity and light-
ness. In the earlier period there had been an em-
phasis on elaborate presentations; these now
came to be concentrated in the last course of the
meal, where ice creams, gelatins, and other
molded sweets could delight the eye without re-
quiring too many compromises on flavor and
texture.

In the last decades of the century, new cooks
such as Auguste Escoffier, Prosper Montagné,

and Philéas Gilbert came forward to simplify both the menus and the presentation of individual dishes within the repertoire of *la grande cuisine*. However, dinner might still consist of seven courses or more! Escoffier, working chiefly for the Ritz enterprises, led in creating the modern luxury hotel and hotel restaurant — of which the Paris Ritz is the archetype — where much lighter food was served and ladies were welcomed. If the typical dish of 1870 had been an elaborate poached fish bristling with ornamental skewers, by the turn of the century the typical offering was a delicately poached filet of sole, served in a sauce made with concentrated fish-stock and wine, enriched with cream, and garnished with shellfish, fluted mushrooms, and small crescents of puff pastry. A menu in the earlier period was made up of a succession of relatively heavy dishes; in the later period light and heavy dishes alternated. In composing a menu of some seven courses, the planner had to follow certain basic rules. Repetition was to be avoided; the principal course usually featured a roast. Courses based on white foods (poultry, veal, fish) and brown (beef and game) alternated, insofar as it was possible, and the meal concluded with a selection of delicate desserts. Relatively light wines were served at the beginning of a meal, leading to a progression of increasingly rich and complex ones, so that no wine would suffer by comparison with an earlier one.[59] The people who chose to dine upon such meals would have felt that they were, quite literally, people of taste.

With the rise in international travel, by steamship and train, restaurants and hotels were serving an increasingly varied clientele and had to accommodate themselves to any suitably dressed person who could pay for a meal. They were open even — or especially — to foreigners, who did not necessarily subscribe to the local customs. Hotel restaurants, catering to travelers from the provinces and from abroad, cut back on the complexities of their menus. As early as the Second Empire, some of the larger hotels had two dining rooms, one in which individual dishes could be ordered from a special menu (*à la carte*) and a second room where a meal was served at a set price (*table d'hôte*). The elegant dining room of the Grand Hotel, built in 1857, was famous (fig. 6); reservations had to be made days in advance for a fine meal served to a "brilliant" crowd in "a style utterly beyond anything seen in [American] hotels."[60]

As earlier in the century, access to the pleasures of Parisian tables was still very unequal. Relatively few people ate at the most celebrated restaurants; relatively few families could afford to pay for sumptuous meals at home, even if the women had enough time to cook them. But there were many places where good meals could be had in a tremendous variety of settings: dignified classic restaurants frequented by epicures, suburban open-air inns, lively student brasseries, and inexpensive chain restaurants. All contributed to the spectacle of Paris and to the pleasure of its citizens.

Notes

1. Châtillon-Plessis, *La vie à table à la fin du XIXe siècle: Théorie pratique et historique de la gastronomie moderne* (Paris, 1894), pp. 90-91.

2. Edmond and Jules de Goncourt, *Journal: Mémoires de la vie littéraire*, vol. 2, *1866-1886* (Paris, 1989), p. 347.

3. Nathan Shepard, *Shut up in Paris* (London, 1871), pp. 152-153.

4. Ibid., p. 165.

5. Châtillon-Plessis, *La vie à table*, p. 351.

6. James D. McCabe, *Paris by Sunlight and Gaslight* (Philadelphia, 1869), p. 85.

7. Patricia Mainardi, *Art and Politics of the Second Empire: The Universal Expositions of 1855 and 1867* (New Haven, 1987), p. 40. The Palais de l'Industrie was built in the early 1850s in emulation of London's Crystal Palace to supply space for the Salon exhibitions, formerly held in the Louvre, and for industrial expositions of all sorts.

8. Henry James, *The Tragic Muse* (Library of America), pp. 727, 737.

9. Elizabeth Robins Pennell, *Nights: Rome, Venice in the Aesthetic Eighties; London, Paris in the Fighting Nineties* (Philadelphia and London, 1916), p. 242.

10. Émile Zola, *The Masterpiece*, trans. Thomas Walton (New York, n.d.), p. 301. (First published in 1886 as *L'Oeuvre*.)

11. René Héron de Villefosse, *Histoire et géographie gourmandes de Paris* (Paris, 1956), p. 263.

12. Goncourt, *Journal*, vol. 2, pp. 938, 1003, 1069; Héron de Villefosse, *Histoire*, p. 263.

13. Nathaniel Newnham-Davis, *The Gourmet's Guide to Europe*, 3d ed. (New York [ca. 1909-1914]), p. 24. (First edition 1903.)

14. Henry James, *Parisian Sketches* (New York, 1957), p. 144.

15. Newnham-Davis, *Gourmet's Guide*, p. 55; Augustus J.C. Hare, *Days near Paris* (New York [1895]), p. 300.

16. Pierre Lacam, "Banquet annuel du syndicat des pâtissiers-glaciers-confiseurs," *La cuisine française et étrangère*, 1900, p. 105.

17. Newnham-Davis, *Gourmet's Guide*, p. 55.

18. Châtillon-Plessis, *La vie à table*, p. 11.

19. Baronne Staffe, *Traditions culinaires et l'art de manger toute chose à table*, 4th ed. (Paris, 1894), p. 1.

20. Stuart Henry, *Paris Days and Evenings* (Philadelphia, 1896), p. 84.

21. McCabe, *Paris*, p. 78.

22. Ibid., p. 85.

23. Richard Kaufmann, *Paris of To-day*, trans. from the Danish by Olga Flinch (New York, 1891), p. 178. (Originally published in 1887.)

24. Ibid., pp. 179-180.

25. Henry, *Paris Days*, pp. 44-45.

26. Goncourt, *Journal*, vol. 2, p. 678.

27. Héron de Villefosse, *Histoire*, p. 18.

28. Goncourt, *Journal*, vol. 2, p. 177, September 26, 1868.

29. *Paris: Guide par les principaux écrivains et artistes de la France* (Paris, 1867), vol. 2, pp. 1551-1552.

30. R.-J. Courtine, *Zola à table* (Paris, 1978), p. 25.

31. George Augustus Sala, *Paris Herself Again in 1878-9*, 8th ed. (London and New York, 1884), p. 236.

32. Ibid., p. 248.

33. McCabe, *Paris*, p. 86.

34. W. Blanchard Jerrold, *Paris for the English* (London, 1867), pp. 33-34.

35. F. Berkeley Smith, *How Paris Amuses Itself* (New York and London, 1903), p. 44.

36. McCabe, *Paris*, p. 85.

37. Jerrold, *Paris*, pp. 33-34.

38. Pascal Ory, *Les expositions universelles de Paris* (Paris, n.d.), pp. 30-31.

39. Theodore Zeldin, *France, 1848-1945: Taste and Corruption* (Oxford, 1980), p. 394.

40. E. Besnard, "Le banquet des maires," *La cuisine française et étrangère*, 1900, p. 157.

41. Hugo, *Vingt ans maître d'hôtel chez Maxim's* (Paris [1951]), pp. 160-161.

42. Ibid., pp. 186-220.

43. Berkeley Smith, *Paris Amuses*, p. 41.

44. Héron de Villefosse, *Histoire*, p. 211.

45. A. Herbage Edwards, *Paris through an Attic* (London, 1919), p. 295. The author is describing her experiences in the 1890s.

46. Auguste Colombié, *Traité pratique de la cuisine bourgeoise*, 3d ed. (Paris, 1897), p. 9.

47. Edwards, *Paris*, pp. 310-311.

48. Robert de Massy, *Des halles et marchés et du commerce des objects de consommation à Londres et à Paris* (Paris, 1861), pp. 483-484.

49. Sala, *Paris Herself*, pp. 497-504.

50. Ibid., p. 504.

51. Edwards, *Paris*, p. 190.

52. Châtillon-Plessis, *La vie à table*, pp. 19-20.

53. Jacques Morlaine, *La tour Eiffel* (Paris, n.d.), p. 159.

54. Goncourt, *Journal*, vol. 3, *1887-1896*, pp. 289-290.

55. Ibid., vol. 2, p. 803.

56. Newnham-Davis, *Gourmet's Guide*, p. 47.

57. McCabe, *Paris*, pp. 89-91.

58. Ibid., p. 76.

59. Ernest Verdier, *Dissertations gastronomiques: Monographie et dégustation des vins de France* (Paris, n.d.), p. 8.

60. McCabe, *Paris*, p. 83.

The Cult of the Circus

Phillip Dennis Cate

"Vive le Cirque!" That was the cry of an anonymous writer in the May 27, 1888, issue of *Le Courrier français* as he contrasted the seemingly moribund state of contemporary theater with the fresh appeal of the circus in his announcement of A. Dalsème's new book, *Le cirque à pied et à cheval*: "Long live the Circus, where there is nothing that disturbs the spectator, neither the events often difficult to follow — even while traveling — nor the dialogues of the living, which recall so many times the dialogues of the dead! Long live the Circus with its sandy ring, its prideless palfreys, its jovial clowns, its gracefulness, its robustness, its mockery, its rides, its mimicry, its trapeze at the top, its carpet at the bottom, its somersaults, its gibberish, its acrobatic prowess and the mystery of its morals."[1]

In the last quarter of the nineteenth century, the circus acquired a high level of social and professional acceptability among the artistic and literary communities in Paris and even among members of the social elite. Although the circus was traditionally appreciated as entertainment and spectacle, it was now becoming evaluated as an art form in itself to the extent that, as the comment from *Le Courier français* illustrates, it could be compared favorably with theater.

The phenomenon of popular entertainment perceived by some as art also extended at this time to the café-concert, the cabaret, and the dance hall, which, like the circus, were now the topics of documentaries and histories.[2] They were also the subjects of novels and of visual depictions by writers and artists in search of a new art uncontrolled by traditional, academic themes and standards. In fact, many of the avant-garde sought with their art to directly document "modern life" and their own daily experiences, which, especially in the case of the young artists living in Montmartre, meant depicting the night spots and other places of entertainment that surrounded their apartments and studios, such as the Chat Noir cabaret, the Casino de Paris, the Élysée Montmartre, the Moulin Rouge, the Moulin de la Galette, and the Cirque Fernando. Yet a commitment to portraying modern life does not fully explain the attraction of the circus for artists such as Henri de Toulouse-Lautrec and Henri-Gabriel Ibels. Rather, their enthusiasm for an art of the circus was symptomatic of the unofficial cult of the circus that permeated Parisian society at the end of the century.

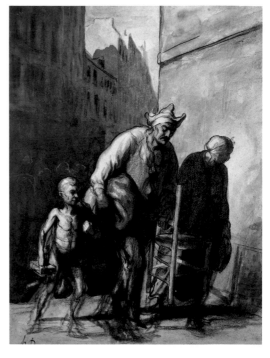

Fig. 1. Honoré Daumier, *The Mountebanks Changing Place*. Wash on paper. Wadsworth Atheneum, Hartford

With its many varied acts from animal taming to clowns and acrobats, the circus is a bit of everything: theater, vaudeville, athletic contest. The circus offers drama, humor, as well as physical prowess. It pushes human abilities to the edge of the superhuman and makes possible what is normally considered impossible. While Lautrec and Ibels depicted the reality of the circus, it was specifically its next-to-impossible quality, its unreality that was appealing. In the circus, people fly, wild animals are transformed to docile pets, pretty women jump through paper-covered hoops while standing on horseback, and the real identities and personalities of clowns are hidden by colorful costumes and paint.

There was a strong kinship between the young radical artists and the performers whom they depicted that attracted the former to the latter. Many from both groups were on the fringe of what was generally considered acceptable society. Actors and circus performers were outcasts simply because they had unconventional and unstable jobs that engendered or reflected rather strange lifestyles with "mysterious morals." The small-time, impoverished performers who traveled from city to city participating in local fairs or on street corners literally had to set up their tents on the fringe of town. These ennobled *saltimbanques*

(itinerant entertainers) as depicted by Daumier (fig. 1), Ibels, and Picasso, in particular (cat. 184, 185, 189), serve as metaphors of the isolation and despair of some nonestablishment artists or, at the very least, are an empathetic recognition by artists of their common place in society with jugglers, clowns, and acrobats.

Artists were often dropouts from society because of their antibourgeois stance and bohemian demeanor. Toulouse-Lautrec, for instance, felt more comfortable in the company of café-concert performers and Moulin Rouge dancers or mingling with the acts in the wings of the Cirque Fernando than among his aristocratic peers. While part of "modern life," the circus was, however, as escapist and exotic a subject for Toulouse-Lautrec as Brittany and Tahiti were for Paul Gauguin. Not only did artists and writers depict and associate with circus entertainers, but some also allowed fantasy and reality to merge as their position as voyeurs and recorders changed to that of actual participants in the circus or to that of clowns and acrobats at the numerous artists' costume balls in Montmartre.

Three permanent circuses existed in Paris at this time. All three specialized in equestrian acts, clowns, and acrobats, and each had its own clientele. The Cirque d'Été, open from April through September and located on the fashionable Champs-Élysées, catered to the upper crust of society. The Cirque d'Hiver, on the Boulevard du Filles-du-Calvaire, not far from the Bastille, with a diverse local audience, was open from October through early April. Located at the corner of Boulevard de Rochechouart and Rue des Martyrs, the Cirque Fernando opened on June 25, 1875, to an enthusiastic reception from the citizens of Montmartre and of the other surrounding working-class districts.[3] Constructed of stone and able to hold twenty-five hundred spectators, it replaced the temporary circus tent erected by Ferdinand Beert (Fernando) two years earlier. With seats priced from 50 centimes to 3 francs, the Fernando was the least expensive of the three circuses; it gave performances roughly all year round, bringing entertainment of a sort not previously readily available to this northern and poorer section of Paris.

From the early part of the century artists had found Montmartre an inexpensive and attractive place to live and work. Auguste Renoir and Edgar Degas, among others of the Impressionist generation, were residents of the district and fre-

quented the Cirque Fernando; in 1879 both executed paintings of performances at the Fernando, and for both artists the circus became another means of investigating their ongoing aesthetic concerns.[4]

At the end of 1881 the artist-entrepreneur Rodolphe Salis established the Chat Noir cabaret in Montmartre (see cat. 111-120). It soon became a lively gathering place of young artists and writers and by mid-decade was the center and catalyst of avant-garde literary and artistic activity.[5] It was just three short blocks from the Cirque Fernando, which continued to be an attraction for artists of the quarter, including Georges Seurat and habitués of the Chat Noir such as Toulouse-Lautrec and the little-known artist Joseph Faverot, whose circus paintings still decorate the walls of the Bon Bock cabaret at 2 Rue Dancourt (two blocks away from the Fernando).

In contrast to the large American three-ring circus, the standard nineteenth-century European circus, whether under a tent or within a permanent structure, consisted of one ring, which always measured thirteen meters in diameter and had one entrance and one exit, face to face across the ring.[6] This uniformity in size and format made it possible for itinerant performers to move from circus to circus, from season to season, and from country to country without adapting their acts to each location. The small one-ring circus created an intimacy and a rapport between performers and audience that were favored by the public and by artists over the impersonal relationship generated by the grandiose events presented in the vast arena of the Hippodrome, which was located near the center of Paris, between l'Avenue Marceau and l'Avenue de l'Alma (now called Avenue George V). The Hippodrome held ten thousand spectators and, in addition to circus acts, presented sports competitions, massive equestrian events, and, when flooded, simulated epic naval battles. It closed, however, in 1897 because of its inability to sustain such a large attendance on a regular basis. Three years later, the Hippodrome, with a fifty-percent reduction in seating capacity, opened at its new home at 1 Rue Caulaincourt, only a few blocks from the Cirque Fernando (now named Cirque Medrano after the popular clown Geronimo Medrano, or "Boum Boum," who, in 1897, acquired the circus from the Fernando family). The Hippodrome's inaugural event, as advertised by Orazi's poster (cat. 188), included two hundred performers, six elephants,

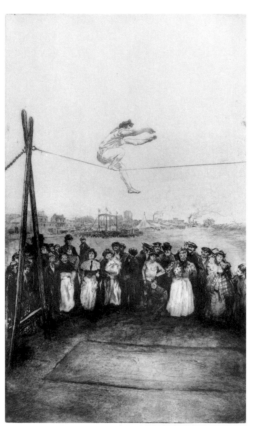

Fig. 2. Edgar Chahine, *Dancer on a Tightrope*, 1906. Color etching. Jane Voorhees Zimmerli Art Museum, Rutgers, The State University of New Jersey, David A. and Mildred H. Morse Art Acquisition Fund

and fifty horses! Only seven years later, however, it was converted to a movie theater as the public's enthusiasm for elaborate live spectacles changed to fascination with the cinema.[7]

At the other end of the scale, Paris also had its *fêtes foraines*, fairs made up of traveling entertainers called either *forains* or *saltimbanques*. Each Easter the Foire au Pain d'Épice (Gingerbread Fair) was held on the Avenue du Trône in Vincennes, the eastern part of the city, and every June the Fête Neuilly, near the Bois de Boulogne, attracted large crowds. Itinerant performers including tight-rope walkers (see fig. 2), acrobats, wrestlers, jugglers, a variety of freaks such as the bearded woman, the giant, the tattooed lady, as well as merchants with diverse products all traveled to Paris in their *roulettes* (covered wagons), which, when set up along the avenues of Vincennes or Neuilly, expanded into tents and platforms or display stands. At these, the two largest of the official Parisian annual *fêtes foraines* (as at similar fairs throughout Europe), spectators were

enticed to pay the entrance fee to a side show by the music and chatter of an assortment of costumed *forains* or *saltimbanques* lined up on a narrow elevated platform at the entrance of their tent. This was the *parade*. Once inside, the spectator could encounter much of what one found at the circus: clowns, wrestlers, jugglers, midgets, acrobats, animal acts, a variety of pantomimes and dramas. "For one franc he may study their talent from a kitchen chair, alluringly termed a 'fauteuil d'orchestre.' A bench seat generally within a foot of it rents at half price, and a bleacher seat at five sous, with a reduction to children and the military."[8]

The November 1897 issue of *Figaro illustré* is dedicated to "Forains et Saltimbanques"; reminiscent of the journalist's exclamation in *Le courrier français*, "Vive le Cirque!" of nine years earlier, is the announcement of Tancrède Martel, "Vive la foire de Neuilly!" as he indicates this fair's great popularity and praises its many attractive qualities:

> Oh the fair of Neuilly, the noisiest, the most tumultuous of all! Where do the thousands of bourgeois and workers, idle soldiers and nannies go on their free time, if not to the fair? They go where having fun is possible without an open account at the Bank, without stocks in the government or in some great credit house. You can have fun at Neuilly for nothing, for a fabulously modest sum. From Flobert shooting galleries to panoramas about the Franco-Russian alliance, from snake-like ladies to Lapland dwarfs, from gunmen to fortune tellers, one can picturesquely kill one's day without going bankrupt. Long live the fair of Neuilly![9]

On the other hand, only a year before, Georges d'Esparbes in his 1896 article "Les forains," which is illustrated by Ibels, sees the *fête foraine* as a thing of the past: "Thus the fairs, the 'exhibitions' will disappear. But these pages will survive. This book of drawings gets the entire attention of an artist; it will be, I think, the last glance at the large, already empty place, at the fair." Esparbes then eulogizes the *fête foraine*, comparing it to a religious experience: "This Fair, this deformed church, this great temple of ugliness, so necessary to man's search for beauty, we, the new generation, we loved it."[10]

Whether they were viewed nostalgically or symbolically, or viewed as a slice of "modern life" by artists and writers, the *fêtes foraines* at

the end of the century were as much café-concert and theater as they were circus. As Tancrède Martel's article explains: "The fairs have become the strongest pillars of dramatic art. The one who will want to write the complete history of the forains . . . will definitely have to study their evolution in the past ten or twelve years. . . . The smart people of the fairs have perfectly understood that the public ardently needs spectacles; and little by little, . . . they have succeeded in creating real theaters, where, although preserving the principles of dramatic action, they remain close to the real events. Not that the old banque has suffered in its tradition. The French forains strongly keep the tradition of their bizarre professions which made their glory."[11]

With a history going back to medieval times, these wandering entertainers, who knew much of the world — or at least Europe — and many of its languages, brought with them to each town they visited an aura of mystery and unconventionality. These particular characteristics, mystery and unconventionality, in addition to the *forain*'s dedication to a skill and talent with no obvious usefulness in a bureaucratic world, were, as we have seen, also common to the circus performer and were perceived by the avant-garde at the turn of the century as virtuous and ennobling qualities.

In 1879 two novels were published that reflect these attitudes: *Les frères Zemganno* by Edmond de Goncourt and *Aziyadé* by Julien Viaud, better known by his pseudonym Pierre Loti; both, in varying degrees, expound upon the noble qualities of the life of a circus performer.[12] *Les frères Zemganno* is the tedious and sad story of two brothers, who as members of a family of *forains*, become skilled gymnasts to the point that they eventually become regular performers at the Cirque d'Hiver. The younger brother, however, finally has what is always feared by circus athletes, a devastating fall that ends his career as a gymnast. To avoid jeopardizing their close brotherly relationship through jealousy, the older brother gives up gymnastics as well. Goncourt's novel was an effort to create, in his own words, a "réalite poétique" (poetic reality), for which he consulted with top members of the circus world. Within his story Goncourt offers reasons for that sad and pensive demeanor of the *saltimbanque* to which artists of the period related and which they interpreted in their work:

These gymnasts and especially the clowns . . . with the buffoonery of their bodies, display the sadness of comic actors. And, English or French, gymnasts, more than comic actors, are particularly taciturn. Is it the fatigue of exercising, is it the everyday mortal danger in the midst of which they live, that makes them so sad and silent? No, there is another cause. When these men leave the fever of their work, when they rest, when they think, the apprehension always comes to their mind that this skillful force which makes their living could be suddenly suppressed by an illness . . . by something that wouldn't work in their body. Also, they often think . . . that there will be a limit to the youthfulness of their nerves and muscles, and that long before their death, their aged bodies will refuse to carry on with the work. Finally, there are among them . . . the "demolished" ones, those who have had two or three falls . . . among which there was maybe one that kept them in bed for eleven months; then, these people remain, according to their own expression, "demolished" under the appearance of full recovery, and need, in order to fulfill their feat, an effort that kills them and makes them sorrowful.[13]

In 1875 Pierre Loti, then a young naval officer and recently rejected by his lover, was on six months' leave of duty to improve his physique and to regain his ego by training like an athlete at the École de Gymnastique.[14] There he mastered acrobatics, a skill that soon became useful when he was stationed near Toulon, in the south of France, and performed in costume with the local Etruscan Circus. In *Aziyadé*, Loti's first book, he tells the story, apparently part autobiographical, part fictional, of a young man seeking to escape his bourgeois upbringing in the exotic world and mores of Constantinople and Salonica. Here he encounters a harem girl named Aziyadé, who quickly becomes his all-admiring and devoted lover; the narration consists principally of correspondence between Loti and his sister and two friends. In his letters Loti debunks everything his sister holds sacred: religion, family, and commitment. In his several brief references to his circus experience, he stresses only the physical benefits of such training. He informs his friend Plunkett: "I tasted a little bit of all pleasures; but I do not believe anymore that there is any kind of pain that [was] spared me. I find myself very old, de-

spite my extreme physical youthfulness, which I maintain by fencing and by doing acrobatics." And later, he advises: "The pure love that you dream of is a long expectation like friendship; forget the one you love for a runner. You . . . should fall in love with a girl from the circus who is beautifully formed."[15] For Loti the cult of ancient Greek athletes merges with the cult of the circus. It is this physically perfect façade of the acrobat that Loti hides behind as if it were a mask. His need for such means of escape is emphasized when he explains his strong attraction to the city of Constantinople: "[It] is the only place where one could try this kind of thing; it is the real human desert, the same as that of which Paris used to be typical, a collection of many large cities where everybody lives his own life, without being controlled, where one can manage to have many different personalities at once — Loti, Arif et Marketo."[16]

By 1880, with the creation of the Cirque Molier, the circus became the means for others besides Pierre Loti to have several personalities. On March 21, 1880, Ernest Molier, who from childhood had been infatuated with the circus and horsemanship, presented the first of what were to be, for the next approximately fifty years, annual amateur circus performances. Molier had created a makeshift circus out of the wooden structure that enclosed his riding stable, located at his home on the Rue Bénouville, next to the Bois de Boulogne; his amateur troupe was recruited from those among his society friends and acquaintances who were proficient at riding, fencing, and gymnastics.[17] For the first year of his circus, Molier listed the members of his troupe as follows: "Count Hubert de la Rochefoucauld, Mr. Vavasseur the well-known fencer and Mr. Wagner would be the gymnasts. Mr. Van Huyssen and Dr. Laburthe would both play the roles of Hercules and the one of wrestlers. The equestrians would be Count De Maulde, Baron de Bizy, Count de Montherot and Lieutenant Bourgeois. Captain Paret would have the double role of equestrian and clown. As far as I am concerned, I would present my trained horses; I would ride standing like a circus rider and I would be like Monsieur en Haute-École."[18]

Count Hubert de la Rochefoucauld and Théophile Pierre Wagner, listed above as gymnasts, had attended the École des Beaux-Arts together. According to the pointillist painter Paul Signac, there they had known Georges Seurat, whose

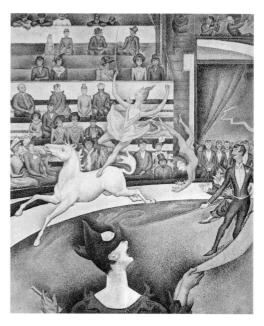

Fig. 3. Georges Seurat, *Circus*, 1890-1891. Oil on canvas. Musée d'Orsay, Paris (Photo: Documentation photographique de la Réunion des musées nationaux)

paintings *The Side Show at the Circus* and *Circus* (fig. 3) are as much masterpieces of pointillist theory as they are circus icons.[19] Signac also relates that Wagner was a muscular athlete, but not well-to-do; he would model nude at the École for one week and return the next to paint his replacement. The first critical recognition as a painter that Wagner received was from the symbolist writer and art critic J.-K. Huysmans in 1888:

> What a unique canvas was revealed to us at the Exhibition of Independents which opened, in 1884, at the booths in the Tuileries!
> One day at sunset, a day that brightens the nightmares of the bad nights, . . . one could catch sight of half of a circus, where shadow-like clowns were juggling or holding with the tip of their arms the paper hoops broken by the riders.
> These clowns were living a fluid, strange life: one could say they were ghosts passing through a dead circus; . . . one could see them coming to life and smiling with mortally sad eyes.[20]

Huysmans was evidently disappointed that the exhibition catalogue provided no information about Wagner (other than his last name) and that none of the writers and artists knew him. Not until long afterwards was he told by chance, in conversation, that the painter was a wrestler and

clown. "Provided that this was the truth!" commented Huysmans. "But then how to explain the sickly elegance of this painting streamed with dream, the painful and delicate whisper of an art achieved by a weight-lifting buffoon?"[21]

Signac responded to Huysmans's article with the brief biography of Wagner already mentioned, which recounts further that Wagner worked at the Cirque Molier with La Rochefoucauld, was an habitué of the Chat Noir cabaret, and had made a watercolor entitled *Le Cirque Molier* at his Montmartre studio, 13 Rue Ravignan.[22] Today we have little more knowledge of Wagner's life and work than that offered by Signac in 1888. The fact that Wagner painted and most probably lived in Montmartre places him physically close to the Cirque Fernando, which, in contrast to the Cirque Molier's two performances a year, allowed Wagner and many other artists ample opportunity to acquire a taste for and to indulge vicariously in the circus and to depict it in their work. Although the artists John Lewis Brown, Jules Chéret, Jean-Louis Forain, Henri Gerbault, Lucien Métivet, Adolphe Willette, and others illustrated programs for the Cirque Molier, only Wagner and Gerbault performed there.

In Molier's circus, the members of his troupe who were outside of his aristocratic milieu were definitely in the minority; as Baron de Vaux observes in his 1893 history of European circuses: "The saltimbanques and the clowns who perform once or twice a year for the Parisian high life are not at all like those at the Hippodrome. These are young men from the best circles of society who wanted to "launch" a new kind of sport, and who succeeded: they have been conscientiously working and, after several exercises, they are able to compete with real equestrians and professional clowns. I can mention among them: Count Hubert de la Rochefoucauld."[23]

Wagner and La Rochefoucauld performed together at the Cirque Molier, either on the trapeze or on the parallel bars, at each soirée from 1880 to at least 1886, after which their names do not appear on the programs. Tissot's painting *The Amateur Circus*, of 1882-1885, depicts Hubert de la Rochefoucauld, wearing a monocle, facing us as he sits on the trapeze of an amateur circus in Paris (cat. 197).[24] Although the interior decoration of Tissot's circus is not that of the Cirque Molier, the Molier's confined space is similar to that in the painting, and it is clear that the Molier was the only nonprofessional circus in the city at

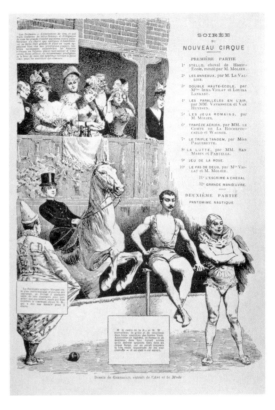

Fig. 4. Henri Gerbault, *Program for the Benefit Performance of the Cirque Molier at the Nouveau Cirque*, 1886. Reproduced from Ernest Molier, *Cirque Molier, 1880-1904* (Paris, ca. 1905), p. 51. (Photo: Jane Voorhees Zimmerli Art Museum)

that time. It is apparent, therefore, that Wagner, La Rochefoucauld's regular partner, sits with his back turned to the viewer on the other trapeze. The two performers are depicted again in Henri Gerbault's illustration of 1886 in which the program for Molier's benefit performance at the Nouveau Cirque is superimposed on an interior view of the Cirque Molier (fig. 4).[25] Number six on the program is "Flying trapeze, starring Count de la Rochefoucauld and Mr. Wagner," while the text in the square to their lower left reads: "Count de la Rochefoucauld and Mr. W. magnificently graceful and supple in their performance on the parallel bars. Admirable lightness, delicacy and smoothness of their aerial work which they have to do always in a closed circus, because one would always worry to see them fly away if one were in the open air."

In spite of Huysmans's appraisal of Wagner's work, it may be that the latter was a better acrobat than painter; nevertheless, one watercolor by Wagner depicting himself and a nude woman in the dressing room of the Cirque Molier (fig. 5) expresses well the melancholy quality of the *sal-*

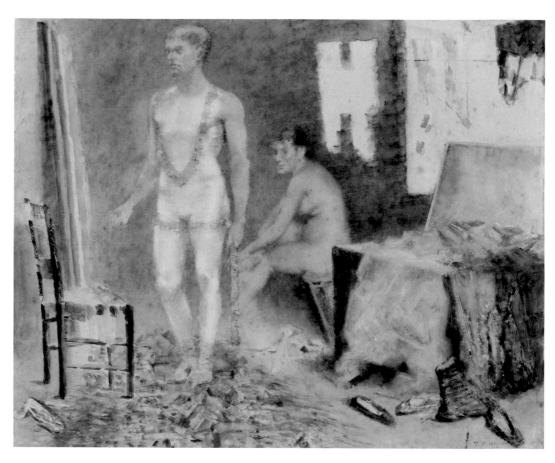

Fig. 5. Théophile Pierre Wagner, *Self-portrait of T.P. Wagner in the Dressing Room of the Cirque Molier*. Watercolor on paper. Jane Voorhees Zimmerli Art Museum, Rutgers, The State University of New Jersey, David A. and Mildred H. Morse Art Acquisition Fund

timbanque that one finds in Goncourt's *Les frères Zemganno* and that Huysmans encountered in Wagner's work at the 1884 Salon des Indépendants. On the other hand, Tissot's La Rochefoucauld reflects the attitude of Pierre Loti toward the athlete.

Even though the performances of the Cirque Molier were infrequent and the audience was limited in number, Ernest Molier had an impact on the Parisian social and circus scenes. The Parisian press covered events at the Molier annually; particularly attentive, with full-page illustrations and commentaries, was *Le Courrier français*, which was the primary social organ of Montmartre artists and writers.

A number of Molier's female amateurs, whom he trained as *écuyères* (equestrians), became professional circus performers; among them were Louisa Lankast, Le Bailly d'Inghem, and — the

most famous — Blanche Allarty, whom he married. Because of objections by "respectable" women of the uppercrust who did not want to associate with women of a lower social order, Molier initiated in 1880 a second and separate performance for women of the theater and of the *demimonde*. Thus his circus reached both the aristocratic set and the world of entertainers, instilling in both groups a respect for and interest in the circus. Although circus acts were often incorporated into the nightly shows of the Folies-Bergère, the Ambassadeurs, and other popular cafés-concerts, in 1888 the writer Félicien Champsaur produced for the Cirque Molier a pantomine, *Les eaux de Bénouville*, that was the first of such acts to combine basic elements of theater and café-concert at the circus.[26] Likewise, with the publication of a group of his short stories two years earlier, Champsaur had integrated a formal as-

pect of the circus into his own writing. Entitled *Entrée des Clowns*, these stories themselves have nothing to do with the circus; rather, as the author explains in his preface, the purpose of the short stories within his overall oeuvre is analogous to that of clown acts within a total circus performance.[27]

In February 1886 the entertainment impresario Joseph Oller opened the fourth professional circus in Paris, the Nouveau Cirque at 251 Rue Saint-Honoré. As a special attraction, it had a hydraulically powered movable floor that allowed the circus ring to become a swimming pool.[28] In June of that year for a benefit performance held by Molier at the Nouveau Cirque, he choreographed an aquatic pantomime called *La grenouillère*, which combined the gymnastic talents of his amateur performers with the new circus technology.[29] From that point on, *La grenouillère* became a regular act at the Nouveau Cirque. Eventually, in the 1890s, the Nouveau Cirque became a strong competitor of the Cirque d'Été because of the former's highly skilled *écuyères* and the comic team of Footit and Chocolat. These two popular clowns combined the sophisticated humor and social satire that appealed to the Parisian wry sense of humor; their act, however, was just as much at home on a café-concert stage as it was at the Nouveau Cirque.

At the turn of the century, both the circus and the *fête foraine* transcended class distinction and mere entertainment as they pervaded Paris in one form or another from the grand spectacles at the Hippodrome to the single act of a *saltimbanque* on a street corner of the poorest neighborhood. While the circus was amusing and thrilling, it was also perceived by many as serious and symbolic of life. If the bourgeoisie doubted the moral rectitude of circus performers, artists and writers empathized with the latter and even emulated and idealized their physical abilities. Toulouse-Lautrec himself looked to the circus as therapy when, in 1899, he was convalescing at a sanatorium on the outskirts of Paris from a serious bout of alcoholism. There he drew a series of circus scenes from memory (see cat. 200-204) in order to prove his mental competence and thus gain release from the hospital.[30]

Three years earlier in *Demi-cabots* (Ham Actors), André Ibels paid homage to the circus in a poetic verse, "Le cirque," which owes its style and cadence to the symbolist work of Stéphane Mallarmé.[31] Elevated to the stature of "vers im-pressioniste" and profusely illustrated by Henri Ibels, the poem reflects the level of sophistication and the position of respect attained by the circus within the world of the literary and artistic avant-garde and belies the circus's great populist appeal. Indeed, the cult of the circus was a unifying force for Parisian society, which, at the end of the century, was often otherwise bitterly segmented and split along economic, political, and social lines.

Notes

The circus in French art from Daumier to Picasso is a theme that Richard Thomson, of the Department of Art History at the University of Manchester, and I have discussed for some years and have hoped would materialize into a full-scale exhibition and publication. Since that may never come to fruition, I am grateful to Barbara Shapiro for giving me the opportunity to introduce briefly in this essay some ideas and information that may contribute to a better understanding of the circus's significance in turn-of-the-century French art and society. I also acknowledge with appreciation the help of Lisa Simpson, research assistant at the Zimmerli Art Museum, in gathering material for this essay.

1. Anonymous, *Le Courrier français*, May 27, 1888, p. 10.

2. Prior to Dalsème's 1888 publication, the earliest serious study of the circus is Gaston Escudier, *Les saltimbanques: Leur vie — leurs moeurs* (Paris, 1875); three subsequent publications are Hugues Leroux, *Les jeux du cirque et la vie foraine* (Paris, 1889); Baron de Vaux, *Écuyers et écuyères: Histoire des cirques d' Europe (1680-1891)* (Paris, 1893); Henry Frichet, *Le cirque et les forains* (Tours, 1899). For contemporary documentation on cafés-concerts and dance halls, see Maurice Delsol, *Paris-Cythère* (Paris, ca. 1896); and Horace Valbel, *Les chansonniers et les cabarets artistiques* (Paris, 1896).

3. See Tristan Rémy, "Le Cirque Fernando: Vingt-cinq ans de cirque (1873-1897)," *Le cirque dans l'univers*, supplement to no. 115, 1979.

4. Renoir's *Circus Girls* (The Art Institute of Chicago) and Degas's *Miss La La at the Cirque Fernando* (National Gallery, London) are quite different in approach. Renoir concentrated on the modeled pose of two young female performers and was most interested in the rich colors and textures of costumes, the surface of the ring, the warmth of the young bodies; the circus is really quite incidental in this portrait. In contrast, Degas ignored the individual and emphasized the amazing and awkward physical feat of hanging from one's teeth high up in the rafters of the circus; he took full advantage of the dramatic perspective view offered by the incongruous relationship of figure to ceiling.

5. For the Chat Noir and its environment, see Phillip Dennis Cate and Patricia Eckert Boyer, *The Circle of Toulouse-Lautrec*, exhib. cat. (New Brunswick, N.J.: Jane Voorhees Zimmerli Art Museum, Rutgers, the State University of New Jersey, 1985).

6. Frichet, *Le cirque*, p. 8.

7. Phillip Dennis Cate, ed., *The Graphic Arts and French Society, 1871-1914* (New Brunswick, N.J., 1988), p. 33.

8. F. Berkeley Smith, *How Paris Amuses Itself* (New York, 1903), p. 232.

9. Tancrède Martel, "Le théâtre chez les forains," special issue of *Figaro illustré*, Nov. 1897, p. 201.

10. *Demi-cabots, le café-concert, le cirque, les forains*, text by Georges d'Esparbes, André Ibels, Maurice Lefèvre, Georges Montorgueil, illustrations by Henri Ibels (Paris, 1896), pp. 201, 203. As an example of the quantity of fairs in Paris at the turn of the century, the annual *Attractions de Paris*, published by Dido-Bottin, lists twenty-seven fêtes foraines for 1902 throughout Paris.

11. Martel, *Le théâtre*, p. 202.

12. Edmond de Goncourt, *Les frères Zemganno* (Paris, 1879); Pierre Loti [pseud.], *Aziyadé* (Paris, 1977). (First published 1879.)

13. Goncourt, *Frères Zemganno*, pp. 222-223.

14. Loti's real-life circus experience is mentioned as early as 1889 by Leroux, *Les jeux du cirque*, p. 228. See also Lesley Branch, *Pierre Loti* (New York, 1983), p. 95; Keith G. Millward, *L'Oeuvre de Pierre Loti et l'esprit "fin de siècle,"* (Paris, 1955); and N. Serban, *Pierre Loti* (Paris, 1924).

15. Loti, *Aziyadé*, pp. 25, 54.

16. Ibid., p. 86.

17. While the male performers were all nonprofessionals, it was necessary for Molier to include a number of professional female circus performers along with the few aristocratic amateurs and other young women whom he trained as *écuyères*. Ernest Molier, *Cirque Molier, 1880-1904* (Paris, 1904), p. 8.

18. Ibid., pp. 6-7.

19. Paul Signac, in *La Cravache*, Sept. 22, 1888, p. 2.

20. First published by J.K. Huysmans, in *La Cravache*, Aug. 4, 1888, pp. 1-2, and later reprinted in Huysmans's 1889 collection of articles on art entitled *Certains*. The quotation is taken from *L'art moderne/Certains*, preface by Hubert Juin, Fins de siècles series (Paris, 1975), pp. 269-270.

21. Ibid., p. 270.

22. Signac, *La Cravache*, p. 2.

23. Vaux, *Écuyers*, pp. 334-335.

24. David S. Brooke, "James Tissot's Amateur Circus," *Boston Museum Bulletin* 67 (1969), pp. 4-17.

25. Reproduced in Molier, *Cirque Molier*, p. 51.

26. Ibid., pp. 65-66; Leroux, *Les jeux du cirque*, p. 239.

27. Félicien Champsaur, *Entrée des clowns* (Paris, 1886), pp. 6-8.

28. Molier, *Cirque Molier*, p. 56; Vaux, *Écuyers*, p. 325; Oller is best remembered as the owner of the popular Montmartre Moulin Rouge dance hall, which opened to the public in the fall of 1889.

29. Molier, *Cirque Molier*, p. 55.

30. P. Huisman and M.G. Dortu, *Lautrec by Lautrec* (New York, 1964), p. 202.

31. The relation between Mallarmé's "éventail" poems and André Ibels's poem in *Demi-cabots* was brought to my attention by Anna Dull, a Ph.D. candidate in the Department of French at Rutgers University.

Parisian Entertainments

Boulevards and Promenades
I

Museums and Galleries
III

The Bois de Boulogne
II

Theatrical Entertainments
IV

Cafés and Cabarets
V

Fairs and Circuses
VI

Boulevards and Promenades

The topographical face of Paris that we recognize today was essentially the creation of Louis Napoleon during his rule as Emperor Napoleon III. From his long exile in England, he brought back ideas for creating broad avenues and open spaces that would favor public festivities and would replace the existing dark and narrow streets that he believed provided havens for uprisings and blockades. (The Revolution of 1848 that secured his power was won owing to the maze of barricades built in the working-class quarters of the old city.) In order to enact this sublime vision, Napoleon appointed, in 1853, Georges-Eugène Haussmann as Prefect of Paris, whom history has variously described as a man of great integrity and energy or as a misguided and ruthless zealot. His responsibility was the daily administration of Paris, and in this undertaking he implemented Napoleon's grand design. With all possible speed, Haussmann, supported by the emperor and the municipal council, demolished much of medieval Paris; historic monuments were destroyed, and workers' homes were torn down and replaced by high-rental apartments or luxurious private mansions. Entire neighborhoods, involving some twenty thousand buildings, were lost, causing an increase in the number of the city's homeless. With relentless force, Haussmann saw to the expansion of Paris by the annexation of adjacent suburbs, creating the twenty *arrondissements* that exist today and pushing the poorer people farther away from the city's vibrant social center.

Just as Haussmann's "transformation of Paris" is still analyzed and argued about, so he was greatly criticized by many of his most thoughtful contemporaries. Eventually, pressure was brought to bear against this formidable juggernaut, and in early 1870 Napoleon III reluctantly dismissed "le Grand Préfet," the "devoted instrument of that great and difficult work." Although it is generally agreed that Haussmann did not personally profit from the massive real-estate manipulations that took place, as did many entrepreneurs, the estimated 2.5 billion francs that were spent had been borrowed through irregular means, providing justification to remove him from power. Ludovic Halévy, Degas's old friend and the librettist for Offenbach's operettas, poignantly wrote in his diary: "It is an important event. . . . Paris is a marvel, and M. Haussmann has done in fifteen years what would not have been done in a century. But for the moment that is enough.

There will be a twentieth century. Let us leave a little work for it to do."[1]

One should not forget that in the midst of this daily and inexorable destruction, there were innumerable "improvements" or, at least, major alterations that took place in Paris during this period. Napoleon and Haussmann were responsible for many of the new streets and widened avenues, the gracious open areas, the protection of notable buildings and monuments, such as the Louvre, from urban encroachment, the construction of bridges over the Seine, the provision of a new sewer system and water supply, the commission of Charles Garnier's Opéra, as well as the opening of numerous public parks and squares with a profusion of plantings, benches, ornate lights, and paths. The popular *grands boulevards*, however, that encircle the historic center of Paris on the Right Bank were not the creation of the Second Empire urban planners, as is often thought, but were designed by Louis XIV, the Sun King, to commemorate his military victories.

Haussmann's engineering feats, undertaken for a city whose population had doubled between 1850 and 1880 — along with the awareness that leisure time for many Parisians had become an assumption rather than a privilege — created the environment in which the pleasures of late nineteenth-century Paris took place. Although historians recognize that there was grievous social and political unrest during the last half of the century, they acknowledge that the Second Empire provided the physical conditions and the financial support for the abundant celebrations and entertainments with which the city is always identified.

The Parisian boulevard, one Danish visitor claimed in 1889, was "the great rendezvous where the whole population flocks together to satisfy its great craving for sociability, where people meet with the wish of being together, and associate with the amiable courtesy and easy approach that is a consequence of the consciousness of being mutually entertaining. The cafés form its main feature. They lie side by side, in countless number, along the thoroughfare between the Bastille and the Place de la Concorde. . . . The café is a reserved seat in the street, a sort of comfortable sofa-corner in the great common parlor."[2] These streets became the giant connectors to all parts of the city, where the daily rhythm of life was comfortably and constantly observed.

Honoré Daumier
Now my flower pot will have some sunshine . . . I will finally know whether it is a rose or a gillyflower
(Voilà donc mon pot de fleurs qui va avoir du soleil . . . je saurai enfin si c'est un rosier ou une giroflée), 1852
Museum of Fine Arts, Boston, William P. Babcock Bequest. 147/4184
(cat. 22)

Maxime Lalanne
Demolition for the Creation of the Rue des Écoles
(Démolitions pour le percement de la rue des Écoles), 1865
Museum of Fine Arts, Boston, Gift of Miss Ellen Bullard. 25.1216
(cat. 32)

Once Daumier had abandoned his politically sensitive cartoons, he amusingly and gently caricatured the mores and traditions of the petit bourgeois, *always aware of the wide-ranging effects that current events had on the lifestyle of his fellow citizens. Baron Haussmann's demolitions did not evade his eye, nor did the frequently difficult life of many of the Parisians with whom he explored both the hazards and diversions of the city.*

Like many photographers, Lalanne recorded for posterity the demolitions that affected most Parisians in the 1850s and early 1860s. With his etched line, he graphically described the overwhelming and inexorable destruction that took place during the regime of Napoleon III and his "Prefect of Paris," Baron Haussmann. Residents in dilapidated buildings were never certain when their date for major disruption was approaching.

Jean Béraud
*On the Boulevard Montmartre, in Front of the Théâtre
des Variétés,* 1880
Private Collection
(cat. 4)

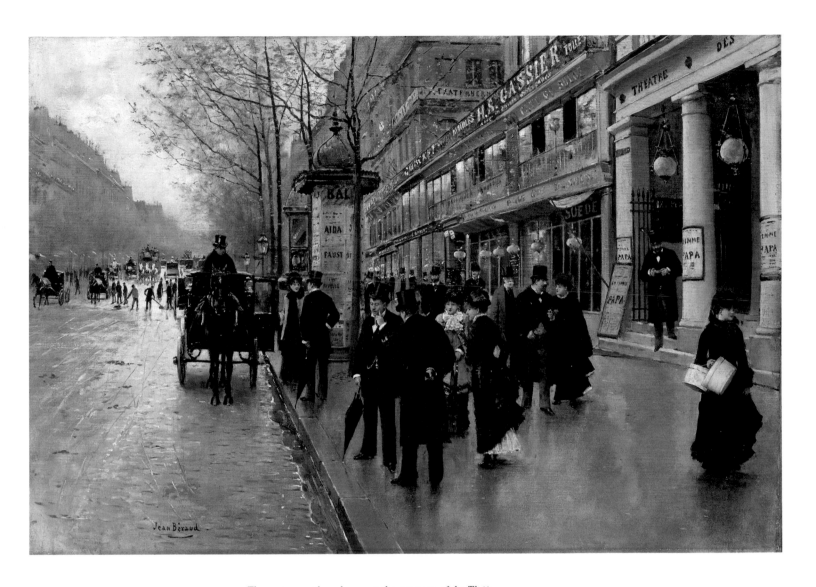

The posters on the columns at the entrance of the Théâ-
tre des Variétés advertise a play called La Femme du
Papa. *It opened in December 1879 and closed in De-
cember 1880. The trees that appear to be leafing out
suggest that this scene was painted in the spring of
1880. Though a contemporary of the Impressionist art-
ists, Béraud did not follow their style; he preferred in-
formative detail and a more highly finished application
of pigments. His paintings are veritable records of so-
phisticated urban life and the display of fashion of a
special part of French society. The Morris columns with
green-painted metal roofs that carried theater advertise-
ments were common street fixtures in nineteenth-century
Paris and were considered an important source of
information.*

At night the boulevards were a different spectacle with another audience. There were those who flocked to favorite places for aperitifs and others who enjoyed the hundreds of glittering shops and boutiques that flourished everywhere. Around the middle of the century, the production of large sheets of plate glass made it possible for shops at ground level to open their window displays for pleasurable viewing, extending the lavish interiors out of doors. Made more dazzling with artificial lighting — first gas, then electric — these "fantasy palaces" were another accessible amusement. "Always festively illuminated, golden cafés, a stylish and elegant throng, dandies, literati, financiers. The whole thing resembles a drawing-room."[3] Commenting on the method of lighting, Henry James wrote in the summer of 1876: "The inordinate amount of gas in all the thoroughfares heats and thickens the atmosphere, and makes you feel of a July night as if you were in a vast concert hall."[4]

Among the most important and enduring features of the city streets were the omnibuses, which by 1888 had accommodated more than 150 million passengers (see cat. 6). They were large conveyances seating forty and for the major routes were drawn by a team of three horses. By 1890 the omnibuses were centers of social interaction where "elegant ladies and men of the world rubbed shoulders with the lower classes," and an alertness for pickpockets united all the customers![5] Frequently mentioned drawbacks of the system were the excessive traffic and the deafening noise that resounded from the streets. (In his apartment on Boulevard Haussmann, the noted writer Marcel Proust always kept his windows closed and had his rooms sound-proofed with cork-lined walls.) Nonetheless, when the omnibuses were supplemented by tramways and private cabs for hire, Parisians could traverse the city with relative ease even before the advent of the Métro in 1900.

Like the boulevards, the parks and squares provided their own form of entertainment; there the well-to-do could stroll or take an afternoon outing on horseback or by carriage, frequently observed by those who sat on small chairs on the sidelines. Children of the upper classes played in elegant parks, watched over by nursemaids in their distinctive garb: "Nine out of ten of the nurses one meets in the parks and squares are decked with long richly folded cloaks, headgears

adjusted with gold pins, and long silk ribbons falling down their backs" (cat. 8, 21).[6]

Promenading was one of the special pleasures of Paris. When Napoleon III opened the garden of the Tuileries to the public, it became a popular place in which to ambulate. (The gift of the gardens was a political device, employed by both the emperor and Haussmann to placate the public while further unfavorable demolition was undertaken.) Numerous plantings of trees and flowers from the Louvre to the Place de la Concorde made it one of the "most pleasing memories of [his] reign." Pissarro frequently painted the Tuileries garden view (cat. 44), and Raffaëlli also depicted lively scenes of nearby squares staffed with well-dressed Parisians (cat. 45).

In the Bois de Boulogne, a favored park, the most prestigious walkway was the Allée des Acacias, where the fashionable elite along with celebrated courtesans (aptly called *les grandes horizontales*) would either stroll leisurely or ride in handsome *équipages* while being on display. One could expect encounters, introductions, or rejections, depending on one's position in society. Marcel Proust based many of his characters on the distinctive and stylish persons that he observed during his walks. When the Church joined the labor movement in insisting that Sunday be a day of rest, promenading became a notable leisure-time activity that blurred class distinctions.[7]

Paris, "a perpetual and kaleidoscopic Fair," reached exceptional proportions during the Expositions Universelles (International Exhibitions). Napoleon III opened the first Exposition in 1855, which was succeeded in 1867 by another and grander spectacle that won universal acclaim for the city. Although the thrust of these fairs was toward commerce and industry, Louis Napoleon's recognition of art and culture as a means to social power moved him to encourage all types of exotic presentations, theatrical events, foreign pavilions, and bazaars. The use of new methods to duplicate the art of the past was especially applauded. After the emperor's downfall in 1870, when he was forced to surrender to the Prussians, the next Universal Exposition did not take place until 1878, under the regime of the Third Republic. As the result of the general feeling of relief following the end of the Franco-Prussian war and the ensuing Commune in 1871 (cat. 40, 41), the government set aside certain monies and plans for another extravaganza. The realized hope was to

entice visitors to admire the more than fifty thousand exhibits, concessions, and balloon ascensions and to announce to the world that Paris was herself again!

The Exposition of 1889, which marked the centennial of the French Revolution in 1789, surpassed all expectations. It was a spectacular amusement and pleasure garden that Parisians could share along with millions of their countrymen and foreign visitors. The attractions, both industrial and cultural, spread over some two hundred acres on the Champ de Mars and included over sixty thousand architecturally innovative projects, displays of new products, and many culturally diverse pavilions and beautiful parks. The ultimate symbol of the social and economic changes that were underway was the tall iron structure, the "triumphal arch," the new wonder of the world — the Eiffel Tower (cat. 43). More than three million people visited or ascended it in 1889, and another thirty million people crowded into the exhibition halls and grounds from early May through November; the railroad alone carried twenty million passengers during these six months. Both chic and popular, the Exposition made Paris the irresistible mecca of pleasures and entertainment.

The Exposition of 1900 was of even greater proportions. The Eiffel Tower, still the principal "titanic structure" at the fair, was joined by the Palace of Electricity, demonstrating the new technology. Light shows at night, such as the *fontaines lumineuses*, bedazzled the crowds, and the unusual applications of electricity like a moving sidewalk (cat. 42) enchanted the fifty million visitors who attended the fair. The architectural style throughout was baroque and rococo; two structures intended for preservation were the Grand Palais and the Petit Palais, both of which are still used for the presentation of art exhibitions. Also retained was the Pont Alexandre III over the Seine; ornate and decorative with gas-fitted candelabra, it was named after the father of Czar Nicholas II of Russia to signify the Franco-Russian friendship at that time. The bridge's single span was the major engineering achievement of the 1900 Exposition.[8]

This Exposition marked the end of the *grands spectacles* in Paris that had occurred every eleven years from 1855. What had been undertaken as a celebration of a century of achievement and progress, as well as a means to raise the country's morale after the prolonged Dreyfus Affair, created new resentments instead; the colossal spaces, the vast distances, the overabundance of exhibits, and the lack of a focus or an ideal led to much criticism and disappointment. Originally intended as proud monuments to progress and fabulous centers of recreation for people from all walks of life, the international fairs had become gross exaggerations. Expositions on such a grand scale were too costly and too controversial for the government to undertake again. The Parisians and foreign visitors, however, continued to enjoy the abundant entertainments that took place on the boulevards and thoroughfares, and only with the coming of World War I did the mood change and the pace slacken.

Notes

1. Quoted in Joanna Richardson, *La vie parisienne, 1852-70 (New York, 1971),* p. 219.

2. Richard Kaufmann, *Paris of To-day,* trans. from the Danish by Olga Flinch (New York, 1891), p. 73. (Originally published in 1889.)

3. Emma von Niendorf's description of the Boulevard des Italiens at night, quoted in Wolfgang Schivelbusch, *Disenchanted Night: The Industrialization of Light in the Nineteenth Century,* trans. Angela Davies (Berkeley, 1988), pp. 148-149.

4. Henry James, *Parisian Sketches: Letters to the* New York Tribune, *1875-1876* (New York, 1957), pp. 189-190.

5. Eugen Weber, *France, Fin de Siècle* (Cambridge, Mass., 1986), p. 73.

6. Kaufmann, *Paris of To-day,* p. 146.

7. Philippe Aries and Georges Duby, eds., *A History of Private Life,* vol. 4: *From the Fires of Revolution to the Great War,* chap. 3, "Scenes and Places," by Michelle Perrot and Roger-Henri Guerrand (Cambridge, Mass., 1990), p. 490.

8. For a discussion of the 1900 Universal Exposition, see Miriam R. Levin, *When the Eiffel Tower Was New,* exhib. cat. (South Hadley, Mass.: Mount Holyoke College Art Museum, 1988), pp. 2 - 46.

William James Glackens
Flying Kites, Montmartre, 1906
Museum of Fine Arts, Boston, Charles Henry
Hayden Fund. 38.7
(cat. 27)

Jean Béraud
Avenue des Champs-Élysées, ca. 1885
Private Collection, United States
(cat. 5)

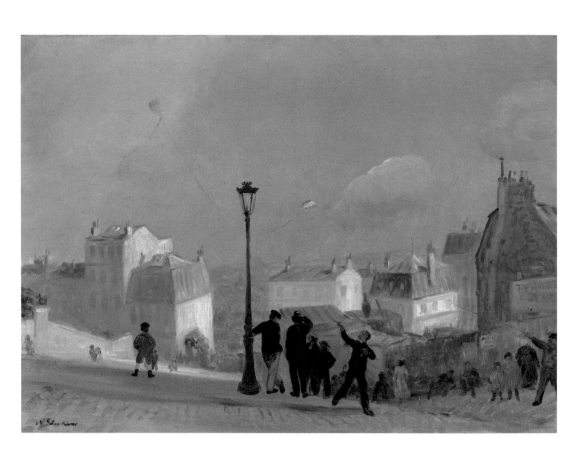

According to Glackens's son, Paris was the artist's favorite city and France "his spiritual home." He loved the people in the streets, the public gardens, the color of the houses and, in general, "the flow of life." When Glackens painted this picture from the highest part of the hill in Montmartre, there were still open spaces with cottages and small gardens that gave the area an undeniable sense of the countryside.

The Avenue des Champs-Élysées is the most famous of all the streets in modern Paris. It was conceived initially as a monumental axis joining the Tuileries gardens through the Place de la Concorde to the Arc de Triomphe, which was begun in 1806 by Napoleon I. During the nineteenth century the Champs-Élysées was lined with elegant mansions that eventually gave way to apartment houses and hotels and finally, at the turn of the century, became clogged with commercial shops, banks, cafés, and automobiles. The fashionably dressed woman seen crossing the avenue is probably a member of the privileged class for whom promenading was an essential part of the daily routine; although she may well be one of the grandes horizontales, *whose costumes were often more* à la mode *than those of their married sisters. The top-hatted gentleman in the carriage is acutely aware of her presence in the manner of the* boulevardiers, *who made a pastime of assessing females.*

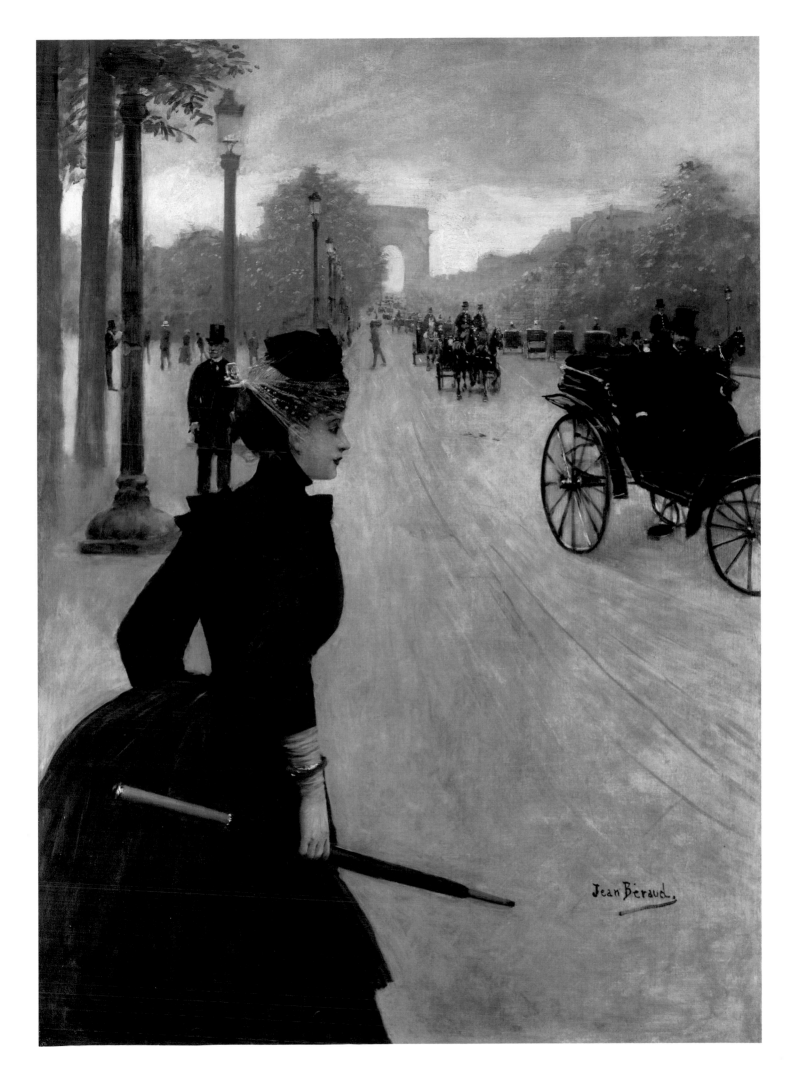

Edward Darley Boit
Place de l'Opéra, Paris, 1883
Museum of Fine Arts, Boston, Gift of the artist.
1888.331
(cat. 7)

**Anonymous Photographer, French,
19th century**
Place de l'Opéra, ca. 1888
Private Collection
(cat. 1)

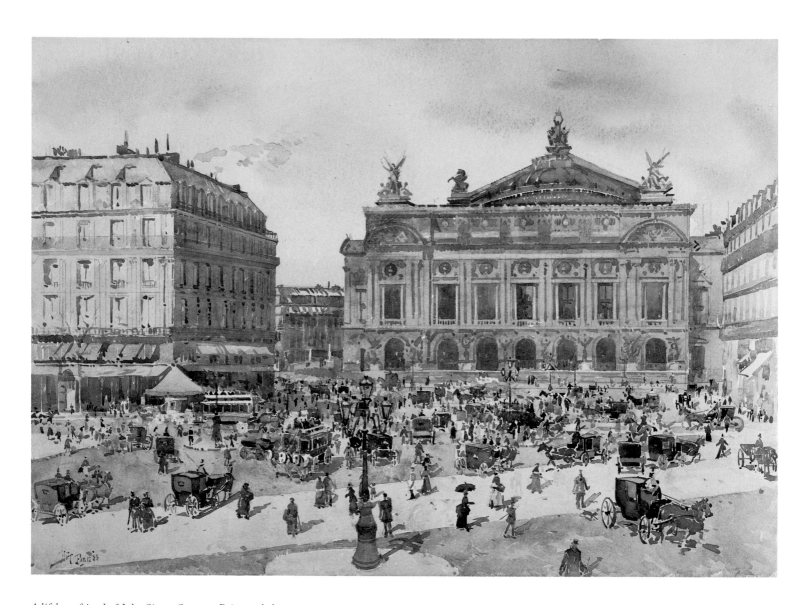

A lifelong friend of John Singer Sargent, Boit traveled ex-
tensively, making frequent trips to Paris. He was aware of
the Impressionists' new approach to painting and embraced
their technique of short, broken brushstrokes, using a narrow
range of colors. The construction of the new Opéra began in
1861 during the Second Empire, but it was not inaugurated
until 1875 under the Third Republic. Baron Haussmann's
choice of location required the demolition of a large number
of charming hôtels *(mansions)* dating from the end of the
eighteenth century. Instead of placing this important hall in
a residential section, Haussmann might have considered the
Champs-Élysées, which was already an urban center of
pleasure for "le plus high-life."

The horse-drawn omnibuses were the primary means of
transportation from 1850 to the late 1870s and were a fea-
ture of the Parisian streets. They were then supplemented by
tramways on rails. According to a guidebook of 1878, a vis-
itor could use either system to get a general view of the city.

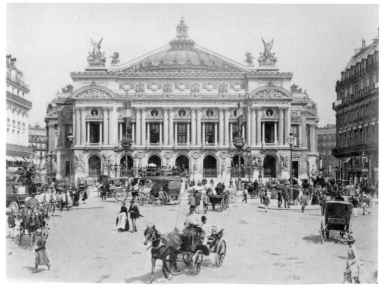

Eugène Guérard

*Physiognomies of Paris, no. 4: The Boulevard des
Italiens (the Tortoni, 4 o'clock in the evening)*
(Physionomies de Paris, no. 4: Boulevard des Italiens [Tortoni,
4 heures du soir]), 1856
Sterling and Francine Clark Art Institute, Williamstown, Massa-
chusetts. No. 2531
(cat. 28)

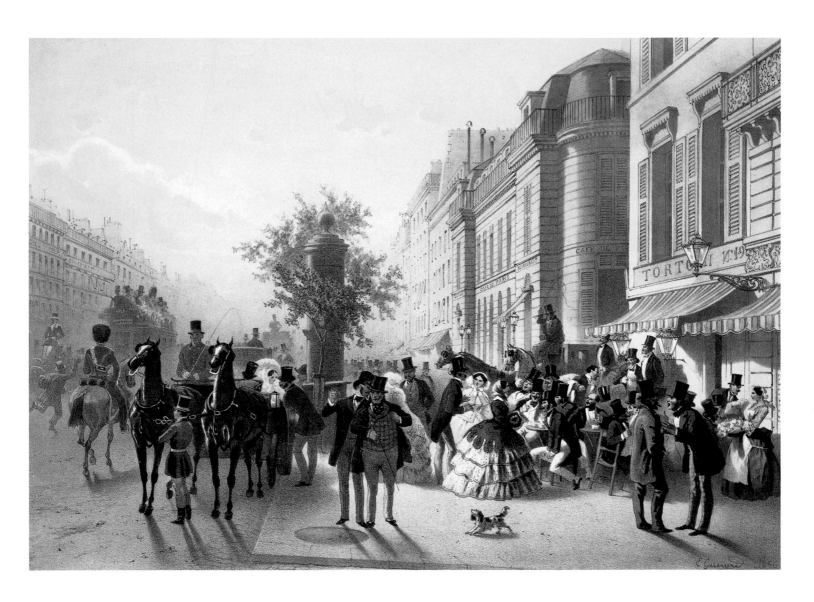

During the Café Tortoni's fashionable years, le tout
Paris *would pass by it daily in the late afternoon. Estab-
lished at the corner of the Boulevard des Italiens and
Rue Taitbout about 1798, it was soon favored by dan-
dies who were successively called "citizens," "unbeliev-
ers," "dandys," and "lions." Manet, who may have
abandoned other old haunts, was always drawn back to
the Café Tortoni, the symbol of the spirit of the boule-
vards until it closed in 1893.*

Anonymous Photographer (H.P.), French, 19th century

General View of the Place de la Concorde
(Vue générale de la Place de la Concorde), before 1889
Museum of Fine Arts, Boston, Gift of Clifford S. Ackley.
1977.163
(cat. 3)

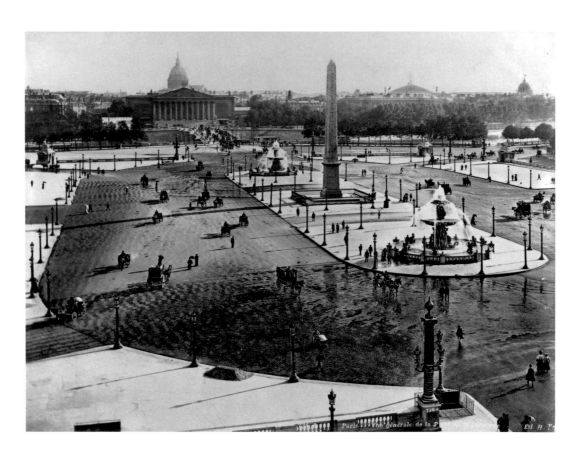

The most spacious plaza in Paris, the Place de la Concorde was conceived in 1745 as part of a design competition to honor Louis XV. The site where more than 2,800 people were guillotined after the Revolution, it received its final name only after 1830. The desire to ornament the square with a nonpolitical monument was realized when Charles X was offered in 1829 the Obelisk of Luxor from Egypt. It was installed in 1836 during the reign of Louis Philippe along with two fountains and eight stone figures representing major towns in France. A description in the November 23, 1867, issue of Harper's Weekly *describes the scene: "The foreign visitor . . . is not long in Paris before he drives through the Place de la Concorde, with its gilded fountains pouring out their showers of diamonds glittering in the gaslight, and along the broad avenue of the Elysian Fields, to the gate which opens from that brilliant thoroughfare to the embowered garden of Mabille."*

In the early 1880s Raffaëlli often depicted the ragpickers and urchins of Paris; by 1884 he was devoting his attention to portraits and cityscapes. One of the most appealing subjects to artists was the Place de la Concorde. Its spacious proportions and unobstructed vistas have remained relatively intact even today, although from early on it became a busy center for traffic and pedestrians. The young woman riding her bicycle suggests a date of execution for the painting of about 1895, when the upperclass diversion of biking as a private exercise became an accepted public activity. By this time, certain tailors even specialized in women's outfits for the sport (Steele, p. 175).

Jean-François Raffaëlli
Place de la Concorde, Paris, ca. 1895-1900
Museum of Art, Rhode Island School of Design, Providence, Gift
of Colonel Webster Knight. 28.040
(cat. 45)

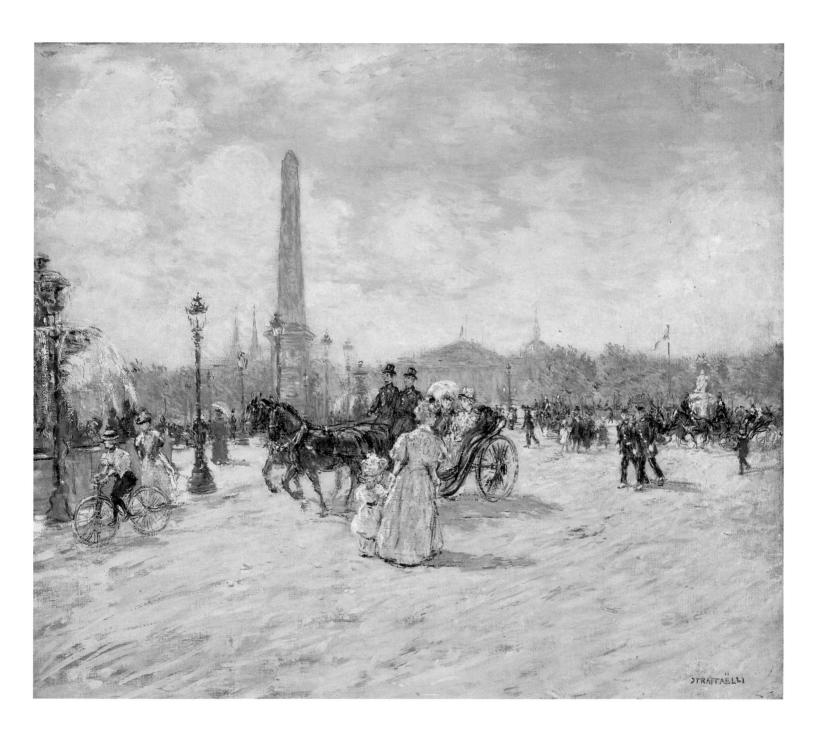

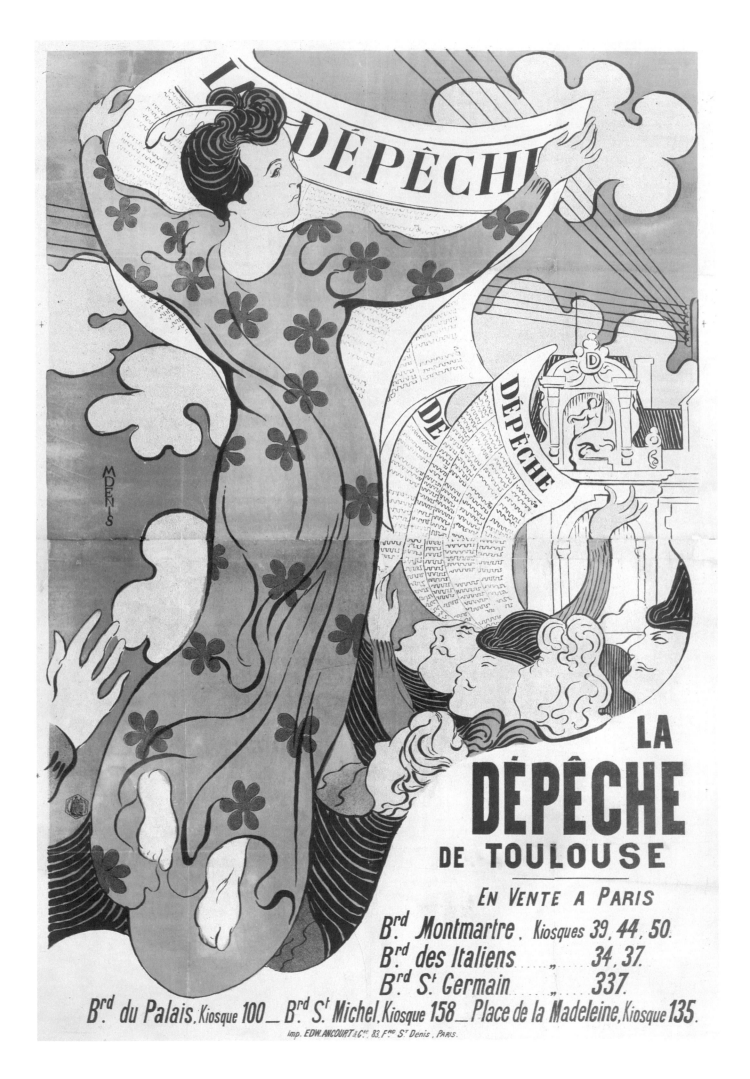

Maurice Denis
The Toulouse Dispatch
(*La Dépêche de Toulouse*), 1892
Jane Voorhees Zimmerli Art Museum, Rutgers,
The State University of New Jersey, Alvin and
Joyce Glasgold Purchase Fund. 1986.0089
(cat. 25)

*Denis's patron and friend Arthur Huc, the
owner and publisher of* La Dépêche, *com-
missioned the young Nabi artist to design
a poster advertising his newspaper. The
project consisted of a large painting (The
Detroit Institute of Arts), a watercolor
squared for transfer (Kunsthalle, Bremen),
and the poster itself, issued in four colors
and in a greatly reduced black and white
version. The poster lists (in the lower right
corner) the locations in Paris where the
paper could be purchased. The Freedom of
the Press laws enacted in 1881 and later
the Exposition of 1889 encouraged an
outpouring of newspapers, journals, peri-
odicals, and prints for the delectation of
Parisians and the thousands of visitors
who crowded the city. By the mid-1880s
there were at least thirteen hundred news-
papers, and by the 1890s the Parisian
press was one of the most influential in the
world. All of Paris could be informed
about the political events and festive activ-
ities of the period.*

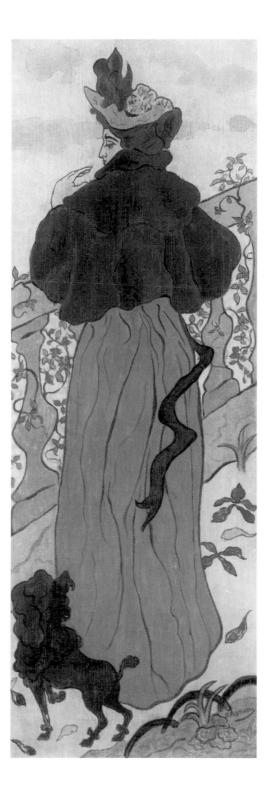

Paul Ranson
Woman Standing beside a Balustrade with a Poodle
(*Femme debout contre une balustrade avec un caniche*), ca. 1895
Mr. and Mrs. Arthur G. Altschul
(cat. 46)

*Ranson, a founder of the group of French artists called
the Nabis, achieved a decorative style through the use of
elongated figures, sinuous contour lines, flat color areas,
and backgrounds often strewn with flowers — all char-
acteristics of "Japonisme." The figure and face of the
fashionably dressed woman, who has paused during a
stroll in the Tuileries, bear an uncanny likeness to the
portrait of Madame Ranson painted by Maurice Denis
three years earlier.*

Félix Vallotton
The Demonstration
(La manifestation), 1893
The Museum of Modern Art, New York, Gift of
Victor S. Riesenfeld. 367.48
(cat. 55)

Alfred Stieglitz
A Wet Day on the Boulevard
Negative 1894, photogravure 1897
Museum of Fine Arts, Boston, Gift of David
Bakalar. 1975.657
(cat. 51)

*Vallotton, a member of the Nabis group,
frequently focused on social issues, espe-
cially during the 1890s, when street riots
were a common event. The fleeing figures
in this woodcut, especially the frightened
nursemaid and the elderly man who has
lost his top hat, imply the approach of the
police and imminent violence. These up-
risings anticipated the political ills of the
Dreyfus Affair, with which Vallotton was
deeply concerned.*

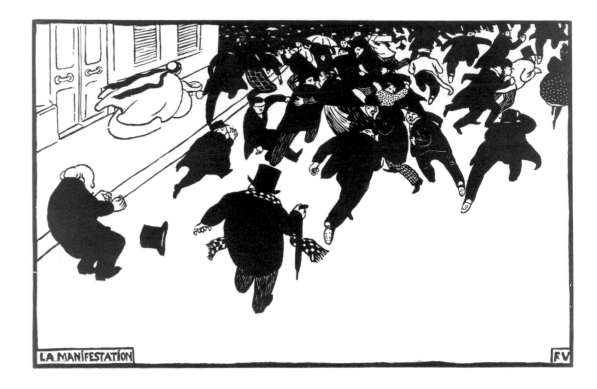

*In 1894 Alfred Stieglitz and his first wife,
Emmeline, went on their honeymoon, a
Grand Tour that took them from Italy to
England. This image, a picturesque view
of pedestrians shielding themselves from
the elements, was taken during this trip;
like many of Stieglitz's photographs, it
was routinely printed in photogravure, a
technique of which he had an intimate
knowledge. Contemporary writers men-
tioned the popularity of the Old England
Shop on the Boulevard des Capucines,
with its expensive objects from overseas.
The shop's name offers a clue to the loca-
tion of Stieglitz's photograph.*

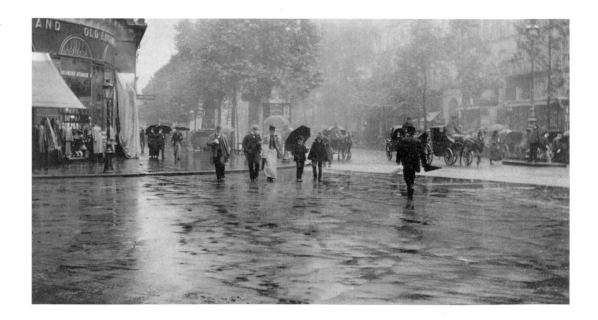

Henri de Toulouse-Lautrec
The Photographer Sescau
(Le photographe Sescau), 1896
Courtesy of the Boston Public Library, Print Department, Gift of
Albert H. Wiggin
(cat. 53)

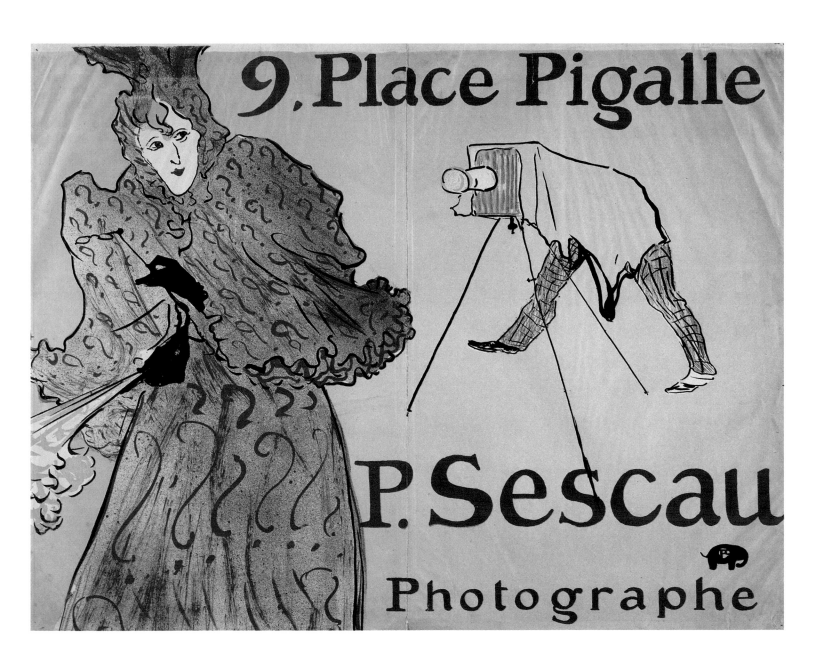

Lautrec pokes fun at the photographer Paul Sescau, his good friend and fellow carouser, who was known for his constant pursuit of young women with his camera. A stylishly dressed woman, possibly on her way to a masked ball, hurries to evade the scrutinizing eye of Sescau's camera. In the first stage of the lithograph the woman wears a mask, suggesting her destination, but it was removed in the final printing. The recently invented and influential medium of photography is celebrated in this colorful poster of an amusing street encounter.

Frank Meyer Boggs
Paris Street Scene, 1893
The Metropolitan Museum of Art, Gift of Mr. and Mrs. Arthur G.
Altschul, 1971. 1971.246.1
(cat. 6)

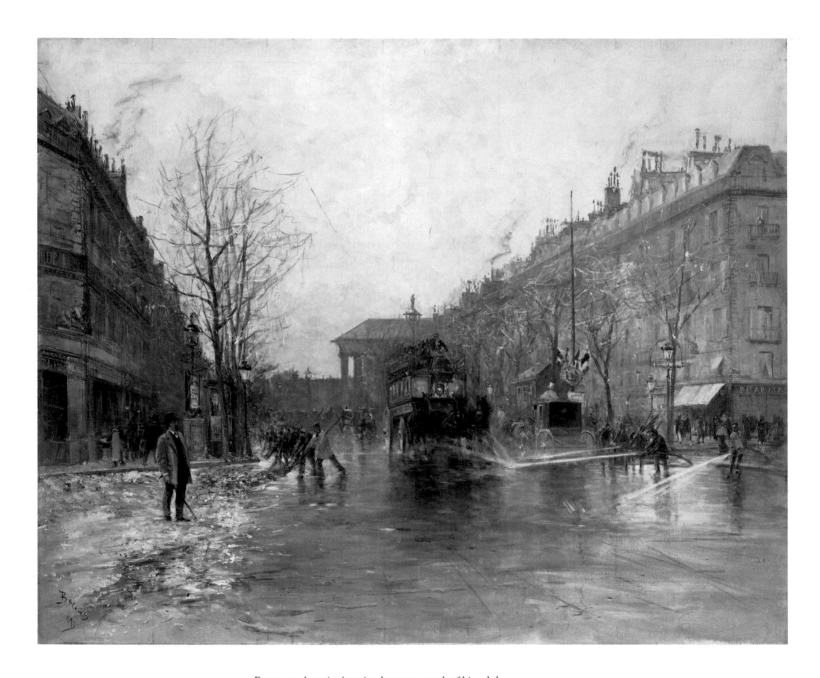

*Boggs was born in America but spent much of his adult
life abroad, eventually becoming a French citizen. Al-
though he is termed an "Impressionist," his work fits
that description only in his choice of contemporary ur-
ban scenes; indeed, the overall gray tonality of most of
his pictures is not typical of the Impressionist palette.
This painting represents the busy corner where the
Boulevard de la Madeleine, the Rue Sèze, and the
Boulevard des Capucines intersect. The horse-drawn om-
nibuses were first used in 1855, and by 1882 they could
transport about 200 million passengers a year across
Paris. The ubiquitous street sweepers, who formed a
large part of the lower-class work force, were a constant
sight in the city.*

Honoré Daumier
Sunday at the Jardin des Plantes
(Le dimanche au Jardin des Plantes), 1862
Museum of Fine Arts, Boston, William P.
Babcock Bequest. 16/4265
(cat. 23)

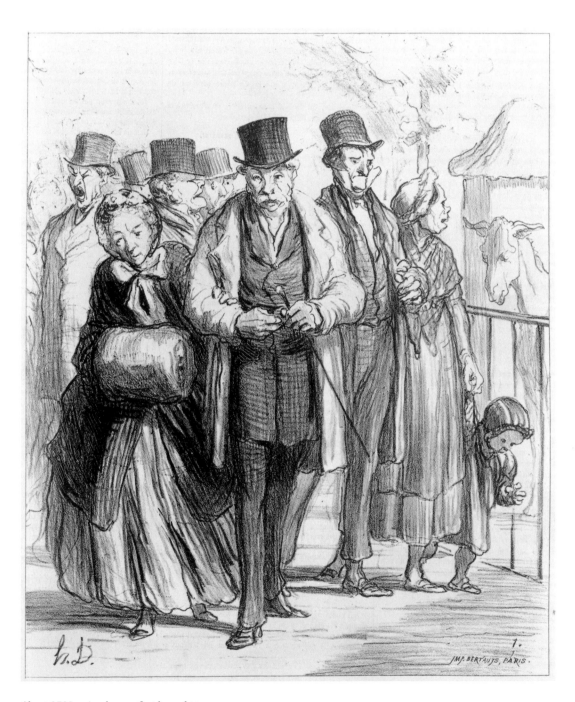

About 1793 animals were first brought to the Jardin des Plantes, a botanical garden founded in the 1630s, from a menagerie at Versailles, where wild or foreign beasts were kept and trained for exhibition. The Jardin was a popular site for artists, including Delacroix and Antoine Barye, who were interested in the captive lions. Both Gustave Doré and Daumier, however, were more amused by the responses of the visitors to the zoo and its inhabitants.

Pierre Bonnard
The Barrel-Organ Grinder
(L'orgue de Barbarie), 1895
William Kelly Simpson
(cat. 9)

Bonnard's affection for Parisian life in its many aspects is well known from his series of color lithographs. In this painting he recorded a street event that we assume provided enjoyment for those who lived behind the anonymous façade.

Pierre Bonnard
Rue Tholozé, ca. 1898
William Kelly Simpson
(cat. 10)

Situated on the western peak of Montmartre, the Moulin de la Galette could be reached by climbing the narrow and very steep Rue Tholozé. The dance hall at the foot of the highly restored but distinctive windmill was founded in 1834. Instead of showing the spectacular scene from the top of the street (cat. 215), Bonnard preferred to give an intimate view of the approach to the renowned hall, which was a favorite haunt of many artists, writers, and the working classes.

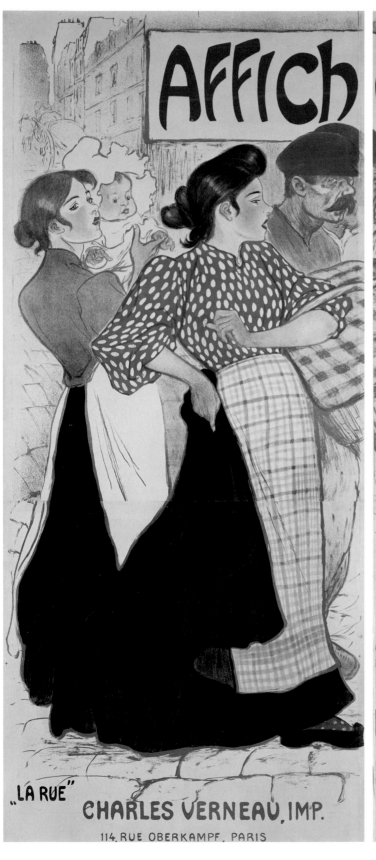
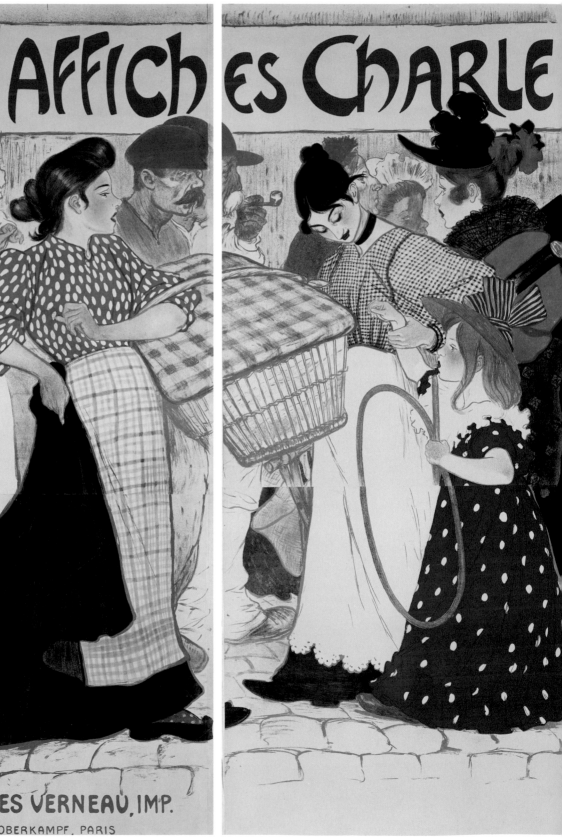

"LA RUE"

CHARLES VERNEAU, IMP.

114, RUE OBERKAMPF, PARIS

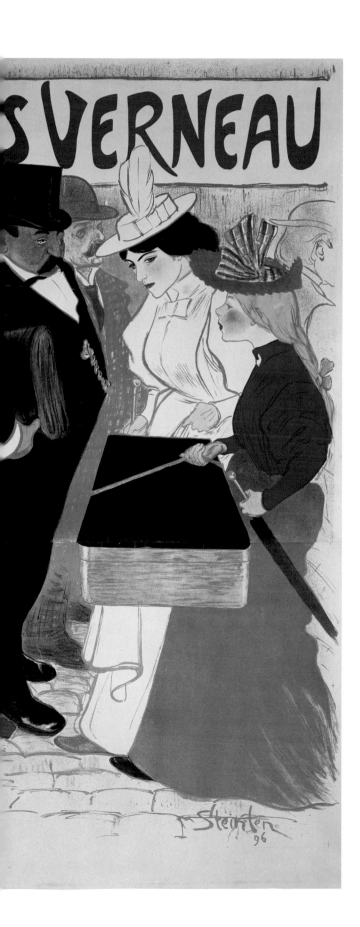

Théophile-Alexandre Steinlen
The Street
(La rue), 1896
The Metropolitan Museum of Art, Harris
Brisbane Dick Fund, 1932. 32.88.18
(cat. 49)

*Charles Verneau and his brother were the
founders in 1894 of* L'Estampe murale,
*whose goal was to publish and distribute
large-scale prints for the home. This litho-
graph, on six sheets and three vertical
panels, advertised the work of the printer,
Verneau. The title* La rue *does not evoke
the sense of fashion and elegance associ-
ated with* les grands boulevards. *Yet in
this exceptional lithographic achievement,
Steinlen included a variety of personages
who represent a cross section of social
classes: the laundress, the bourgeois shop-
pers, the businessman with his gold chain,
as well as his daughter, Colette, with a
hoop. Steinlen used stereotypical Jewish
features to depict the banker-businessman,
expressing a form of incipient anti-Semi-
tism common in nineteenth-century
French illustrations. Nevertheless,
Steinlen's profound concern for human
justice in general persuaded him to be-
come a staunch defender of the unjustly
accused military officer Alfred Dreyfus.*

Henri de Toulouse-Lautrec
Cover for *Les vieilles histoires*, 1893
Courtesy of the Boston Public Library, Print
Department, Gift of Albert H. Wiggin
(cat. 52)

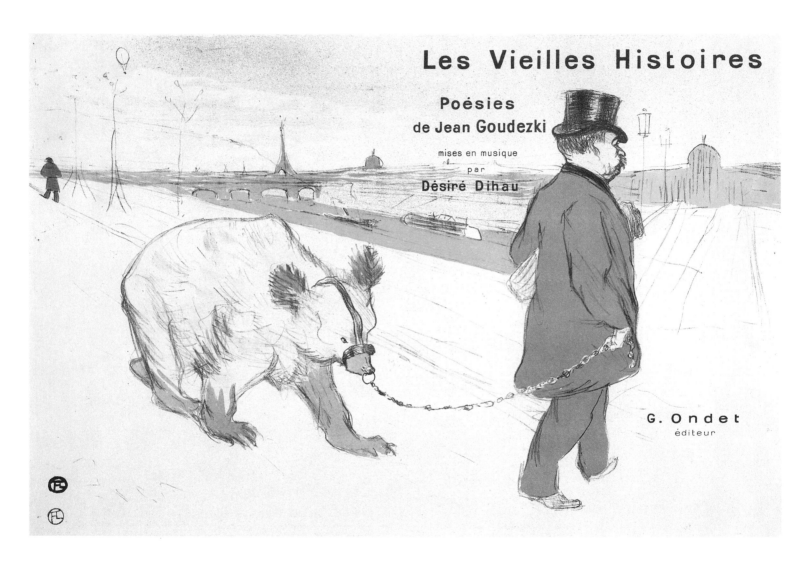

This cover was created for an album of poems by Jean Goudezki set to music by Désiré Dihau, a composer and bassoonist in the Paris Opéra. With nearly three hundred cafés-concerts in Paris in the 1890s, there was a brisk business in the presentation of ten to fifteen thousand new songs. In this image Toulouse-Lautrec has shown Dihau on the Right Bank leading a muzzled bear across the Pont des Arts, with a balloon ascent and the Eiffel Tower in the distance — both favorite Parisian images. (The cityscape is accurate but in reverse owing to the printing process.) The title Vieilles histoires refers to old-fashioned peasant amusements that were the forerunners of the programs at the cafés-concerts; here it suggests an album of "old favorites."

Bonnard experimented with night scenes and the effects of light on crowded city squares. It is probable that he was attracted to the novelty of electric lighting in combination with large shop windows and their impact on street life after dark. The splashes of light that illuminate the rushing shoppers have extended the Parisian interior onto the darkened street.

Steinlen often depicted working-class couples, their arms linked in comradeship, parading or protesting a deprivation. The hilly incline and the windmill on the horizon establish the locale as Montmartre, where the artist lived. This proof was designed as a cover for the book Dans la rue (1895), a compendium of songs and monologues by the cabaret owner Aristide Bruant.

Pierre Bonnard
The Square at Evening, ca. 1897-1898
Museum of Fine Arts, Boston, Bequest of W.G. Russell Allen.
60.58
(cat. 12)

Théophile-Alexandre Steinlen
In the Street
(Dans la rue [Gigolots et gigolettes]), 1895
Museum of Fine Arts, Boston, Bequest of W. G.
Russell Allen. 60.743
(cat. 50)

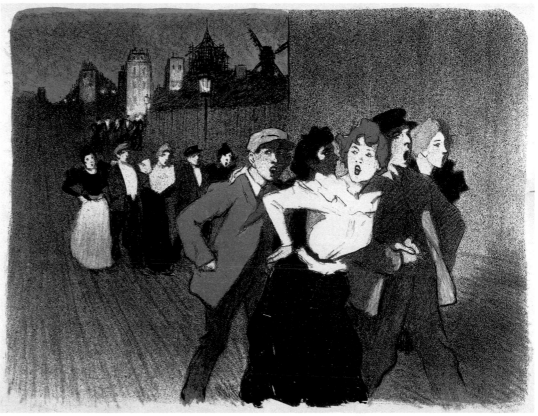

Auguste Lepère
July 14, 1881, Venetian Fête in the Bois de Boulogne during the Fireworks
(Le 14 juillet 1881, Fête de nuit au Bois de Boulogne)
The Metropolitan Museum of Art, The Elisha Whittlesey Collection, The Elisha Whittlesey Fund, 1963. 63.625.20(1)
(cat. 33)

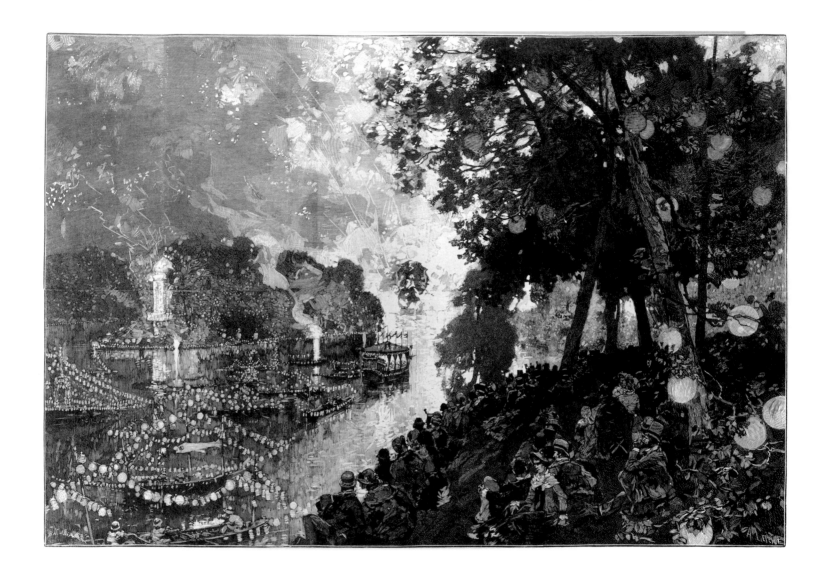

Overlooking the lake and island in the Bois de Boulogne, a brilliant pageant and fireworks display celebrate, officially and for only the second time, the fall of the Bastille in 1789. In 1880 the conservative government of the Third Republic had passed a law declaring that July 14 would be a national holiday. Lepère has shown the lavish outdoor entertainment, illuminated by thousands of lights, that could be enjoyed by all who welcomed this new civic festival.

Auguste Lepère
July 14, Illumination of the Palais du Trocadéro
(La fête du 14 juillet, l'illumination du palais du Trocadéro), 1883
The Metropolitan Museum of Art, The Elisha Whittlesey Collection, The Elisha Whittlesey Fund, 1963. 63.625.20(3)
(cat. 34)

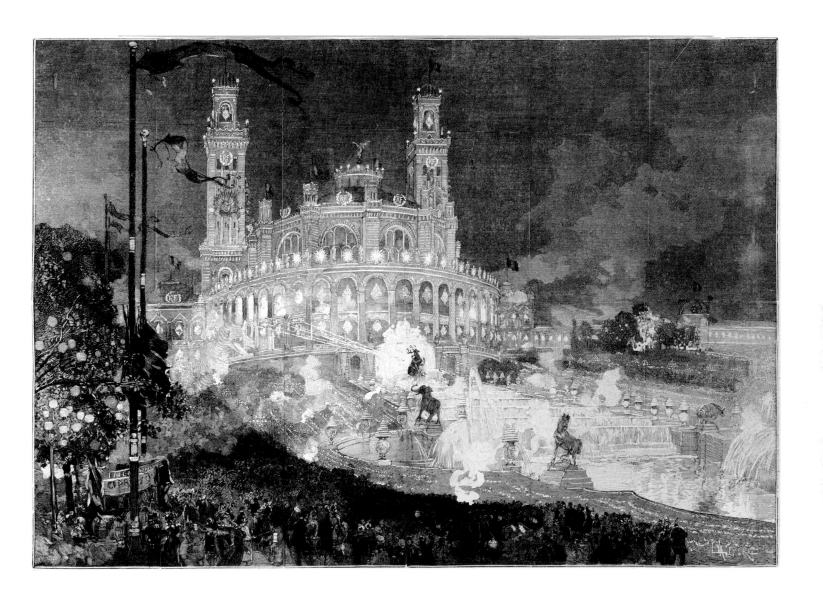

Camille Jacob Pissarro
The Gardens of the Tuileries on a Winter Afternoon, II
(Le Jardin des Tuileries, après-midi d'hiver), 1899
The Metropolitan Museum of Art, Gift from the Collection of
Marshall Field III, 1979. 1979.414
(cat. 44)

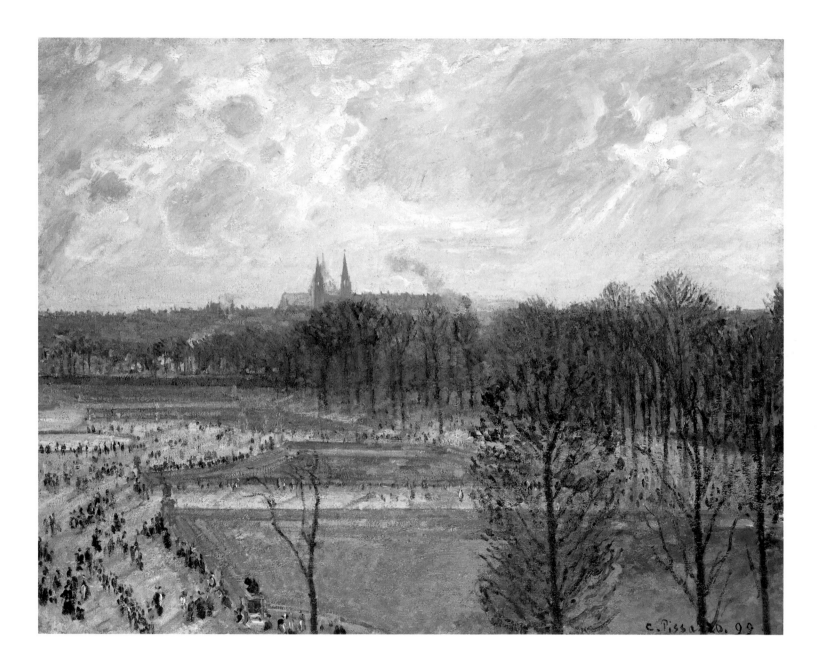

Under the Second Empire, the Tuileries gardens were opened by Napoleon III, and along with the Champs-Élysées they became a favorite promenade for all Parisians from the millionaire to the worker. After the razing of the palace at the Tuileries during the Commune in 1871, only groves of orange trees and a population of statues on pedestals remained in the gardens. In 1898 Pissarro rented rooms on the Rue de Rivoli to observe and paint this scene. He executed six versions of the gardens looking toward the Seine with the spires of St. Clothilde in the distance. Eight other paintings show the view west toward the Louvre. Pissarro conceived of these canvases as a series in which he studied the effects of different kinds of weather and times of day. All the works display blurred, anonymous figures engaged in

a host of activities. Working in his apartment above street level, Pissarro was obviously enchanted with the the vast perspective, the patterns, and colors of the popular Jardin des Tuileries.

Édouard Manet

Little Girls in the Tuileries
(Petites filles aux Tuileries), ca. 1861-1862
Museum of Art, Rhode Island School of Design, Providence,
Museum Appropriation. 42.190
(cat. 38)

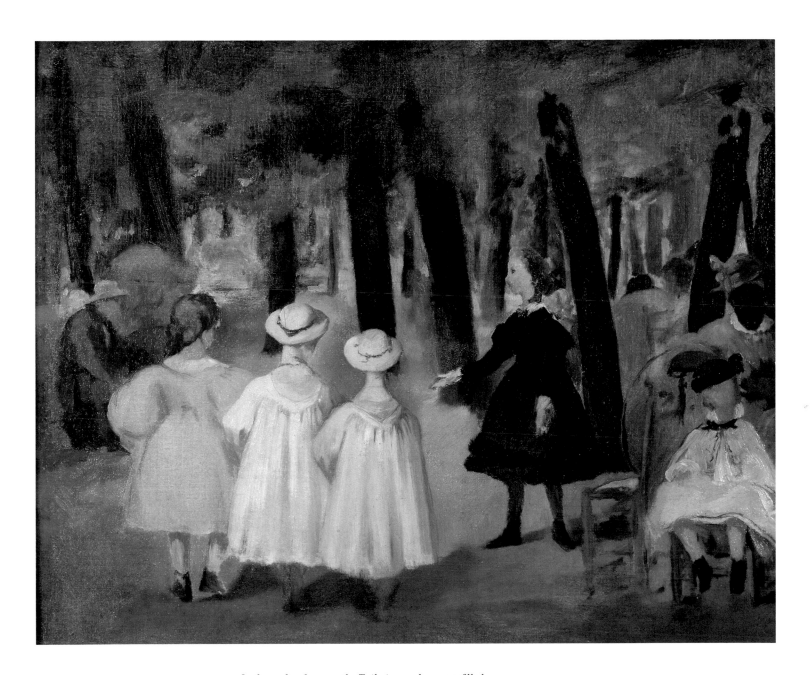

*In the early afternoon the Tuileries gardens were filled
with children in delightful frocks who played and
watched a variety of staged events. At least twice a week
elegant crowds gathered in the gardens for concerts —
another popular spectacle. Manet's friend Antonin
Proust recalled that the artist visited the Tuileries almost
daily from two to four o'clock to make studies "under the
trees, of children playing and groups of nursemaids re-
laxing on the chairs" (Manet, 1983, p. 38). This paint-
ing, more sketchy than the large version of* Music in the
Tuileries, *may indeed have been painted* en plein air *in
the gardens.*

Auguste Lepère
The Pond in the Tuileries
(Le bassin des Tuileries), 1898
Private Collection
(cat. 35)

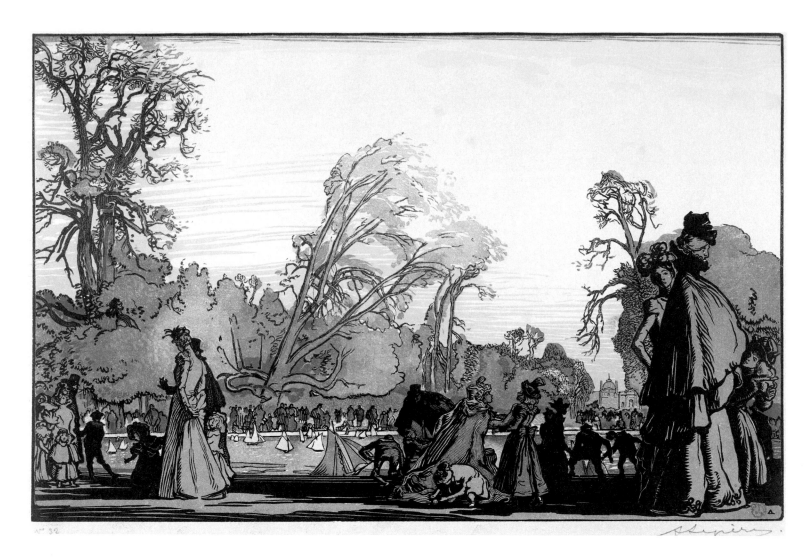

Like Pissarro and Vuillard, Lepère depicted the Tuileries gardens as a popular and constantly animated recreation center — a paradise for nursemaids and children. Two circular ponds permitted an active competition of toy boats.

In 1898 *Pan*, the international revue of art and literature, commissioned Cross to make a color lithograph. He chose the Avenue des Champs-Élysées, where robust nursemaids were enveloped in flowing capes. Their ruffled bonnets with attached streamers, indicative of their professional standing, lay as "light as cream on their heads."

Eight fine gateways led into the Tuileries gardens, and at each one stood a sentinel to prevent "the intrusion of men in blouses, persons with heavy parcels, and dogs" (McCabe, p. 172). This lithograph is one of only three known impressions printed in green; the published edition of one hundred was in black and white.

Henri-Edmond Cross
The Nursemaids at the Champs-Élysées
(Les Nourrices aux Champs-Élysées), 1898
Museum of Fine Arts, Boston, Gift of Mr. and
Mrs. Peter A. Wick. 59.1013
(cat. 21)

Édouard Vuillard
At the Tuileries
(Les Tuileries), 1895
William Kelly Simpson
(cat. 58)

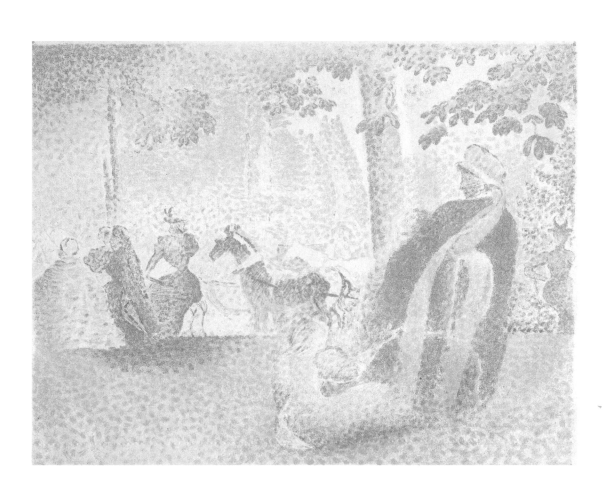

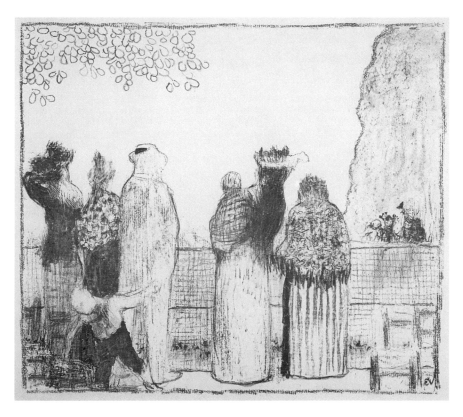

Auguste Lepère
Modern Bucolic Pleasures
(Bucolique moderne), 1901
Museum of Fine Arts, Boston, Purchased by sub-
scription. M19224
(cat. 37)

Abel Truchet
Luxembourg Gardens, ca. 1900
Jane Voorhees Zimmerli Art Museum, Rutgers,
The State University of New Jersey, Gift of Mr.
and Mrs. Herbert Littman. 1986.1214
(cat. 54)

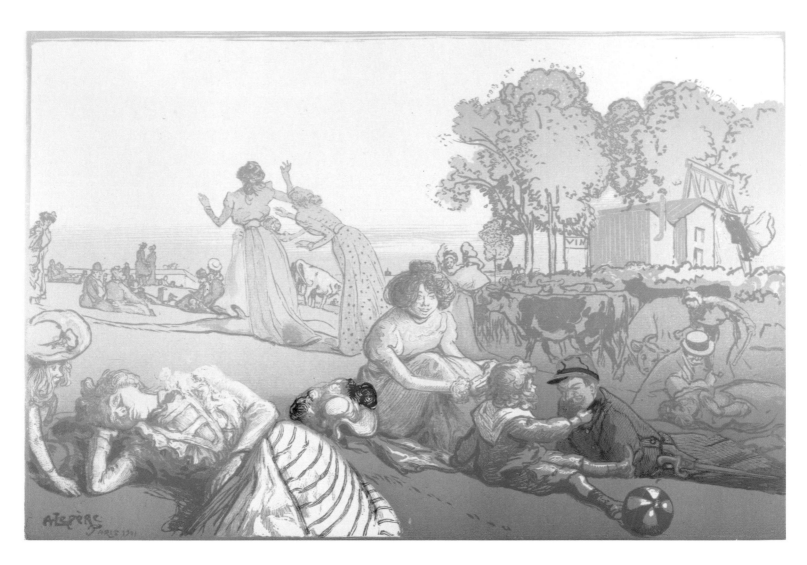

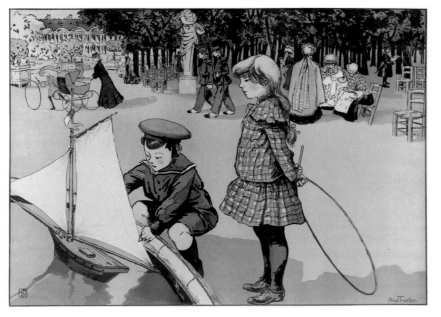

On Sundays, men of the lower middle class, including
artisans, civil servants, pensioners, and small business-
men, would take a day off and gather, along with their
families, to "take the air." They often lolled and pic-
nicked on the outskirts of the city, where the remains of
the old fortifications could be seen. Placed as a deterrent
against invaders, these masonry walls were considered
useless after the Franco-Prussian war.

The Luxembourg gardens in the Latin Quarter of the
Left Bank, were (as they are today) a favorite haunt of
young students, small children, nursemaids, and
mothers, who came for "sport and health" and to watch
the performances at the marionette theaters scattered
about the grounds. The central bassin (pond) was ideal
for experimental boat racing.

Paul Cézanne
On the Banks of the Pond
(Au bord de l'étang), 1872-1875
Museum of Fine Arts, Boston, Tomkins Collection. 48.244
(cat. 18)

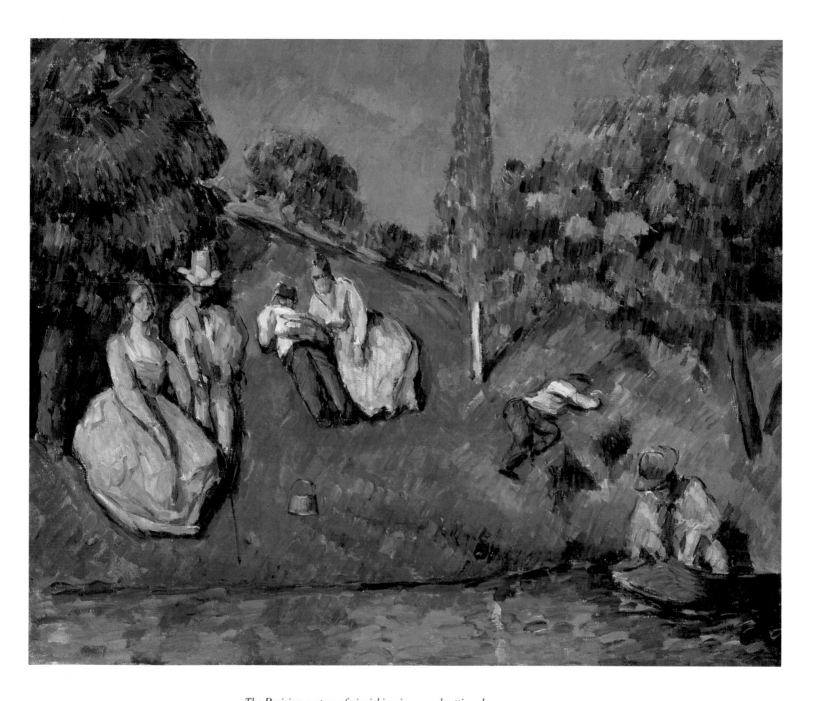

The Parisian custom of picnicking in a rural setting de-
rived from an eighteenth-century practice of the aristoc-
racy, who followed their morning hunts with festive
breakfasts. From early 1872 until the spring of 1874,
Cézanne lived in the picturesque region near Pontoise,
northwest of Paris, and studied with Pissarro. His stay
there may have inspired this painting as well as others in
a small group of similar views. Since the site is not spe-
cific and the placement of the figures is awkward, it is
also likely that this work was painted from memory in
his studio. Cézanne was not unmindful of the working
class who sought out congenial and pleasant spaces to
spend their limited leisure hours.

Marc Chagall
Pont de Passy and the Eiffel Tower
(Pont de Passy et le Tour Eiffel), 1911
The Metropolitan Museum of Art, Robert Lehman
Collection, 1975. 1975.1.161
(cat. 19)

*Chagall left his native Russia to live in
Paris in his early twenties, and with the
exception of the war years, he resided
there for the rest of his life. Though usu-
ally associated with the School of Paris,
he drew inspiration from the Fauves and
Cubists. More important, he distilled the
strengths of these various movements and,
using his own palette of intense colors,
formed a distinctive personal style. Cha-
gall roamed the streets of Paris and was
captivated by its unusual light — the
"lumière liberté," as he called it. Here he
set the Eiffel Tower, the symbol of Parisian
urban life, against a luminous back-
ground, combining both the discipline of
centrality with an intense expressiveness.
The rays of light that emanate from the
tower remind the viewer that the sweeping
electrical illumination was made possible
by the immense height of this structure.
The tower also served for radio transmis-
sions, and the first overseas broadcast was
beamed from it in 1907. The nearby Pont
de Passy, built in 1903-1906, has two sto-
ries, the upper level forming a viaduct for
a Métro line.*

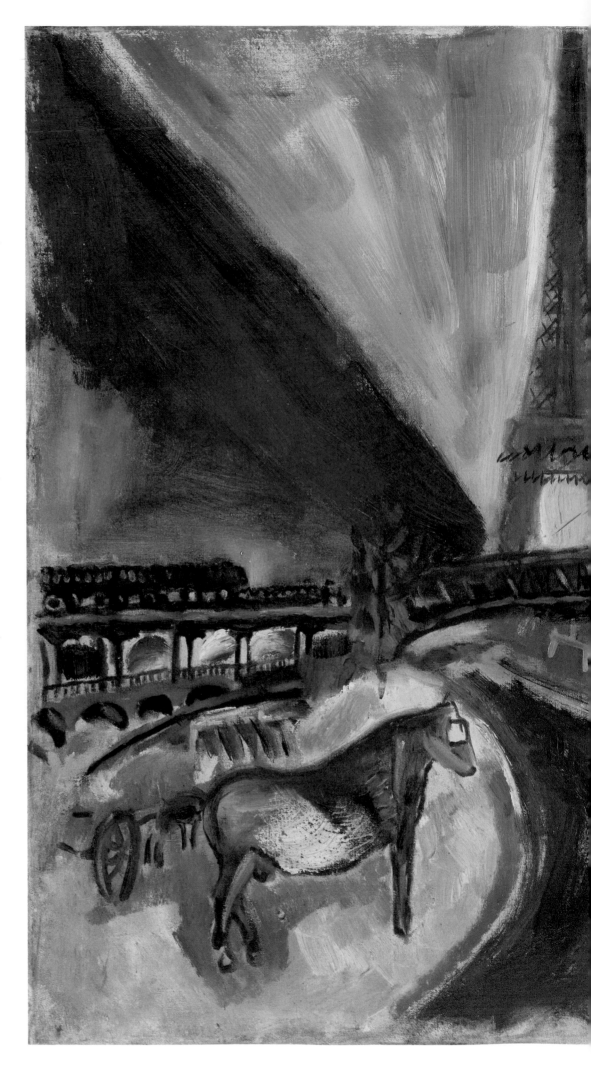

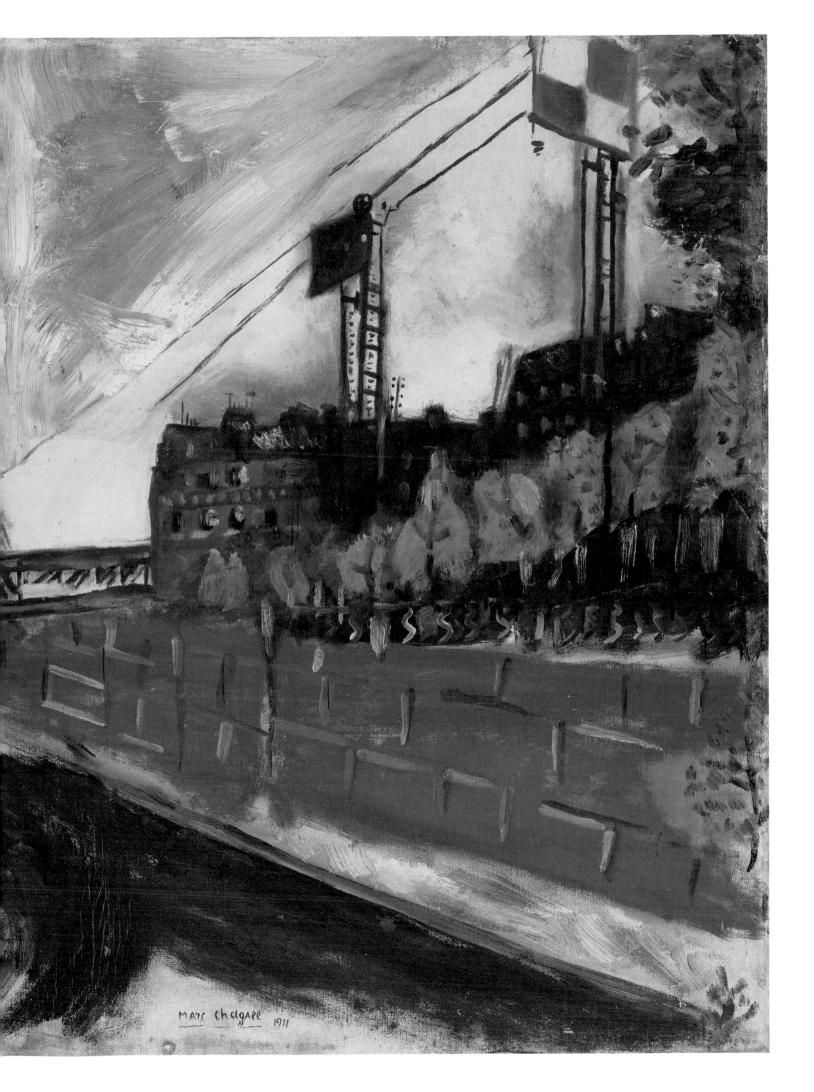

Neurdein Brothers (Étienne and Antoine)
Universal Exhibition of 1900: View of the Eiffel Tower
(Exposition Universelle de 1900: Vue sur la Tour Eiffel), 1900
Smith College Museum of Art, Northampton, Massachusetts, Purchased with funds given in honor of Ruth Wedgewood Kennedy and Beaumont Newhall, and with the combined Hillyer-Tryon-Mather Funds, 1982. TR 4625-19
(cat. 43)

For centuries Notre-Dame Cathedral was the tallest building in Paris and symbolized the supremacy of the religious spirit. In 1889 the desire to create a dazzling monument for the Universal Exposition, in honor of the 100th anniversary of the Revolution, resulted in a national competition that was won by the engineer Gustave Eiffel. Although scientists joined well-known writers and artists in protesting his proposed iron tower — "which American commercialism itself would not want" — it became, after completion, a landmark for Parisian pleasure and recreation. The plan to dismantle the tower at the end of the fair was laid aside; its popularity and inventiveness had ensured its role as a triumph of architectural design. The celestial globe, built specially to accompany the tower for the 1900 Exposition, acquired a reputation for being unsafe, and thus few visitors ventured to explore it. But the audacious tower has continued to be a source of Parisian pride.

Anonymous Photographer, French, 19th century
Esplanade of the Invalides — Palais des Arts Décoratifs
(Esplanade des Invalides — Palais des Arts Décoratifs), 1900
Museum of Fine Arts, Boston, Abbott Lawrence Fund. 1984.177
(cat. 2)

The 1900 Paris Exposition saw the triumph of ornamental ceramic, sculpted stone, and plaster over glass and iron, which had been so inventively used in the Universal Exposition of 1889 (Silverman, pp. 284ff). Contemporary critics of the 1900 fair commented that the narrow street between these two "palaces" prevented a visitor from being able to view adequately either masonry façade so that the rococo decorations were not especially noticeable. The critics were further displeased that the street between the buildings was uncommonly rough and filled with "aggressively" small and uncomfortable pebbles!

Kees van Dongen
The Carrousel
(Le carrousel), 1904
Melas Kyriazi Collection
(cat. 26)

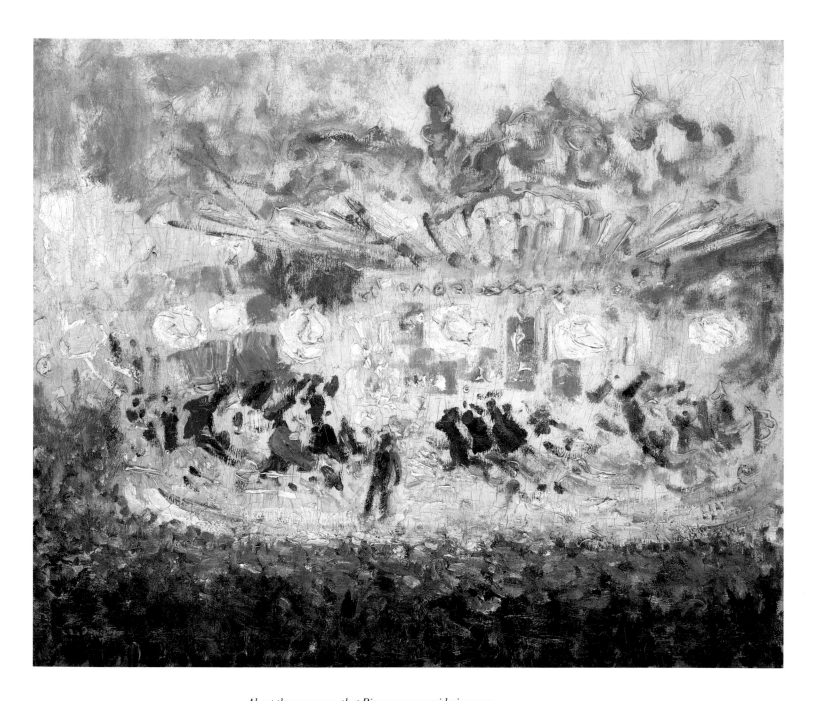

*About the same year that Picasso was considering mov-
ing to Paris, the Dutch artist van Dongen settled on the
Butte overlooking Montmartre. Sensitive to the tech-
niques of the French Impressionists, particularly those of
Monet, he lightened his palette and concentrated on city
themes.* Le carrousel *probably represents a delightful
time in Montmartre when an itinerant fair arrived in the
neighborhood; van Dongen conveyed this atmosphere of
good cheer, using thick touches of paint in a lively, ab-
stract manner. This painting is also known as* Le car-
rousel de cochons *(The Carrousel of Pigs), a common
type of merry-go-round with pink wooden pigs on which
the patrons sat for their ride.*

The Bois de Boulogne: Horse Races and Other Sporting Events

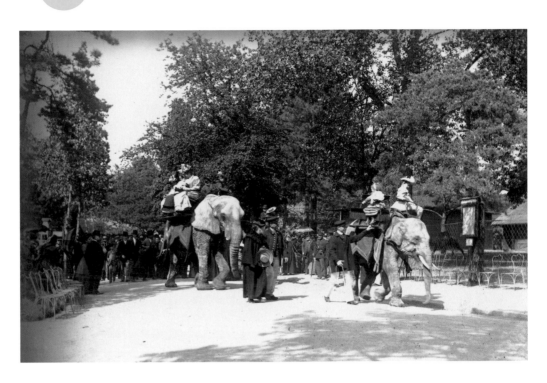

Fig. 1. *The Bois de Boulogne.*
Photograph by Henri Lemoine.
Musée d'Orsay, Paris.

Fashioned after London's Hyde Park, which Louis Napoleon so greatly admired, the Bois de Boulogne, on the western outskirts of Paris, was entirely rebuilt between 1852 and 1858. Under Baron Haussmann's guidance, more than two thousand acres of royal forests, given by the emperor to the city, were extensively carved, molded, and landscaped with wide, shaded roads that led to ornamental lakes, flower gardens, two racecourses, a skating rink, cafés, and restaurants. Some four hundred thousand trees were planted in picturesque arrangements, and by the manipulation of natural materials, a popular and famous park was created.[1] "Apart from the ground and the trees," one writer commented, "everything is artificial in the Bois de Boulogne. . . . All that is missing is a mechanical duck."[2] And Marcel Proust referred to "that sense of the complexity of the Bois de Boulogne which makes it an artificial place and, in the zoological or mythological sense of the word, a Garden."[3] The man-made character of the park was somewhat compensated for by the founding in 1860 of the Jardin d'Acclimatation, where species of animals and plants newly imported into France were housed. A turn-of-the-century guidebook describes the scene on fine Sundays: "when elephants and camels laden with people stalk about the drives, and children are driven in llama and even in ostrich carts. The collection of dogs is a remarkable one" (fig. 1).[4]

The park attracted large throngs of people who used the sporting facilities throughout the year, and it enticed the socially elite who visited the Bois to promenade, especially during the fashionable hours of three to five in the winter and five to seven in the summer. During a drive through the park, Mark Twain took evident delight in the colorful spectacle: "There were thousands upon thousands of vehicles abroad, and the scene was full of life and gaiety. There were very common hacks, with father and mother and all the children in them; conspicuous little open carriages with celebrated ladies of questionable reputation in them; there were Dukes and Duchesses abroad, with gorgeous footmen perched behind, and equally gorgeous outriders perched on each of the six horses; there were blue and silver, and green and gold, and pink and black, and all sorts and descriptions of stunning and startling liveries out, and I almost yearned to be a flunkey myself, for the sake of the fine clothes."[5] From this cultivated wilderness, there was easy access to Paris by way of the spacious Avenue de l'Impératrice (now Avenue Foch), past the Arc de Triomphe, and descending the Champs-Élysées, the avenue that has been, historically, the most popular thoroughfare and diversion in Paris (see cat. 71, 73).

The racetrack at Longchamp, a favorite attraction of the Bois, was restored and reopened in 1857. (A second racecourse, the Auteuil, was completed in 1870.) Although the season at

Félix Bracquemond
At the Zoological Gardens
(Au Jardin d'Acclimatation), 1873
Museum of Fine Arts, Boston, Frederick Keppel Memorial Fund,
Gift of David Keppel. 13.5094
(cat. 15)

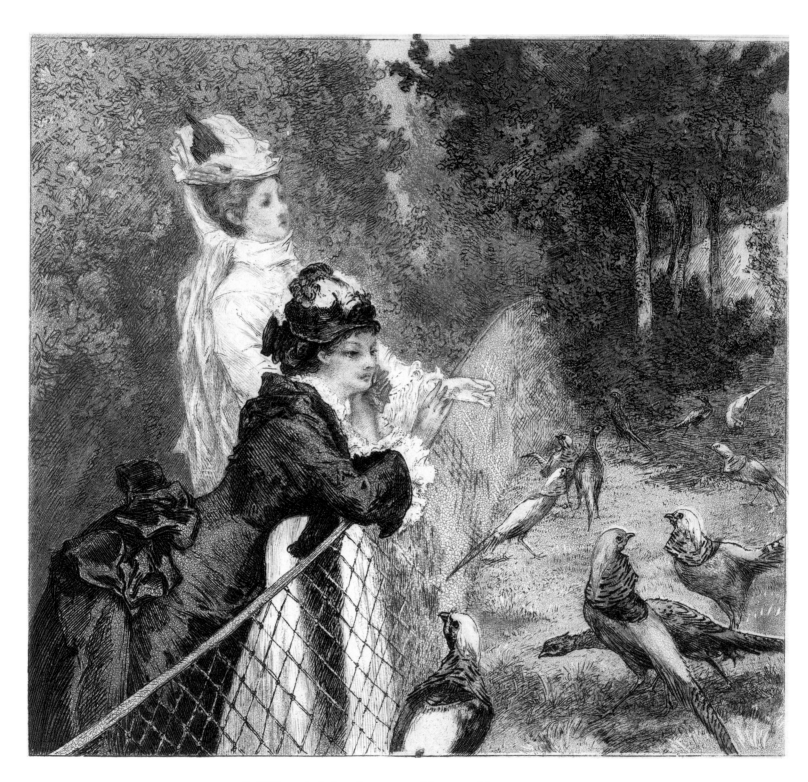

*In 1860 a zoological garden was opened in a part of the
Bois de Boulogne to house domesticated exotic animals.
Two large aviaries were one of the most popular areas of
the garden. In Bracquemond's experimental color etch-
ing, the fashionably dressed young women and the lush-
ness of their surroundings convey the park's reputation
for luxury and elegance.*

Longchamp was relatively brief, consisting of a few weeks in the spring and fall, the Grand Prix de Paris, an international race instituted during the Second Empire, was an important communal occasion, "a type of commercialized leisure and social display."[6] Numerous contemporary articles and journals document this event when "aristocratic ladies and wealthy prostitutes mingled [and there were] long processions of carriages, rivaling each other in ostentation, . . . swarms of bookmakers and bettors, of journalists and adventurers."[7] The conduct of horse racing in France was administered by an organization, modeled after the prestigious English Jockey Club, with the unwieldy title of Société d'Encouragement pour l'Amélioration des Races de Chevaux en France. The founding of the Société, in 1833, had confirmed horse racing as a sport of strong political and social significance. Le Jockey Club, as it was known, became a powerful male bastion in France, with members from the upper strata of society, most of whom were royalists (and conservatives); these same privileged men also attended the theater and opera and became the "protectors" and admirers of the young women in the ballet corps.

Of the Impressionist artists, only Manet and Degas avidly depicted the races. Between 1864 and 1872 Manet did several oils, watercolors, and one lithograph (cat. 72) of Longchamp. In the same period Degas explored the racetracks in all media (cat. 66, 67), although his racecourse scenes are more generic than specific. Rather than concentrating on the class relationships of the crowds, Manet and Degas were primarily interested in the energy and action of the horses and in the multicolored costumes of the jockeys, also adopted from the English tradition.

Renoir described other sporting activities that enlivened the park throughout the year. During the winter months there was skating on the ponds in the Bois as well as on a grand indoor rink provided by the city in 1866; Renoir's painting *Skaters in the Bois de Boulogne* of 1868 shows Parisians on a new pond, carved from "nature," enjoying one of the recreations that were accessible to all classes of society.

As a young man, Toulouse-Lautrec also favored horses and outdoor scenes as subjects, and after 1897, near the end of his life, he became a familiar figure at the races, making a series of prints and drawings (cat. 76, 77). He was equally enthusiastic about new inventions in methods of transportation. He depicted his cousin Dr. Gabriel Tapié de Céleyran, a fan of the automobile, who was appropriately dressed for his outing (cat. 75). Lautrec's interest in bicycling (albeit an activity in which he was physically unable to take part) inspired him to make posters of this popular recreation as well, often including recognizable portraits of friends.

At first, bicycling had been an expensive recreation for the rich. In the 1880s and 1890s the new clubs were confined to the upper and middle classes, but by 1897 the number of cyclists in France had grown to 300,000;[8] even women could ride, especially if accompanied by their husbands. By the end of the century cycling had become a highly popular national racing sport. No sooner had the bicycle become the ultimate democratic means of transportation and entertainment than the automobile caught the attention of the wealthy, who again formed exclusive clubs and organized specialized events. Within a few years, however, enthusiasm for both machines permeated all social classes, reaching even the poorest workers. Many artists as well as the press documented and illustrated these new forms of sport, which had become an affordable aspect of daily life (see, for example, Vuillard's poster advertising a tonic for cyclists; cat. 78). No longer "rich men's toys," bicycles and automobiles soon assumed the role of utilitarian conveyances in the march of progress; as excuses for velodromes, races, attendant teams, and competitions, they united France and made her proud.

Notes
1. Robert L. Herbert, *Impressionism: Art, Leisure, and Parisian society* (New Haven, 1988), p. 145.

2. Quoted in Joanna Richardson, *La vie parisienne, 1852-1870* (New York, 1971), p. 208.

3. Marcel Proust, *Remembrance of Things Past*, trans. C.K. Scott Moncrieff and Terence Kilmartin, vol. 1 (New York, 1982), p. 456.

4. Augustus J.C. Hare, *Paris* (London, 1897), p. 475.

5. Mark Twain [pseud.], *The Innocents Abroad* (Hartford, 1870), p. 132.

6. Valerie Steele, *Paris Fashion: A Cultural History* (Oxford, 1988), p. 169.

7. Theodore Reff, *Manet and Modern Paris*, exhib. cat. (Washington, D.C.: National Gallery of Art, 1982), p. 129.

8. Eugen Weber, *France, Fin de Siècle*, (Cambridge, Mass., 1986) chap. 10, and pp. 195-212.

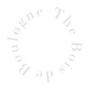

Childe Hassam
Grand Prix Day, 1887
Museum of Fine Arts, Boston, Ernest Wadsworth Longfellow
Fund. 64.983
(cat. 71)

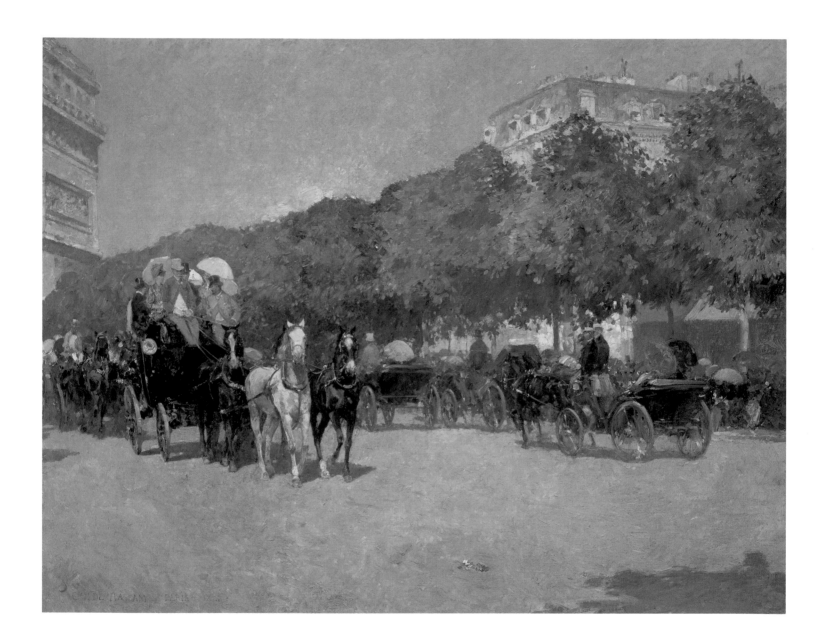

*When Hassam visited Paris in 1884, he was obviously
inspired by the Impressionists and by this special day at
the races, which he represented in both a pastel and a
larger version of the painting. Longchamp, the principal
racetrack near Paris, continues to attract huge crowds
during the racing season. The Grand Prix (dating from
1834 and copied from its English example) is often re-
ferred to as the "French Derby" and is still the most im-
portant race in Paris. Held in late May or early June, it
inaugurates the summer season in France. In the nine-
teenth century this race, in particular, brought out a
luxurious fashion display, where high-society ladies and
courtesans competed in finery with ornate and elegant
horse-drawn carriages. A corner of the Arc de Triomphe
can be seen at left, and one can only imagine the con-
gestion at the Place de l'Étoile as the crowds converged.*

It was in the Champs-Élysées and the Bois de Boulogne
that the leisured classes preferred to ride in their car-
riages and to rendezvous. For many Parisians their day
was a failure if it lacked a promenade around the lake
in the park, which had become a social necessity instead
of an enjoyable habit. One writer likened these circular
excursions to the antics of "squirrels in a cage but not as
rapid!" (Rues de Paris, p. 32). Furthermore, it was in
these locations that one could praise the work of Napo-
leon III and Baron Haussmann, since they had been
able to realize their architectural and landscape designs
without destroying existing buildings and communities.

Édouard Manet
The Races
(Les courses), 1865-1872, published in 1884
Museum of Fine Arts, Boston, Gift of W.G. Russell Allen.
23.1325
(cat. 72)

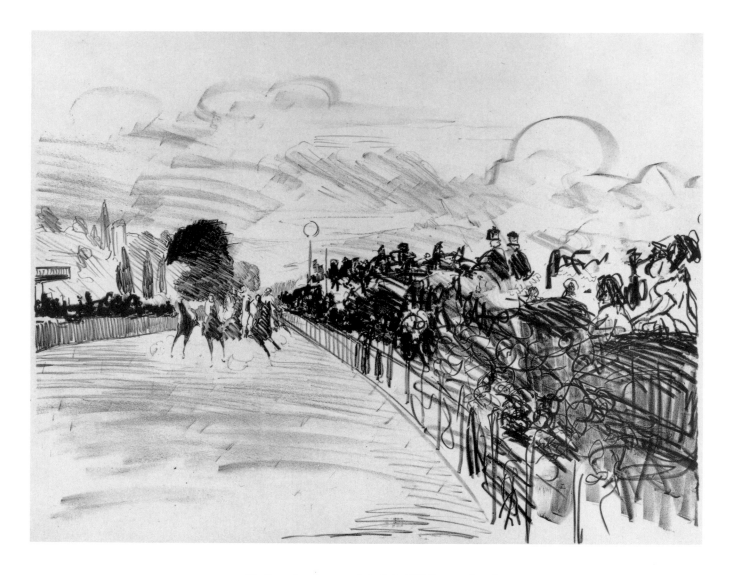

The Longchamp racetrack, built in 1857 in a section of the Bois de Boulogne, was strongly supported by a select group of men who founded "Le Jockey Club." Manet probably joined Degas and other socially prominent spectators from the fashionable west side of Paris to attend the seasonal races, a major recreation especially during the Second Empire. Manet's striking print with its erratic scribbling on the stone, implies speed and motion; his view of spirited on-coming horses was unique for its time. The spectators are only sketchily indicated, thus heightening the sensation of a frenzied crowd.

Louis Anquetin
The Finish
(L'arrivée), 1894
Jane Voorhees Zimmerli Art Museum, Rutgers, The State University of New Jersey, Edward and Lois Grayson Purchase Fund.
1988.0935
(cat. 62)

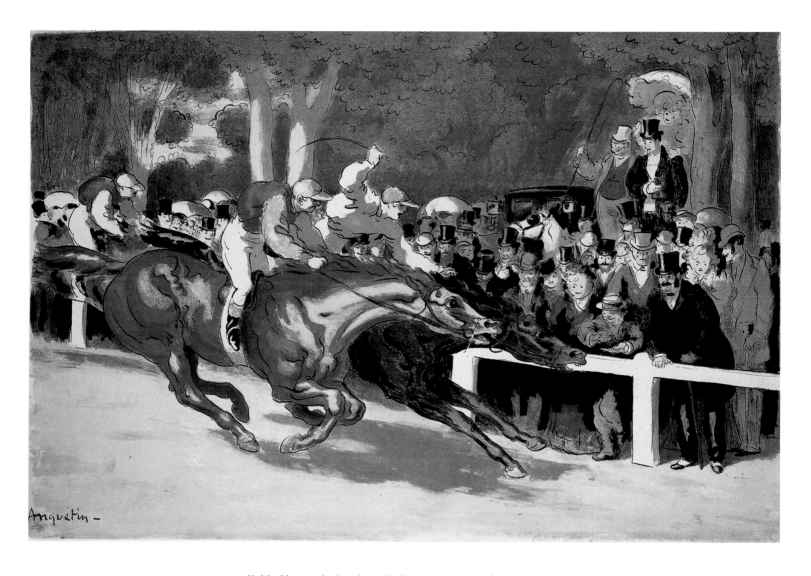

Unlike Manet, who has shown the horses racing toward the viewer, Anquetin places his spectators at the rail to observe at close range the jockeys and their mounts as they gallop by. Furthermore, he has more clearly described the racetrack at Longchamp, with details of the crowd in which top-hatted gentlemen and stylish young women mingle with racing fans. This image was reproduced as a centerfold in the 1894 issue of the popular journal Le Courrier français, *which was devoted to reporting entertainment events that were illustrated by artists.*

Jean-Louis Forain
The Racetrack
(Champ de course), ca. 1890
The Springfield Museum of Fine Arts, Springfield, Massachusetts,
The James Philip Gray Collection. 55.03
(cat. 70)

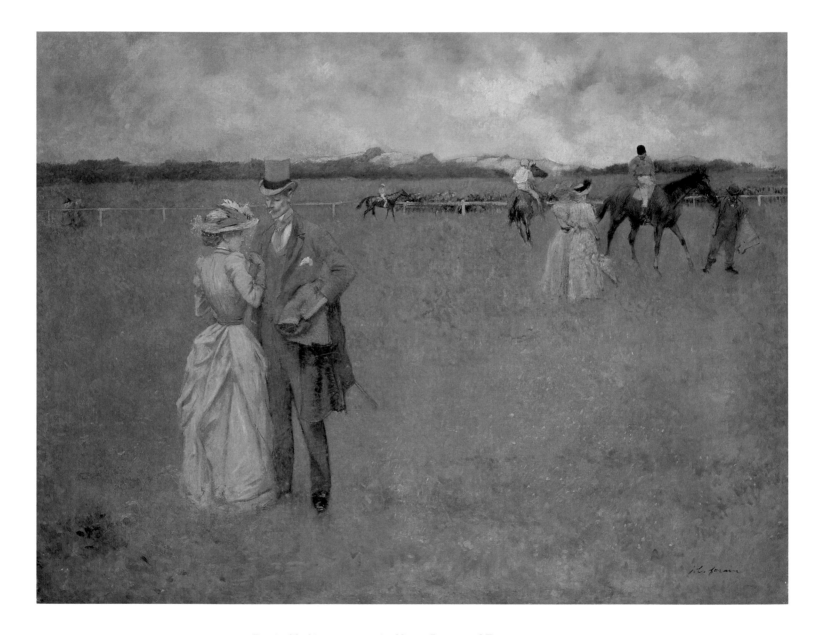

Forain, like his contemporaries Manet, Degas, and Tou-
louse-Lautrec, probably attended the races at
Longchamp. More interested in urban scenes, particu-
larly life in the theater, he only rarely depicted land-
scapes and animals. In this painting Forain has concen-
trated on the fashionably dressed couple whose attention
is diverted from the event about to take place. In fact,
they are physically removed from the two women who
are studying a horse beyond, and they are far from the
crowd in the distance that clusters near the fence. The
field is undoubtedly Longchamp, with the low-lying hills
of the Bois de Boulogne on the horizon; however, the dis-
parate parts of the composition suggest that it was
painted in the artist's studio and may be a work from
memory. Rather than depicting the lively activity of the
spectators that these races evoked, Forain has implied a
possible social intrigue.

Hilaire Germain Edgar Degas
Race Horses at Longchamp, 1871, reworked in 1874
Museum of Fine Arts, Boston, S.A. Denio Collection. 03.1034
(cat. 66)

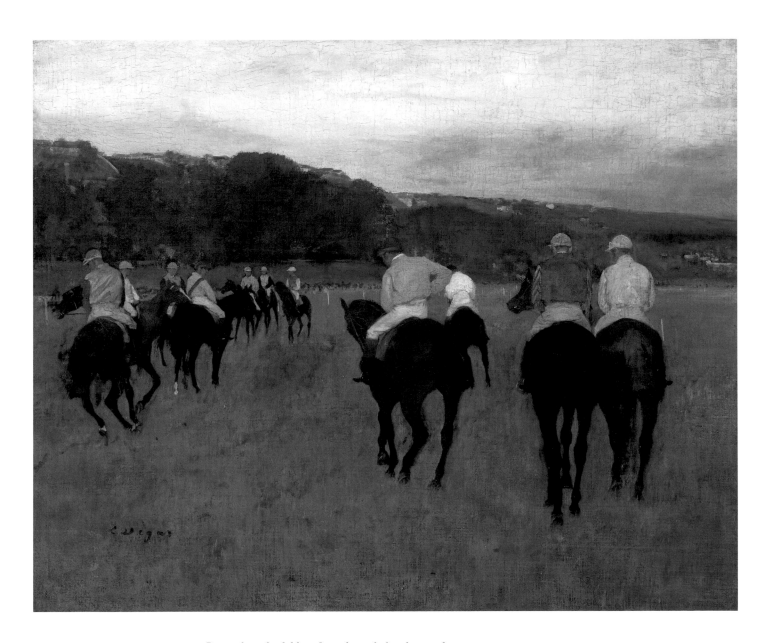

Degas chose the fields at Longchamp before the race for this appealing composition. Like Manet, he was a frequent visitor to this particular racetrack, although his painting of the site is not a precise depiction of the stands and crowds. Degas focused on the animals and their riders rather than on the fashionable spectators from his own social milieu. He was particularly interested in the relaxed pace of the horses as they sauntered in the fields at dusk. The colorful silks of the jockeys were in the traditional style borrowed from the English.

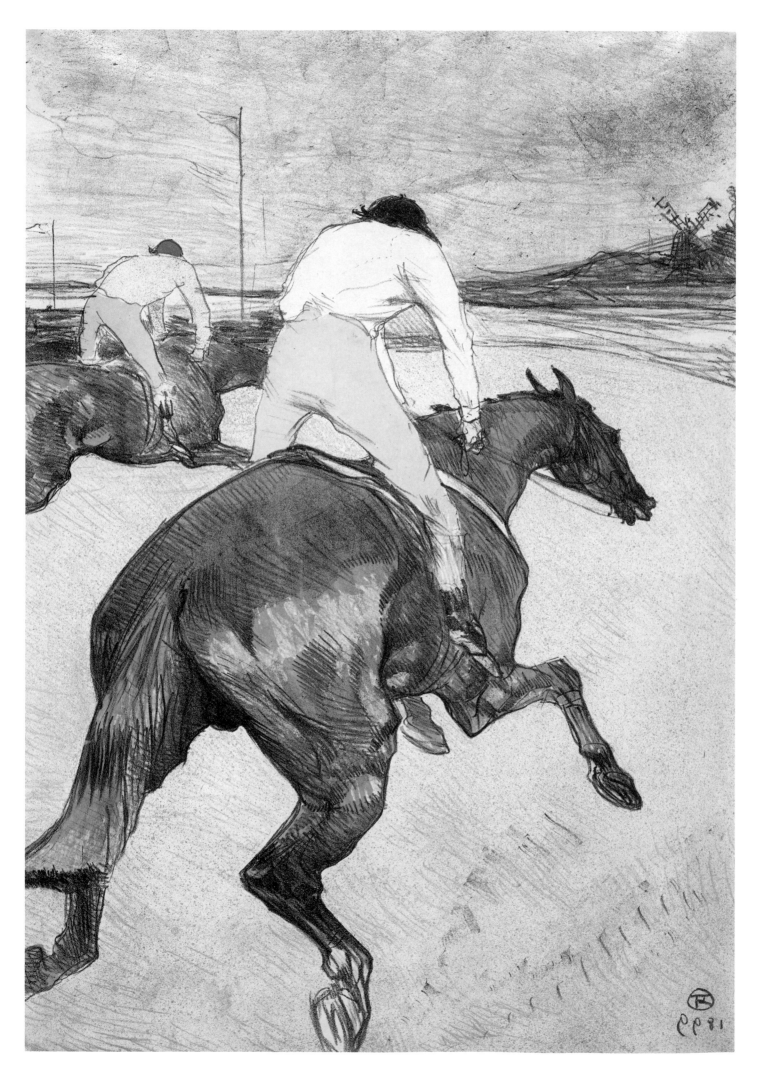

Henri de Toulouse-Lautrec
The Jockey
(Le jockey), 1899
Museum of Fine Arts, Boston, Horatio Greenough Curtis Fund.
24.1704
(cat. 76)

Henri de Toulouse-Lautrec
The Jockey Led to the Post
(Le jockey se rendant au poteau), 1899
Museum of Fine Arts, Boston, The Helen and Alice Colburn
Fund. 55.951
(cat. 77)

During Lautrec's three-month stay in a Neuilly psychiatric clinic in the spring of 1899, he began a series of lithographs on the subject of the racecourse with the title Les courses, *to be published later in the year. Four prints in all were made, but in the end only* The Jockey *was issued. The windmill in the background of the image identifies the racetrack as Longchamp, in the Bois de Boulogne, which Lautrec enjoyed visiting.*

Of the four images that Lautrec planned in 1899 for a series on horse racing, only one (cat. 76) was issued. The three others, including The Jockey Led to the Post, *were held back by the publisher Pierrefort and are known today in only a few impressions. This version with watercolor may represent an effort by the artist to try out a set of colors for possible publication.*

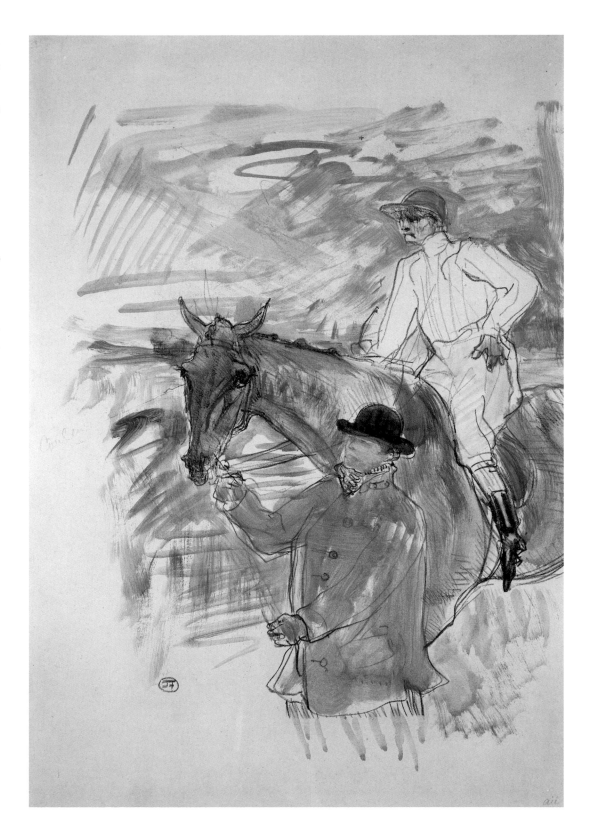

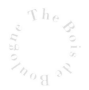

Jules Chéret
*Palais de Glace, Champs-Élysées, front
view,* 1894
Sterling and Francine Clark Art Institute,
Williamstown, Massachusetts. No. 2395
(cat. 64)

*The luxuriously decorated Palais de Glace
opened in 1893 at the Champs-Élysées.
Paid access to the skating rink was rea-
sonable, but the well-to-do "sportsmen"
and the fashionable women, including
cocottes, made certain that their skating
hours and seating arrangements on the
side lines were separated according to so-
cial class. This image is a reduced version
of the 1894 poster for the supplement of
Le Courrier français, issued January 20,
1895.*

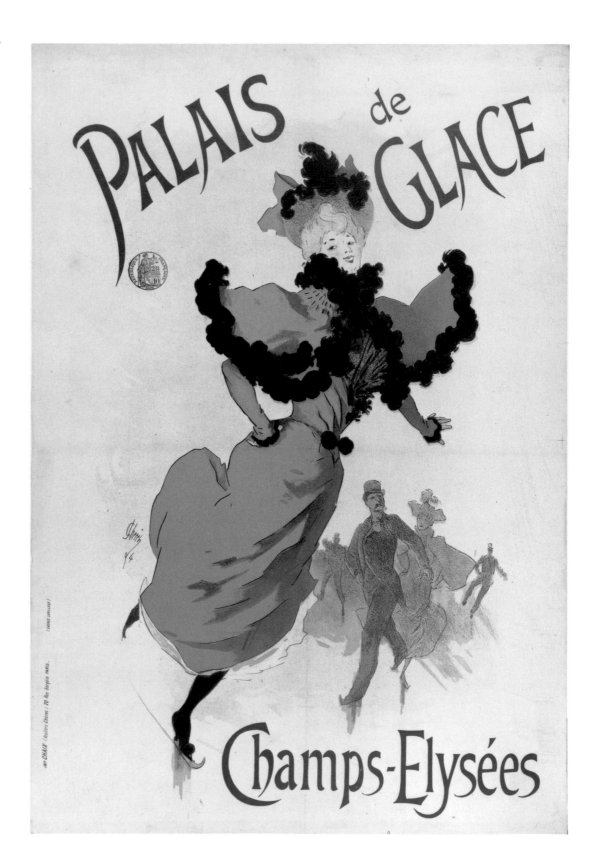

Henri de Toulouse-Lautrec

The Automobilist
(L'automobiliste), 1898
Museum of Fine Arts, Boston, Bequest of W. G.
Russell Allen. 60.771
(cat. 75)

Lautrec's cousin Dr. Gabriel Tapié de Céleyran was a pioneer advocate of the motorcar, and like Lautrec, he was delighted with this new technical invention. The artist has caricatured with humor his distinguished cousin, whose ruddy complexion and upturned mustache blowing in the wind suggest that he is driving at an unaccustomed speed and is at the mercy of the elements. The sizable cloud that emanates from the car's exhaust portends that this machine will forever alter the landscape.

Édouard Vuillard
Bécane, ca. 1894
Museum of Fine Arts, Boston, Gift of
Mrs. Frederick B. Deknatel. 85.242
(cat. 78)

After the mid-nineties a number of cycling clubs were formed. Since the sport had become extremely popular in France, these clubs cut across social levels and now included workers and laborers, who were strong athletes. This poster, Vuillard's only such commission, advertised Bécane, a meat-based, fortifying drink for cyclists. Using an unusual perspective and decorative colors, the artist has captured the energy and excitement of the race at a velodrome.

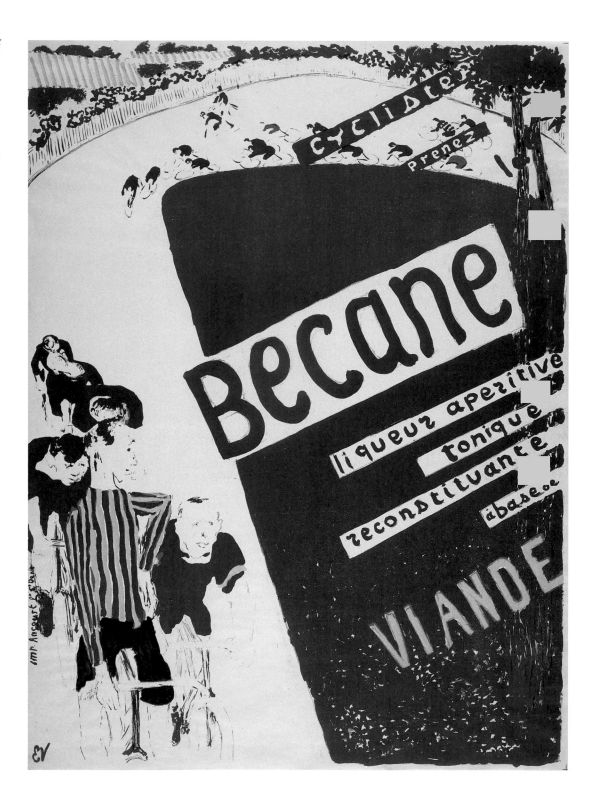

Museums and Galleries

To achieve fame and success, an artist in Paris had to show his work at the official Salon exhibitions. These annual events stimulated great public and critical interest and could provide a turning point in an artist's career. Of the many thousands of paintings accepted and exhibited, however, few of the creators are known to us today. In the early years of the nineteenth century, these government-sponsored exhibitions were held in the Salon Carré of the Louvre, which gave its name to the shows that eventually became immense and invaded other nearby galleries in the museum. After 1855 the "Salon" moved to the Palais de l'Industrie on the Champs-Élysées, a large, undistinguished building (demolished in 1897) that was used for a variety of events, from trade fairs to horse shows.

To understand the role of the Salon exhibitions as an important recreation for Parisians, one need only turn to Émile Zola's novel *The Masterpiece (L'Oeuvre)*, where he describes an opening day of the Salon at the end of the Second Empire: "With the passage of years it had become established in Paris that 'varnishing day,' originally reserved for artists to put the last finishing touches to their pictures, was an important date in the social calendar. Now it was one of those acknowledged 'events' for which the whole town turned out in full force. [The artists] fascinated Paris and Paris focused all its interests on them . . . in one of those sudden, violent, irrepressible crazes that sent swarms of trippers and soldiers and nursemaids elbowing their way through the place on 'free' days, and accounted for the startling figure of fifty thousand visitors on certain fine Sundays."[1] These major exhibitions became a highly successful spectator sport in which the artists performed for approval from the huge audience that filed through the numerous rooms, although for many of the visitors the exhibition was no more than a "boutique of images."

In 1863 there was great discontent with the Salon jury system when more than half the pictures submitted were not accepted, forcing Napoleon III to make a gesture and establish an official Salon des Refusés. At least seven thousand people came on opening day to view the paintings by artists such as Fantin-Latour, Harpignies, Manet, and Whistler.[2] Manet's then controversial painting *Le déjeuner sur l'herbe* was among the works shown in the first Salon des Refusés. The curious audience that attended this novel exhibition gave the artist instant notoriety. As a result of the em-

peror's shock and the public's displeasure, no such Salon was ever held again.

After 1870 a small group of artists — "a dozen talented people" — who were interested in effects of color and light raised enough money to present their works without official government sanctions and without the judgment of a jury. The First Impressionist Exhibition, as it was soon to be known, opened in 1874 in the former studios of the renowned photographer Nadar. Unlike the Salon exhibitions, which were attended by many thousands of people, this small but significant presentation drew 3,500 visitors.[3] Judging from the critical reviews, most of them negative, that appeared in numerous publications and the attacking cartoons in the popular satirical journals, it seems that public knowlege about the Impressionist movement became widespread; and attendance increased exponentially at these "private" exhibitions, which continued until 1886. Manet, however, believed strongly in the importance of a Salon acceptance and never exhibited with his friends.

As trends changed in the Salon exhibitions, there were other spaces that featured displays of specialized subjects or techniques, and public interest shifted to the many smaller private exhibitions frequently held in dealers' galleries; indeed, the names of Durand-Ruel and Vollard are synonymous with those of the Impressionist and Post-Impressionist painters. Early on, Durand-Ruel considered himself a patron of the artists as well as a "crusader for the modern tradition in art" and recognized the commercial advantages of publicity and sales campaigns.[4]

The 1890s witnessed an explosion of artistic activity that heightened the public's enjoyment of and response to museums, private viewings, Salons, auctions, and dealers' shows. Artists were frequently motivated to create prints and posters, and there was a proliferation of publishers, print organizations, and exhibitions. The literary and artistic journal *La Plume* was a major contributor to this phenomenon not only through its reviews and articles that dealt with the visual arts but also through its sponsorship of a series of group exhibitions called the Salon des Cent (Salon of the One Hundred). Between 1894 and 1900, there were forty-three exhibitions, generally held monthly, and to publicize these, artists produced both lithographic (see cat. 79) and stencil-colored photorelief posters.[5] Although the posters often depicted elegant potential buyers, the exhibitions

Honoré Daumier

A day when one does not pay. — Twenty-five degrees celsius.

(Un jour où l'on ne paye pas. — Vingt-cinq degrés de chaleur.)
Museum of Fine Arts, Boston, William P. Babcock Bequest.
9/4247
(cat. 81)

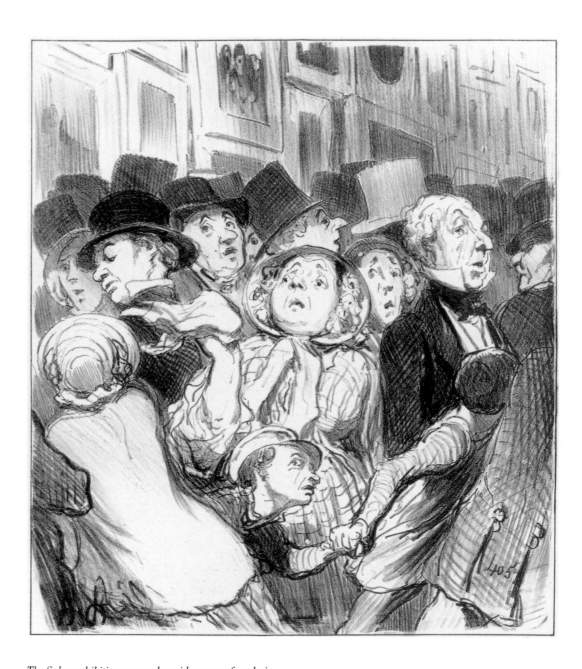

The Salon exhibitions covered a wide range of works in all media, style, and size. Each artist's works were kept together and were hung without consideration of size or method of execution. Often smaller prints and watercolors were included in the hope that sales would be encouraged. In his book The Masterpiece (L'Oeuvre), *Zola recorded an image of the fierce crowds on free days, when the heat, noise, and crush of people who were enjoying a special outing were virtually beyond description.*

frequently took place in small "alternative spaces," such as cabarets, theater foyers, and commercial offices or galleries. Here young avant-garde artists hoped to reach out to a larger general audience. During the 1889 Universal Exposition, for example, Paul Gauguin and Émile Bernard showed much of their work at the nearby Café Volpini. Another outlet for sales and a source of public entertainment was developed in 1853 when the auction house of the Hôtel Drouot was founded. Situated near the Bourse (Stock Exchange), it presented auctions of a wide diversity of objects. Linked to "popular capitalism," the auction house — and the Hôtel Drouot was the most powerful of its kind — was "incorporated into the pageant of metropolitan life and entertainment."[6]

The standard by which all these varied exhibitions were judged was still the Louvre, to which Parisians, citizens from the outlying areas, and foreign tourists flocked. In 1879 one English traveler commented: "I fell into the ranks of a dense, but most orderly throng, who were scaling the grand staircase of the Museum. I found the due contingent of civil and attentive guardians, in their traditional cocked hats; but I was pleased to see that under a Republican *regime* the sovereign people were no longer deprived of their sticks and umbrellas at the door. [See the distinctive prints showing Mary Cassatt at the Louvre, etched by Degas in this same year; cat. 83, 84.] And on Palm Sunday afternoon the incomparably magnificent art-galleries of the Louvre were thronged by a vast multitude of Frenchmen who knew how to behave themselves, and did so most scrupulously."[7]

Notes

1. Émile Zola, *The Masterpiece*, trans. Thomas Walton (Ann Arbor, Mich., 1977), p. 285. (First published in 1886 as *L'Oeuvre*.)

2. Jacques Lethève, *Daily Life of French Artists in the Nineteenth Century*, trans. Hilary E. Paddon (New York, 1972), pp. 118-128.

3. Paul Tucker, "The First Impressionist Exhibition in Context," in *The New Painting: Impressionism, 1874-1886*, exhib. cat. (The Fine Arts Museums of San Francisco, 1986), p. 106.

4. Nicholas Green, "Dealing in Temperaments: Economic Transformation of the Artistic Field in France during the Second Half of the Nineteenth Century," *Art History* 10, no. 1 (March 1987), p. 60. This article presents an interesting analysis of the relationships of dealers, writers, and auction houses to the economic processes of the art market.

5. Phillip Dennis Cate, "La Plume and Its 'Salon des cent,'" *Tamarind Technical Papers, Print Review* 8 (New York, 1978), pp. 61-68; and Phillip Dennis Cate, ed., *The Graphic Arts and French Society, 1871-1914* (New Brunswick, N. J., 1988), pp. 38-39, 126.

6. Green, "Dealing in Temperaments," p. 63.

7. George Augustus Sala, *Paris Herself Again in 1878-9*, vol. 2 (London, 1879), p. 270.

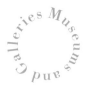
Frédéric-Auguste Cazals
Salon des Cent, 1894
Jane Voorhees Zimmerli Art Museum, Rutgers,
The State University of New Jersey, David A. and
Mildred H. Morse Art Acquisition Fund.
85.055.009
(cat. 79)

The Salon des Cent held frequent exhibitions on the premises where the related journal La Plume *was published. Each exhibition included approximately one hundred works and made the art very accessible to the public in these small and informal spaces. Rather than depicting anonymous faces in crowded audiences, as Daumier did, Cazals has caricatured his friends, the poets Paul Verlaine and Jean Moréas, who are examining a selection of drawings.*

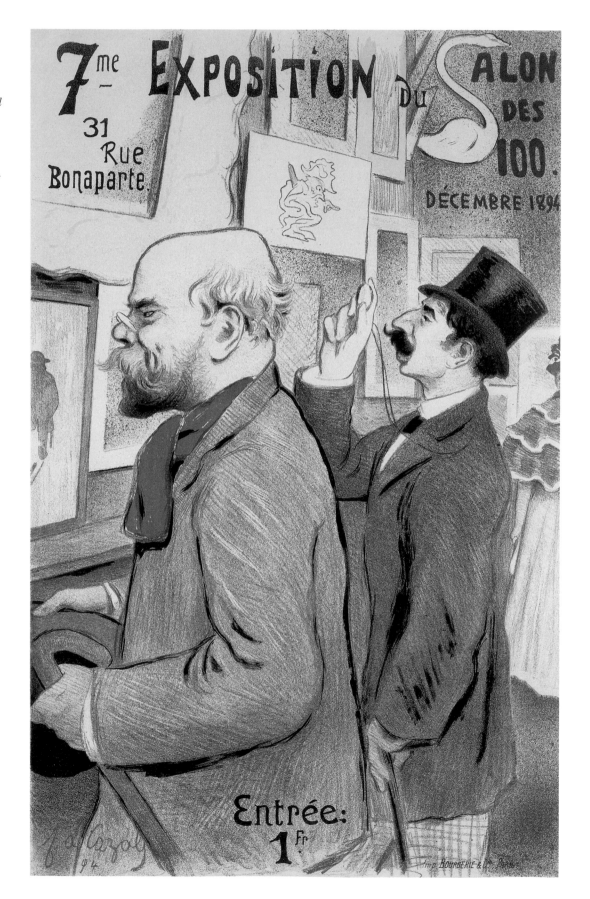

Armand Louis Rassenfosse
Salon des Cent, 1896
Museum of Fine Arts, Boston, Gift of Benjamin A. and Julia M.
Trustman. 1989.249
(cat. 89)

In December 1893 the journal La Plume
*announced that it would sponsor monthly
exhibitions of pictures in all media. The
publisher of the journal commissioned art-
ists to design posters to advertise this se-
ries, which lasted for six years.
Rassenfosse's poster, without lettering,
publicized the nineteenth exhibition, a
group show with drawings that was held
from February to March 1896.*

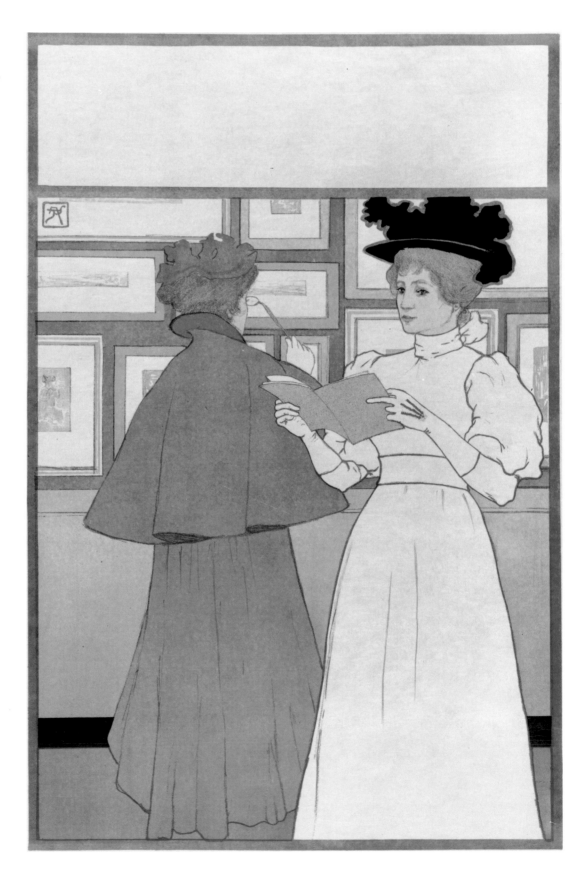

Honoré Daumier

THE VISITOR — Oh! for once here is a picture which is really senseless! and what color!

THE ARTIST — Bourgeois Cretin, go away!

(LE VISITEUR — Oh! pour le coup voilà une composition qui est réellement insensée! et quelle couleur!

L'ARTISTE — Crétin de bourgeois va!), 1864

Museum of Fine Arts, Boston, Bequest of W. G. Russell Allen. 63.2038

(cat. 82)

Henri de Toulouse-Lautrec

Henry Nocq, 1897

The Alex Hillman Family Foundation. L.1988.92.21

(cat. 90)

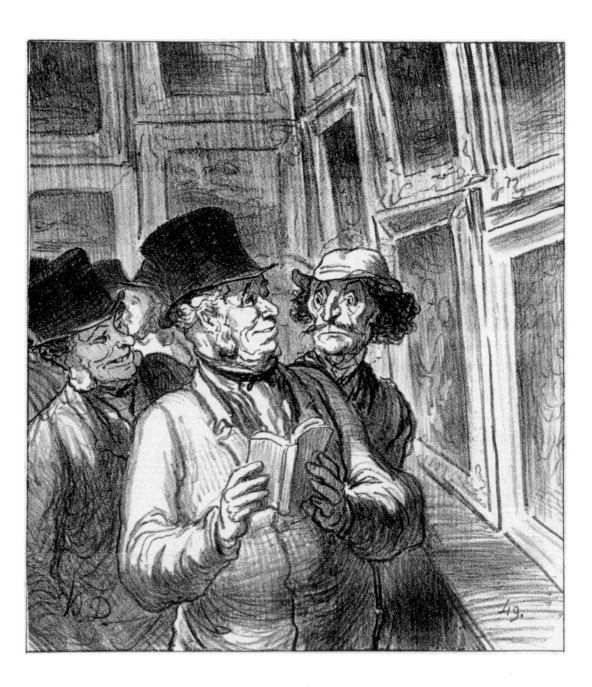

Lautrec relied on the studio environment to complete most of his compositions, even those of cabarets, which carry an air of spontaneity. By 1897 he owned a studio in Montmartre, very near the Moulin Rouge. Here he has depicted his friend the Belgian craftsman M. Nocq examining the unfinished oil painting of Marcelle Lender dancing the bolero in Chilpéric, *an operetta that met with great success in 1895. Like many artists of the period, Lautrec received well-to-do clients in his studio, which was taking on the role of an art gallery. Lautrec, however, was mainly interested in the social interaction of entertaining friends. Close associates also came to his studio to admire the artist's more erotic paintings that he preferred not to exhibit publicly.*

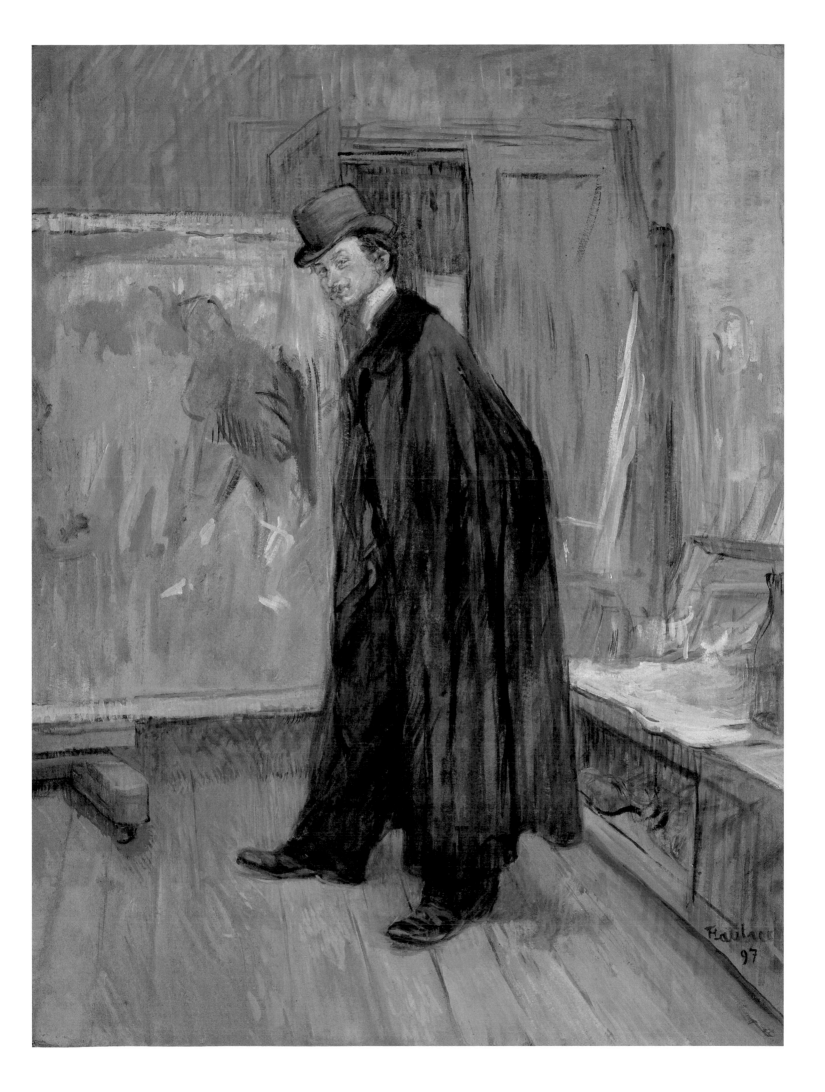

Hilaire Germain Edgar Degas
*Mary Cassatt at the Louvre: The Paintings
Gallery,* 1879-1880
Museum of Fine Arts, Boston, Katherine E.
Bullard Fund in Memory of Francis Bullard and
proceeds from sale of duplicate prints. 1983.309
(cat. 84)

Hilaire Germain Edgar Degas
A Visit to the Museum, ca. 1885
Museum of Fine Arts, Boston, Gift of Mr. and
Mrs. John McAndrew. 69.49
(cat. 85)

*This painting is one of several works, in-
cluding the two etchings (cat. 83, 84),
that depict women visiting a museum.
Traditionally, it is believed that in the
prints the standing figure is Degas's friend
and occasional model Mary Cassatt, ac-
companied by her sister Lydia, but for the
painting the identification is less secure.
Cassatt, who was known for her fashiona-
ble dress, may be the model shown here in
a rather plain gown, although Degas's in-
terest was evidently piqued by the women's
perky hats with feathers. Visiting muse-
ums was a well-accepted form of recrea-
tion in the nineteenth century, especially
for highborn women, who could travel
there alone without stigma. Parisians have
always considered their museums as per-
sonal treasures to be shared and enjoyed
by all classes; indeed, Daumier, before
Degas, frequently depicted crowds of visi-
tors attending picture galleries.*

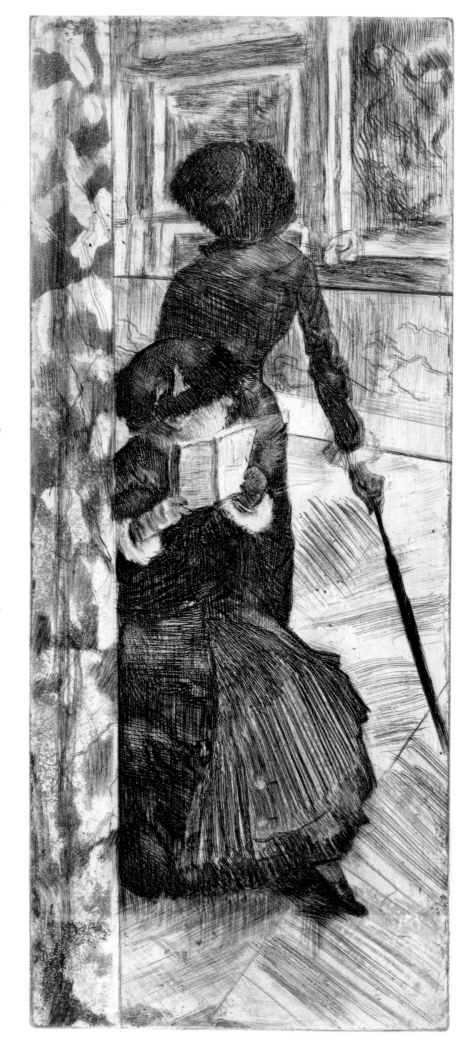

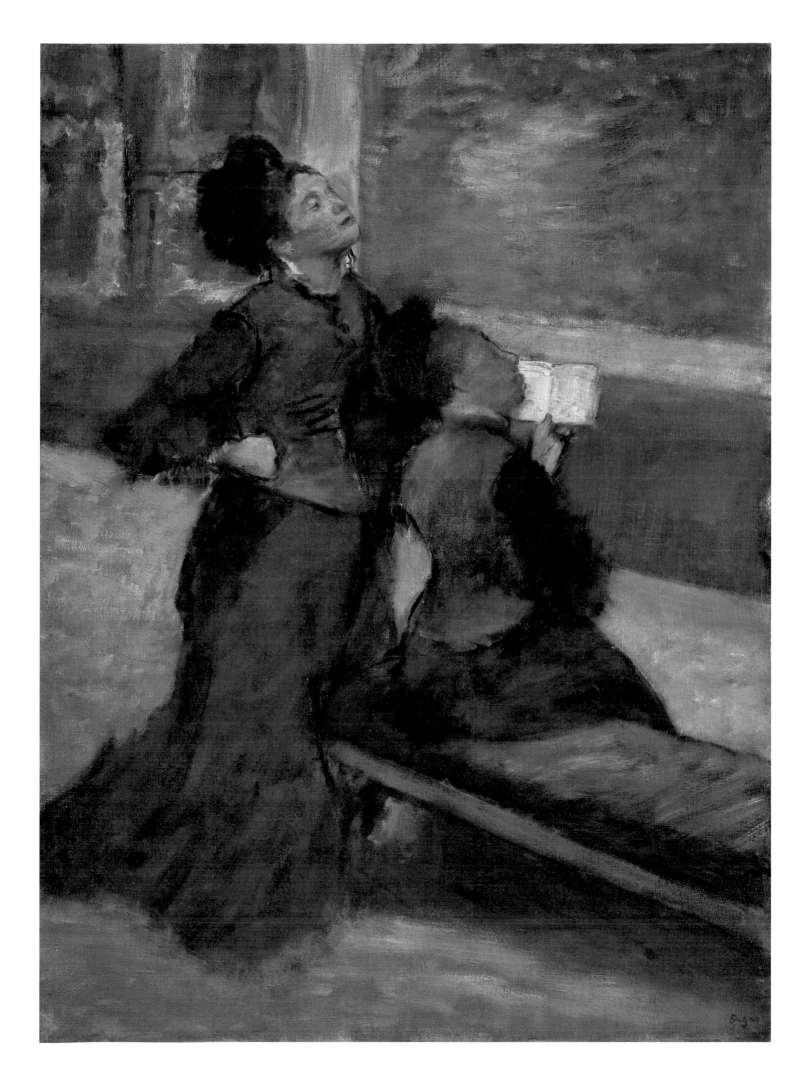

Paul César F. Helleu
Madame Helleu Looking at Drawings by Watteau at the Louvre
(Madame Helleu devant les dessins de Watteau au Louvre),
ca. 1895
Museum of Fine Arts, Boston, George R. Nutter Fund. 62.991
(cat. 86)

Winslow Homer
Art Students and Copyists in the Louvre Gallery, Paris,
1868
Addison Gallery of American Art, Phillips Academy, Andover,
Massachusetts. 1989.56
(cat. 88)

Helleu was introduced to leading figures of Parisian society, who launched him into a career as a portraitist of stylish women. In one of his most striking drypoints, Madame Helleu is shown visiting the Louvre to see an exhibition of Watteau drawings that had been acquired by the museum in the late 1850s.

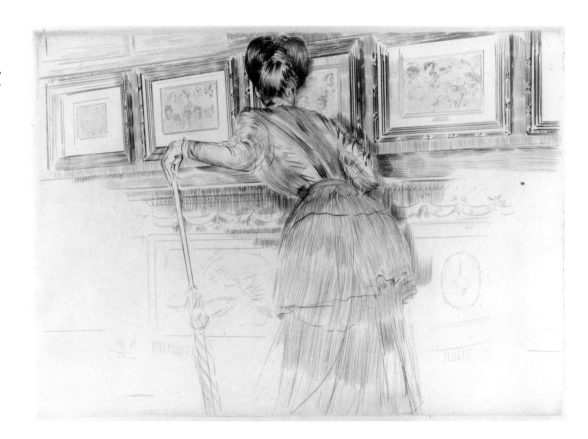

In 1869 the American traveler James Mc-Cabe offered his opinion of the copyists at the Louvre: "Along the galleries are numerous temporary stands, easels, etc., at which artists are constantly at work copying such paintings as they may have orders for, or hope to find purchasers for. Many of these workers are women. They are ugly and careless in their dress, and altogether unattractive specimens of their sex" (McCabe, p. 360). Apparently Mc-Cabe did not recognize that many of these artists were American students completing their studies of Old Master techniques.

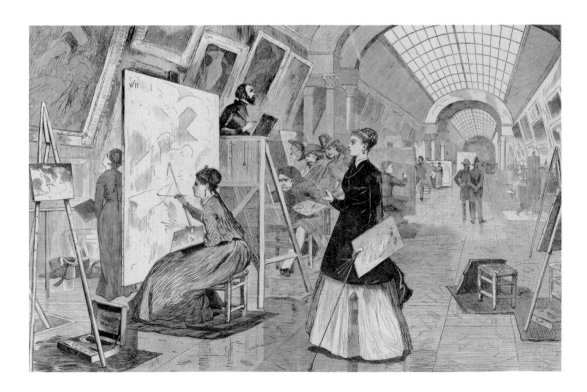

Theatrical Entertainments

In the 1880s and 1890s half a million Parisians went to the theater once a week, and with the influx of countrymen from the provinces who could easily commute to Paris as well as the foreign tourists who came for the Universal Expositions, more than one million visitors attended at least once a month.[1] Theatrical entertainments, a significant aspect of Parisian glory, flourished from the Second Empire to the turn of the century. Included in this type of spectacle were traditional and legitimate theaters such as the Théâtre Français, a government-sponsored institution where successful dramatists introduced new plays starring illustrious actors. There were also the experimental and privately supported companies, especially Lugné-Poë's Théâtre de l'Oeuvre (cat. 105) and André Antoine's Théâtre Libre (cat. 106), that gave avant-garde presentations. Musical performances, in the form of operas, concerts, and operettas were also among the attractions. With the inclusion of music halls and similar entertainments, it was possible to accommodate more than fifty thousand people per evening.[2]

An enduring source of pride was the Paris Opéra, upon which monies were always lavished by the government. In 1861 Haussmann commissioned Charles Garnier to build an important new home for the Opéra to be located at the hub of the redesigned grand boulevards; it was finally completed in 1875 under the Third Republic. Profusely ornamented with statues and innumerable "gilded shapes," it is representative of the most opulent aspects of the Second Empire. With its vast stage, the largest in the world at the time, and with lighting that "demanded eight thousand five hundred gas-jets, at a daily cost of one thousand three hundred francs,"[3] it was capable of presenting spectacular performances, which included interludes of admirable ballets. An enormous foyer and a grand marble stairway provided their own theatrical settings. Mary Cassatt's painting *At the Opera* (cat. 91) depicts the tiers of loges where one could both observe the audience and be observed. The inattention of Cassatt's subject to the performance on the stage was characteristic of an opera goer's response. Until the theaters perfected the dimming of the "house lights" while maintaining a brightly lit stage, the frivolous socializing by the audience and its often noisy and impulsive participation was a distracting but accepted mode of behavior (cat. 108).

Renoir also pictured the Opéra interiors in several paintings (cat. 104); his fashionably dressed

spectators confirm that their enclosed environment was an elegant one. Marcel Proust described such a scene: "The society people sat in their boxes (behind the tiered circle) as in so many little suspended drawing-rooms, the fourth walls of which had been removed . . . without letting [themselves] be intimidated by the mirrors in gilt frames or the red plush seats, in the Neapolitan style, of the establishment."[4] Renoir, who would have been less familiar with the world of the opera than Mary Cassatt or the urbane, well-to-do Manet, for example, successfully depicted the women in one of Paris's most celebrated "temples of fashion."

Finally, it was Degas who moved his viewers from the loges to the main floor and the orchestra pit of the Opéra (where women were not permitted to sit) and who explored the recesses of the backstage with its special hierarchy of ballet society. The artist frequently visited the former Opéra house on rue Le Peletier (which burned down in 1873); after 1885 he received his own card of "privilege" that permitted him to sketch backstage the dancers practicing, exercising, and waiting in the wings.

During this period, the public became accustomed to the world of "theater" in its broadest meaning: legitimate theaters, opera houses, hippodromes, and even music halls were brought under one umbrella, all with the most complicated and lavish displays. The large, expansive stages became settings for great pictorial compositions, employing every melodramtic effect that was technically possible at this time: "fairy worlds of light and color, rich costumes, songs, and bowers of bliss . . . whisked the viewer from bustling streets to exotic locations to celestial harmonies."[5]

The innovative developments in gas and electricity altered both the technical and aesthetic standards of the stage. Gaslight, which had infinite possibilities for creating brightness and was successful along the boulevards, had limitations within the theater. Its enormous consumption of oxygen produced unpleasant effects on people within confined areas. Before the perfection of the electric bulb, the transition from an open gas flame to the closed electric bulb with a filament, as we know it today, was achieved by a form of "open electrical incandescent lighting" called "arc lighting."[6] Though developed as early as the 1840s, arc lighting was not operational until the 1870s, when many of the Impressionist artists

were turning their attention to images of the night. The use of "limelight" and arc lighting heightened the dazzling effects that could be created, and with the introduction of polished plate glass, mirrors, and sparkling costumes, designers could fashion extravaganzas that guaranteed large and appreciative audiences. Thus, the history of theater is inextricably linked to the evolution of lighting; the Paris Opéra, for example, experimented with electric light as early as 1846 and installed it by 1887. By the end of the century, electricity was a principal feature in most theatrical houses.[7] Theater productions and other spectacles continued to provide an attractive form of recreation for all classes of Parisian society, except for the very poor, who clustered around the entrances to these "fairy worlds" and grimly observed the opulent scenes.

Notes

1. Eugen Weber, *France, Fin de siècle* (Cambridge, Mass., 1986), p. 159.

2. Robert L. Herbert, *Impressionism: Art, Leisure, and Parisian Society* (New Haven, 1988), p. 93.

3. Joanna Richardson, *La vie parisienne, 1852-70* (New York, 1971), p. 228.

4. Marcel Proust, *Remembrance of Things Past*, trans. C.K. Scott Moncrieff and Terence Kilmartin, vol. 2 (New York, 1982), p. 35.

5. Weber, *France*, p. 164.

6. Wolfgang Shivelbusch, *Disenchanted Night: The Industrialization of Light in the Nineteenth Century*, trans. Angela Davies (Berkeley, 1988), p. 52.

7. Weber, *France*, p. 165.

Honoré Daumier

They say that the Parisians are difficult to please, on these four benches there is not one discontent. — it is true that all these Frenchmen are Romans.
(On dit que les Parisiens sont difficiles à satisfaire, sur ces quatre banquettes pas un mécontant. — il est vrai que tous ces Français sont des Romains.), 1864
Museum of Fine Arts, Boston, William P. Babcock Bequest. 2/4218
(cat. 92)

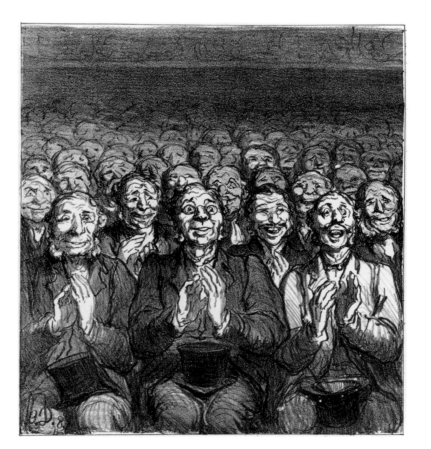

Daumier's audience resembles the professional claque, an institution in every Parisian theater of the nineteenth century. The members of the claque numbered from twenty to fifty and sat in a compact body immediately behind the orchestra, applauding night after night at the same passages.

Cassatt's figure, dressed simply in black (some say in mourning dress), suggests that she is attending an afternoon event. Rather than looking at the performance on stage, the sitter very pointedly uses her opera glasses to examine other loges while she herself is being studied from across the way by a male observer. Cassatt has depicted a part of the theater in which two rows of elegant boxes were set between the open balconies.

Mary Cassatt
At the Opera, 1879
Museum of Fine Arts, Boston, Charles Henry
Hayden Fund. 10.35
(cat. 91)

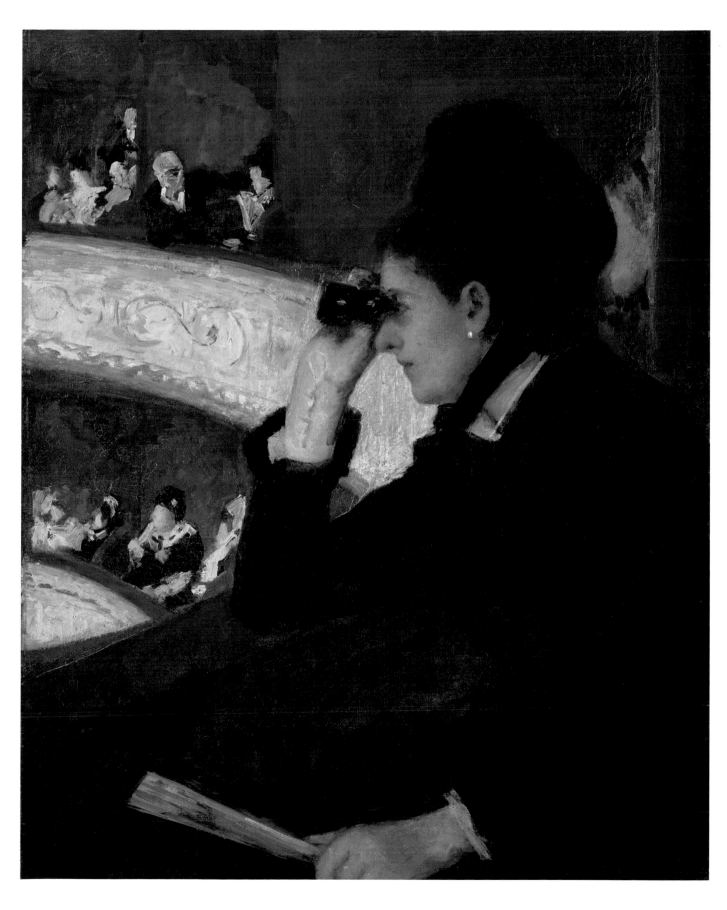

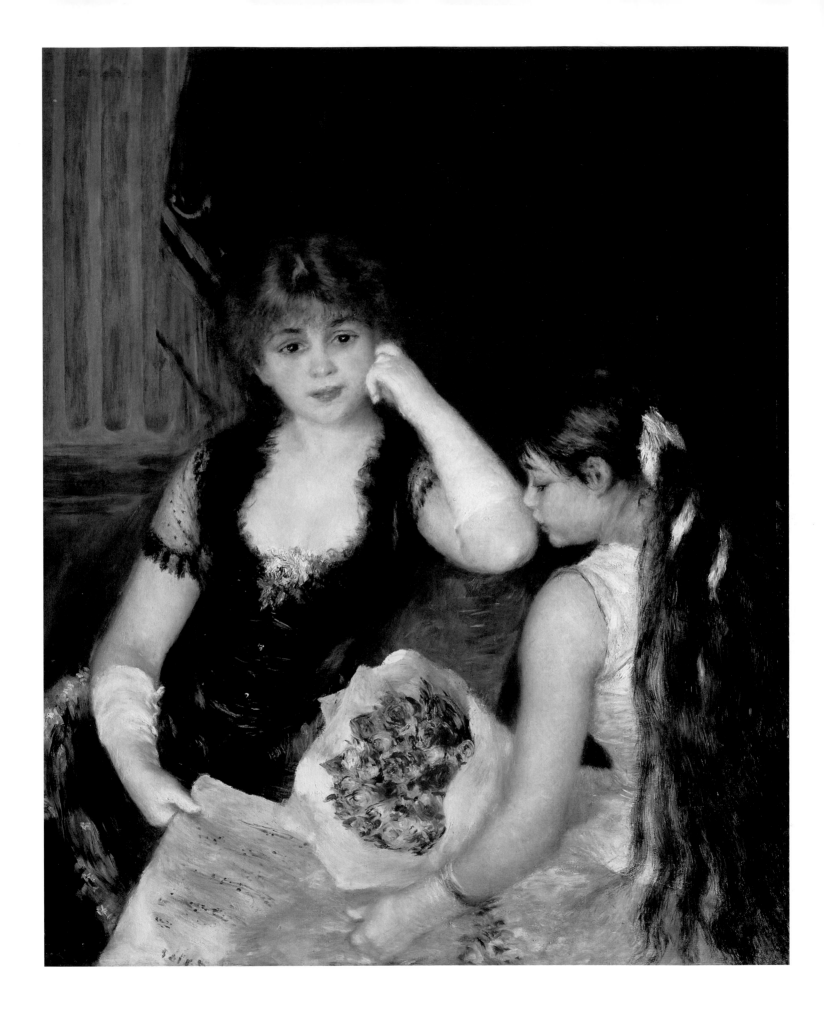

Henri de Toulouse-Lautrec
The Loge with the Gilt Mask
(La loge au mascaron doré), 1893
Courtesy of the Boston Public Library, Print Department, Gift of
Albert H. Wiggin
(cat. 106)

Pierre Auguste Renoir
A Box at the Opera
(Une loge à l'Opéra), 1880
Sterling and Francine Clark Art Institute,
(cat. 104)

*Renoir reached above his own social class
to paint this high-society woman, who
discreetly occupies her loge with a shy
young girl. The head and shoulders of a
man, now painted out, show through
faintly in the upper right of the painting
and suggest that Renoir may have been
commissioned to do a family portrait. The
elegant box, the sheet music, the bouquet,
and the splendid dresses imply that this
was a special occasion in which Renoir
was not a participant but an observer. He
has offered us a privileged view of a princi-
pal loge at the Opéra and revealed a
world that was available only to the very
wealthy.*

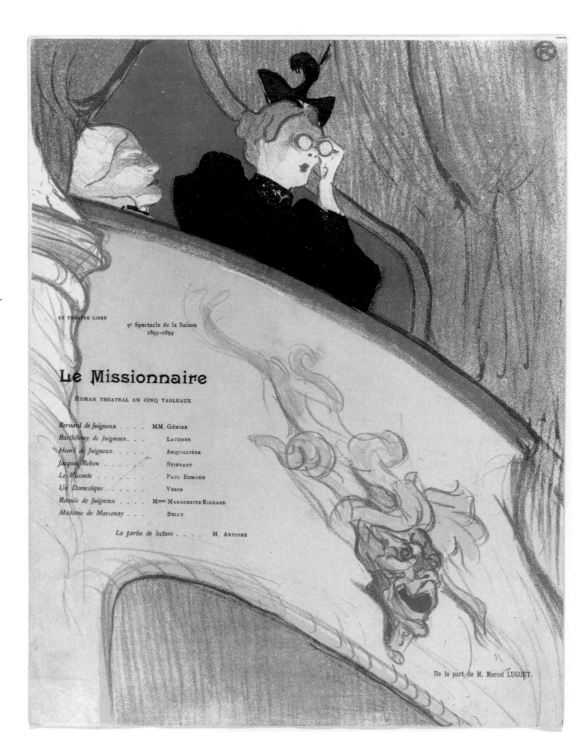

*The lithograph was published in 1892 and was used a
year later by the Théâtre Libre as the program for Mar-
cel Luguet's play* Le missionnaire.

Honoré Daumier
A Literary Discussion in the Second
Balcony
(Une discussion littéraire à la deuxième galerie),
1864
Museum of Fine Arts, Boston, William P.
Babcock Bequest. 4/4218
(cat. 93)

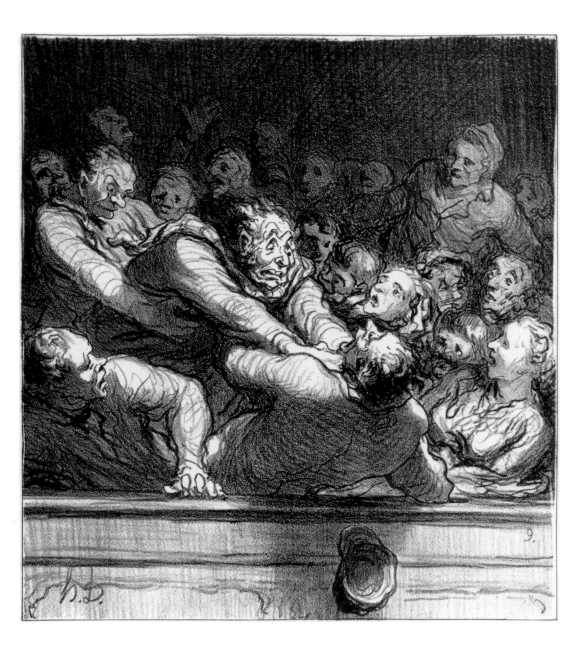

The theater was a popular form of entertainment in Paris, and from the boxes to the top gallery, every level of society was represented. According to the American traveler James McCabe, "the lively and emotional audiences of Parisian theaters [are] an interesting study. Exclamations of delight, or mutterings of disapproval arise all around you . . . with impulsive shouts . . . and the emotion produced by some harrowing tragedy is equally unrestrained" (McCabe, p. 673).

Degas was one of the first artists to focus on the audience on the "floor," where women were not seated. He himself sat in the first rows to make sketches of the musicians, spectators, and the stage, where, at this moment, nuns were dancing. This was a favorite scene from the extremely popular opera by Meyerbeer, which ran throughout the nineteenth century for 758 performances. The gentleman who looks through his binoculars at the boxes in the grand circle is representative of the indifferent subscribers who were more interested in the social climate in the theater than in the often repeated musical production (Degas, 1988, pp. 171-173).

Hilaire Germain Edgar Degas
The Ballet from "Robert le Diable," 1871-1872
The Metropolitan Museum of Art, Bequest of
Mrs. H. O. Havemeyer, 1929. 29.100.552
New York only
(cat. 94)

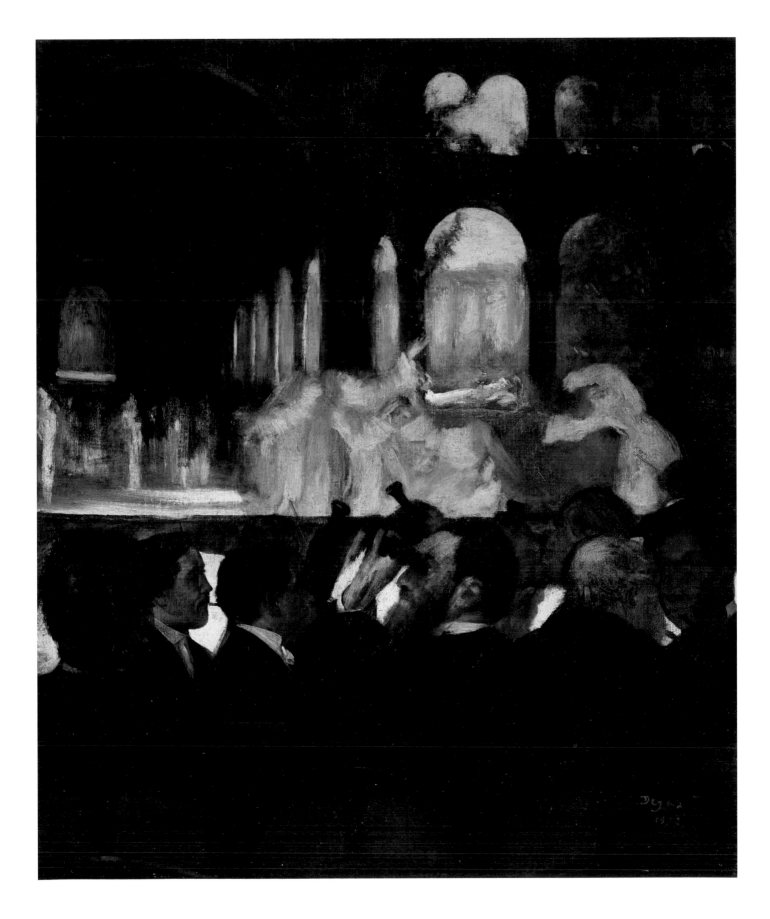

Hilaire Germain Edgar Degas
Four Dancers, ca. 1900
Private Collection
(cat. 99)

Hilaire Germain Edgar Degas
Dancers in Rose, ca. 1898
Museum of Fine Arts, Boston, Seth K. Sweetser
Fund. 20.164
(cat. 98)

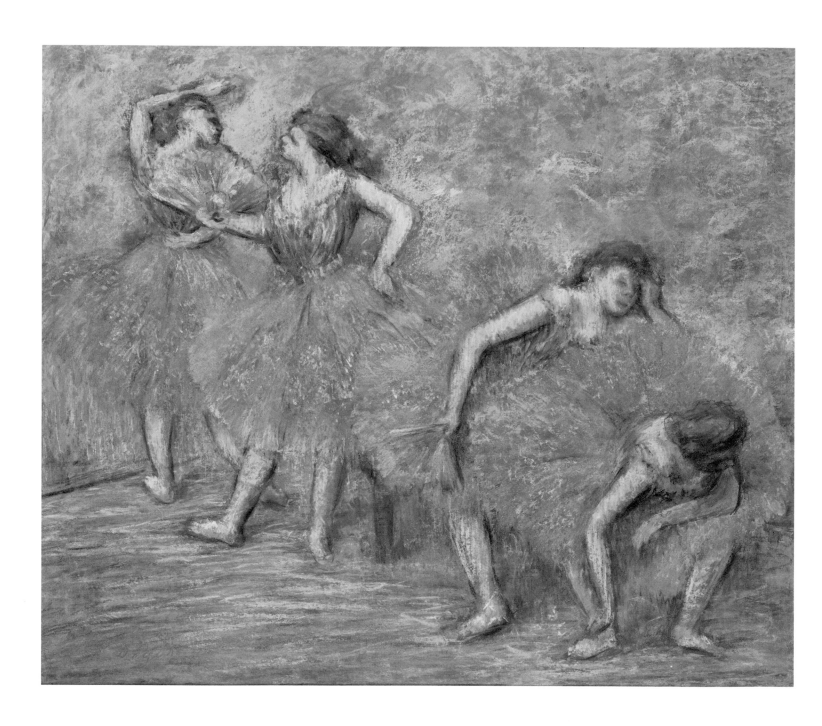

Dancers who wait in the wings — a favorite theme of the artist — are caught as they gesture, stretch, and pose in anticipation of their formal choreography. Here Degas appears to have used a single figure and repeated it, creating a sequence of rhythms, cinematic in effect. In the later years of his work, he layered pastels in rich colors to achieve a vibrating surface. "Dancers . . . occupied a twilight world where the bright artifice of the performance met the grim reality of back-stage life. In this area, privileged male visitors could watch the performance and mingle with the dancers both during and after the evening's entertainment" (Kendall, p. 49). The social position of these dancers as young working women was only marginally more acceptable than that of the laundresses, shop girls, milliners, and the demi-mondaines.

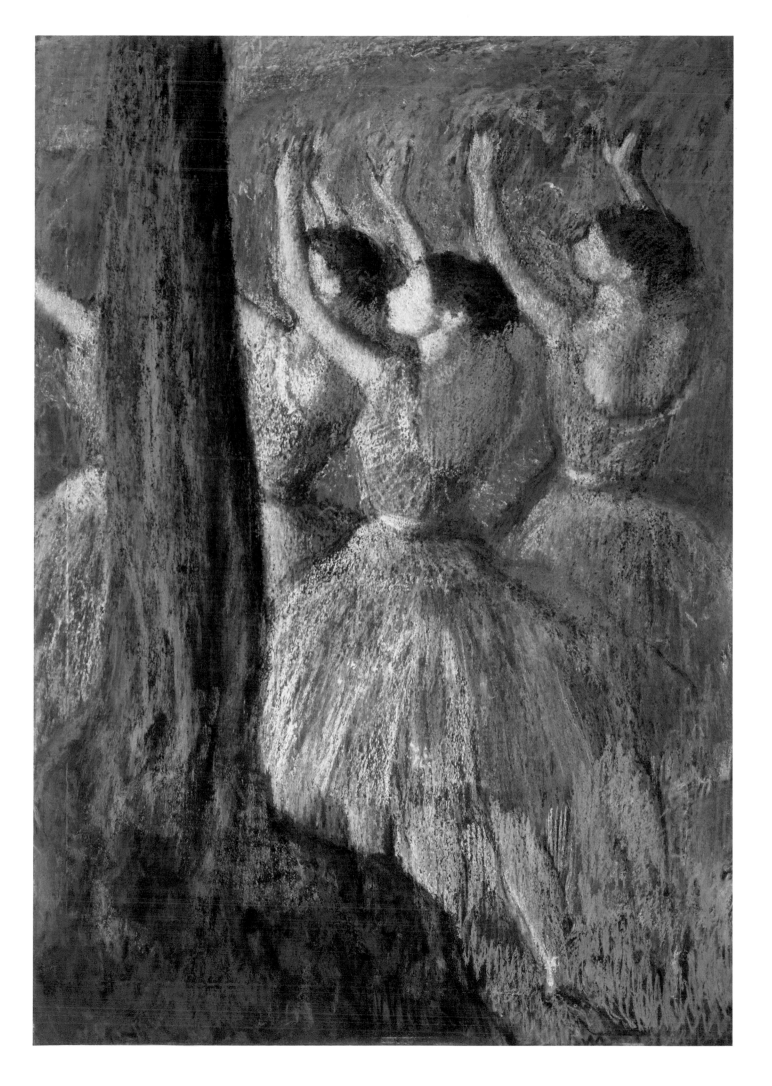

Jean-Louis Forain
Foyer of the Opéra
(Foyer de l'Opéra), ca. 1880
Museum of Fine Arts, Boston, Lucy Dalbiac Luard Fund.
1971.306
(cat. 101)

Jean-Louis Forain
A Box at the Opéra (Une loge à l'Opéra), ca. 1880
Harvard University Art Museums, Bequest of Annie Swan Coburn.
1934.32
(cat. 102)

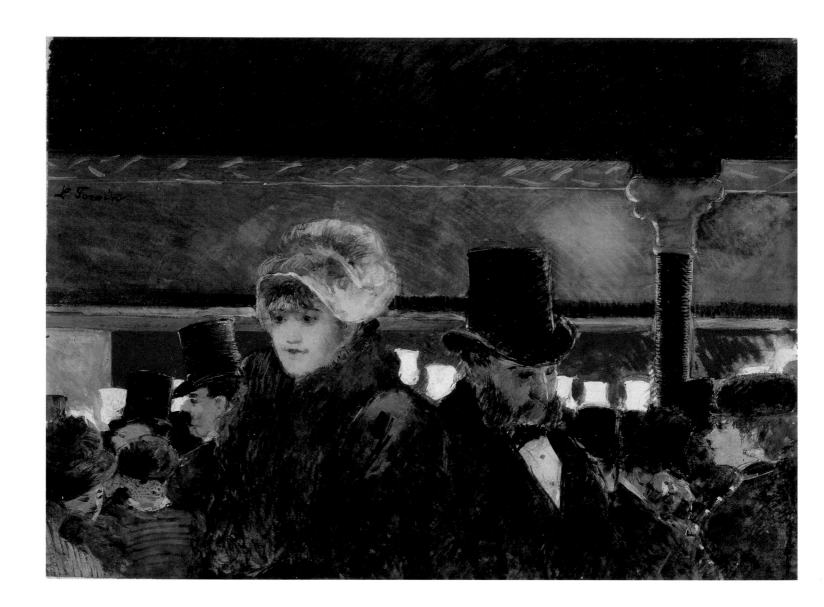

In a group of small gouache paintings, Forain revealed his indebtedness to Degas in subject and style. He has moved the well-to-do and generally idle dandies into the theater, where their black and white formal dress suits have become foils for the touches of color, particularly on the attentive and delightful cocotte in A Box at the Opéra. *Although the audience may have been predominantly male, the presence of women as objects of desire and observation was always encouraged. Forain has chosen to present two anecdotal interludes in the course of an evening at the opera; the narrative tone of entrance and departure is characteristic of the artist's interest in the bourgeois of modern Paris. His caricatural depictions of the opéra goers are well noted.*

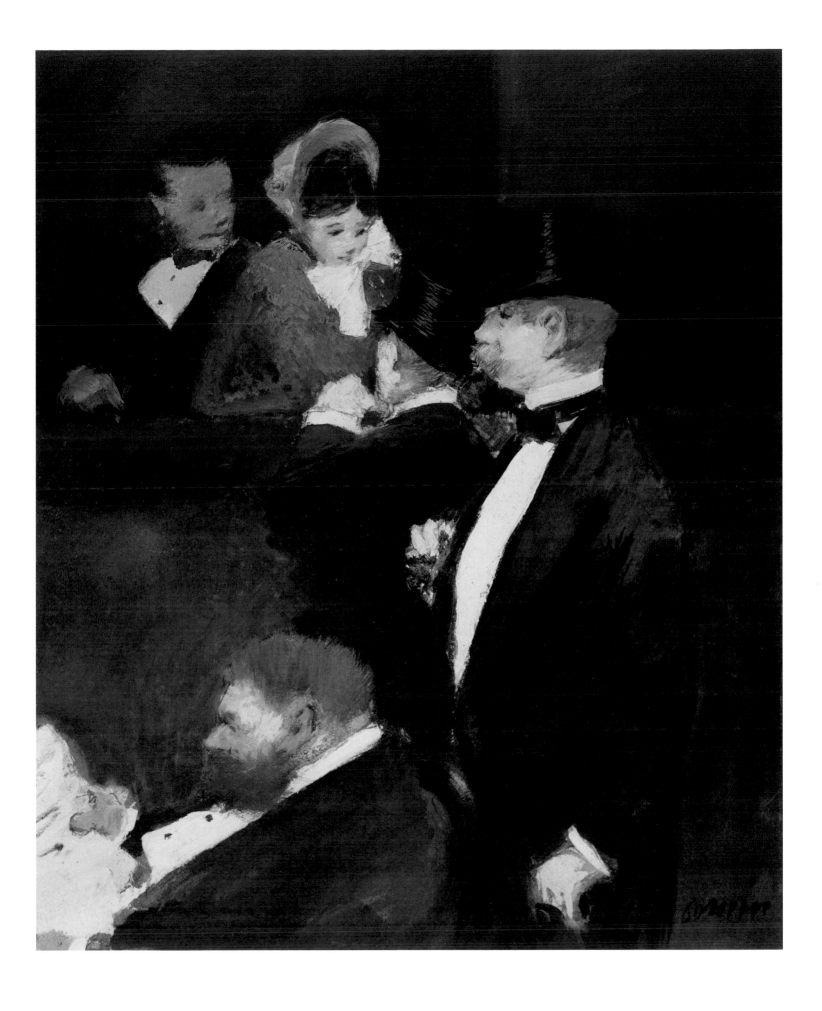

Alphonse Mucha
La dame aux camélias, 1896
Museum of Fine Arts, Boston, Gift of Charles
Sumner Bird. 1970.514
(cat. 103)

*In the 1880s theater managers recognized
the importance of advertising their pro-
ductions, particularly through the me-
dium of posters. By the 1890s they real-
ized that the public was enchanted with
these works both as advertisements and as
artistic statements. When Sarah Bern-
hardt wanted a new poster, she turned to
the printing house of Lemercier, and on
Christmas Eve 1894 Mucha was hastily
commissioned to make a design for her
play* Gismonda. *She accepted his draw-
ing, and for the next five years Mucha cre-
ated posters for nearly all of Bernhardt's
new plays, including* La dame aux came-
lias, *in which she performed the title role
more than one thousand times throughout
the world.*

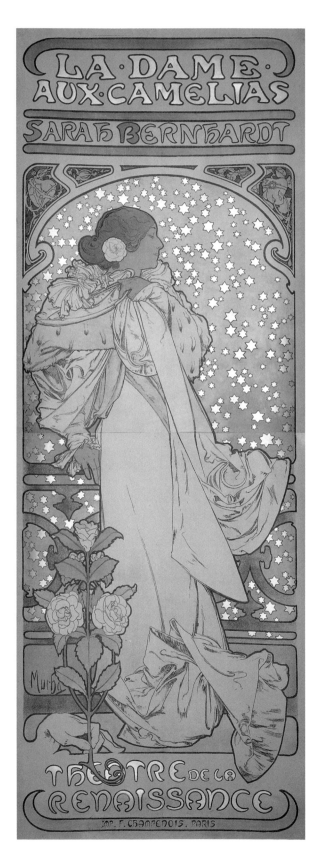

Jan Toorop
L'Oeuvre, 1895
Museum of Fine Arts, Boston, Lee M. Friedman
Fund. 1990.255
(cat. 105)

*Toorop's poster was created for a play at
the Théâtre de l'Oeuvre in keeping with
the 1890s vogue for artist-designed pos-
ters, programs, menus, and the like.
Founded by the actor and producer
Lugné-Poë, the theater was known for its
Symbolist plays. This proof, without the
text at the upper right, was produced at
the height of Toorop's Symbolist period; it
advertises Thomas Otway's play* Venice
Preserved, *written in 1682 and a stock
piece on the European stage until the late
nineteenth century.*

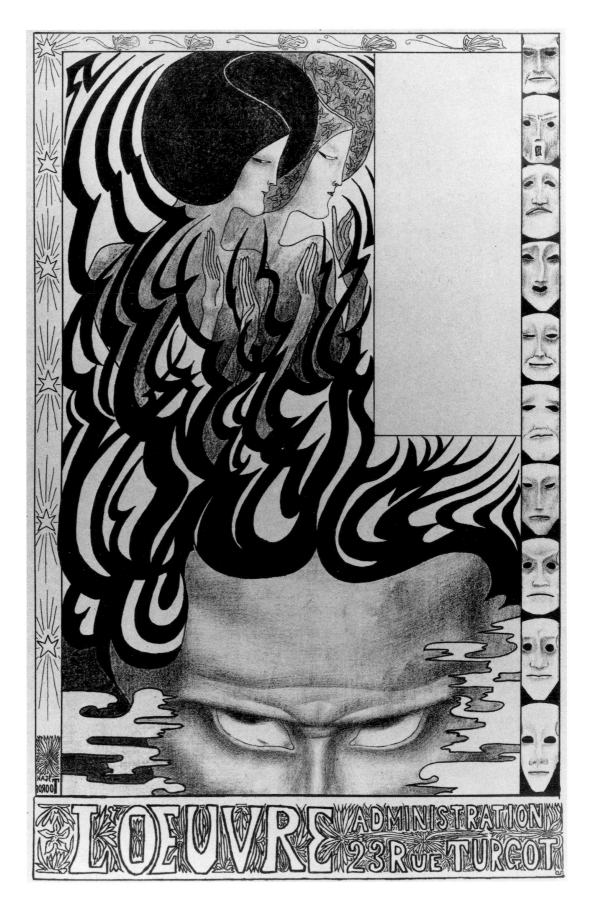

Jean-Louis Forain
A Masked Ball
(Un bal masqué), 1885-1890
Private Foundation
(cat. 100)

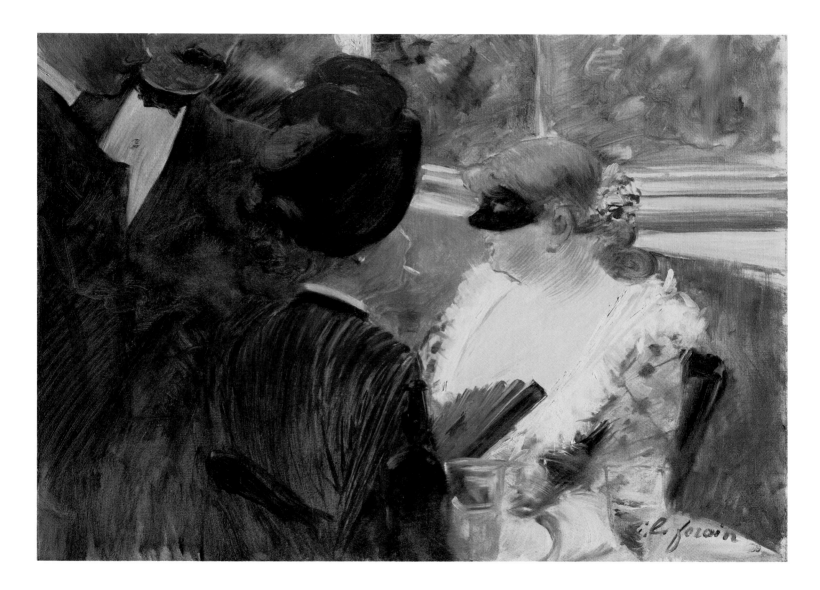

Masked balls flourished during the Second Empire and continued into the Third Republic as key social events. According to an 1884 Baedeker guide, public masked balls were held weekly from mid-December until Mardi Gras and were among the most "striking and extravagant of the peculiar institutions of Paris." The balls began at midnight and lasted until dawn and the most important ones were those given in the new opera house. Everyone who could afford the admittance fee tried to attend these "vigorous revels." The upper classes considered them as reckless evenings and did not appear on the dance floor without a mask, remaining for the most part as observers in their loges. Small tables and chairs were placed around the edges of the dance floor of the Opéra where vendors circulated with their cigarettes, fans, masks, gloves, and other wares (Herbert, p. 131). The mirrored wall behind the two women and the top-hatted gentlemen suggest an opulent interior such as the Opéra; nonetheless, the more pedestrian fashions of the

models and the fact that one woman does not wear a mask offers the possibility that the setting is a music hall, where such events were also held during Carnival time. The buxom, blond-haired woman in this painting is the same model as in two others by Forain, both catalogued as A Ball at the Opéra.

V

Cafés, Cafés-Concerts, and Cabarets

The café is "the great meeting-place where the whole city takes its rest," a visitor to Paris wrote in 1889, "and it is also the fair where it shows best all the peculiarities and types it possesses. It is Paris in essence; Paris displaying the most variegated, most radiating, most singularly attractive side of her character."[1]

Although cafés existed in Paris in the late seventeenth century, when coffee was first introduced into Europe, and prospered in the eighteenth century (the Café Procope shows with pride the table at which Voltaire wrote for fifteen years), it was in the second half of the nineteenth century that such places became the focal point of a Parisian's public life. (On the role of the café, see the essay by Susanna Barrows.) The very plan of the city as designed by Baron Haussmann encouraged the proliferation of the cafés that spilled out onto the wide pavements, filled the garden areas of the Champs-Élysées, interrupted the vast distances and long vistas, and provided enjoyable and important recreational centers for Parisians; by 1869 there were at least four thousand true cafés. As their number increased, the cafés ranged from small, dark rooms for the working man to large, fashionable establishments frequented by the well-to-do. In the long history in France of social interaction and entertainment, the cafés and their attached bars and restaurants were the logical centers for conversation and companionship. Many guidebooks of the period, written mainly for American and English tourists, give vivid accounts of prominent cafés, and their descriptions of Paris as "the capital of pleasure" or "the gayest of gay cities"[2] often overshadowed information about historical monuments, especially during the Universal Expositions of 1867, 1878, 1889, and 1900.

The cafés became the extension of the Parisian home: a place in which to dine, to socialize, to conduct business, or to use as a club. Many of the Impressionist artists and literary figures gathered their own coterie around them and patronized for years particular cafés that became sources of subject matter and inspiration (cat. 143). Those which served light food and drinks were deemed respectable by the "proper" bourgeoisie under certain circumstances and could be frequented without embarrassment. In 1869 the American traveler James McCabe offered a lively description of such places: "As soon as the sun sets the *cafés* of the Boulevards are all aglow. They are all handsome establishments, gorgeous

with plate-glass, frescoes, and gildings. Scores of lights dazzle the eye, and multiply themselves in the long mirrors. In the summer no one thinks of sitting indoors, and the sidewalks, or *trottoirs*, are lined with little tables and with chairs. Persons of all classes sit here, smoking, drinking, chatting, reading the journals. Here is a true democracy — the only social equality to be seen in Christendom."[3]

The evolution of cafés and brasseries to cafés-concerts (familiarly known as *caf'-conc'*), where performers provided song and dance entertainments, began as early as the 1840s, but their popularity grew mainly during the 1850s and 1860s. During the Second Empire the government exerted control over the cafés to prevent political intrigues, and in the early years of the Third Republic that followed the Commune any flamboyant activities were viewed with concern. By the late 1870s, however, live entertainment flourished either on small indoor stages in popular cafés or in open-air gardens and pavilions. Indeed, the "twins" of the cafés-concerts, the Ambassadeurs (cat. 132) and the Alcazar d'Été, were housed in matching Antique Revival buildings set among the trees on the Champs-Élysées near the Place de la Concorde.[4] The extensive gas lighting favored by Haussmann illuminated the avenues and these pleasure centers, making them more festive for nocturnal celebrations (fig. 1). The crowds that attended were "a diversified public representing every class of the Parisian population, from the purest snob to the lowliest store clerk."[5] The noted Karl Baedeker claimed in his 1884 guidebook that the cafés-concerts were of a "very mixed character" and, like moths to a flame, attracted a variety of female habituées, both employees and clientele.[6] These urban entertainments supplied artists such as Manet, Forain, and Degas with a repertoire of modern subject matter and composition. The literary critic Edmond de Goncourt, who visited one of the cafés-concerts on the Champs-Élysées, sarcastically noted in his journal, August 6, 1876: "An enthusiasm, an electricity, a fraternization of the audience joining in the refrain [of a popular song], as if it was truly a patriotic anthem. In this regime of comic songs, twenty years from now France will be rewarded, and there will only be a population of clowns [and] buffoons."[7]

The cafés, where one could eat, drink, rest, or participate in witty coversations, and the cafés-

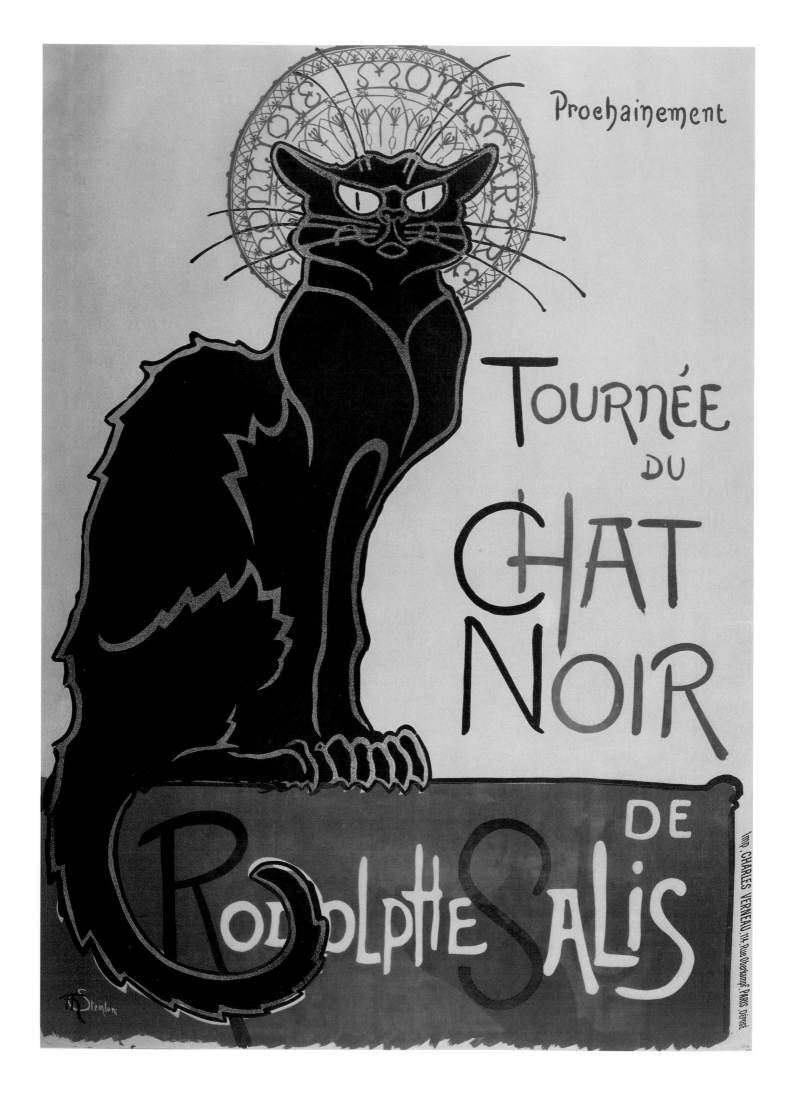

Théophile-Alexandre Steinlen
Tour of the Chat Noir of Rodolphe Salis
(Tournée du Chat Noir de Rodolphe
Salis), 1896
Jane Voorhees Zimmerli Art Museum, Rutgers,
The State University of New Jersey, Gift of Susan
Schimmel Goldstein. 77.050.003
(cat. 120)

*In his posters, Steinlen often turned to less
serious subjects such as commercial prod-
ucts for the home and, more constantly,
the cats he adored. His most striking
poster was the one he designed for Salis's
cabaret, Le Chat Noir. Using a large
black, sinister cat with a drooping tail,
Steinlen added an ambiguous halo in-
scribed: "Mon Joye Montmartre." When
the poster appeared, one writer com-
mented: "The walls of Paris have been
dignified by the presence of this haloed
cat, hieratic, Byzantine, of enormous size,
whose thin fantastic silhouette hangs high
above the crowd in the streets" (quoted in
Abdy, p. 96). Its success can be under-
scored by the many versions of it that
Steinlen made over the years. It was
printed in several sizes with various in-
scriptions to announce the reopening of Le
Chat Noir, advertise summer tours to the
provinces, publicize shadow puppet shows,
and, finally — in an entirely new, slightly
smaller format in 1898 — to announce
the auction of Salis's art collection after
his death and the closing of the city's most
influential cabaret.*

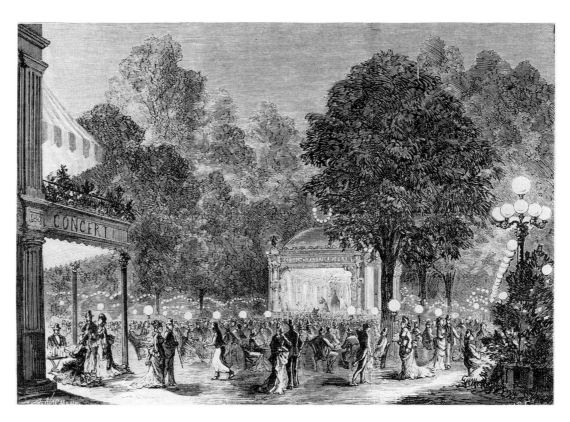

Fig. 1. S.T. after A. Normand, *The Café-Concert des Ambassadeurs on the Champs-Élysées.* Wood engraving. From
L'Illustration, May 29, 1875. National Library of Canada, Ottawa

concerts with their nighttime amusements com-
peted, in turn, with the music halls; of a similar
type but with much more exuberant dancing, the
latter eventually included grander spectacles
such as selective circus and vaudeville acts, com-
mercial ballets, short operettas, and farces. One
of the most celebrated of these casinos was the
Jardin Mabille (cat. 121, 141), where the volup-
tuous cancan and the frenetic *chahut* — "against
which French nature [was] powerless" —
originated. Mark Twain evoked such an evening
at the Mabille: "The dance had begun. . . . I
backed up against the wall of the temple, and
waited. Twenty sets formed, the music struck up,
and then — I placed my hands before my face for
very shame. But I looked through my fingers.
They were dancing the renowned 'Can-can'. . . .
The idea of it is to dance as wildly, as noisily, as
furiously as you can; expose yourself as much as
possible if you are a woman; and kick as high as
you can, no matter which sex you belong to.
There is no word of exaggeration in this."[8] Later,
the Moulin de la Galette and the Moulin Rouge,
made visually famous by Renoir and Toulouse-
Lautrec, became the popular nightspots in
Montmartre, formerly an outlying suburb of

Paris. The Butte Montmartre (Hill of Montmartre)
was incorporated in 1860 into the City of Paris.
Soon it acquired a lasting reputation as a sensa-
tional locale for gaiety and pleasure, where a vis-
itor could indulge himself in a wide variety of ar-
tistic and literary activities.

Another offshoot of these social centers of Pa-
risian life was the cabaret, in which the art of
"miniaturization" was embraced. "The innovators
of the cabaret intended to distill from the vaude-
ville, circus, and music halls their vitality, im-
mediacy, and vivacity; to adopt the rapid alterna-
tion of attractions . . . in order to convey a
rarefied artistic style."[9] One of the most innova-
tive *cabarets artistiques* was Le Chat Noir (The
Black Cat), which opened in 1881 in Montmartre
(cat. 120). Its founder was the painter Rodolphe
Salis, who immediately attracted a following of
poets and artists. In addition to presenting seduc-
tive readings, private concerts, and playlets,
Salis provided witty commentary and encouraged
audience participation. Four years later, he
moved to larger quarters at a nearby location and
arranged a new cabaret where members of the ar-
tistic community and Parisian high society were
regularly in attendance. In an intimate environ-

Benjamin Jean Pierre Henri Rivière
The Théâtre d'Ombres at the Chat Noir Café, ca. 1888
Jane Voorhees Zimmerli Art Museum, Rutgers, The State University of New Jersey, Mindy and Ramon Tublitz Purchase Fund. 1987.0194
(cat. 118)

Emmanuel Caran d'Ache
The Epic (L'épopée), 1888
Jane Voorhees Zimmerli Art Museum, Rutgers, The State University of New Jersey, Gift of Carleton A. Holstrom. 1986.0883
(cat. 113)

In 1881 Le Chat Noir was founded by Rodolphe Salis in Montmartre, where it soon became a rendezvous for important and unusual entertainments, at first, poetry readings and musical recitals. When Salis moved to larger quarters, the cabaret established a reputation for its shadow plays. Henri Rivière was put in charge of these, and forty-three plays were offered from 1886 to 1897. In this small drawing, Rivière reveals the enormous response to these shows, at which Parisian high society joined the habitués, including notable poets, writers, artists, and composers.

Of special interest were the ambitious shadow plays first mounted by the talented artist Henri Rivière. These included the Napoleonic legend L'épopée, which was produced with a combination of zinc cutouts and light effects that anticipated motion pictures. The performances were very popular with all Parisians. This drawing in india ink was probably made as a preparatory study for zinc cutouts.

Benjamin Jean Pierre Henri Rivière
The Sky
(Le ciel), 1887
Jane Voorhees Zimmerli Art Museum, Rutgers,
The State University of New Jersey, Norma B.
Bartman Research Library Fund. 1986.1680
(cat. 114)

Benjamin Jean Pierre Henri Rivière
The Temptation of Saint Anthony
(La tentation de Saint-Antoine), 1887
Jane Voorhees Zimmerli Art Museum, Rutgers,
The State University of New Jersey, Gift of Uni-
versity College, New Brunswick Alumni Associa-
tion. 1986.0081
(cat. 115)

In December 1887 Rivière offered his first shadow-theater play, La tentation de Saint-Antoine, *which was recorded in this small album with stencil-colored images.*

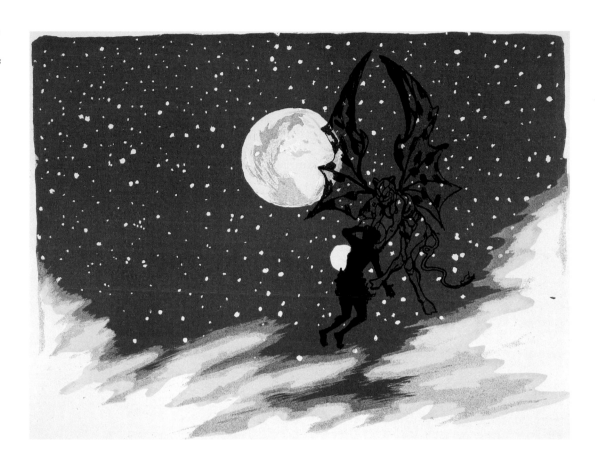

In the early productions of their plays, Rivière and his colleagues used zinc or cardboard cutouts as solid silhouettes, which were moved across or projected against a back-lit screen. These "black and white" plays were soon enhanced by the use of overlapping glass panels and the introduction of color fillers within the cutouts, which created innovative and sophisticated presentations (Boyer, 1988, pp. 54-55). The connection with the motion pictures of the future is readily apparent.

127

George Auriol (Jean-Georges Huyot)
Menu for Le Chat Noir, before 1895
Worcester Art Museum, Worcester, Massachusetts, Eliza S. Paine
Fund. 1990.29
(cat. 112)

When Auriol came to Paris, he was soon employed by Rodolphe Salis as an editor of the Chat Noir *journal, a position that he held for ten years. From 1883 he wrote articles for the paper, and in 1886 his first illustrations appeared. The popularization of Japanese prints influenced Auriol's style, and his designs for many of the Chat Noir cabaret programs reflect these distinct motifs. In this instance, the artist provided a decorative menu that could serve as a memento of the popular establishment.*

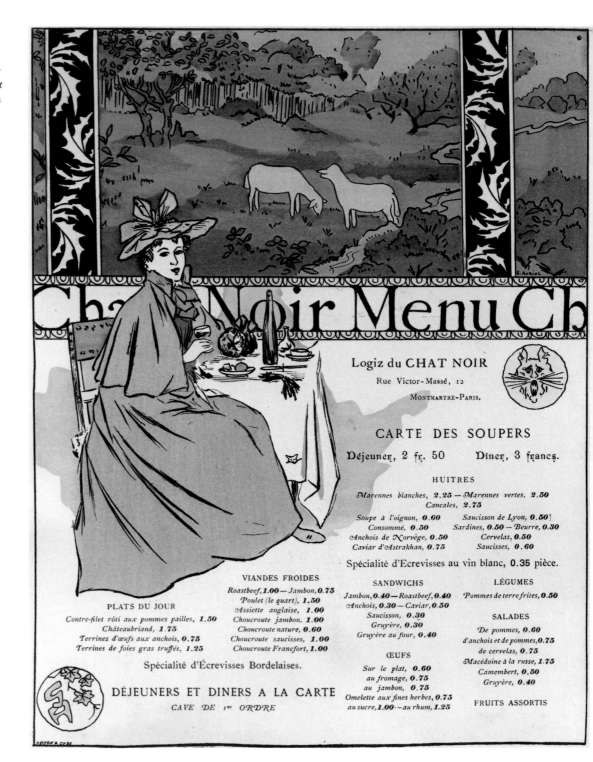

ment, richly but eccentrically decorated, clients were graciously welcomed and treated to unusual performances that ranged from dramatic to comic readings. Less than a year after it opened, the cabaret began a weekly journal, also called *Le Chat Noir*, which consisted of a few pages of literary compositions by notable writers and poets and artwork by prominent illustrators. By 1889 the cabaret was a landmark in Montmartre, mentioned in the guidebooks and recommended for its ambience and talent. Nevertheless, like most of the cafés-concerts and cabarets whose reputations faltered, Le Chat Noir, an exceptional representative for its time of innovative programs and bohemian gaiety, could not survive the death of its founder and closed its doors in 1897, sixteen years after its inauguration.

Not insignificant among the pleasures of Paris were the brothels, which served as meeting places for every social class. They were regarded as variations of the brasseries and cafés, where prostitutes frequently searched for clients. To seek such a convivial environment outside marriage was considered a natural way of life for Parisian husbands and an ordinary privilege for men who were unmarried. The writer Guy de Maupaussant described a brothel as a place of relaxation where respectable businessmen and young men met regularly, just as in a café, and where the Madame was treated with respect.[10] These establishments were accepted by the public and controlled by government regulations according to which prostitutes were registered and monitored. In 1869 there were an estimated thirty-five thousand prostitutes; this figure did not include those who worked clandestinely, such as milliner's assistants, seamstresses, shop girls, and waitresses who were often forced to supplement their pathetically low wages.[11]

As places of entertainment, bordellos were certainly not novel, and as a clearly acceptable way of life they provided contemporary models for the avant-garde artists of the Third Republic. Degas, Forain, Toulouse-Lautrec, as well as Émile Bernard (cat. 124-127) made studies of this milieu. Using the monotype medium, Degas painted images of the prostitutes' domain (cat. 133-135), private views of "workers" in anonymous salons. Toulouse-Lautrec, who resided for a time in an elegantly decorated brothel, produced a portfolio of ten color lithographs that gave pictorial form to the daily routine of the bordello's inhabitants instead of to their sexual intentions (cat. 174, 175).

Within this *demi-monde*, there was a hierarchy that ranged from the begging prostitutes, to the *grisettes*, often young, hard-working clerks who were the mistresses of students or workmen, to the *lorettes*, women of easy virtue with greater demands for luxury, who were often "dazzlingly, voluptuously, miraculously dressed"; more than a few of these became sought-after courtesans who "rose" in their profession. Though not accepted in high society, these women were an undisputed part of the Paris scene. Their world was a source of fascination and inspiration to the artists; see, for example, SEM's depiction of the dining room at Maxim's, a favorite place for prostitutes to find their clientele (cat. 154). Many of the modern writers such as Zola, Huysmans, Maupassant, and the Goncourt brothers joined the artists in presenting a searching view of this segment of French society, recognizing the appeal such subjects held for the entire population.

With exceptions at both ends of the spectrum — the very wealthy who frequented their own clubs and private evening events and those on the poverty line who could not afford the costs of admission or a drink — all classes of Parisian society freely gathered at the cafés, cafés-concerts, and cabarets, which served as democratic pleasure institutions.

Notes

1. Richard Kaufmann, *Paris of To-day*, trans. from the Danish by Olga Flinch (New York, 1891), p. 84. (Originally published in 1889.)

2. Quoted in Charles Rearick, *Pleasures of the Belle Époque: Entertainment and Festivity in Turn-of-the-Century France* (New Haven, 1985), p. 40.

3. James D. McCabe, Jr., *Paris by Sunlight and Gaslight* (Philadelphia, 1869), p. 75.

4. Michael Shapiro, "Degas and the Siamese Twins of the Café-Concert: The Ambassadeurs and The Alcazar d'Été," *Gazette des Beaux-Arts 95* (April 1980), p. 154.

5. Quoted in Douglas Druick and Peter Zegers, "Degas and the Printed Image, 1856-1914," in Sue Welsh Reed and Barbara Stern Shapiro, *Edgar Degas: The Painter as Printmaker*, exhib. cat. (Boston: Museum of Fine Arts, 1984), p. xlvii.

6. For a discussions of the female types in the cafés, see Theresa Ann Gronberg, "Femmes de Brasserie," *Art History* 7 (Sept. 1984), pp. 329-344.

7. Edmond and Jules de Goncourt, *Journal: Mémoires de la Vie Littéraire*, vol. 2, 1866-1886 (Paris, 1989), p. 707.

8. Mark Twain [pseud.], *The Innocents Abroad* (Hartford, 1870), pp. 135-136.

9. Laurence Senelick, *Cabaret Performance*, vol. 1: *Europe 1890-1920* (New York, 1989), p. 8.

10. As related in Theodore Zeldin, *France 1848-1945: Ambition and Love* (Oxford, 1979), p. 309.

11. Gronberg, "Femmes de Brasserie," p. 331.

Winslow Homer
*A Parisian Ball — Dancing at the
Mabille, Paris,* 1867
Museum of Fine Arts, Boston, Gift of Edward J.
Holmes. 30.934
(cat. 141)

**Anonymous Photographer, French,
19th century**
Jardin Mabille, 1870s
Museum of Fine Arts, Boston, Charles Amos
Cummings Fund. 1979.214
(cat. 121)

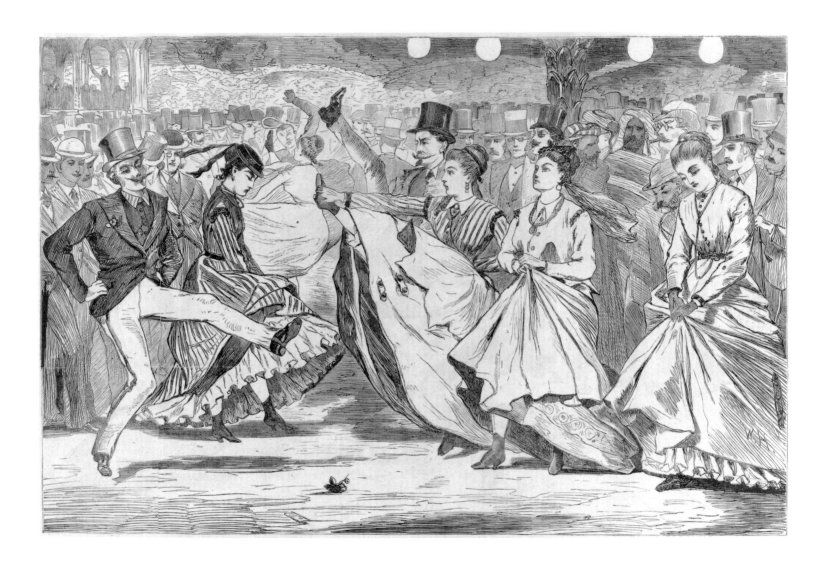

*When Homer made this print, the Mabille was a noted
rendezvous for the lorettes of the city. These women of
the evening considered themselves to be the better mem-
bers of their class and came to the Mabille to form new
acquaintances. The participants who jumped into the
dancers' circle to perform the cancan with lusty abandon
were usually professional dancers whose passion and en-
ergy could not be matched by any amateur. According
to the American traveler James McCabe, "whatever you
may see at Mabille, you will hardly find respectable wo-
men here, unless they come under the cover of their
masks, and you may safely assume that there is not a
lady in the entire assembly" (McCabe, pp. 706-707). He
admitted, however, that the "the crowd [was] merry, and
the halls [resounded] with laughter."*

*One of the most popular dance halls in Paris, the Jardin
Mabille was founded in 1844 by a professor of dance of
the same name. For thirty years it was the principal
place in the city for exuberant dancing and attracted
numerous foreign visitors. A long entry lighted with gas
lamps led to the central dance floor, which was sur-
rounded by an extraordinary forest of palm trees made
of zinc. The Jardin Mabille eventually fell out of favor
and closed in the late 1870s. The land was sold, and
the building was demolished in 1882.*

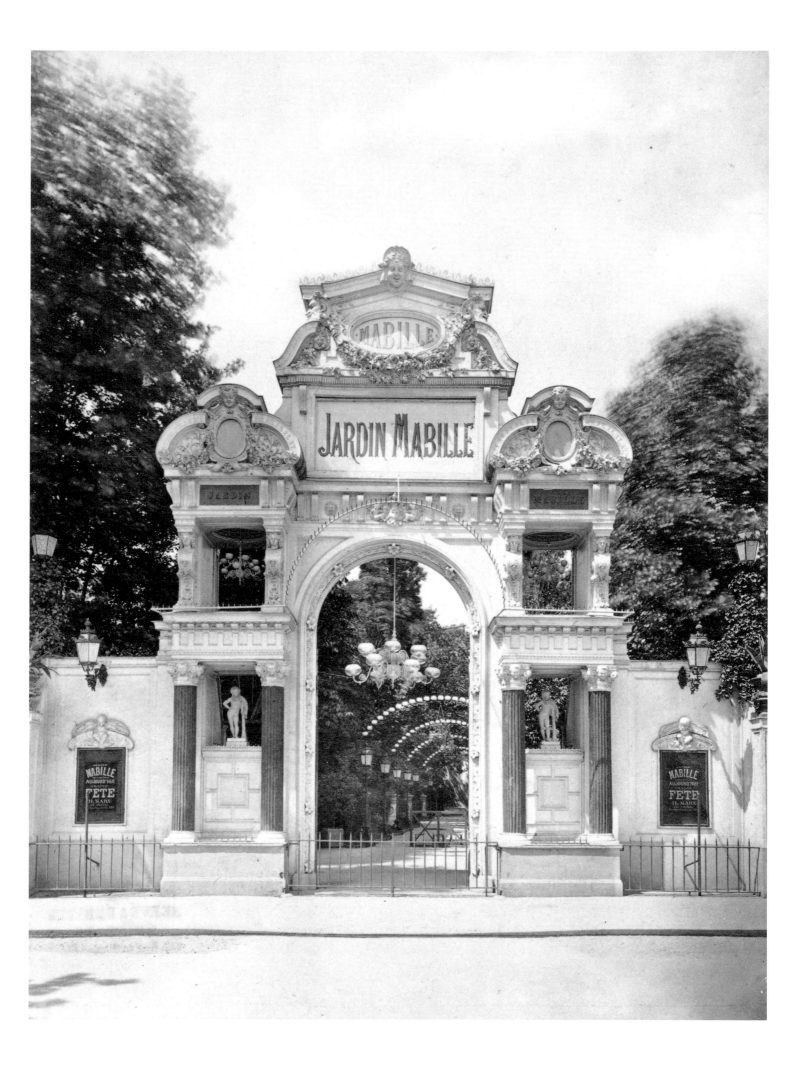

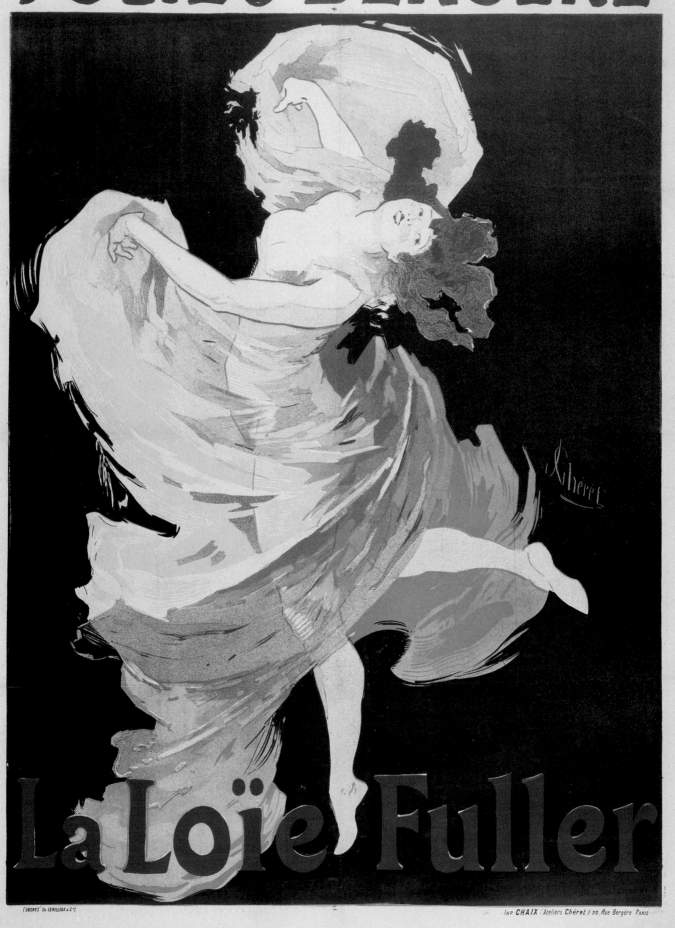

Jules Chéret
Folies-Bergère — La Loïe Fuller, 1893
Barbara and Ralph Voorhees
(cat. 130)

Jean-Louis Forain
Bar at the Folies-Bergère (Le bar aux Folies-Bergère),
1878
The Brooklyn Museum, Gift of Frank Bell Babbott. 20.667
(cat. 137)

The Illinois-born dancer Loie Fuller had always dreamed of performing in Paris, and in November 1892 she made her debut at the Folies-Bergère. Chéret designed her first poster, and his airy figures were perfectly suited to the dancer's routines; his swirling curves imitated the gestures of Loie Fuller in motion. Wands attached to her garments allowed her to manipulate the yards of veils with great freedom. To capture the rainbow of color that she achieved with multiple light effects, Chéret printed this poster in four color combinations. The first performer to institute afternoon programs, Loie Fuller was considered the "Fairy of Light" by the mothers and children who came to applaud.

Recent research has proved that this small but informative gouache is a particular view of the Folies-Bergère. Although its inscription reads "Siri," it probably means "Sari," the name of the director of the Folies at this time. Forain has shown a young barmaid who stands before a compote of fruit, a bar with bottles, and diverse objects. Her back, along with the theater, its balconies, and spectators, is reflected in a mirror placed above the banquettes. During this period when the music hall was enjoying great popularity, it was common to employ a population of barmaids who took the place of male waiters. They served not only to encourage drinking but also to provide sexual favors. Forain's precise statement anticipates Manet's great work A Bar at the Folies-Bergère of 1882 (see p. 14, fig. 3).

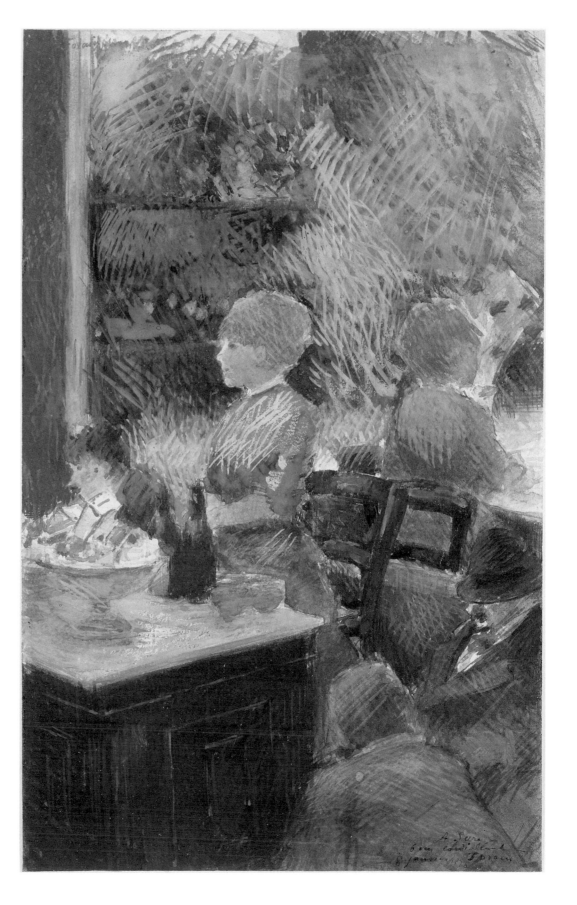

133

Henri de Toulouse-Lautrec
Loie Fuller, 1893 (detail)
Courtesy of the Boston Public Library, Print Department, Gift of
Albert H. Wiggin
(cat. 165)

Henri de Toulouse-Lautrec
Loie Fuller, 1893
Museum of Fine Arts, Boston, Bequest of W. G. Russell Allen.
60.761
(cat. 166)

*Loie Fuller may have chosen not to have
Lautrec design a poster for her because of
this small colored lithograph in which the
dancer is essentially unrecognizable. She
appears to be suspended in space, not in
control of the voluminous veils that make
her airborne. Nevertheless, Lautrec has
captured her remarkable floating move-
ments as well as the changing light effects
that Fuller achieved by using glass plates,
large lantern projectors, colored gelatins,
and other inventive devices. Lautrec
printed each impression of the lithograph
with slightly different colored inks that imi-
tated the variations of lighting. Fuller's
ingenious* spectacle optique *met with
lasting acclaim, and she was a long-
standing sensation in Paris.*

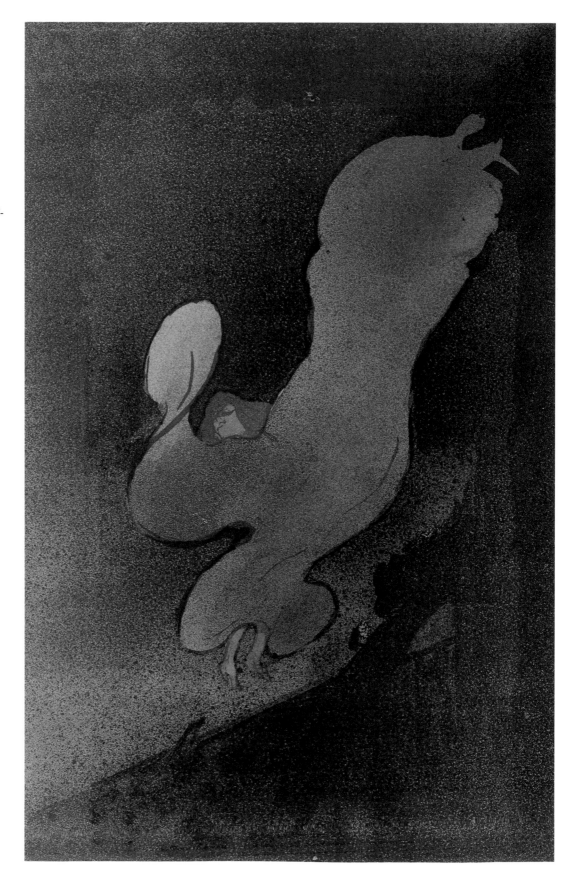

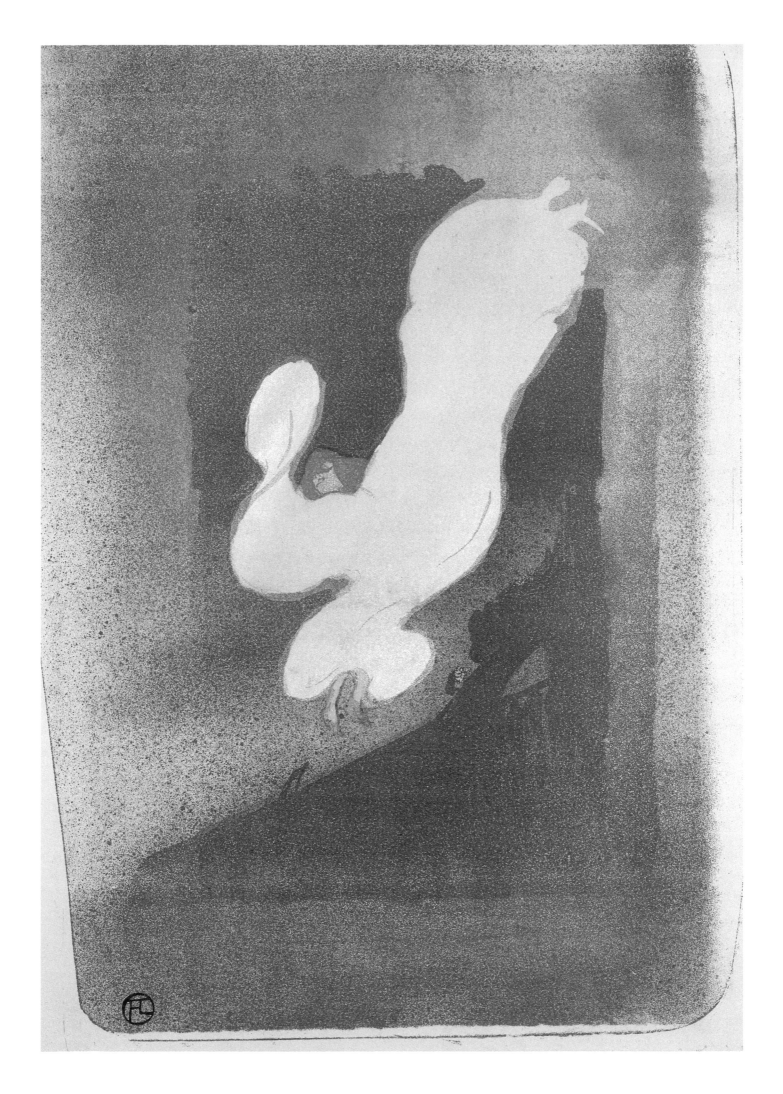

Emmanuel-Joseph-Raphaël Orazi
Loie Fuller, 1900
Harvard Theatre Collection. HTC ACC76-77.001
(cat. 146)

*For the 1900 Universal Exposition, Loie
Fuller, the dancer with veils, was permit-
ted to have her own pavilion. It was com-
pletely dedicated to her image and rou-
tines and designed with Art Nouveau
flourishes; it became a magical center for
her "danses lumineuses." The artist's
poster is a tribute to the floating image of
light and stars that Loie Fuller created
with each enchanting performance. Orazi
has also captured the rich coloring, orna-
mental flowers, and swirling effects that
were characteristic of her art and style.
Fuller was enormously popular and fre-
quently copied. She even applied for pat-
ents to protect the unusual costume de-
signs and creative lighting devices that
she invented for her productions.*

Facing page:

Jules Chéret
Ball at the Moulin Rouge (Bal du Moulin
Rouge), 1889
Jane Voorhees Zimmerli Art Museum, Rutgers,
The State University of New Jersey, Museum
Purchase. 74.016.001
(cat. 129)

*The first poster for the Moulin Rouge was
executed by Chéret in 1889. In a lively,
eye-catching format, he included all the
notable aspects of the music hall. His
nymphlike young women, later dubbed
"Chérettes," sit astride donkeys that were
provided by the proprietors to give rides to
their female clientele; this practice was
part of the entertainment in the summer
garden adjacent to the dance floor. The
popular poster was printed in several sizes
and was reissued in 1892. It proved to be
a challenge for Toulouse-Lautrec when he
was commissioned to prepare a new poster
to replace those by Chéret.*

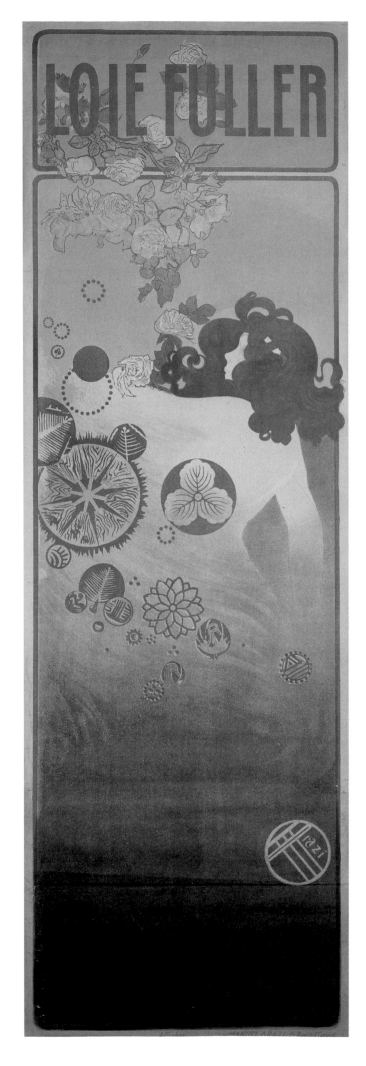

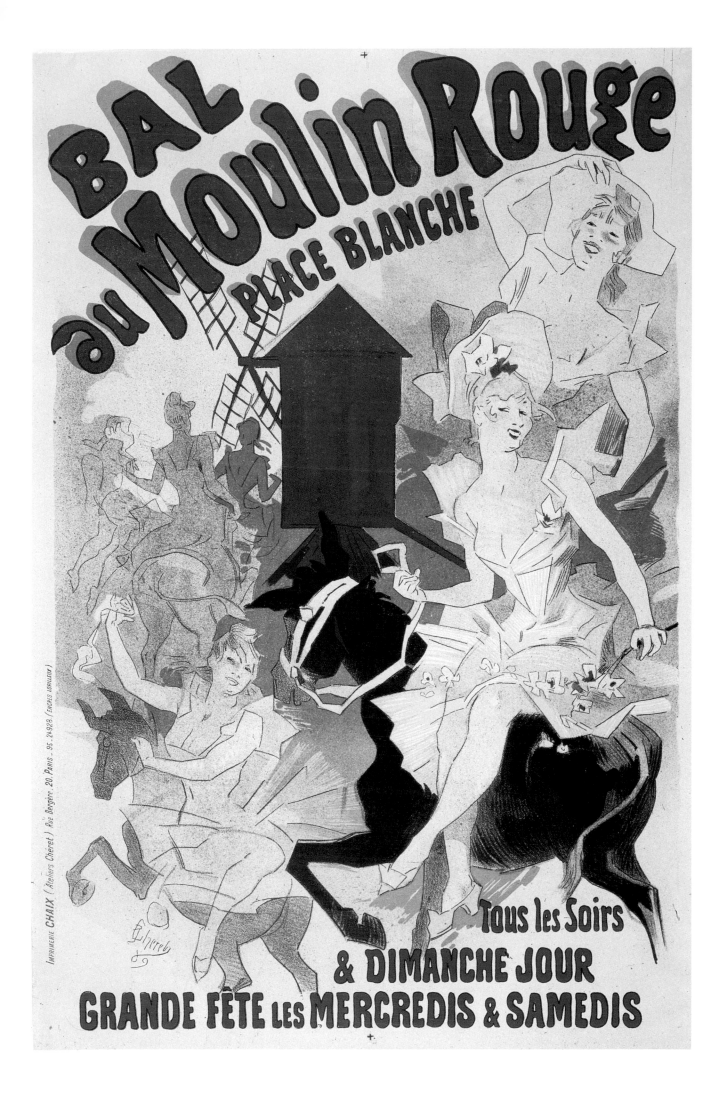

Louis Anquetin
The Dance at the Moulin Rouge
(La danse au Moulin Rouge), ca. 1893
Josefowitz Collection
(cat. 122)

Henri de Toulouse-Lautrec
Jane Avril, 1893
The Metropolitan Museum of Art, Harris Brisbane Dick Fund,
1932. 32.88.15
(cat. 168)

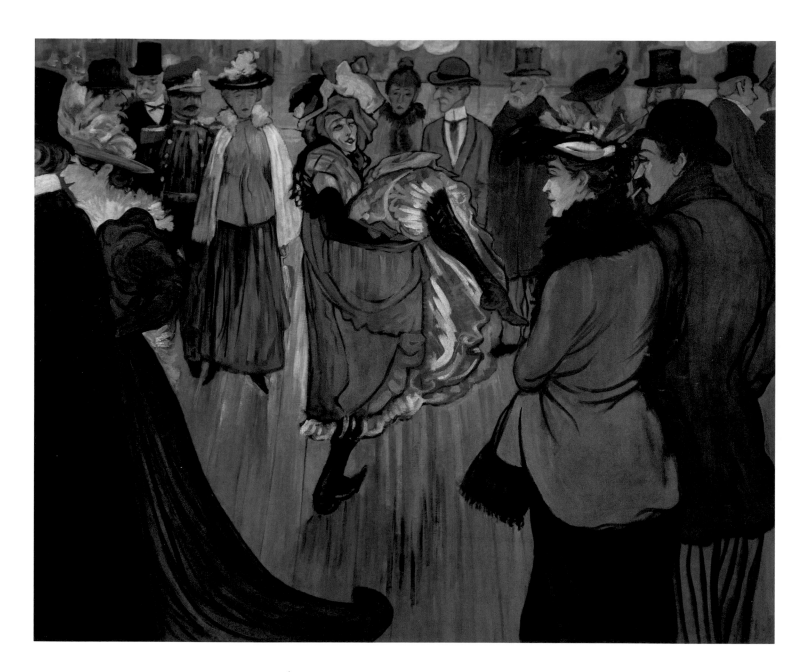

When the Moulin Rouge dance hall opened its doors in 1889, it provided a mine of imagery for its artist neighbors who lived in Montmartre. In the same year, Toulouse-Lautrec completed a large canvas of dancers performing, and in 1893 Anquetin consciously imitated its essential composition. He substituted Lautrec's central image with a portrait of Jane Avril "high-kicking" (see cat. 168). Whether these "quotations" were made by Anquetin in tribute to his colleague or as a purposely amusing parody is debatable (Welsh-Ovcharov, p. 86). Though predominantly a successful dance hall, the Moulin Rouge was also a center of amusement for all classes. Nonetheless, it routinely catered to the fashionable, here caricatured by Anquetin as they encircle the dancer and soberly observe her antics.

Jane Avril, the daughter of a demi-mondaine and an Italian count, began her dancing career at the Moulin Rouge in 1889. She commissioned this poster in 1893 to advertise her performance at the café-concert Jardin de Paris, located on the Champs-Élysées. The poster's design is one of Lautrec's most inventive: the cleverly distorted figure of a musician is shown with his double bass, parts of which encircle the dancer. When Jane Avril made her reappearance after two years of retirement, Lautrec's poster put her in the limelight. She danced like a "shy bird or tremulous flower," her admirers claimed. Here, isolated by the frame, she indeed seems nervous and fragile.

138

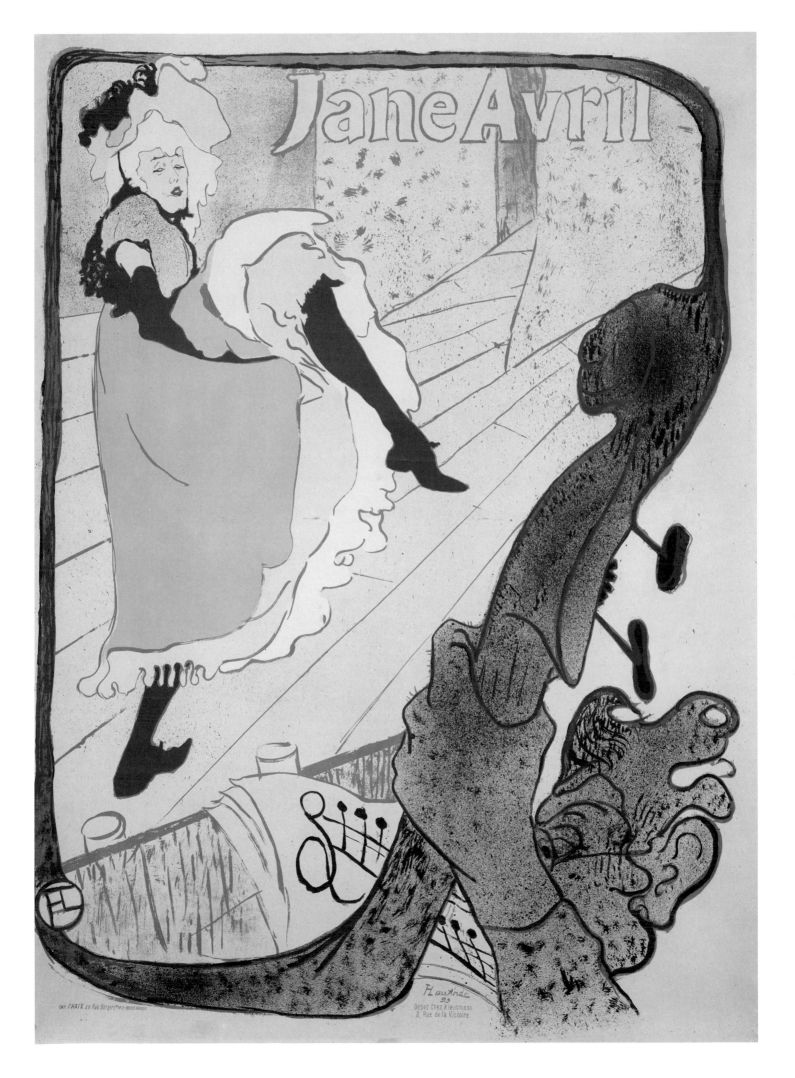

Henri de Toulouse Lautrec
Jane Avril, 1893
Museum of Fine Arts, Boston, Bequest of W. G. Russell Allen.
60.750
(cat. 164)

Henri de Toulouse-Lautrec
Moulin Rouge — La Goulue, 1891
Collection of Mr. and Mrs. Jack Rennert, New
York
(cat. 160)

In this first print in the album Le Café-
concert, *Lautrec represented the cele-
brated performer by her characteristically
swirling skirts and rapid, dainty feet.
Jane Avril made her debut in 1889 at the
Moulin Rouge, where her animated danc-
ing technique brought her quick fame.
With a combination of frenzied movements
and childlike costume, she gave an en-
gaging impression of both worldliness and
innocence. The swirl of her skirt and the
precise steps of her little black feet against
the diagonal floorboards enhance the diz-
zying intensity of her dance. She is shown
here performing at the Moulin Rouge,
identifiable by its lamp depicted in the
background. The* Café-concert *portfolio
pictured the most famous performers of the
day and was published as part of a trend
in popular loose-leaf picture albums made
for the middle-class market.*

Facing page:

*Charles Zidler, the manager of the Mou-
lin Rouge, commissioned Toulouse-Lau-
trec to design a poster for the 1891 au-
tumn season. Chéret had already made
posters for the music hall (cat. 129), and
this was Lautrec's first exploration of the
lithographic medium. The effect of sponta-
neity in the finished work was, in reality,
the result of several preliminary drawings.
The artist has captured the essence of the
music hall by repeating the title three
times to produce an impact and by mak-
ing the central characters easily recogniz-
able. La Goulue (the Glutton), known for
her high spirits, purposefully kicks up her
heels, revealing flesh and underclothes.
Valentin le Désossé (the Boneless One) was
incredibly loose-limbed and projected a
disjointed profile. The black silhouettes of
the background audience were in imita-
tion of the figures that paraded across the
screen of the popular shadow plays. Lau-
trec's poster enhanced the reputation of
this main tourist attraction.*

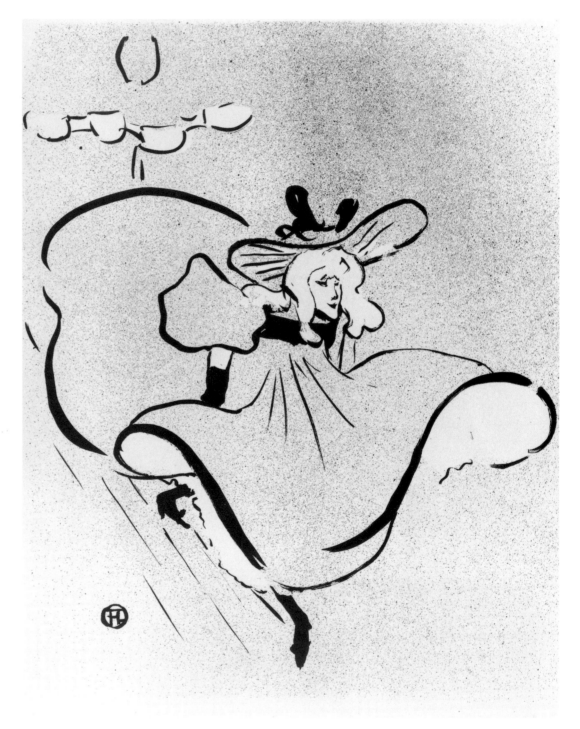

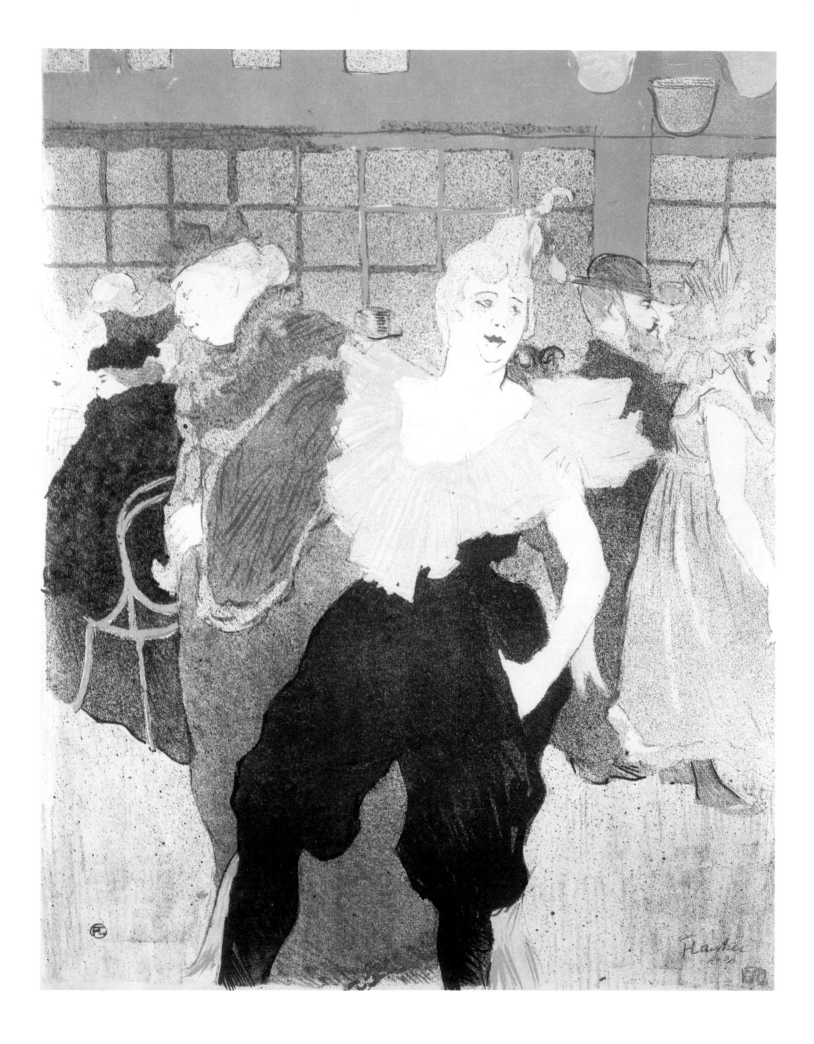

Henri de Toulouse-Lautrec
Dancing at the Moulin Rouge
(La danse au Moulin Rouge), 1897
Sterling and Francine Clark Art Institute,
Williamstown, Massachusetts. 62.119
(cat. 177)

Henri de Toulouse-Lautrec
The Clowness at the Moulin Rouge
(La clownesse au Moulin Rouge), 1897
Museum of Fine Arts, Boston, Bequest of
W. G. Russell Allen. 60.767
(cat. 176)

*Cha-u-ka-o, whose name was an exotic
shortening of* chahut-chaos, *a wild ver-
sion of the cancan, was a well-known
clown and acrobat who performed at the
Moulin Rouge and the Nouveau Cirque.
A member of the lesbian community, she
fascinated Lautrec, as did many others
from the cabaret scene with their uncon-
ventional lifestyles.*

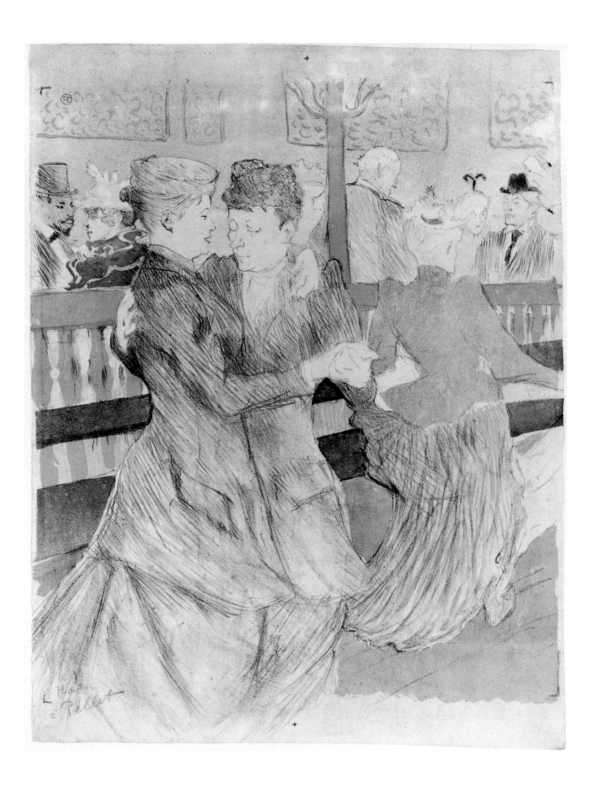

Pierre Auguste Renoir
Dance at Bougival
(Bal à Bougival), 1883
Museum of Fine Arts, Boston, Picture Fund.
37.375
(cat. 152)

*It seems as if Renoir extracted a dancing
couple from his lively painting of 1876,*
Ball at the Moulin de la Galette *(see p.
14, fig. 2), and focused his attention on
the dancers' pleasure while their crowd of
friends remain more obscurely in the
background. The theme of couples danc-
ing attracted Renoir's interest in the sum-
mer of 1882, and by the spring of 1883 he
had completed three large paintings of
this subject. An easily reached community
near Paris, Bougival, like other neighbor-
ing villages, catered to the working class,
who traveled there on Sundays and vaca-
tions for recreation and leisure. Renoir's
brother Edmond, who wrote an article on
the artist's work, alluded to Bougival as
"quite select and expensive, and girls go
there without particular expectations." Al-
though the painter was opposed to a nar-
rative interpretation of his works, he in-
scribed on a related drawing: "She was
waltzing, deliciously abandoned in the
arms of a fair-haired man with the air of
an oarsman." It is probable that these
words illustrated a passage of a short
story by a friend (Renoir, 1985, p. 236);
but the connection to this painting is an
appropriate one. The more informal set-
ting and costumes, with the exception of a
few men in top hats, suggest an outing
rather than a "dress-up" Sunday in
Montmartre. The bouquet of violets that
have dropped to the ground, the stamped-
out cigarettes and discarded matches con-
tribute to the air of relaxation.*

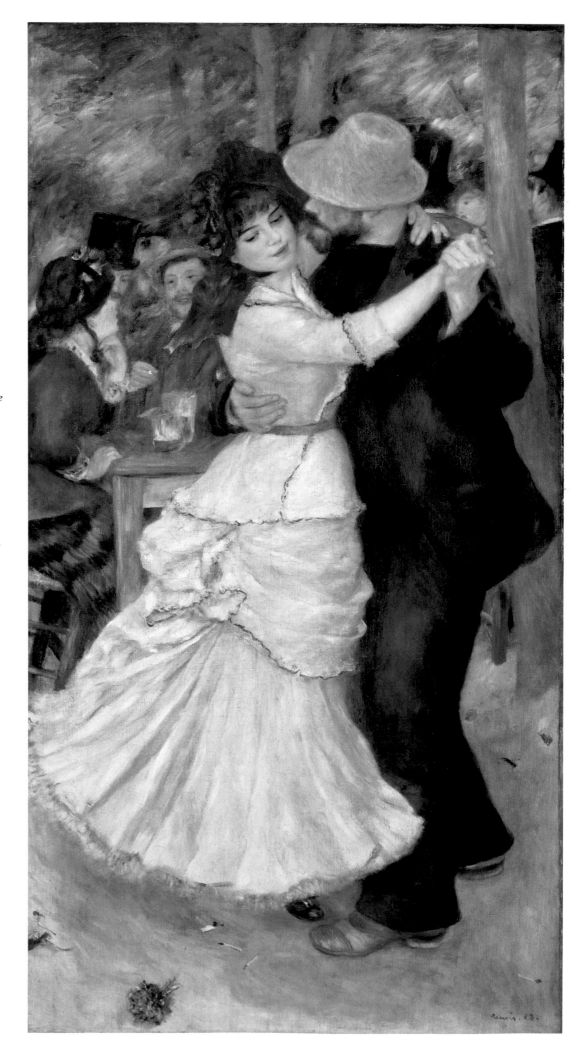

Théophile-Alexandre Steinlen
A Chahuteuse at a Café-Concert, 1893
The Metropolitan Museum of Art, Robert Lehman Collection,
1975. 1975.1.730
(cat. 155)

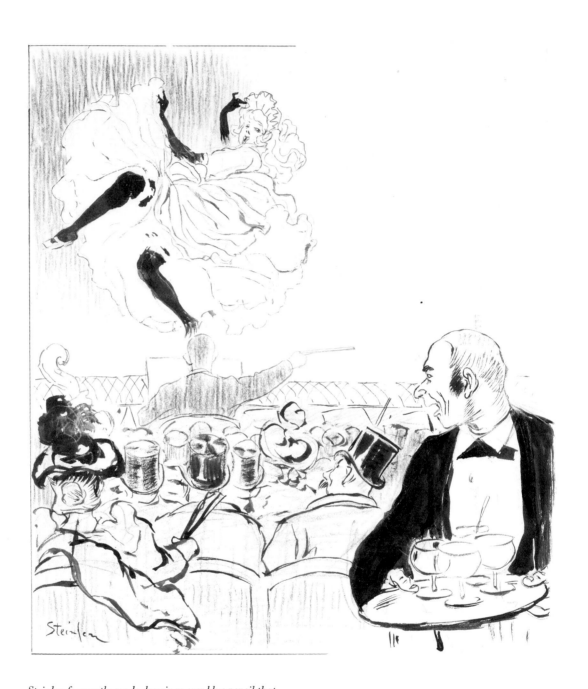

*Steinlen frequently made drawings over blue pencil that
were intended for transfer; this study was printed on the
cover of* Le Mirliton *for February 17, 1893. Sponsored
by Aristide Bruant, the journal appeared twice monthly
and publicized his cabaret. It generally carried an illus-
tration, some poems, and always a collection of songs
written by Bruant that became quite popular in French
society. In this drawing an especially high-kicking
dancer performs the* chahut, *a frenetic version of the
cancan. The waiter responds enthusiastically to the per-
formance while the audience, a range of social types,
finds it very seductive.*

Alfred Henry Maurer
Le bal Bullier, ca. 1904
Smith College Museum of Art, Northampton,
Massachusetts, Purchased, 1951. 1951:283
(cat. 145)

Jules Chéret
Frascati, 1874
Jane Voorhees Zimmerli Art Museum, Rutgers,
The State University of New Jersey, Class of 1937
Art Purchase Fund. 82.053.001
(cat. 128)

The Bullier, a large salon that was named after its owner at one time, accommodated several thousand visitors. It was primarily known as a dancing place for the students of the Left Bank who congregated, as they do today, near the Boulevard Saint Michel. By the 1890s the crowds of students were joined by clerks and shop girls, who made the Bullier one of the favored pleasure centers for these diverse groups. By the time Maurer made his painting, however, the hall had lost much of its splendor and reputation.

One of Chéret's earliest posters, made before he had established his recognizable style of "floating" women in diaphanous gowns, this design shows the dance and concert hall Frascati, founded in 1873 as an attractive arena for masked balls. Under the disguise of masks and costumes, the sharp distinctions between the classes of the revelers were erased. It is possible that Chéret was acquainted with Manet's well-known and admirable painting Masked Ball at the Opéra, *completed in late 1873. The horizontal organization of the compositions, an attention to two architectural levels, and the cast of characters, which includes some* demi-mondaines *and costumed Pierrot figures, reveal a provocative resemblance. Manet concentrated on the densely packed lobby or corridor of the old Opéra house and indicated the balcony only partially. Chéret, however, focused his attention on the balcony, with its groups of lively participants and the crowded dance floor beyond. Manet recorded an evening with a mysterious mixture of refinement and explicit sensuality, whereas Chéret emphasized the advertisement of the Frascati, giving predominance to the large letters of its name. After six years the hall was taken over by an association of artists, writers, and composers who converted it into an all-purpose recreation center (Cate, ed., p. 33).*

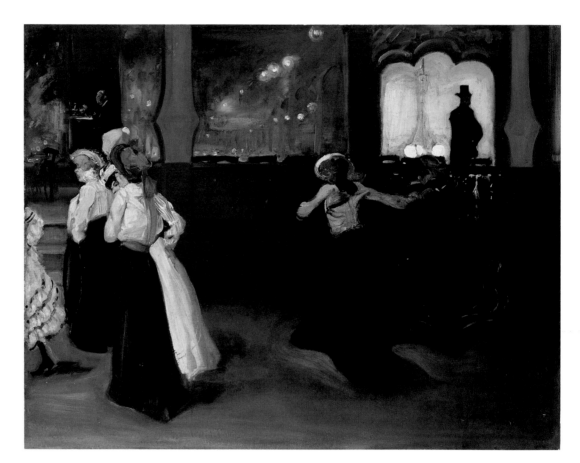

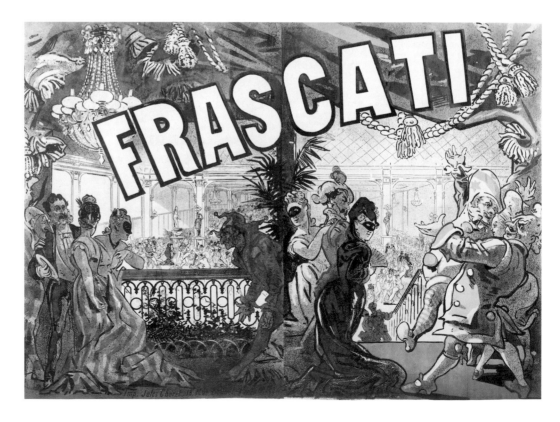

Théophile-Alexandre Steinlen
Fins de Siècle: Monologue par Aristide Bruant, 1894-1895
Arthur and Charlotte Vershbow, Boston
(cat. 157)

Aristide Bruant presided over the evening entertainments at his café in Montmartre, Le Mirliton (The Reed Pipe) and was known for his noisy, energetic, and shocking performances. Steinlen has depicted Bruant delivering a song from atop a long table, much to the amusement of the neighborhood customers who frequented his café. Bruant used the term fins de siècle *to describe the rich bourgeoisie and their most decadent characteristics. A frequent visitor was the distinctive man in the center of the image, wearing a monocle: Maurice Barrès. A writer and right-wing politician, he published articles against Alfred Dreyfus that contributed mightily to the polarization of opinion of the French people. This drawing, one of two versions, was reproduced on page 5 of the journal* Le Gil Blas illustré, *February 24, 1895, a literary supplement to the newspaper* Le Gil Blas.

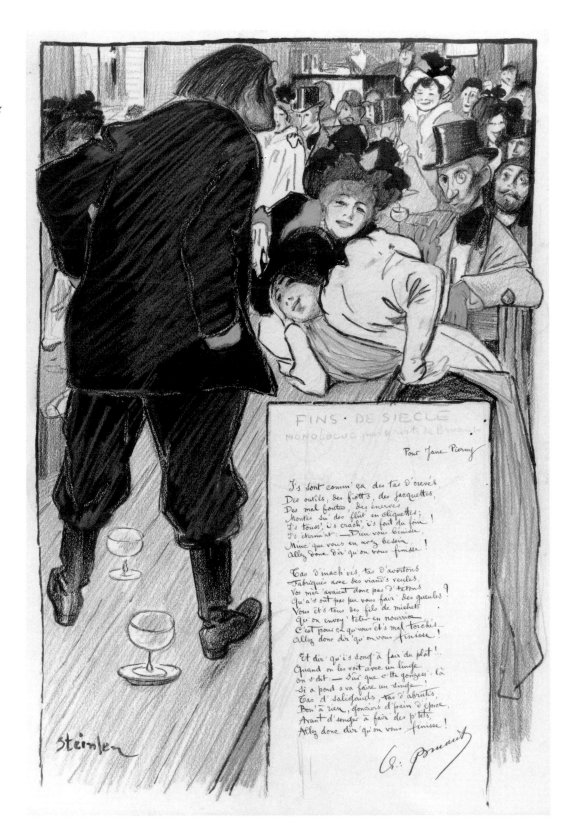

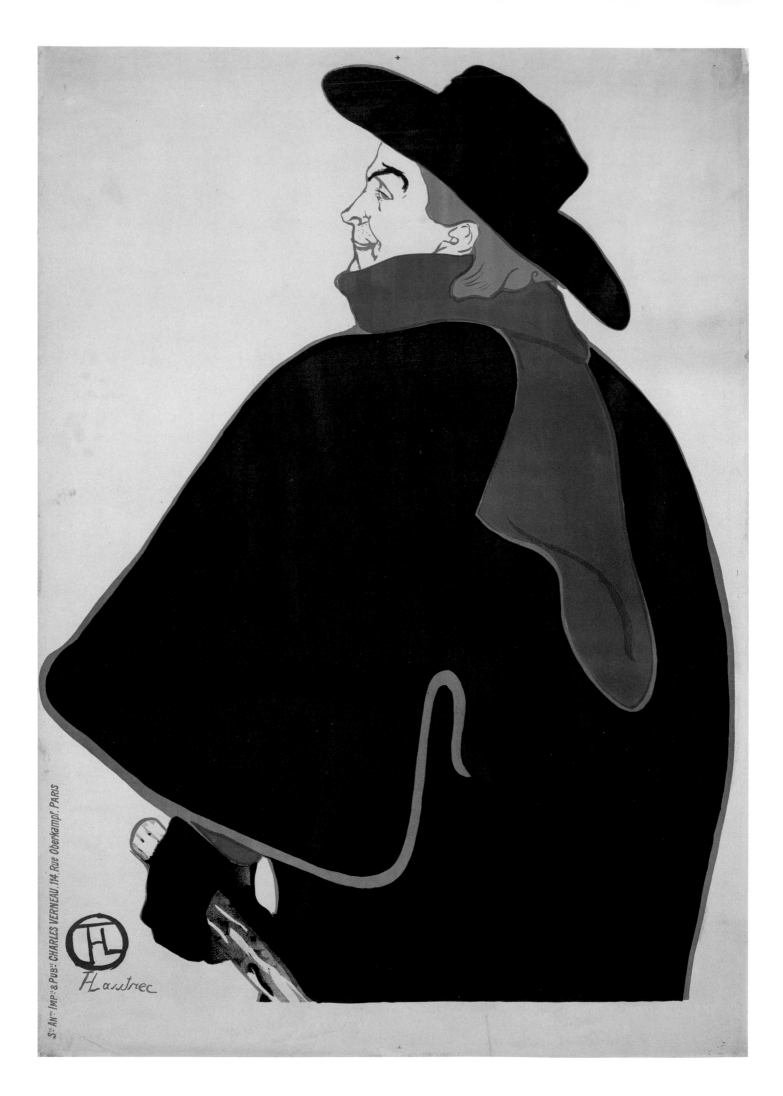

Lautrec

Henri de Toulouse-Lautrec
Aristide Bruant in His Cabaret
(Aristide Bruant, dans son cabaret), 1893
Museum of Fine Arts, Boston, Otis Norcross
Fund. 56.1190
(cat. 169)

Pablo Picasso
Stuffed Shirts (Les plastrons), 1901
Museum of Fine Arts, Boston, Gift of Julia Appleton Bird.
1970.475
(cat. 148)

When the cabaret Le Chat Noir moved from its first location, one of its performers, Aristide Bruant, remained and became the proprietor of his own cabaret. Bruant made only a few changes in the decor and continued with his acerbic repartee and songs that he composed and interpreted for a growing audience (see cat. 157). Although his running commentary was often vulgar and caustic, he attracted a wide audience that cut across the social classes. The working people considered his jibes at those above them both hilarious and just; yet Bruant reserved Friday evenings for the smart and well-to-do, who found his uniquely insulting performances very thrilling. Bruant chose to have Toulouse-Lautrec design his posters, and this striking lithograph conveys the impresario's forceful image. Lautrec used simplified blocks of color to describe the familiar costume of this powerful man, who wore a black outfit with high boots, a broad-brimmed hat, and a long, distinctive red scarf that he kept on even in warm weather. His appearance was so individualistic that when another performer appeared in a similar outfit, Bruant went to court to copyright his costume.

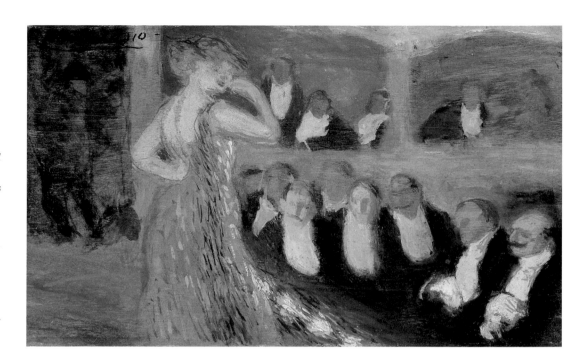

During his second trip to Paris in 1901, the young Picasso frequented the cafés and music halls of Montmartre. In the pastel (see frontispiece) and the small oil painting Stuffed Shirts, *he captured the seductive chanteuses who entertained nightly the predominantly male audiences. In the painting, the position of the singer's hand behind her back and the exclusively male audience suggest that she may be preparing to perform a "striptease." This form of entertainment originated in the 1890s and became immensely popular.*

149

Henri de Toulouse-Lautrec
Yvette Guilbert Taking a Curtain Call
(Yvette Guilbert saluant), 1894
Museum of Art, Rhode Island School of Design,
Providence, Rhode Island, Gift of Mrs. Murray S.
Danforth. 35.540
(cat.171)

*In 1894 Lautrec collaborated with the so-
cialist art critic Gustave Geffroy to produce
an album on the celebrated* diseuse *Yvette
Guilbert. Lautrec's sixteen lithographs
were designed as marginal illustrations to
accompany Geffroy's discussion of the Paris
cafés-concerts. This drawing is a prelimi-
nary study for the last of Lautrec's sixteen
illustrations.*

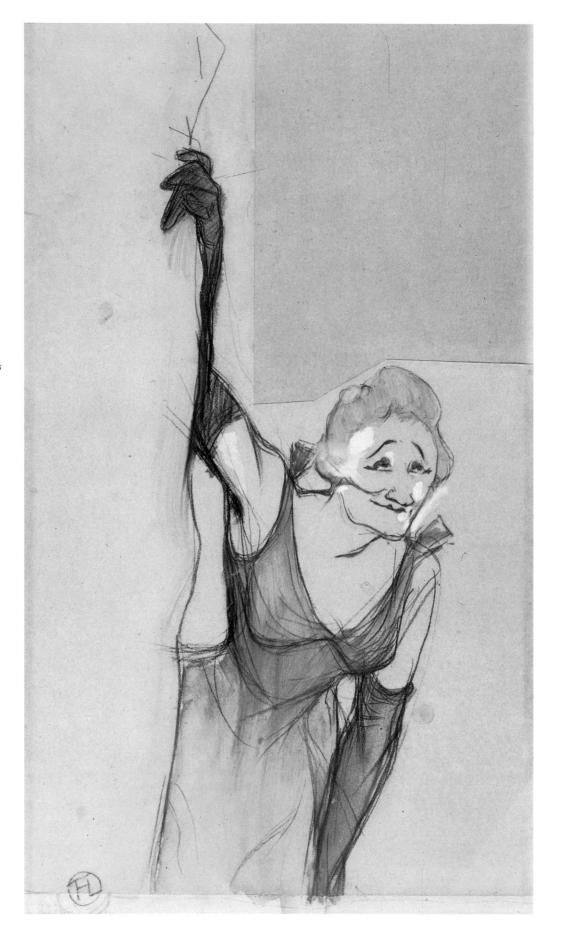

Pablo Picasso
Jardin [de] Paris: Design for a Poster, 1901
The Metropolitan Museum of Art, Gift of Raymonde Paul, in
memory of her brother, C. Michael Paul, 1982. 1982.179.17
(cat. 149)

Picasso joined artists such as Toulouse-
Lautrec, Bonnard, and Steinlen in mak-
ing drawings for poster designs. This
watercolor, typical of the animated works
produced during his early visits to Paris in
1901, apparently did not result in a poster
commission. Nevertheless, the artist has
conveyed the most popular form of en-
tertainment for which this select music
hall was recognized: women dancing the
cancan or singing songs. Located on the
Right Bank in the Élysées district, the
Jardin de Paris, a summer branch of the
Moulin Rouge, catered to a smart clien-
tele who enjoyed lively, high-kicking
dancing without vulgarity. Its beautiful
outdoor setting became a natural meeting
place for the elite of Paris. Picasso's hu-
morous depiction of dancers here as well
as other works of similar subject matter
chronicle the young Spanish artist's dis-
covery of Parisian pleasures. These visual
observations marked the beginning of Pi-
casso's lifelong interest in theatrical enter-
tainments, which included the circus, the
music hall, and any other performances
on a stage.

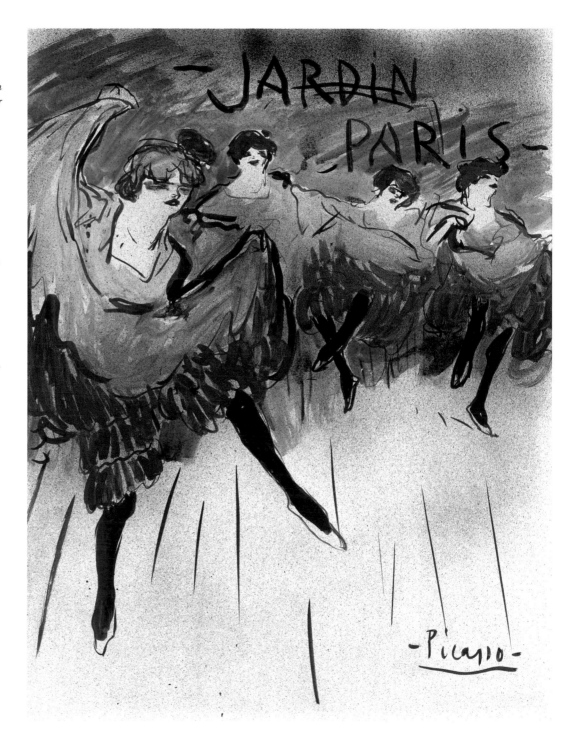

Hilaire Germain Edgar Degas
Mlle Bécat at the Café des Ambassadeurs,
1877-1878
Museum of Fine Arts, Boston, Bequest of W. G.
Russell Allen. 60.258
(cat. 132)

Théophile-Alexandre Steinlen
Yvette Guilbert, 1896
Sterling and Francine Clark Art Institute, Williamstown, Massachusetts. No. 1842
(cat. 158)

A star performer at the Ambassadeurs, Mlle Émélie Bécat had an energetic singing style that was vividly depicted by Degas in this lithograph. He also fully recorded her environment, including the striking light effects in all their forms: a large gas lamppost, a cluster of gas globes, and a string of lights reflected — along with a prominent hanging chandelier — in the mirror at left. Even the moon shines through the trees on the Champs-Élysées, while fireworks send down streamers of light. Frequented chiefly by the working and middle classes, these popular cafés-concerts also appealed to members of high society, who came to observe the lively scene.

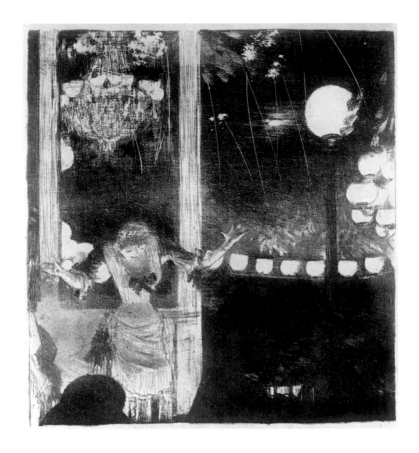

A critic and journalist, Jean Lorrain wrote of the singer Yvette Guilbert: "She is tall — oh, so tall and thin . . . Her chest is of a chalky whiteness and her figure slightly rounded but she has no bosom to speak of and her chest is quite extraordinarily narrow. She has long — too long — thin arms clad in high black gloves that look like flimsy streamers, and a bodice that seems about to be slipping off her shoulders" (quoted in Rudorff, p. 90).

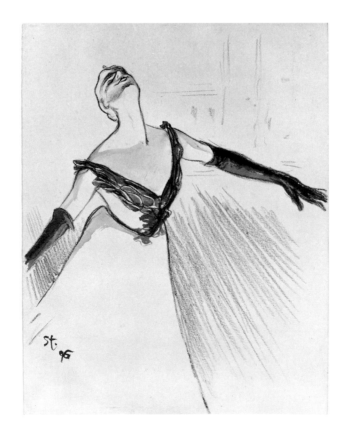

152

Jacques Villon
Night Cabaret (Cabaret de nuit), 1902
Sterling and Francine Clark Art Institute,
Williamstown, Massachusetts. No. 1970.9
(cat. 180)

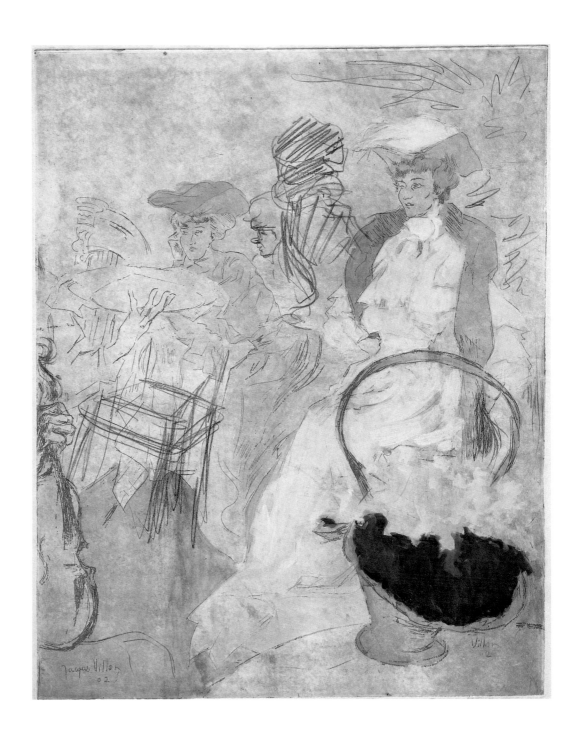

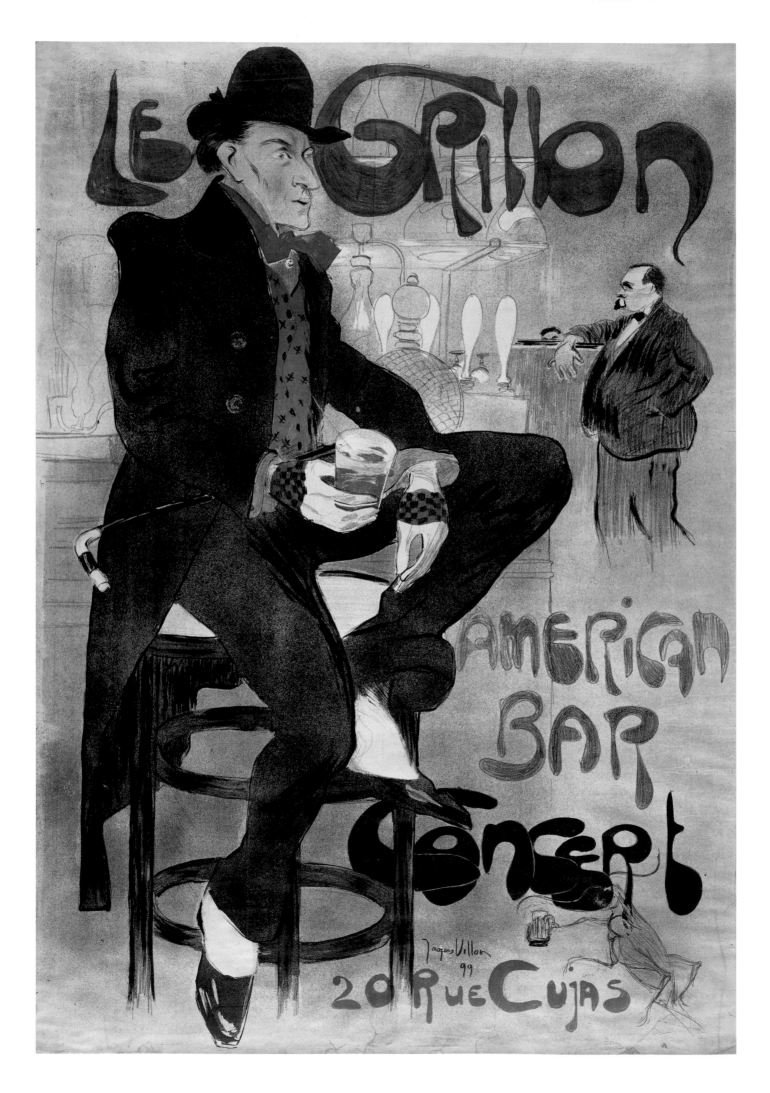

Jacques Villon
The Cricket — American Bar
(Le Grillon — American Bar), 1899
The Museum of Modern Art, New York, Abby Aldrich Rockefeller
Fund. 246.51
(cat. 178)

Édouard Manet
George Moore at the Café, 1878 or 1879
The Metropolitan Museum of Art, Gift of Mrs. Ralph J. Hines,
1955. 55.193
(cat. 144)

*At the turn of the century, Villon made
prints that included this large poster ad-
vertising the Latin Quarter cabaret Le
Grillon (The Cricket). The man at the bar
who imitates an Englishman's mode of
dress has been identified as the poet J.M.
Levet, a well-known habitué of Paris night
spots; the other patron at the bar was ap-
parently the singer Dominique Bonnaud.*

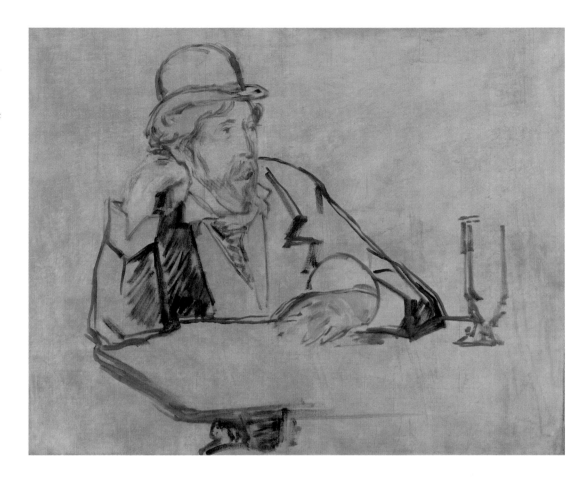

*When the artist Marcellin Desboutin changed his alle-
giance in 1875 from the Café Guerbois to La Nouvelle
Athènes on the Place Pigalle, he was joined by his
friends, including Manet and many painters from the
relatively new Impressionist group. In this unfinished
portrait, Manet has captured the "aesthetic refinement"
of the Irish writer George Moore, who claimed, "I did
not go to either Oxford or Cambridge, but I went to La
Nouvelle Athènes." The tall glass sketched in by Moore's
left hand suggests that Manet intended to show his sub-
ject with a drink of absinthe — the "green fairy" that
caused much havoc and ruin, especially among the
working classes, until it was banned in 1914. Moore
himself evoked the atmosphere of the café when he de-
scribed its diurnal smells, beginning with "eggs frizzling
in butter" in the morning and "at five o'clock the vegeta-
ble smell of absinthe" followed by the "mingled smells of
cigarettes, coffee and weak beer."*

Émile Bernard
The Café (Le café), 1885
Jane Voorhees Zimmerli Art Museum, Rutgers,
The State University of New Jersey, Edward and
Lois Grayson Purchase Fund. 1987.0439
(cat. 124)

Between 1885 and 1886 the young Émile Bernard made some twenty drawings on the subject of prostitution that were dedicated, for the most part, to Vincent van Gogh. Although the drawings bear descriptive titles, the café locations are not specific but depict generically the meeting places for prostitutes and clients. Both the images and their titles were recognizable to his contemporaries. Bernard found literary and artistic precedents for his treatment of bordellos; but his interest in them as subject matter was short-lived.

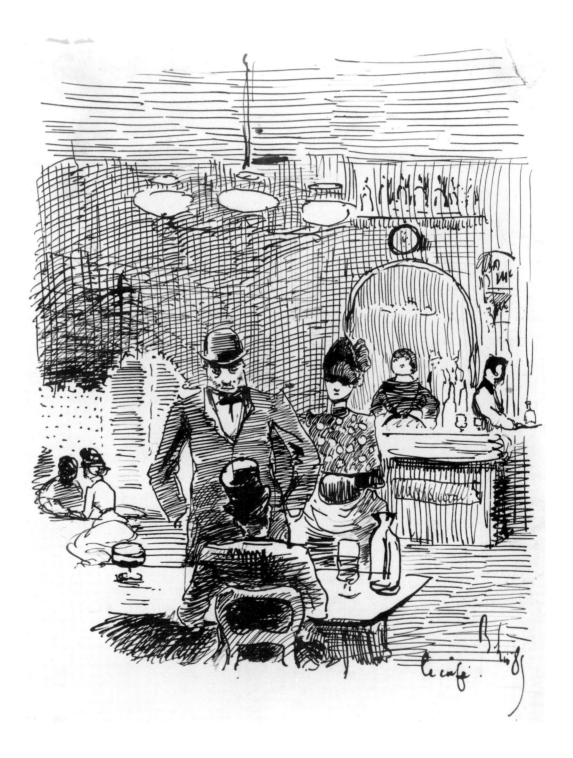

André Derain
Outdoor Café on the Champs-Élysées, ca. 1905
Private Collection
(cat. 136)

Édouard Manet
At the Café (Au café), 1874
Museum of Fine Arts, Boston, Gift of W. G. Russell Allen.
27.1319
(cat. 143)

Derain commented that the first signs of Fauvism appeared in his work at about the time of his meeting in 1899 with Matisse, whose revolutionary ideas on color influenced many artists. Along with other painters such as his friend Maurice de Vlaminck, Derain responded to the visual stimuli that Paris offered, and his palette of vivid colors reflects this enthusiasm. The exaggerated level of energy in Derain's café scene is expressed by his use of short, rapid strokes, high-keyed colors, and brilliant light.

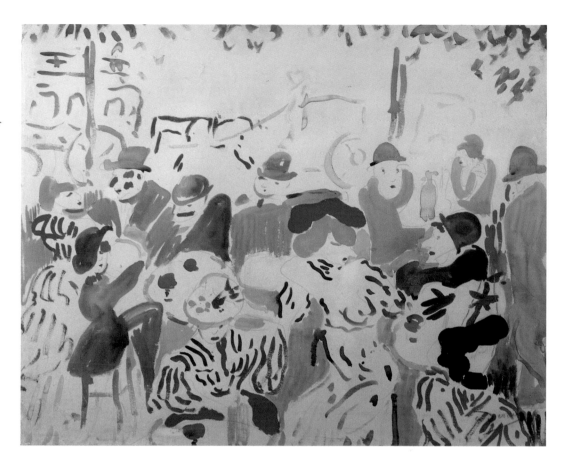

The billiard tables and their lamps in the background suggest that this café was the Guerbois, frequented by Manet and his literary and artistic friends. The spontaneous effect of the "pen and ink" lines further suggests that Manet drew the image on the spot rather than recording it from memory in his studio. Later the drawing was transferred to a lithographic stone for printing, although only a few impressions are known. From about 1866 to 1875, a group of friends gathered with Manet at the Guerbois to exchange ideas; it was here that the theories of Impressionism evolved. The writer Émile Zola used the Guerbois as the model for the café in his great novel The Masterpiece (L'Oeuvre), *published in 1886, in which many of his artist friends believed that they had been studied too closely.*

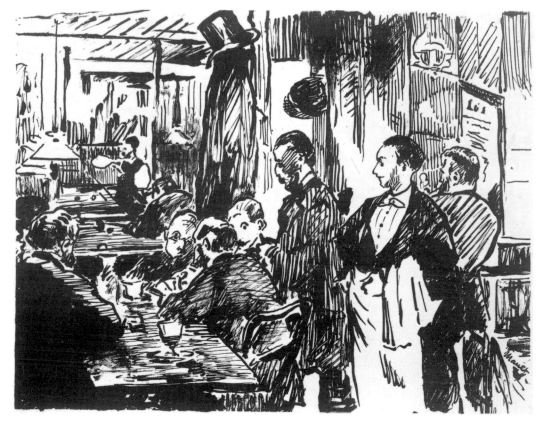

157

Henri de Toulouse-Lautrec
At the Café La Mie, 1891
Museum of Fine Arts, Boston, S. A. Denio Collection, and General Income. 40.748
(cat. 161)

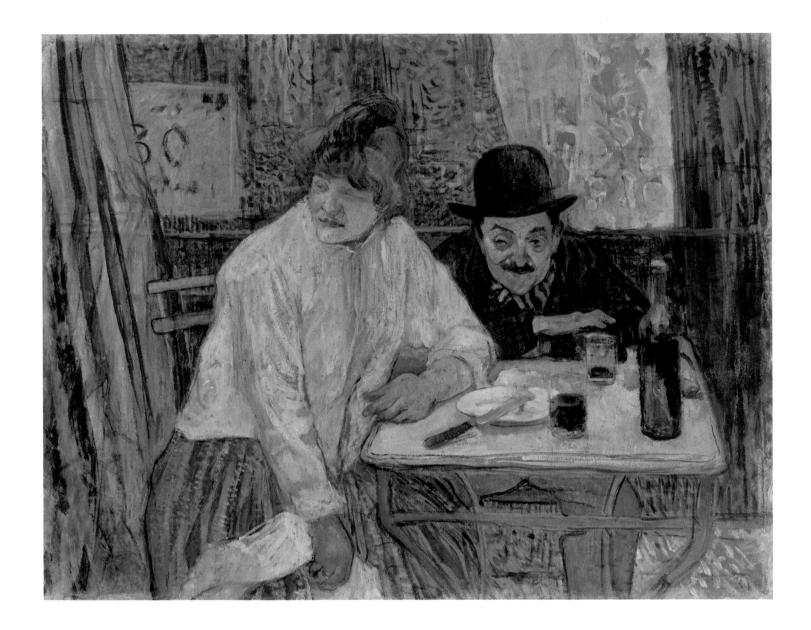

It is generally believed that the setting for this painting is outdoors at the Café La Mie, situated on the outskirts of Paris. Lautrec posed the sitters — a young professional model and Maurice Guibert, his friend and companion — and the scene was then photographed by Paul Sescau, a photographer friend (see cat. 53). Using this aide-mémoire, the artist made changes in the details of costumes and background decorations; above all, he dramatically altered the expressions of his models to convey melancholy and disengagement, the emotions that he frequently witnessed in the bohemian world. The slumped postures of the drinkers suggest that they have pursued the daily ritual in France of "spinning out" the act of drinking. The subject of café drinking was not, artistically, an unfamiliar one. The closest comparison to this work would be Degas's famous In a Café, *better*

known as The Absinthe Drinker, *of 1876. Since Degas's painting remained in an English collection until 1893, however, it is uncertain whether Lautrec had direct knowledge of it. Here he has conveyed the dispiritedness of the working classes rather than the lively exuberance that he often exhibited in his portraits of music hall entertainers.*

Pablo Picasso
The Diners
(Les soupeurs), 1901
Museum of Art, Rhode Island School of Design, Providence,
Bequest of George Pierce Metcalf. 57.237
(cat. 150)

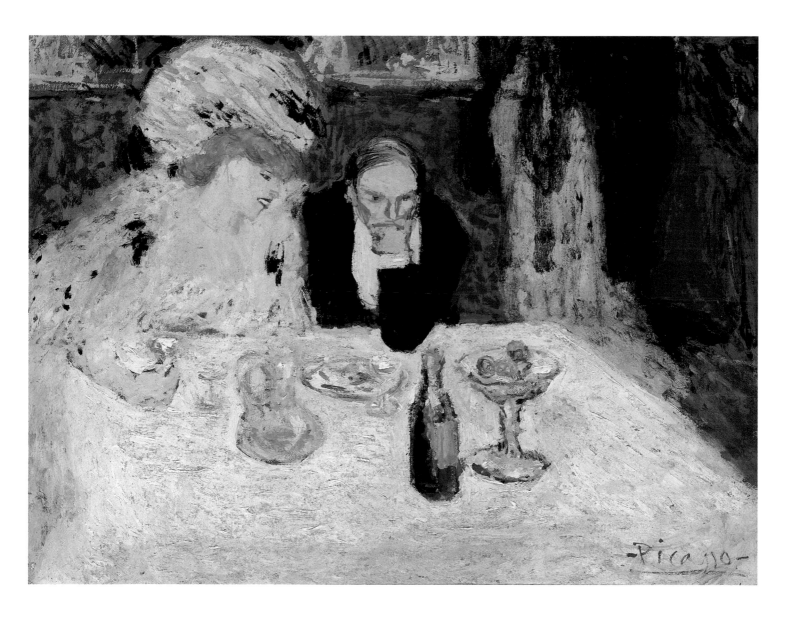

The theme of couples seated at café tables was a recur-
ring one in Picasso's works in the early years of the cen-
tury as he was establishing himself in Paris. These pic-
tures, made while he was in his twenties, reflect the
young man's attraction to the nightlife of Paris and to
the work of Toulouse-Lautrec. The two diners seem ill-
matched; the fashionably dressed woman, smiling, tries
to engage the attention of the morose gentleman who
leans on his hand. Such dining, with a clothed table
and in attractive surroundings — possibly in a private
room used for more discreet social liaisons — was only
available to the well-to-do.

Pablo Picasso
The Frugal Repast
(Le repas frugal), 1904
Museum of Fine Arts, Boston, Ellen Frances Mason Fund. 34.577
(cat. 151)

Though only the second print that Picasso made, The Frugal Repast *is a tour-de-force in both technique and imagery. Picasso's interest in café life is deeply probing in this haunting etching. The woman stares at the viewer while her blind companion, who is entirely dependent upon her, seems to gaze into space. The emaciated figures with attenuated limbs, expressive of gripping poverty, were characteristic of Picasso's "Blue Period" during his early years in Paris. One impression of this major etching was printed in blue, while the few early impressions and the edition published by Vollard in 1913 were in black and white. This major print is a brilliant assessment of the darker side of life in Paris during the period generally considered as* la belle époque.

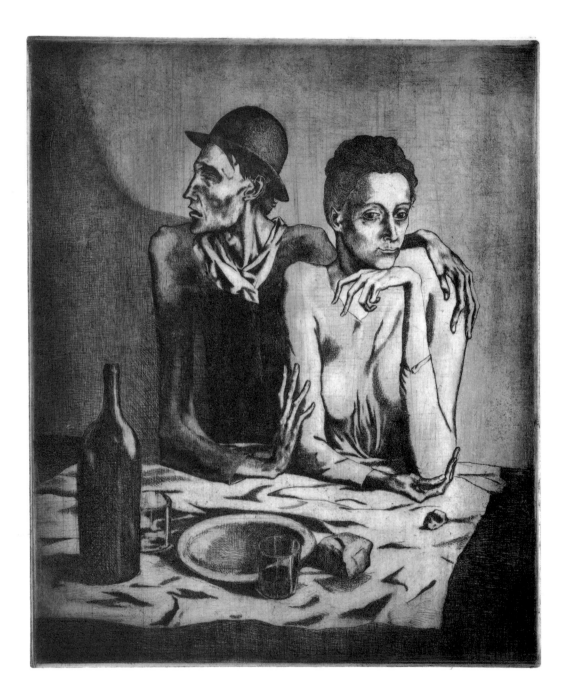

Jean-Louis Forain
The Absinthe Drinker, ca. 1885
Museum of Art, Rhode Island School of Design,
Providence, Anonymous Gift. 60.024
(cat. 138)

The painting is traditionally titled The
Absinthe Drinker, *although there is only
a slight indication of the tall absinthe
glass, and no carafe of water is at hand.
Of more importance are the distracted
gaze and somber mood of the woman,
which strongly suggest a prostitute seated
in a café, waiting for a client. The picto-
rial composition and the pose of the young
woman are strikingly similar to those in
Manet's* The Plum *of 1877-1878 and his
portrait of George Moore at the café (cat.
144). The long mirror behind the ban-
quette that reflects the gaslight globes in
repetition relates this painting to the vari-
ous depictions of the Café de la Nouvelle
Athènes.*

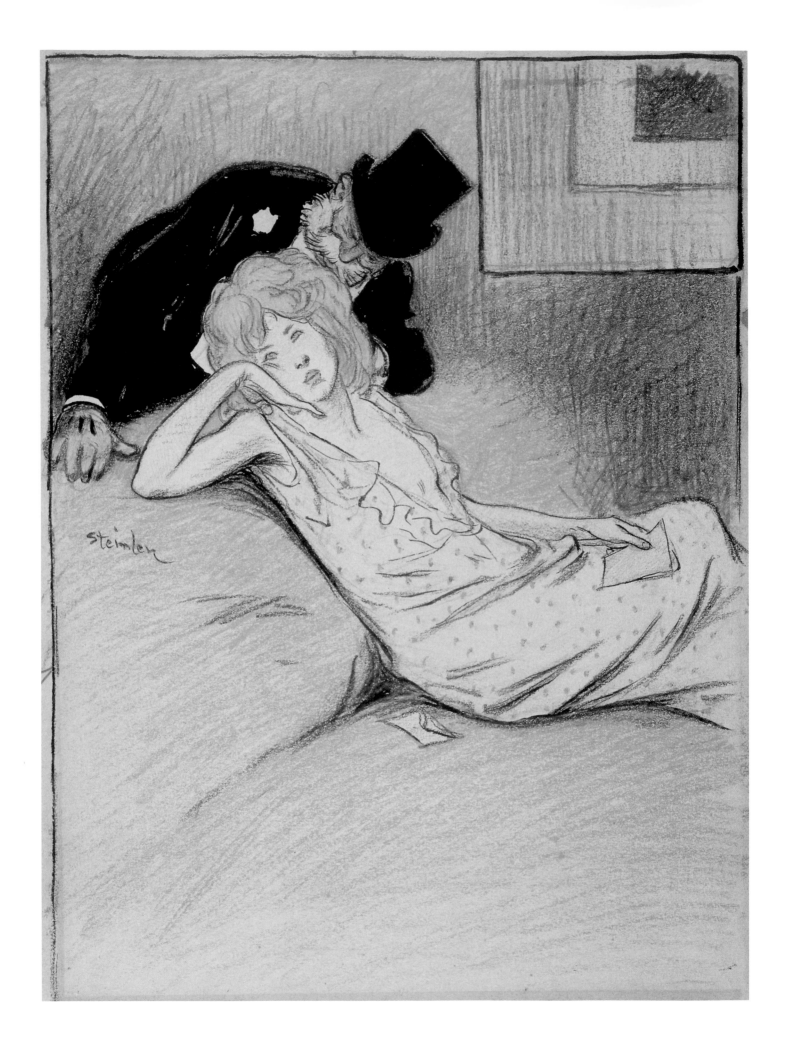

Théophile-Alexandre Steinlen
Design for a Music Program
Private Collection
(cat. 159)

Georges Rouault
The Procuress, 1906
The Museum of Modern Art, New York, Acquired through the
Lillie P. Bliss Bequest. 503.41
(cat. 153)

Steinlen's illustrations for song-sheet covers and journals were concerned chiefly with social issues. The artist frequently depicted prostitutes and pimps and often showed them in depressed circumstances. In this drawing for a music cover that was not published, he reveals an intended assignation in a more attractive brothel, although the woman seems despondent after reading a letter. Despite laws that were issued in 1885 restricting the habits of prostitutes, affluent men still had access to this established form of recreation. The brothels were frequently compared to an Englishman's club, where one went for a drink and conversation.

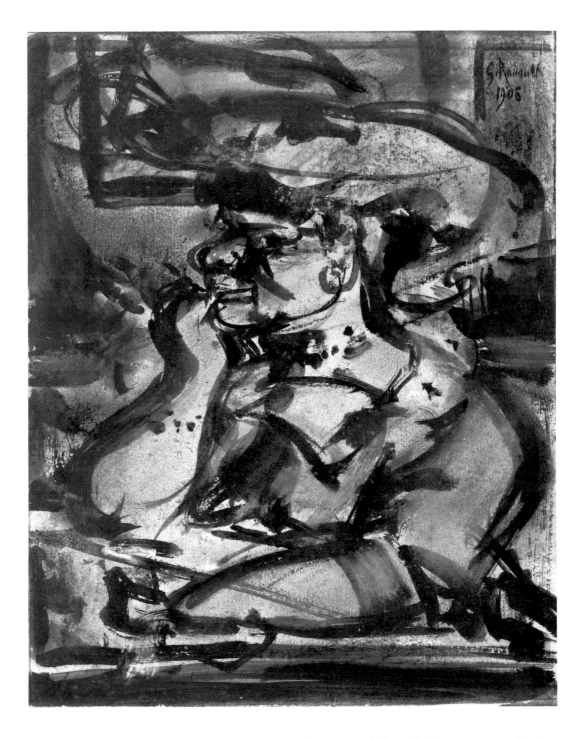

Concurrent with Rouault's circus series executed in the first decade of the twentieth century are his depictions of prostitutes in various settings, in which he always communicated their difficult existence and failures in a glittering environment. Here a grotesque woman tries to arrange assignations; the tragedy of her life reflects the widespread exploitation of such women that took place in the "pleasure capital" of the world.
(cat. 153)

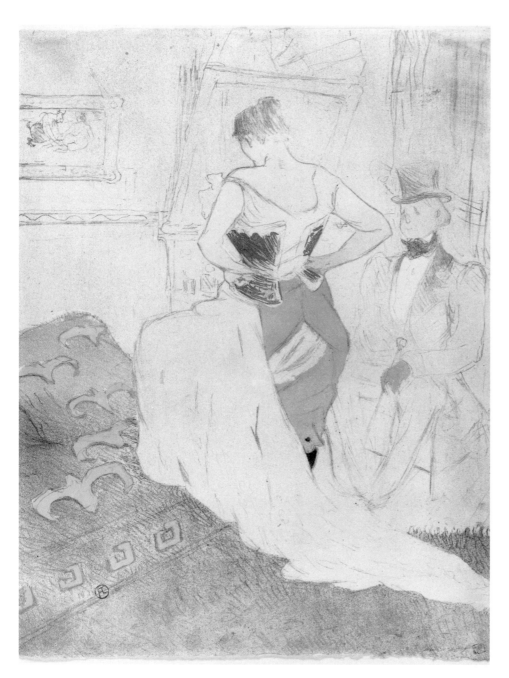

Henri de Toulouse-Lautrec
*Woman Putting on Her Corset — Passing
Conquest*
(Femme en corset — Conquête de passage), 1896
Courtesy of the Boston Public Library, Print Department, Gift of Albert H. Wiggin
(cat. 174)

*The publisher Gustave Pellet persuaded Lautrec to make
a series of prints on brothels in the hope that he would
entice new buyers. Such subject matter could be found in
illustrations in the popular press, but it had not been
tackled before by a well-known and successful artist.
Lautrec, who had lived for many weeks between 1892
and 1895 in various Parisian brothels, approached the
project with experience and sympathy. The portfolio*
Elles, *comprising ten lithographs with a cover and frontispiece, was issued in the spring of 1896. It was probably a disappointment to Pellet, since only two images
give a clue to the brothel setting. Most of the lithographs, printed in a range of sensitive colors, depict the
daily routine of the prostitutes' private world: their caring for each other, their boredom, and the sense of isolation that pervaded their environment.* Woman Putting on
Her Corset *unmistakably represents the prostitute's métier. The act of dressing and undressing before a male
client was one of the accepted practices in a brothel, and
the theme of a woman observed tempted many artists,
including Manet, whose painting of Nana, the* cocotte,
viewed by her male admirer may have served as an example for Lautrec's series.

Eugène-Samuel Grasset
The Morphine Addict
(La morphinomane), 1897
Jane Voorhees Zimmerli Art Museum, Rutgers, The State University of New Jersey, Friends Purchase Fund. 77.054.001
(cat. 139)

*With uncompromising frankness, Eugène Grasset depicts
the marginal existence of the drug addict. Morphine,
discovered in 1817 by a German pharmacist, was regularly prescribed until its addictive power was realized.
Tobacco, alcohol, ether, and hashish were also used as
remedies for ailments, and cocaine, too, was added to
the list of habit-forming drugs. By the end of the century, morphine addiction existed at all levels of French
society; an 1895 state commission appointed to deal
with the problem reported that many doctors, nurses,
and pharmacists, who had ready access to the drug,
were addicted (Brouardel, pp. 249-51, as cited in Boyer,
1984, p. 58). Grasset's acid-colored presentation of the
disheveled woman in her desperation reveals the longterm effects of the drug that had initially given pleasure.*

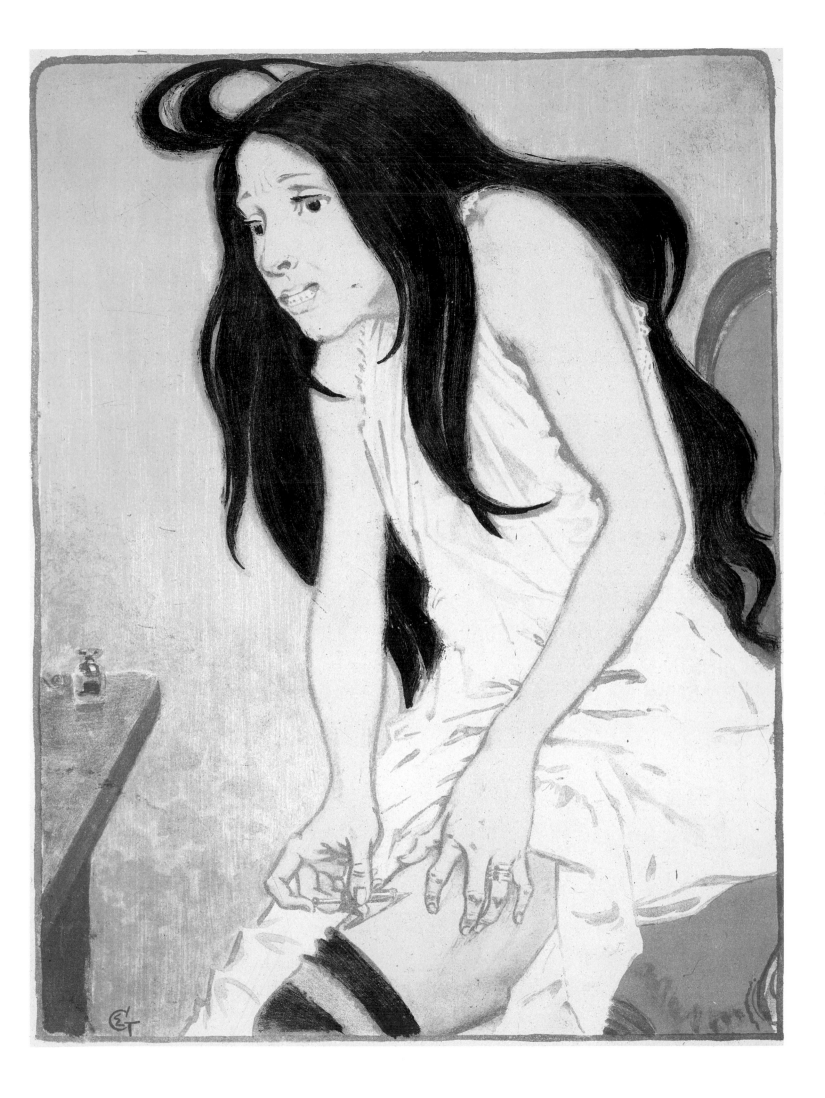

Hilaire Germain Edgar Degas
Two Women — Scene from a Brothel
(Deux Femmes — Scène de maison close), ca. 1877-1879
Museum of Fine Arts, Boston, Katherine E. Bullard Fund in
Memory of Francis Bullard. 61.1214
(cat. 134)

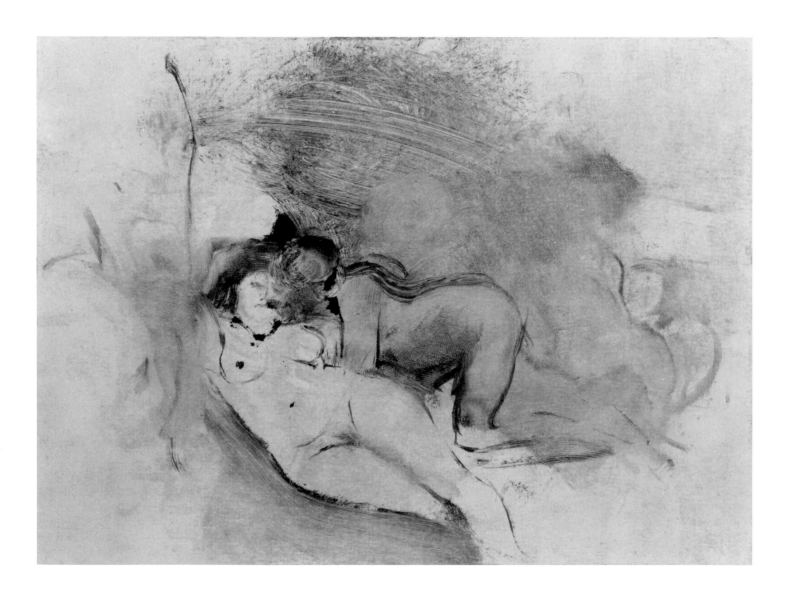

*Between 1876 and 1879 Degas made some fifty mono-
types featuring brothel scenes. Generally small in size
and sequential in content, they may have been intended
as book illustrations, possibly for the "realist" novel by
Edmond de Goncourt entitled* La Fille Elisa. *The subject
of lesbianism never occurs in Degas's paintings and only
appears twice in his monotypes. Such imagery, however,
was not uncommon in nineteenth-century popular prints
that were generally made for the enjoyment of men.
Some twenty years later, Lautrec undertook a number of
paintings of lesbians, recording their behavior as prosti-
tutes in brothels.*

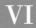

VI

Circuses and Fairs

In London near the end of the eighteenth century, an Englishman named Philip Astley formulated the modern circus as we know it today: a round arena for equestrian events, acrobatic feats, and magical scenes.[1] In 1783 Astley and his son constructed in Paris the first amphitheater of its kind with a covered roof. By 1840 plans were underway for a brilliant, large hall, and in June 1843 the Cirque d'Été was inaugurated in a graceful and elegant structure whose roof was supported by sixteen columns; it had a seating capacity of four thousand. This remarkable hall inspired another in which events could be performed during the winter months. It was first entitled Cirque Napoléon and after 1870 was given the name by which it is known today: Cirque d'Hiver. A painting by John Singer Sargent records the orchestra using the arena to rehearse for a concert (cat. 196).

By the middle of the nineteenth century Paris was the center for wondrous circus performances. (For a discussion of Parisian circuses, see the essay by Phillip Dennis Cate.) In June 1875 the Cirque Fernando opened its doors, to be joined in 1886 by the Nouveau Cirque. Many of the artists whose works are most familiar to us today, such as Degas, Toulouse-Lautrec, Seurat, Renoir, and Prendergast, visited both halls and recorded their uniquely different spectacles. (The critic Félix Fénéon recalled that his first meeting with Manet in 1876 took place at the Cirque Fernando in the company of Puvis de Chavannes and Degas.) In addition to these four halls were the "hippodromes," where similar circus acts and equestrian performances were presented to huge audiences. The competition between these establishments was lively; this led to a gradual evolution from the classic circus, with acrobats, clowns, and animals, to arenas for theatrical events of the kind that were offered at the music halls, such as the Folies-Bergère.

The Cirque Fernando, depicted in Seurat's painting *Circus* (see p. 42, fig. 3) was taken over in 1897 by the clown Medrano, who had worked with Louis Fernando; until its demolition in 1972, it was one of the most frequented circuses in Paris. Numerous illustrations in journals describe this unique sixteen-sided building that occupied a large corner plot in Montmartre. A series of circular tracks were covered by an airy roof from which a number of chandeliers were hung, giving a splendid appearance. There was seating for more than two thousand with additional room

for about four hundred standing spectators. The seats were arranged in tiers according to three "classes." The size of the amphitheater can be comprehended when one learns that it accommodated the 1882 election assembly for Georges Clémenceau.

One of the largest arenas was the Hippodrome du Pont de l'Alma, which opened in 1877 and mounted spectacular events for an audience close to ten thousand. It was torn down in 1897, and the new Hippodrome was built in Montmartre with half the capacity. Emmanuel Orazi's poster (cat. 188), which celebrated its opening, dramatically conveys the exciting events that were offered, including circus acts and expert equestrian presentations, sports competitions, ice skating, and even a naval battle.[2] Despite the large number and great variety of human and animal performers, all the circus halls came to rely on clowns and acrobats to give their stages an individuality and competitive edge and thus to sustain the interest of their socially diverse audiences. No longer merely providing distractions between animal acts, the clowns assumed particular and recognizable personalities, and in their brightly colored costumes they appealed to the avant-garde artists.

The Cirque Molier, founded in 1880 by Ernest Molier, introduced amateur performers who were aristocrats and artists; generally they mounted one annual charity benefit (see cat. 197). These established circuses with permanent homes were supplemented by the *forains*, performers who traveled in wagons and set up their tents at fairs throughout France; they also contributed to the two major annual fairs in Paris. The artist Henri-Gabriel Ibels was especially attracted to these wanderers and their particular style of presentation and frequently portrayed them in his lithographs (cat. 186, 187).[3]

For Picasso every spectacle was a "visual feast," and, indeed, the circus provided an abundant source for his imagery. It is said that although he may not have attended the theater, he frequently went to the circus halls, particularly to the Medrano, where he "would stay all evening — Braque sometimes with him — talking to the clowns. . . . He admired them and had real sympathy for them."[4] Clowns are continually present in Picasso's work to the mid-1920s, but he was far less interested in their performances than in their physical appearance and lifestyle. Although he differentiated between Harlequins, with their

James Jacques Joseph Tissot
The Ladies of the Chariots
(Ces dames de chars), 1883-1885
Museum of Art, Rhode Island School of Design,
Providence, Gift of Walter Lowry. 58.186
(cat. 198)

Emmanuel-Joseph-Raphaël Orazi
The Hippodrome, Boulevard de Clichy
(L'Hippodrome, Brd de Clichy), ca. 1900
Jane Voorhees Zimmerli Art Museum, Rutgers,
The State University of New Jersey, Lillian Lilien
Memorial Fund. 84.023.003
(cat. 188)

From 1882 to 1885 Tissot was preoccupied with the execution of a series of fifteen large paintings that related to the life of Parisian women in the pursuit of their daily routine. In this series, entitled La Femme à Paris, *Tissot focused mainly on a certain group in French society, emphasizing their beauty and recognizable sense of style. In* The Ladies of the Chariots, *the viewer is placed perilously close to the path of the performers at the Hippodrome de l'Alma, "where the glittering Amazons appear almost beautiful 'under the glamour of the electric light and amid the applause of the amphitheater'" (Wentworth, p. 166). The spiked crowns worn by the equestrians bring to mind the Statue of Liberty, which was under construction at this time in the yard of Frédéric Bartholdi and was finally installed in New York harbor in 1886. The rows of spectators encircling the arena indicate the immense popularity of circus events in Paris when many thousands of spectators filled the arena.*

The Hippodrome circus depicted so dramatically by Tissot (cat. 198) was torn down in 1897, and a new arena located on the Boulevard de Clichy was inaugurated in 1900. Although it had the capacity to seat only five thousand spectators instead of ten thousand, as in the old building, it still gave performances on a grand scale that could hardly be undertaken today. Orazi's poster, which celebrated the opening of the new arena, depicts the extraordinary program that was offered, including "two hundred performers, six elephants, and fifty horses" (Cate, ed., p. 33).

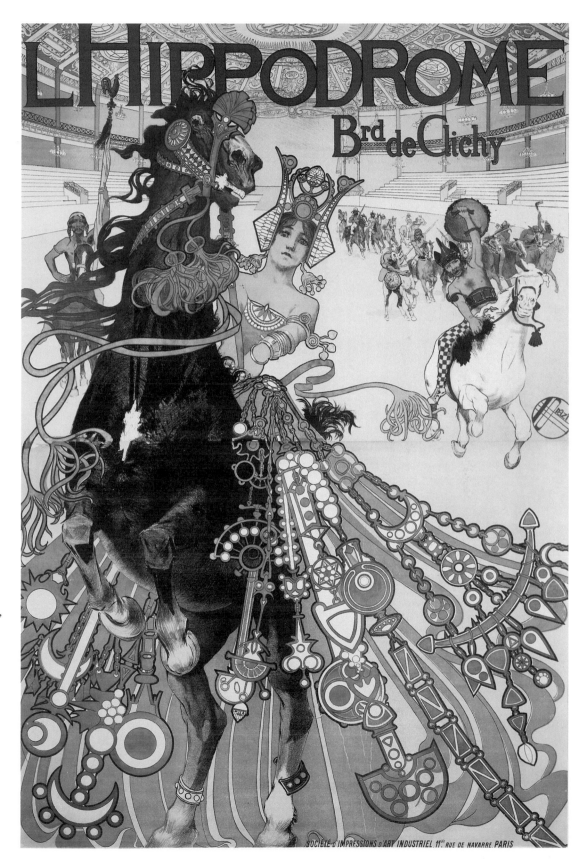

distinctive lozenge-patterned suits (cat. 190, 193), *saltimbanques*, the itinerant acrobats (cat. 189), and the Pierrots, with their elaborate ruffs and wide pantaloons, he freely manipulated the personae and costumes of these traditional types. Picasso's images were inspired by his own encounters at the circus, including his back-stage visits, as well as by literary sources and the works of other artists such as Jules Chéret, Cézanne, and Degas.[5]

Before 1914, circuses in France successfully resisted the enormous changes introduced by the American entrepreneurs Barnum and Bailey, who visited Paris in the winter of 1901-1902. The multiple non-stop acts performed in three rings and on two platforms and the fast pacing and high noise levels were in marked contrast to the French circuses, where the audience concentrated on one central attraction.[6]

Eventually, the diversity and the frenetic tempo of the American circus challenged the traditional style of the Parisian rings. The more lavish the extravaganza, the greater was its appeal to the general public, who relished exposure to glamour in abundance. Although the audience remained steadfast, by the end of the century live acts could no longer hold their attention, and enthusiasm shifted to the motion pictures. In 1911 the Hippodrome itself was finally converted into a successful movie theater that seated thirty-five hundred people![7]

Notes

1. Much of the following information on the circus was drawn from an article by Eric Darragon, "Pégase à Fernando: A propos de *Cirque* et du réalisme de Seurat en 1891," *Revue de l'art*, no. 86 (1989), pp. 44-57.

2. Phillip Dennis Cate, ed., *The Graphic Arts and French Society*, 1871-1914 (New Brunswick, N.J., 1988), p. 33.

3. Phillip Dennis Cate, "'Parades,' Paris and Prostitutes," in *Toulouse-Lautrec*, exhib. cat. (San Diego Museum of Art, 1988), p. 31.

4. Quoted in Theodore Reff, "Harlequins, Saltimbanques, Clowns, and Fools," *Artforum* 10 (Oct. 1971), p. 33.

5. For a thorough discussion of Picasso's visual types and subject matter, see Reff, "Harlequins," pp. 30-43.

6. Charles Rearick, *Pleasures of the Belle Epoque: Entertainment and Festivity in Turn-of-the-Century France* (New Haven, 1985), p. 149.

7. Cate, ed., *Graphic Arts*, p. 33.

James Jacques Joseph Tissot
The Amateur Circus
(Les femmes de sport), 1883-1885
Museum of Fine Arts, Boston, Juliana Cheney Edwards Collection. 58.45
(cat. 197)

In a small and elegant arena, Tissot depicted the "cirque du High-life," in which a fashionable audience watched their own "kind" perform as clowns and acrobats. In 1880 Ernest Molier founded a private circus where members of the aristocracy such as Comte Hubert de la Rochefoucauld — here on the horizontal bars facing the viewer — became clowns, trapezists, and equestrian stars for an annual performance. The audience was of equal importance to the circus's success, and in this painting Tissot made a lavish display of those who attended. The notion of the tragic clown or jaded performer was not part of Molier's or Tissot's circus concept; by contrast, the artist has made quite apparent the sexual titillation created by the near-naked aristocrats who interact with their prominently placed female audience.

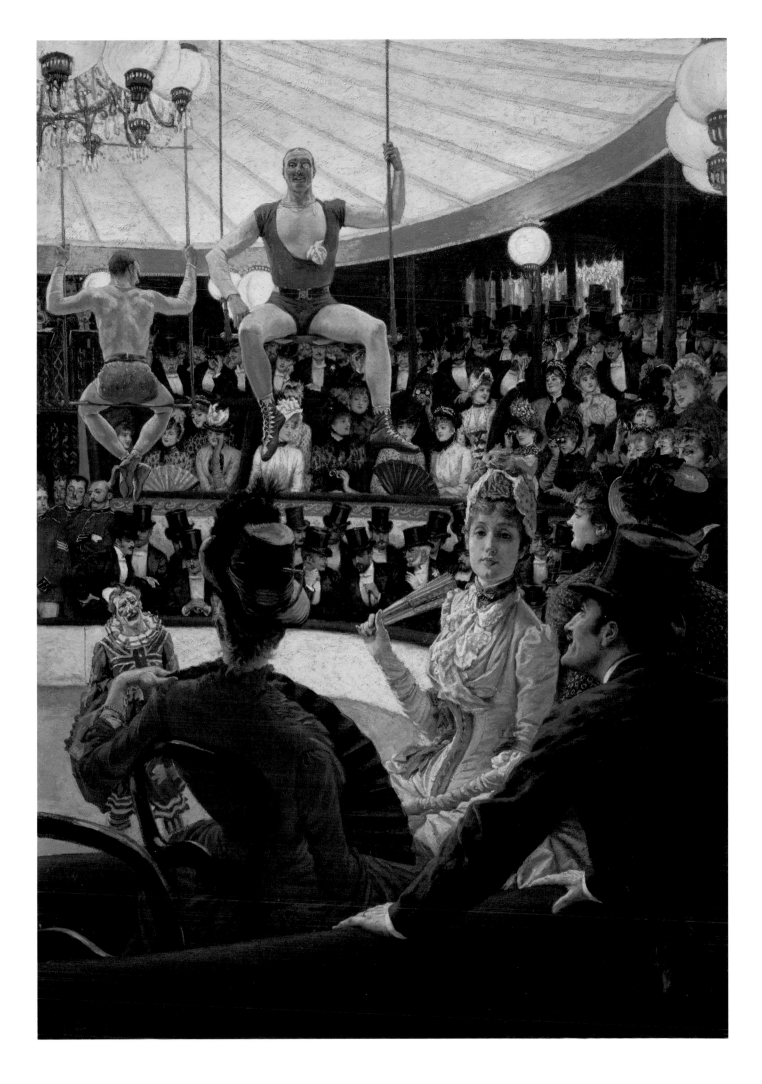

171

Georges Rouault
Circus Act, 1905
The Museum of Modern Art, New York, The Joan and Lester Avnet
Collection. 158.78
(cat. 195)

Maurice Prendergast
The Circus
(Le cirque), ca. 1902
Museum of Fine Arts, Boston, Charles Henry Hayden Fund.
58.981
(cat. 194)

*In a group of fan-shaped watercolors,
Rouault explored the heart-rending side of
the lives of circus performers. At a time
when this subject was generally rendered
in bright colors, the artist couched his cir-
cus acts in dark and obscure environments
signifying the decrepit world that exists
behind the "spangled costumes."*

John Singer Sargent
*Rehearsal of the Pasdeloup Orchestra at the Cirque
d'Hiver*, 1876
Museum of Fine Arts, Boston, Charles Henry Hayden Fund.
22.598
(cat. 196)

*At the Cirque d'Hiver, formerly named the
Cirque Napoléon, equestrian performances
were held during the winter months. It
also served as an auditorium for popular
concerts of classical music, organized in
1861 by Jules Pasdeloup. The attendance
was enormous, and the concerts became
increasingly popular among Parisians
who could not afford high prices for "deli-
cate pleasures." When Sargent painted
this picture, the rehearsals and Sunday-
afternoon winter concerts took place at the
Cirque d'Hiver, while the summer per-
formances were moved to the Théâtre des
Champs-Élysées. A larger version of the
painting (The Art Institute of Chicago)
shows three costumed clowns in the lower
right quadrant who lounge on the side-
lines and listen to the music.*

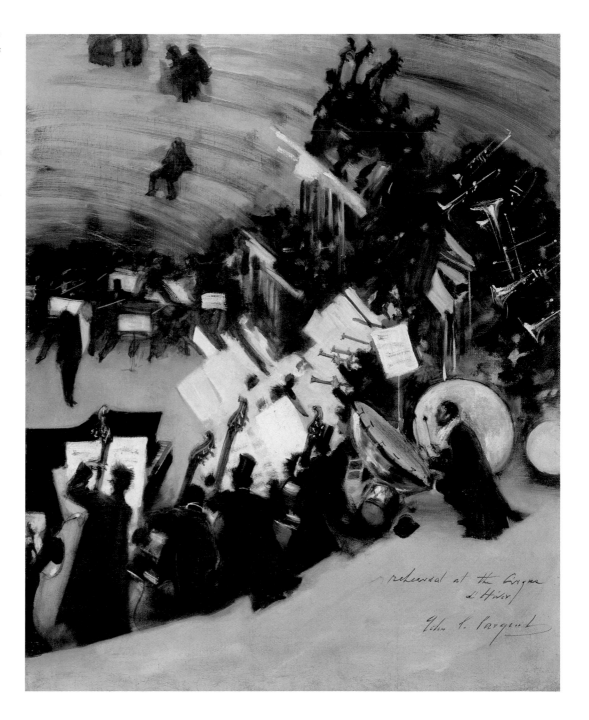

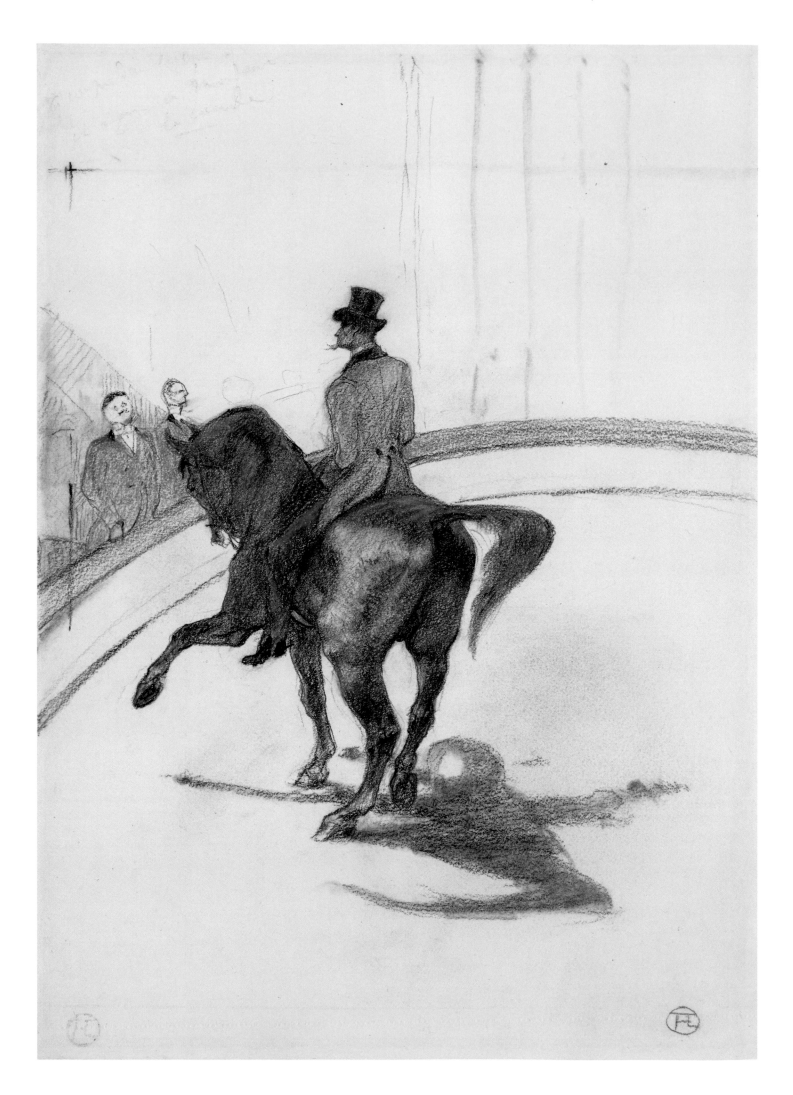

174

Henri de Toulouse-Lautrec
The Spanish Step
(Le pas espagnol), 1899
The Metropolitan Museum of Art, Robert Lehman Collection,
1975. 1975.1.731
(cat. 202)

Henri de Toulouse-Lautrec
The Salutation
(Le salut), 1899
Fogg Art Museum, Harvard University,
Bequest of Frances L. Hofer. 1979.56
(cat. 200)

In March 1899 Lautrec was confined to a sanatorium near the Bois de Boulogne for severe illnesses related to alcoholism. His desire to be free of his confinement by proving his mental abilities spurred him to produce a large number of masterly circus drawings based on his memory of happier times. With crayons and colored pencils, Lautrec made images recalling his many visits to the Cirque Fernando (later named the Cirque Medrano); in highly focused vignettes, he isolated various moments of public amusement. Most of his attention was directed toward the equestrians, the animal trainers, and the clowns. He made heroes of these costumed performers, whose position in society was always ambiguous, and he captured the fleeting pleasure they derived in making a large audience happy. Within many of the spare compositions, Lautrec drew a vignette in exact detail: a dog, a shoe, or a hairdo.

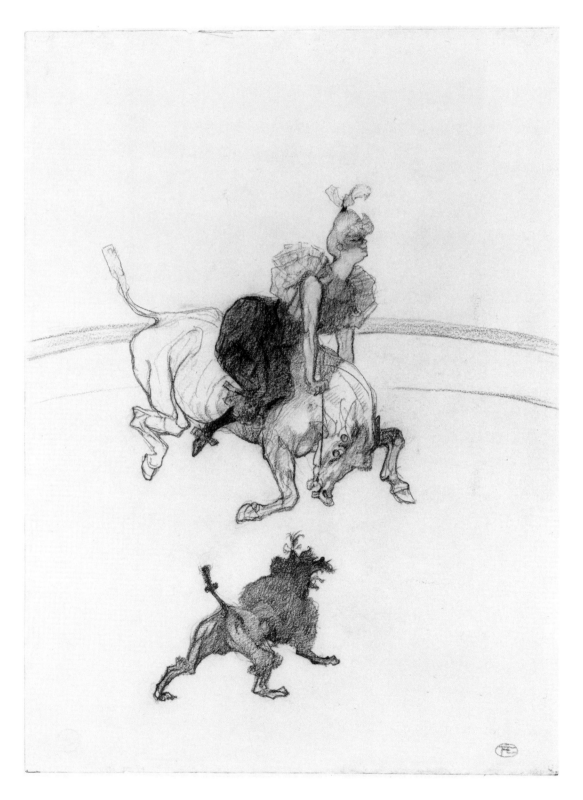

Henri-Gabriel Ibels
At the Circus
(Au cirque), ca. 1893
Private Collection
(cat. 184)

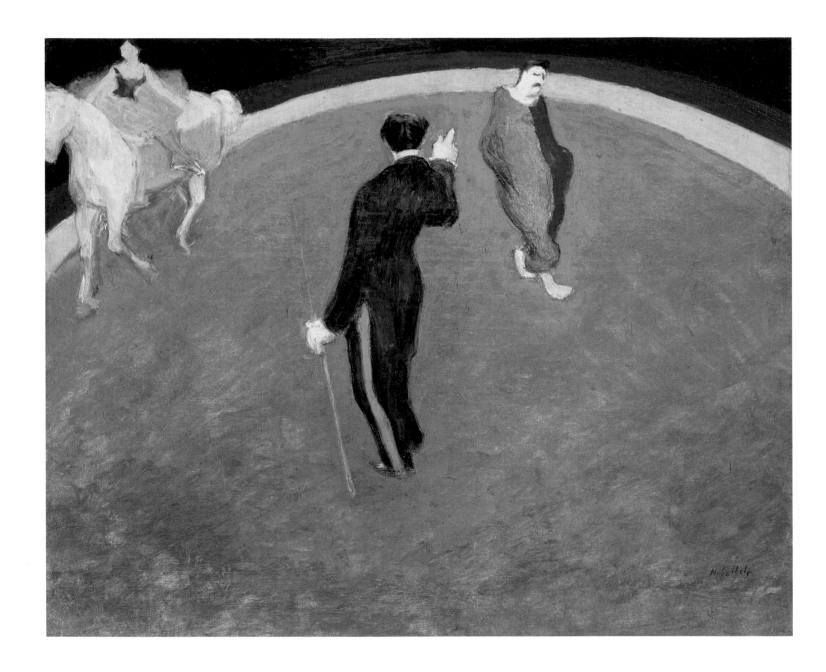

Ibels was a member of the Nabi brotherhood, a group of artists who searched for expressive means to capture inner meanings. He was best known as a printmaker and illustrator; his numerous works on paper were commissions for music sheets, theater programs, and posters, and for illustrations for the popular press. Ibels was devoted to depicting the bars and cafés with their attendant prostitutes, and he also explored circus imagery. Both this painting, which may have served as the prototype, and the lithograph (cat. 185) represent an established circus ring. Ibels's greater interest was to describe the itinerant performers who had more difficulty in sustaining a livelihood. The luminous orange circus rings in both works reflect the more exotic palette of his friend Gauguin, who also influenced Ibels's choice of flattened, unmodeled figures contained by bold contours. In the painting the spare arena conveys a sense of melancholy and loneliness.

Georges de Feure
Le Cirque Corvi, ca. 1893
Sterling and Francine Clark Art Institute,
Williamstown, Massachusetts. No. 1648
(cat. 183)

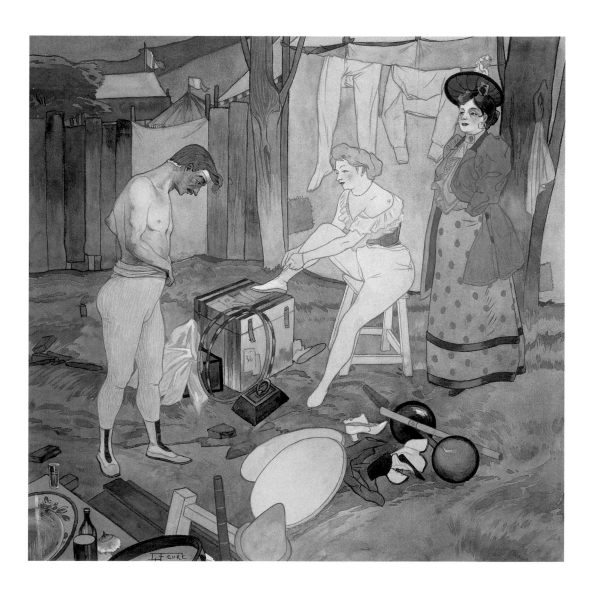

Georges de Feure, who is better known today for the dec-
orative arts he designed for Siegfried Bing's gallery
L'Art Nouveau and also for his posters, painted this
gouache early in his career when he was becoming es-
tablished and beginning to be published in popular jour-
nals. At this time, de Feure was particularly interested
in the behind-the-scenes life of circus performers and the
uncertainty and poverty of their nomadic existence. He
had spent much of his youth wandering from town to
town in the Netherlands with his architect father after
they had fled Paris during the Franco-Prussian war. He
had also traveled as a member of the Frascati d'Art Thé-
âtre and was therefore familiar with the life of itinerant
performers. The gouache reveals as well de Feure's life-

time fascination with women, especially the type of pow-
erful, well-dressed, and prosperous female who is in
marked contrast to the weaker male. Later, this female
figure develops into the wicked femme fatale (Millman,
p. 121). In this circus image, she does not appear
wealthy but is certainly more comfortable than her com-
panions, to whom she seems disdainful. De Feure exhib-
ited similar works at the Galérie des Artistes Modernes in
March 1894. The Cirque Corvi, directed by Ferdinand
Corvi, was a small and unusual circus in Paris that spe-
cialized in animal acts.

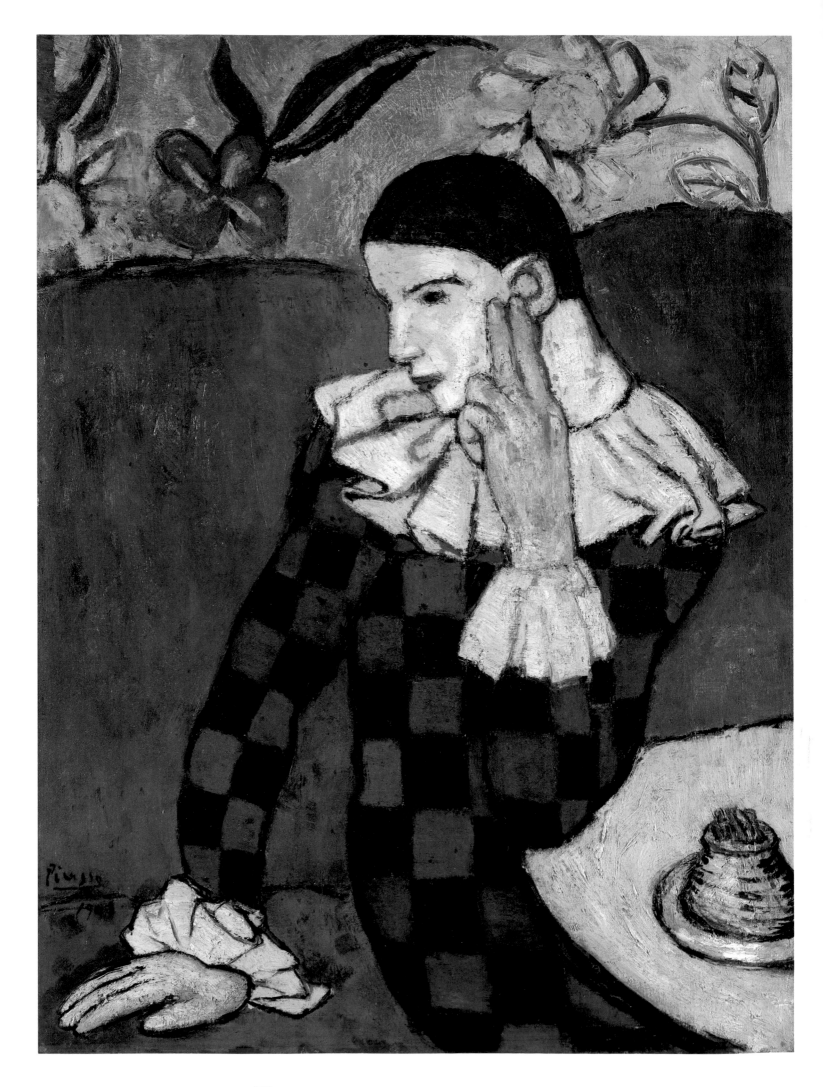

 Fairs Circuses and Pubs

Pablo Picasso
Harlequin, 1901
The Metropolitan Museum of Art, Purchase, Mr. and Mrs. John L.
Loeb Gift, 1960. 60.87
(cat. 190)

Pablo Picasso
At the Circus
(Au cirque), 1905
Museum of Fine Arts, Boston, W. G. Russell Allen Bequest.
60.1234
(cat. 192)

In the late autumn of 1900 when Picasso came to Paris, he was immediately attracted to the circus halls, in particular the Cirque Medrano (formerly Cirque Fernando), which experienced great popularity at the time. Picasso's mistress and friends have attested to his hearty enjoyment of the clown performers, his desire to make their acquaintance and to be with them on a frequent basis. Clearly, this attitude of pleasure hardly prepares one for the melancholy figures of Harlequin and Pierrot that Picasso painted; those of the 1905 Rose Period, according to Gertrude Stein, evolved from the Cirque Medrano setting. The figure in this painting, from the artist's earlier years when more blue was introduced into his palette, is typical of the slender, haunted, and lonely Harlequins that Picasso studied. With their diamond-shaped patterned costumes (in this image, the pattern is squared and the ruffled collar and cuffs are characteristic of a Pierrot), they are noticeably different from their fellow men. The Harlequin, turned away from the café table with his head tilted slightly downward and his unsmiling eyes looking into the distance, displays the heightened isolation of a clown who is not "on stage." Furthermore, the touching of hand to cheek was a traditional gesture, indicating melancholy and contemplation; the pale, painted face adds to the sense of femininity and physical listlessness. Instead of a glass of wine, Picasso included a small clay pot with matches to decorate the table. Although the artist willingly accepted the circus as a source of entertainment, he chose to reach deeply into the image of Harlequin to reveal the psychological effects of unconventionality and isolation.

Picasso's interest in Harlequins and clowns was equaled by his concern for sal-timbanques, the itinerant acrobats. These gentle, anxious people had no connection with a permanent circus arena and were required to drift from street corners to country fairs. In 1905 Picasso executed fourteen prints about circus acrobats; he scratched on the copper plates a series of thin figures in rehearsal or performance. Picasso recognized that these homeless entertainers lived on the edge of society.

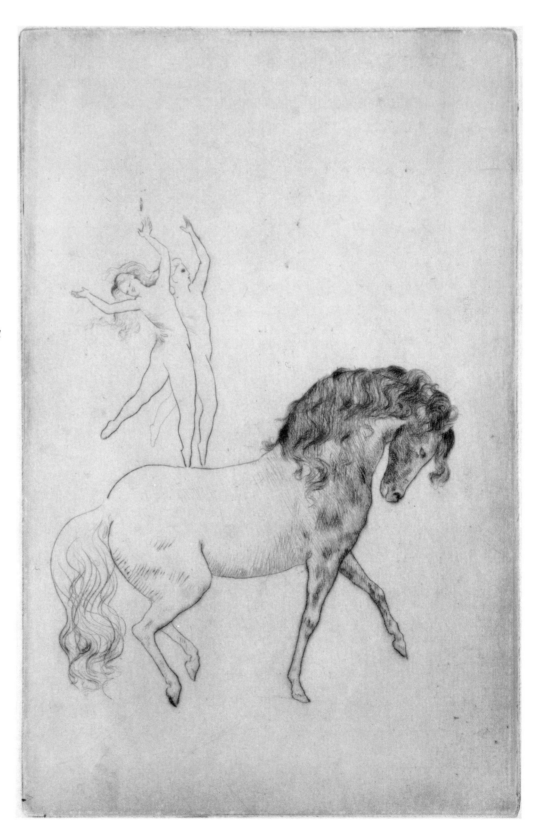

Pablo Picasso
Harlequin with a Guitar, 1916
Mr. and Mrs. Eugene V. Thaw
(cat. 193)

With only a passing reference to Cubism, Picasso painted this Harlequin with a guitar as a conveyor of pleasure. At this time, he was preoccupied with the performing arts, and the theme of Pierrot and Harlequin held his attention for several years. This portrait of a clown, who is less strained and emaciated than the saltimbanques, anticipates the curtain design Picasso made in 1916-1917 for the production of Diaghilev's Parade, "where Harlequin and Pierrot and gay companions drink, dance and make merry" (Bransten, p. 32). Despite Picasso's interest in clowns as stage personalities, he was more concerned with the pathos of their lives. These various figures would always evoke his sympathy and be part of the artist's visual repertoire.

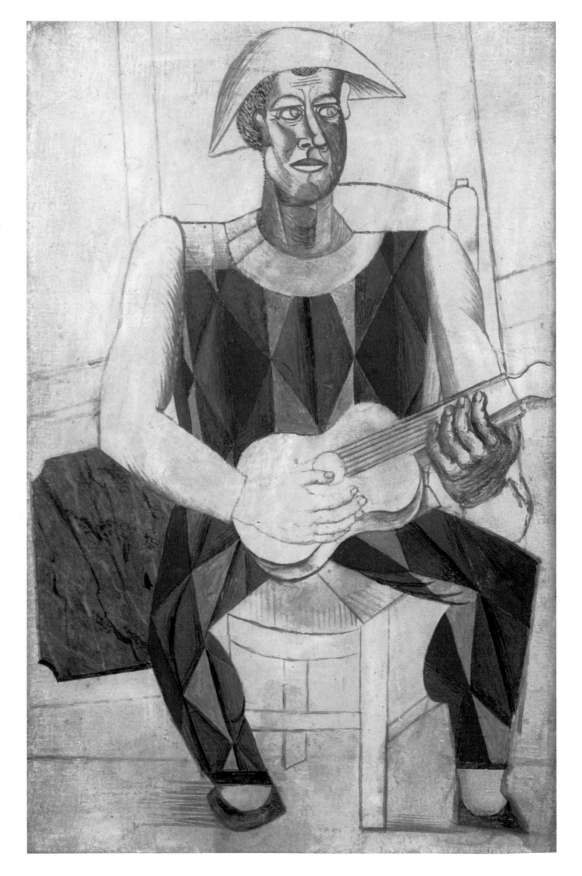

Checklist of the Exhibition

Annotations are included for works not illustrated.

All measurements are sheet size unless otherwise indicated. French titles are given when known.
* Indicates exhibited in Boston only.

Boulevards and Promenades

1. **Anonymous Photographer**, French, 19th century. *Place de l'Opéra*, ca. 1888. Photograph, albumen print, 8⅜x10¾ in. (21.4x27.5 cm). Private Collection

2. **Anonymous Photographer**, French, 19th century. *Esplanade of the Invalides — Palais des Arts Décoratifs* (Esplanade des Invalides — Palais des Arts Décoratifs), 1900. Photograph, albumen print, 10¾x17⅜ in. (27.3x44.2 cm). Museum of Fine Arts, Boston, Abbott Lawrence Fund. 1984.177

3. **Anonymous Photographer (H.P.)**, French, 19th century. *General View of the Place de la Concorde* (Vue générale de la Place de la Concorde), before 1889. Photograph, albumen print, 8¼x10¾ in. (21x27.4 cm). Museum of Fine Arts, Boston, Gift of Clifford S. Ackley. 1977.163

4. **Jean Béraud**, French, 1849-1936. *On the Boulevard Montmartre, in Front of the Théâtre des Variétés*, 1880. Oil on canvas, 15⅛x21¹⁵⁄₁₆ in. (38.8x55.9 cm). Lower left: Jean Béraud. Private Collection

5. **Jean Béraud**, French, 1849-1936. *Avenue des Champs-Élysées*, ca. 1885. Oil on canvas, 58⅛x41⅞ in. (147.6x106.4 cm). Lower right: Jean Béraud. Private Collection, United States

6. **Frank Meyer Boggs**, American, 1855-1926. *Paris Street Scene*, 1893. Oil on canvas, 46½x57¾ in. (118.1x146.7 cm). Lower left: Boggs/1893. The Metropolitan Museum of Art, Gift of Mr. and Mrs. Arthur G. Altschul, 1971. 1971.246.1

7. **Edward Darley Boit**, American, 1843-1915. *Place de l'Opéra, Paris*, 1883. Watercolor, 21½x30 in. (55x76 cm). Lower left: Boit / Paris '83. Museum of Fine Arts, Boston, Gift of the artist. 1888.331

*8. **Pierre Bonnard**, French, 1867-1947. *Promenade*, 1895. Four-panel folding screen. Color lithograph, each panel approximately 59⅞x19⅞ in. (151.8x50.5 cm). Museum of Fine Arts, Boston, Ernest Longfellow Fund. 1976.605 (not illustrated)

This paneled screen made from four separate lithographs was one of at least five screens designed by Bonnard. The artist has conjured up a day in the Tuileries gardens that is drawing to a close (Ives, p. 114, note 37). In the background three nursemaids stroll toward the waiting cabs, while in the foreground an attentive mother shepherds her playful children home across the Place de la Concorde. The frisky dogs beloved by all Parisians romp throughout, and a sense of contemporary pleasure is charmingly described.

9. **Pierre Bonnard**, French, 1867-1947. *The Barrel Organ Grinder* (L'Orgue de Barbarie), 1895. Oil on panel, 16x10¼ in. (41x26 cm). Lower center: 95 / PBonnard. William Kelly Simpson

10. **Pierre Bonnard**, French, 1867-1947. *Rue Tholozé*, ca. 1898. Oil on canvas, 25½x13 in. (64.9x33 cm). Lower left: Bonnard. William Kelly Simpson

*11. **Pierre Bonnard**, French, 1867-1947. *The Pushcart* (Marchand de quatre-saisons), ca. 1897. From the series *Quelques aspects de la vie de Paris*, 1899. Color lithograph; image: 11⅜x13⅜ in. (29x34 cm). Lower right: P Bonnard. Museum of Fine Arts, Boston, Bequest of W.G. Russell Allen. 60.59 (not illustrated)
Itinerant merchants traditionally supplied home kitchens with fresh vegetables from small carts. The title often given by cataloguers to this print, Merchant of Four Seasons, aptly describes the ongoing market. The vendor was part of Marcel Proust's "cries of Paris," representing a daily and pleasurable way of life that has since disappeared. Nonetheless, foreigners are still struck by the attractive displays of foods that appear in such abundance throughout the city.

12. **Pierre Bonnard**, French, 1867-1947. *The Square at Evening*, ca. 1897-1898. From the series *Quelques aspects de la vie de Paris*, 1899. Color lithograph; image: 11x15 in. (28x38 cm). Lower right: P Bonnard. Museum of Fine Arts, Boston, Bequest of W.G. Russell Allen. 60.58

*13. **Pierre Bonnard**, French, 1867-1947. *Boulevard*, ca. 1896. From the series *Quelques aspects de la vie de Paris*, 1899. Color lithograph; image: 11x15 in. (28x38 cm). Lower right: no 16 / P Bonnard. Museum of Fine Arts, Boston, Bequest of W.G. Russell Allen. 60.57 (not illustrated)

In sequential segments, Bonnard has depicted a lively scene from everyday life, including the shops that the artist may have frequented. The Boulevard de Clichy was a favorite avenue for strolling and provided a pleasurable commercial center for its residents and visitors as well.

14. **Pierre Bonnard**, French, 1867-1947. *Paris Boulevard at Night*, 1900. Oil on paperboard, 17¾x22⅞ in. (45x58.2 cm). Lower right: Bonnard 19[00]. Museum of Fine Arts, Boston, Bequest of John Spaulding. 48.520 (not illustrated)

Bonnard selected and transcribed a close-up view of street activity and busy nightlife that he probably observed from his studio window in Montmartre. A preoccupation with light effects at night confirms his interest in new forms of lighting. Rather than depicting life in cabarets, Bonnard chose to emphasize his neighborhood streets.

*15. **Félix Bracquemond**, French, 1833-1914. *At the Zoological Gardens* (Au Jardin d'Acclimatation), 1873. Color etching and aquatint; image: 8⅜x8½ in. (21.3x21.7 cm). Museum of Fine Arts, Boston, Frederick Keppel Memorial Fund, Gift of David Keppel. 13.5094

*16. **Félix Buhot**, French, 1847-1898. *The National Holiday on the Boulevard [de] Clichy* (La fête nationale du 30 juin au boulevard [de] Clichy), 1878. Etching, aquatint, and drypoint printed in black ink with margins printed in brown ink; image: 12⅜x9¼ in. (31.7x23.5 cm). Lower center: épreuve d'essai / Felix Buhot 3. Courtesy of the Boston Public Library, Print Department, Gift of Albert H. Wiggin (not illustrated)

The fluttering tricolored flags and the variety of figural types clearly indicate the festive nature of this special occasion. The holiday was organized by the conservative MacMahon government of the Third Republic in conjunction with the Universal Exposition of 1878. It was intended to celebrate the recovery of the city after the Franco-Prussian war and the Commune that followed. Buhot's preference for multiple vignettes within the margins expands the subject matter of this holiday as it unfolded in Montmartre.

*17. **Félix Buhot**, French, 1847-1898. *Winter in Paris or Paris in the Snow* (L'hiver à Paris ou la neige à Paris), 1879. Etching, aquatint, drypoint; image: 10¼x14⅛ in. (26x35.9 cm). Courtesy of the Boston Public Library, Print Department, Gift of Albert H. Wiggin (not illustrated)

The central image depicts a cold, wintry scene at Place Breda, and the designs in the margin show the devastation the weather caused. The recreations that some may have derived on this fierce day such as skating on the frozen Seine or watching dogs at play are overshadowed by the hardships that the abnormally frigid spell inflicted. Horses froze to death, and workers, including street sweepers, sought out small stoves to keep warm, while coach drivers huddled against the icy cold.

*18. **Paul Cézanne**, French, 1839-1906. *On the Banks of the Pond* (Au bord de l'étang), 1872-1875. Oil on canvas, 18½x22⅛ in. (47x56.2 cm). Museum of Fine Arts, Boston, Tomkins Collection. 48.244

19. **Marc Chagall**, French, born in Russia, 1887-1985. *Pont de Passy and the Eiffel Tower* (Pont de Passy et le Tour Eiffel), 1911. Oil on canvas, 23¾x32 in. (60x80 cm). Lower center: Marc Chagall 1911. The Metropolitan Museum of Art, Robert Lehman Collection, 1975. 1975.1.161

20. CHAM (Charles Henri Amédée de Noé), French, 1818-1879. *Almanach du Charivari*, 1865. Poster, color lithograph, 12⅜x18⅞ in. (31.6x48 cm). Museum of Fine Arts, Boston, Lee M. Friedman Fund. 1990.264 (not illustrated)

A contemporary of Daumier, CHAM was one of the great cartoonists of his time; his humorous images illustrated numerous publications for a large readership. The prints he made for the journal Charivari *from 1848 to 1878 were concerned with the daily life of Parisians (Grand-Cartaret, p. 358). In this almanac, CHAM used just three colors — black, red, and blue — to highlight his compositions.*

21. Henri-Edmond Cross, French, 1856-1910. The *Nursemaids at the Champs-Élysées* (Les nourrices aux Champs-Élysées), 1898. Color lithograph, first state before letters; image: 8x10¼ in. (20.1x26 cm). Museum of Fine Arts, Boston, Gift of Mr. and Mrs. Peter A. Wick. 59.1013

22. Honoré Daumier, French, 1808-1879. *Now my flower pot will have some sunshine . . . I will finally know whether it is a rose or a gillyflower* (Voilà donc mon pot de fleurs qui va avoir du soleil . . . je saurai enfin si c'est un rosier ou une girofleé). From the series *Actualitiés*, published in *Charivari*, December 18, 1852. Lithograph; image: 7½x10⅜ in. (19x26.3 cm). Museum of Fine Arts, Boston, William P. Babcock Bequest. 147/4184

*23. Honoré Daumier, French, 1808-1879. *Sunday at the Jardin des Plantes* (Le dimanche au Jardin des Plantes). Published in *Boulevard*, March 23, 1862. Lithograph, first state on chine appliqué; image: 10¼x8⅜ in. (26.5x21.4 cm). Museum of Fine Arts, Boston, William P. Babcock Bequest. 16/4265

24. Honoré Daumier, French, 1808-1879. *Nadar Elevating Photography to the Height of Art* (Nadar élévant la Photographie à la hauteur d'artiste). From the series *Souvenirs d'artistes*, published in *Boulevard*, May 25, 1862. Lithograph; image: 10½x8¾ in. (26.7x22.2 cm). Museum of Fine Arts, Boston, Bequest of W.G. Russell Allen. 63.1998 (see back cover)

25. Maurice Denis, French, 1870-1943. *The Toulouse Dispatch (La Dépêche de Toulouse)*, 1892. Poster, color lithograph, 55⅝x37⅜ in. (141.3x95.1 cm). Jane Voorhees Zimmerli Art Museum, Rutgers, The State University of New Jersey, Alvin and Joyce Glasgold Purchase Fund. 1986.0089

26. Kees van Dongen, Dutch, 1877-1968. *The Carrousel* (Le carrousel), 1904. Oil on canvas, 18x21¾ in. (46x55 cm). Lower left: Van Dongen. Melas Kyriazi Collection

*27. William James Glackens, American, 1870-1938. *Flying Kites, Montmartre*, 1906. Oil on canvas, 26x34¼ in. (66x87 cm). Lower left: W. Glackens. Museum of Fine Arts, Boston, Charles Henry Hayden Fund. 38.7

28. Eugène Guérard, French, 1821-1866. *Physiognomies of Paris no. 4: The Boulevard des Italiens (The Tortoni, 4 o'clock in the evening)* (Physionomies de Paris no. 4: Boulevard des Italiens [Tortoni, 4 heures du soir]), 1856. Color lithograph with hand-coloring; image: 11½x16⁷⁄₁₆ in. (29.2x41.8 cm). Sterling and Francine Clark Art Institute, Williamstown, Massachusetts. No. 2531

29. Eugène Guérard, French, 1821-1866. *Physiognomies of Paris no. 7: The Skaters (Lake in the Bois de Boulogne)* (Physionomies de Paris no. 7: Les patineurs [Lac du Bois de Boulogne]), 1857. Color lithograph with hand-coloring; image: 11⅝x16⁵⁄₁₆ in. (29.5x41.4 cm). Sterling and Francine Clark Art Institute, Williamstown, Massachusetts. No. 2532 (not illustrated)

Though a native of Nancy, Guérard spent considerable time in Paris. In the late 1850s he worked primarily for the Maison Goupil, a major publisher of popular lithographs.

30. Eugène Guérard, French, 1821-1866. *Physiognomies of Paris no. 9: Ball at the Opéra* (Physionomies de Paris no. 9: Bal de l'Opéra), 1856-1858. Color lithograph with hand-coloring; image: 11¹¹⁄₁₆x16¹¹⁄₁₆ in. (29.7x42.4 cm). Sterling and Francine Clark Art Institute, Williamstown, Massachusetts. No. 2518 (not illustrated)

31. Eugène Guérard, French, 1821-1866. *Physiognomies of Paris no. 10: A Line at the Theater (The Ambigu Comique)* (Physionomies de Paris no. 10: Une queue au théâtre [Ambigu Comique]), 1856-1858. Color lithograph with hand-coloring; image: 11⅞x17⅛ in. (30.2x43.5 cm). Sterling and Francine Clark Art Institute, Williamstown, Massachusetts. No. 2535 (not illustrated)

This theater on Boulevard Saint Martin opened in 1828 after the original building was destroyed by fire. It contained nineteen hundred seats and followed a long tradition of presenting melodramas and vaudeville shows in which the audiences "cried heartily."

32. Maxime Lalanne, French, 1827-1886. *Demolition for the Creation of the Rue des Écoles* (Démolitions pour le percement de la rue des Écoles), 1865. From *Eaux-fortes modernes publiées par la société des aquafortistes*, 4th year, 1866. Etching, proof before letters. Image: 9¼x12⅜ in. (23.5x31.4 cm). Museum of Fine Arts, Boston, Gift of Miss Ellen Bullard. 25.1216

33. Auguste Lepère, French, 1849-1918. *July 14, 1881, Venetian Fête in the Bois de Boulogne during the Fireworks* (Le 14 juillet 1881, fête de nuit au Bois de Boulogne). For *Le Monde illustré*, July 22, 1881. Wood engraving designed by Lepère and engraved in collaboration with Tony Beltrand. Image: 12¼x17⅞ in. (31x45.5 cm). The Metropolitan Museum of Art, The Elisha Whittelsey Collection, The Elisha Whittelsey Fund, 1963. 63.625.20(1)

34. Auguste Lepère, French, 1849-1918. *July 14, Illumination of the Palais du Trocadéro* (La fête du 14 juillet, l'illumination du palais du Trocadéro). For *Le Monde illustré*, July 21, 1883. Wood engraving; image: 12½x18 in. (31.8x45.8 cm). The Metropolitan Museum of Art, The Elisha Whittelsey Collection, The Elisha Whittelsey Fund, 1963. 63.625.20(3)

35. Auguste Lepère, French, 1849-1918. *The Pond in the Tuileries* (Le bassin des Tuileries), 1898. For *L'Estampe nouvelle*. Woodcut variant; image: 8⅝x12½ in. (21.8x31.7 cm). Lower right: A Lepère and EN stamp in lower right of image; lower left: 32. Private Collection

36. Auguste Lepère, French, 1849-1918. *Sunday at the Fortifications* (Dimanche aux fortifs), 1898. Color woodcut, undescribed first state before changes to upper left corner; image: 10¾x13¼ in. (27.2x33.2 cm). Museum of Fine Arts, Boston, Lee M. Friedman Fund. 1990.256

37. Auguste Lepère, French, 1849-1918. *Modern Bucolic Pleasures* (Bucolique moderne), 1901. From *Die graphische Kunst*. Color woodcut; image: 10¹⁵⁄₁₆x15⅜ in. (26.3x39 cm). Museum of Fine Arts, Boston, Purchased by subscription. M19224

38. Édouard Manet, French, 1832-1883. *Little Girls in the Tuileries* (Petites filles aux Tuileries), ca. 1861-1862. Oil on canvas, 15x18¼ in. (38x46.5 cm). Museum of Art, Rhode Island School of Design, Providence, Museum Appropriation. 42.190

39. Édouard Manet, French, 1832-1883. *The Balloon* (Le ballon), 1862. Lithograph; image: 15⅞x20¼ in. (40.3x51.5 cm). Fogg Art Museum, Harvard University, Purchase from the Program for Harvard College. M13,710 (illustrated on page 8)

40. Édouard Manet, French, 1832-1883. *The Barricade* (Le barricade), 1871, published in 1884. Lithograph, proof possibly before publication; image: 18⅜x13⅛ in. (46.5x33.3 cm). Museum of Fine Arts, Boston, Gift of W.G. Russell Allen. 25.717 (not illustrated)

In the last days of the Commune, Manet was well aware of the massacres that took place all over Paris. In sympathetic response to the Communards, he produced two powerful lithographs (cat. 40, 41) based in part on historical events and also on paintings in which he had previously explored the subject, for example, The Execution of Maximilian. *In both prints the barricades of stones that Haussmann had thought he could prevent with his extensive widening of the streets are shown nearly intact. Along with the frivolities and exuberance of the Second Empire, it is important to recall this brief and bloody civil war that altered the history of Paris and planted the seeds of an enduring social discontent.*

41. Édouard Manet, French, 1832-1883. *Civil War* (Guerre Civile), 1871-1873, published in 1884. Lithograph. Image: 15⅝x20 in. (39.7x50.8 cm). Museum of Fine Arts, Boston, Gift of W.G. Russell Allen. 23.1323

42. Neurdein Brothers (Étienne and Antoine), French, late 19th century. *Universal Exhibition of 1900: Moving Sidewalk, Station of the Pont des Invalides* (Exposition Universelle de 1900: Trottoir roulant, station du Pont des Invalides), 1900. Photograph, albumen print, 11x17⅛ in. (28.0x43.6 cm). Smith College Museum of Art, Northampton, Massachusetts, Purchased with funds given in honor of Ruth Wedgewood Kennedy and Beaumont Newhall, and with the combined Hillyer-Tryon-Mather Funds, 1982. TR 4629-27 (not illustrated)

The brothers Étienne and Antoine Neurdein assisted the official photographer Marius Bar with the photographic recording of the Exposition. The fair's mobile sidewalk was a great attraction. According to one observer: "The sensation of moving through the branches of trees while standing upon an apparently stationary platform of boards, is both novel and peculiar, and the enjoyment is so acute that many visitors take special trips on the rolling sidewalk for the pleasure it affords. . . . The trip at night, when all the buildings and the grounds are brilliantly lighted with myriads of colored electric

points, is peculiarly enjoyable, and thousands of gay Parisians, as well as [foreigners] from all quarters of the globe, gladly avail themselves of the opportunity to glide thus smoothly around the Exposition's area" (Mayer, verso of sixth leaf).

43. Neurdein Brothers (Étienne and Antoine), French, late 19th century. Universal Exhibition of 1900: View of the Eiffel Tower (Exposition Universelle de 1900: Vue sur la Tour Eiffel), 1900. Photograph, albumen print, 11 x 17⅛ in. (28.0 x 43.6 cm). Smith College Museum of Art, Northampton, Massachusetts, Purchased with funds given in honor of Ruth Wedgewood Kennedy and Beaumont Newhall, and with the combined Hillyer-Tryon-Mather Funds, 1982. TR 4625-19

44. Camille Jacob Pissarro, French, 1831-1903. The Garden of the Tuileries on a Winter Afternoon, II (Le Jardin des Tuileries, après-midi d'hiver), 1899. Oil on canvas, 27⅞ x 36⅜ in. (73.3 x 92.4 cm). Lower left: C. Pissarro 99. The Metropolitan Museum of Art, Gift from the Collection of Marshall Field III, 1979. 1979.414

45. Jean-François Raffaëlli, French, 1850-1924. Place de la Concorde, Paris, ca. 1895-1900. Oil on canvas, 28 x 32 in. (71.1 x 81.3 cm). Lower right: J Raffaëlli. Museum of Art, Rhode Island School of Design, Providence, Gift of Colonel Webster Knight. 28.040

46. Paul Ranson, French, 1862-1909. Woman Standing beside a Balustrade with a Poodle (Femme debout contre une balustrade avec un caniche), ca. 1895. Oil on canvas, 33½ x 11⅝ in. (85 x 29.5 cm). Lower right: P Ranson. Mr. and Mrs. Arthur G. Altschul

47. Claude-Émile Schuffenecker, French, 1851-1934. Boulevard Arago, 1884. Charcoal and crayon, 14⅛ x 11⅞ in. (36.2 x 30.2 cm). Lower left: E Schuffenecker. Mr. and Mrs. Arthur G. Altschul (not illustrated)

In Boulevard Arago Schuffenecker has depicted a lively street scene in Montparnasse with a "pointillist" method of execution. He was instrumental in arranging for gallery space in the Café Volpini on the grounds of the 1889 Universal Exposition. More than one hundred works were shown there by Gauguin, Bernard, Anquetin, himself, and others. Since the official French arts pavilion did not welcome these artists, the alternative space made their work accessible to visitors to the fair.

48. Claude-Émile Schuffenecker, French, 1851-1934. Concert in the Tuileries (Concert aux Tuileries), ca. 1886. Pen and ink, 9¼ x 12¹⁵⁄₁₆ in. (23.5 x 33 cm). Lower left: monogram and lily symbol. Mr. and Mrs. Arthur G. Altschul (not illustrated)

An admirer of the Impressionists, Schuffenecker was particularly attracted to the work of Georges Seurat, whose theories on composition and technique had a strong influence on his style. From 1884 on, Schuffenecker became an ardent supporter of Seurat's Neo-Impressionism but used his own form of hatching, or small commalike strokes. In Concert in the Tuileries he shows an audience attending a popular musicale, with informative detail rendered in fine pen and ink lines.

*49. Théophile-Alexandre Steinlen, Swiss, worked in France, 1859-1923. The Street (La rue), 1896. Poster, color lithograph on six sheets, 92⅝ x 120⅝ in. (238 x 304 cm). The Metropolitan Museum of Art, Harris Brisbane Dick Fund, 1932. 32.88.18

50. Théophile-Alexandre Steinlen, Swiss, worked in France, 1859-1923. In the Street (Dans la rue [gigolots et gigolettes]). Cover for the second volume of Dans la rue by Aristide Bruant, 1895. Color lithograph, proof; image: 8½ x 10⅞ in. (21.5 x 27.8 cm). Museum of Fine Arts, Boston, Bequest of W.G. Russell Allen. 60.743

51. Alfred Stieglitz, American, 1864-1946. A Wet Day on the Boulevard. Negative 1894, photogravure 1897. Plate: 8½ x 13¼ in. (21.7 x 33.7 cm). Museum of Fine Arts, Boston, Gift of David Bakalar. 1975.657

52. Henri de Toulouse-Lautrec, French, 1864-1901. Cover for Les vieilles histoires, a collection of poems by Jean Goudezki set to music by Désiré Dihau, 1893. Color lithograph; image: 13⅜ x 21¼ in. (34 x 54 cm). Courtesy of the Boston Public Library, Print Department, Gift of Albert H. Wiggin

53. Henri de Toulouse-Lautrec, French, 1864-1901. The Photographer Sescau (Le photographe Sescau), 1896. Poster, color lithograph, 24¼ x 31⅜ in. (61.7 x 79.8 cm). Courtesy of the Boston Public Library, Print Department, Gift of Albert H. Wiggin

54. Abel Truchet, French, 1857-1918. Luxembourg Gardens, ca. 1900. Color lithograph, 24¼ x 33⅞ in. (61.5 x 86 cm). Jane Voorhees Zimmerli Art Museum, Rutgers, The State University of New Jersey, Gift of Mr. and Mrs. Herbert Littman. 1986.1214

55. Félix Vallotton, Swiss, worked in France, 1865-1925. The Demonstration (La manifestation). From L'Estampe originale, 1893. Woodcut; image: 8 x 12⅝ in. (20.3 x 32 cm). Lower right: No. 34 F. Vallotton. The Museum of Modern Art, New York, Gift of Victor S. Riesenfeld. 367.48

56. Félix Vallotton, Swiss, worked in France, 1865-1925. The Shower (L'averse), 1894. Woodcut; image: 7⅛ x 8⅞ in. (18.1 x 22.7 cm). Lower right: 9 F. Vallotton. The Brooklyn Museum, H.L. Batterman Fund. 42.423 (not illustrated)

Vallotton's witty abstraction of passersby scurrying in a downpour is derived from Japanese book illustrations both in subject matter and in the use of flat areas of black tone. The highly simplified and decorative patterns are typical of Vallotton's woodcuts. His prints were enormously important in the development of the Art Nouveau style and appealed widely on a popular level.

*57. Félix Vallotton, Swiss, worked in France, 1865-1925. Street Scene with the Little Laundress, ca. 1895. Oil on cardboard, 10¼ x 13⅜ in. (26 x 34 cm). Lower left: F. Vallotton. Private Collection (not illustrated)

At this time Vallotton, like Bonnard, favored stylish Parisiennes as his subjects. However, in this depiction of a small child walking on a stone-paved street, Vallotton's keen eye for social realism is apparent. The young girl is not a schoolchild but part of the large female work force that constantly transported laundry across the city.

58. Édouard Vuillard, French, 1868-1940. At the Tuileries (Les Tuileries). Published in L'Épreuve, 1895. Color lithograph, printed in green, 9½ x 10¾ in. (24 x 27.5 cm). William Kelly Simpson

*59. Édouard Vuillard, French, 1868-1940. The Tuileries Garden (Le jardin des Tuileries). From L'Album des peintre-graveurs, 1896. Color lithograph; image: 12 x 17 in. (32 x 43 cm). Upper right: E Vuillard / no 89. Museum of Fine Arts, Boston, Bequest of W.G. Russell Allen. 60.103 (not illustrated)

*60. Édouard Vuillard, French, 1868-1940. The Avenue (L'avenue) From the suite Paysages et intérieurs, 1899. Color lithograph; image: 12¼ x 16¼ in. (31.5 x 41 cm). Lower right: E Vuillard. Museum of Fine Arts, Boston, Bequest of W.G. Russell Allen. 60.107 (not illustrated)

61. Édouard Vuillard, French, 1868-1940. The Pastry Shop (La patisserie). From the suite Paysages et intérieurs, 1899. Color lithograph; image: 14⅛ x 11 in. (35.5 x 28 cm). Lower right: E Vuillard. Museum of Fine Arts, Boston, Bequest of W.G. Russell Allen. 60.115 (not illustrated)

The series Paysages et intérieurs, Vuillard's most visually and technically complex prints, was made at the end of the 1890s and published by the dealer Ambroise Vollard. In this image the patisserie, a symbol of the French good life, is a backdrop for a terrace café and its lively evening activity. The print's unusual combination of colors betrays Vuillard's interest in Japanese art and suggests the cacophony of the boulevard cafés, even after dark.

The Bois de Boulogne: Horse Races and Other Sporting Events

62. Louis Anquetin, French, 1861-1932. The Finish (L'arrivée), 1894. Color lithograph, 14 x 20⅝ in. (35.5 x 52.5 cm). Jane Voorhees Zimmerli Art Museum, Rutgers, The State University of New Jersey, Edward and Lois Grayson Purchase Fund. 1988.0935

63. Pierre Bonnard, French, 1867-1947. Boating (Le canotage), 1896-1897. From L'Album d'estampes originales de la Galerie Vollard, 1897. Color lithograph; image: 10⅝ x 18½ in. (27 x 47 cm). Lower left: P Bonnard. Museum of Fine Arts, Boston, Bequest of W.G. Russell Allen. 60.68 (not illustrated)

Bonnard's interests in aspects of city life were broad enough to encompass the suburban pleasures of boating. The Seine at Chatou, just outside Paris, was a favorite location for rowers. The artist shows picnickers on the bank and spectators on a trestle bridge overlooking the enjoyable Sunday scene.

64. Jules Chéret, French, 1836-1932. Palais de Glace Champs-Élysées, front view, 1894. Color lithograph, 23⅞ x 16⅛ in. (60.6 x 41 cm). Sterling and Francine Clark Art Institute, Williamstown, Massachusetts. No. 2395

65. Jules Chéret, French, 1836-1932. Palais de Glace Champs-Élysées, back view, 1894. Color lithograph, 23⅝ x 16⅛ in. (60 x 41 cm). Sterling and Francine Clark Art Institute, Williamstown, Massachusetts. No. 2394 (not illustrated)

In the 1890s many commercial enterprises commissioned posters from Chéret, who executed them in a variety of sizes. The skating rink, one of the passions of Parisians, was frequently and successfully publicized by the Chéret series. This sporting event attracted

stylish young women and gallant men and inspired many of the artists of the period.

*66. **Hilaire Germain Edgar Degas**, French, 1834-1917. *Race Horses at Longchamp*, 1871, reworked in 1874. Oil on canvas, 13⅜ x 16½ in. (34.1 x 41.8 cm). Lower left: E Degas. Museum of Fine Arts, Boston, S. A. Denio Collection. 03.1034

*67. **Hilaire Germain Edgar Degas**, French, 1834-1917. *At the Races*, 1880-1885. Graphite on reddish-brown paper, 13¾ x 19 in. (34.9 x 48.2 cm). Sterling and Francine Clark Art Institute, Williamstown, Massachusetts. No. 1401 (not illustrated)
Although there are several paintings executed by Degas in the 1880s for which this drawing could be a study, one should also keep in mind the accomplished pastel Before the Race, *ca. 1882-1884 (Museum of Art, Rhode Island School of Design, Providence). In both friezelike compositions, Degas has focused on the clustering and horizontal parade of horses and jockeys as they maneuver for a position at the starting gate. Repeated sketches on the drawing sheet clearly reveal Degas's interest in the strong body motions of the horses and the rhythmic movement of their legs and hooves.*

*68. **Hilaire Germain Edgar Degas**, French, 1834-1917. *Horse with Head Lowered*, modeled 1881-1890, cast after 1919. Bronze; height: 7½ in. (19.2 cm). Museum of Fine Arts, Boston, Bequest of Margarett Sargent McKean. 1979.506 (not illustrated)

*69. **Hilaire Germain Edgar Degas**, French, 1834-1917. *Horse Galloping, on Right Foot*, modeled 1881-1890, cast after 1919. Bronze; height: 11⅞ in. (30.3 cm). Museum of Fine Arts, Boston, Centennial Gift of Mrs. Margarett Sargent McKean. 1973.682 (not illustrated)

70. **Jean-Louis Forain**, French, 1853-1931. *The Race Track* (Champ de course), ca. 1890. Oil on canvas, 35½ x 46 in. (90.2 x 116.8 cm). Lower right: j.l. forain. The Springfield Museum of Fine Arts, Springfield, Massachusetts, The James Philip Gray Collection. 55.03

71. **Childe Hassam**, American, 1859-1935. *Grand Prix Day*, 1887. Oil on canvas, 24 x 34 in. (61 x 86.4 cm). Lower left: Childe Hassam Paris — 1887. Museum of Fine Arts, Boston, Ernest Wadsworth Longfellow Fund. 64.983

72. **Édouard Manet**, French, 1832-1883. *The Races* (Les courses), 1865-1872, published in 1884. Lithograph; image: 15⅞ x 20⅜ in. (40.3 x 51.7 cm). Museum of Fine Arts, Boston, Gift of W.G. Russell Allen. 23.1325

*73. **Georges Stein**, French, active late 19th-early 20th century. *Promenade on the Avenue du Bois, and in the Background, the Arc de Triomphe* (Promenade sur l'avenue du Bois, et au fond, l'Arc de Triomphe), ca. 1900. Watercolor over graphite, 13¾ x 19½ in. (35 x 49.6 cm). Lower left: Georges Stein [repeated] Paris. Private Collection, United States

74. **Henri de Toulouse-Lautrec**, French, 1864-1901. *Skating Professional Beauty — Edward Dujardin and Liane de Lancy at the Palais de Glace*
and
Théophile-Alexandre Steinlen, Swiss, worked in France, 1859-1923. *Au Moulin de la Galette*
Front and back covers of *Le Rire*, no. 62, January 11, 1896. Color photorelief, 12⅝ x 18⅝ in. (32 x 47.5 cm). Jane Voorhees Zimmerli Art Museum, Rutgers, The State University of New Jersey, Gift of Norma B. Bartman. 1986.0428.001 (not illustrated)
Toulouse-Lautrec's design for Le Rire *shows Édouard Dujardin and the "professional beauty" Liane de Lancy at one of the most fashionable spots in Paris, the Palais de Glace. The stylish woman has paused by her gentleman friend while skating in the uncrowded rink. Lautrec's image is in marked contrast to Steinlen's social comment that illustrates a typically busy evening at the Moulin de la Galette, frequented by a working-class clientele.*

75. **Henri de Toulouse-Lautrec**, French, 1864-1901. *The Automobilist* (L'automobiliste), 1898. Lithograph; image: 14¾ x 10½ in. (45.4 x 26.8 cm). Museum of Fine Arts, Boston, Bequest of W.G. Russell Allen. 60.771

76. **Henri de Toulouse-Lautrec**, French, 1864-1901. *The Jockey* (Le jockey), 1899. Color lithograph, 20¼ x 14⅛ in. (51.4 x 35.8 cm). Museum of Fine Arts, Boston, Horatio Greenough Curtis Fund. 24.1704

77. **Henri de Toulouse-Lautrec**, French, 1864-1901. *The Jockey Led to the Post* (Le jockey se rendant au poteau), 1899. Lithograph, proof with hand-coloring, 20⅜ x 14¼ in. (51.9 x 36.3 cm). Museum of Fine Arts, Boston, The Helen and Alice Colburn Fund. 55.951

78. **Édouard Vuillard**, French, 1868-1940. *Bécane*, ca. 1894. Poster, color lithograph, 31¾ x 23¾ in. (80.7 x 60.4 cm). Museum

of Fine Arts, Boston, Gift of Mrs. Frederick B. Deknatel. 1985.242

Museums and Galleries

79. **Frédéric-Auguste Cazals**, French, 1865-1941. *Salon des Cent*, 1894. Poster for the seventh exhibition; color lithograph, 24¾ x 15¼ in. (63 x 39.8 cm). Jane Voorhees Zimmerli Art Museum, Rutgers, The State University of New Jersey, David A. and Mildred H. Morse Art Acquisition Fund. 85.055.009

*80. **Honoré Daumier**, French, 1808-1879. *A Short Line at the Door of the Palais de l'Industrie.* (Une légère queue à la porte du Palais de l'Industrie). No. 7 from the series *Les étrangers à Paris*, published in *Charivari*, June 16, 1844. Lithograph with hand-coloring, before publication; page: 13¼ x 10 in. (33.7 x 25.5 cm). Arthur and Charlotte Vershbow, Boston (not illustrated)
In this amusing lithograph, the visitor hopes to avoid the long line by showing his pass to the gendarme, who replies: "It is because of that [pass] that you only have to get in line near the Obelisk . . . without that you would have to go to the other side, near the Arc de l'Étoile . . . for the rest, one eats along the route, there is a restaurant about half way." The Salon painting show was held annually at the Palais de l'Industrie, a large exhibition hall, and on free days the attendance was enormous.

81. **Honoré Daumier**, French, 1808-1879. *A day when one does not pay. — Twenty-five degrees celsius.* (Un jour où l'on ne paye pas. — Vingt-cinq degrés de chaleur.) No. 10 from the series *Le public du Salon*, published in *Charivari*, May 17, 1852. Lithograph; image: 9½ x 8½ in. (24.1 x 21.6 cm). Museum of Fine Arts, Boston, William P. Babcock Bequest. 9/4247

82. **Honoré Daumier**, French, 1808-1879. *THE VISITOR — Oh! for once here is a picture which is really senseless! and what color! THE ARTIST — Bourgeois Cretin, go away!* (LE VISITEUR — Oh! pour le coup voilà une composition qui est réellement insensée! et quelle couleur! L'ARTISTE — Crétin de bourgeois va!) From the series *Croquis pris au Salon*, published in *Charivari*, May 30, 1864. Lithograph; image: 9½ x 8⅜ in. (24.2 x 21.3 cm). Museum of Fine Arts, Boston, Bequest of W.G. Russell Allen. 63.2038

83. **Hilaire Germain Edgar Degas**, French, 1834-1917. *Mary Cassatt at the Louvre: The Etruscan Gallery*, 1879-1880. Soft-ground etching, drypoint, aquatint, and etching; image: 10⁹⁄₁₆ x 9⅛ in. (26.9 x 23.3 cm). Museum of Fine Arts, Boston, Katherine E. Bullard Fund in Memory of Francis Bullard and proceeds from sale of duplicate prints. 1983.310

84. **Hilaire Germain Edgar Degas**, French, 1834-1917. *Mary Cassatt at the Louvre: The Paintings Gallery*, 1879-1880. Soft-ground etching, drypoint, aquatint, and etching; image: 11¹⁄₁₆ x 4¹¹⁄₁₆ in. (30.5 x 12.5 cm). Museum of Fine Arts, Boston, Katherine E. Bullard Fund in Memory of Francis Bullard and proceeds from sale of duplicate prints. 1983.309

85. **Hilaire Germain Edgar Degas**, French, 1834-1917. *A Visit to the Museum*, ca. 1885. Oil on canvas, 36⅛ x 26¾ in. (91.8 x 68 cm). Stamped, lower right: Degas. Museum of Fine Arts, Boston, Gift of Mr. and Mrs. John McAndrew. 69.49

86. **Paul César F. Helleu**, French, 1859-1927. *Madame Helleu Looking at Drawings by Watteau at the Louvre* (Madame Helleu devant les dessins de Watteau au Louvre), ca. 1895. Drypoint printed in black and brown; image: 11¾ x 15¾ in. (29.9 x 40 cm). Lower left: Helleu. Museum of Fine Arts, Boston, George R. Nutter Fund. 62.991

87. **Albert Herter**, American, 1871-1950. *Exhibition of Completely New Art* (Exposition de l'art tous nouveau), ca. 1900. Gouache, 24⅜ x 18⅞ in. (62 x 48 cm). Jane Voorhees Zimmerli Art Museum, Rutgers, The State University of New Jersey, Gift of Mr. and Mrs. Herbert D. Schimmel. 1986.0383 (not illustrated)
Son of the furniture designer and decorator Christian Herter, Albert Herter was active as an artist in Paris in the late 1890s and 1900s, taking classes at the Académie Julian and subsequently winning several awards for his paintings. In this design, Herter pokes fun at the highly successful gallery owner Siegfried Bing and his wares at L'Art Nouveau. Herter has concealed the gallery's name so that it is not fully readable, listed an incorrect address, and depicted the visitors in sharp caricature as if they are attending a ball instead of an exhibition. His poster implies that Bing and his supporters should come up with art that was really "new."

88. **Winslow Homer**, American, 1836-1910. *Art Students and Copyists in the Louvre Gallery, Paris*. From the journal *Harper's Weekly*, January 11, 1868. Wood engraving; image: 9¹⁄₁₆ x 13¹¹⁄₁₆ in. (23 x 35.4 cm). Addison Gallery of American Art, Phillips Academy, Andover, Massachusetts. 1989.56

89. **Armand Louis Rassenfosse**, Belgian, 1862-1934. *Salon des Cent*, 1896. Poster for the nineteenth exhibition; color lithograph,

proof before lettering; image: 21⅞x14⅝ in. (55.5x37.2 cm). Lower left: 3 / A Rassenfosse. Museum of Fine Arts, Boston, Gift of Benjamin A. and Julia M. Trustman. 1989.249

90. Henri de Toulouse-Lautrec, French, 1864-1901. *Henry Nocq*, 1897. Oil on board, 24¼x19⅜ in. (61.7x49.3 cm). Lower right: T-Lautrec / 97. The Alex Hillman Family Foundation

Theatrical Entertainments

91. Mary Cassatt, American, 1844-1926. *At the Opera*, 1879. Oil on canvas, 31½x25½ in. (80x64.8 cm). Lower left: Mary Cassatt. Museum of Fine Arts, Boston, Charles Henry Hayden Fund. 10.35

92. Honoré Daumier, French, 1808-1879. *They say that the Parisians are difficult to please, on these four benches there is not one discontent. — it is true that all these Frenchmen are Romans.* (On dit que les Parisiens sont difficiles à satisfaire, sur ces quatre banquettes pas un mécontant. — il est vrai que tous ces Français sont des Romains.). No. 3 (numbered "2") from the series *Croquis pris au théâtre* published in *Charivari*, February 13, 1864. Lithograph; image: 9¾x9⅛ in. (24.5x23.2 cm). Museum of Fine Arts, Boston, William P. Babcock Bequest. 2/4218

93. Honoré Daumier, French, 1808-1879. *A Literary Discussion in the Second Balcony* (Une discussion littéraire à la deuxième galerie). No. 4 from *Croquis pris au théâtre*, published in *Charivari*, February 27, 1864. Lithograph; image: 9¾x9 in. (24.5x22.8 cm). Museum of Fine Arts, Boston, William P. Babcock Bequest. 4/4218

94. Hilaire Germain Edgar Degas, French, 1834-1917. *The Ballet from "Robert le Diable,"* 1871-1872. Oil on canvas, 26x21⅜ in. (66x54.3 cm). Lower right: Degas 1872. The Metropolitan Museum of Art, Bequest of Mrs. H.O. Havemeyer, 1929. 29.100.552 *(New York only)*

95. Hilaire Germain Edgar Degas, French, 1834-1917. *Fan Design: Ballet Dancers*, 1879. Watercolor, silver and gold paint on silk, 7½x22¾ in. (19.1x57.9 cm). Center right: Degas. The Metropolitan Museum of Art, Bequest of Mrs. H.O. Havemeyer, 1929. 29.100.555 (not illustrated)

Between 1878 and 1885 Degas made a group of fans; twenty-five are believed to be part of his oeuvre. In this unusual format, he has shown sprightly dancers resting, at center, with scattered sets stationed on an almost bare stage. Degas's appreciation of the ballet performances was shared by Parisians, who flocked in great numbers to the theater and opera.

***96. Hilaire Germain Edgar Degas**, French, 1834-1917. *The Little Fourteen-Year-Old Dancer* (La petite danseuse de quatorze ans), modeled 1879-81, cast after 1919. Bronze, partly tinted, cotton tulle skirt, satin hair ribbon, wooden base; height: 38¼ in. (97.3 cm). Museum of Fine Arts, Boston, Frederick Brown Fund and Contributions. 38.1756 (not illustrated)

97. Hilaire Germain Edgar Degas, French, 1834-1917. *Program for the Soirée Artistique*, 1884. Lithograph; image: 19⅞x12⅝ in. (25x32 cm). Museum of Fine Arts, Boston, Lee M. Friedman Fund. 1984.141 (not illustrated)

Degas created this program for a benefit concert organized by the former pupils of the Lycée de Nantes on June 15, 1884. With the exception of the boats and smokestacks, all the images make visual allusions to the musical selections presented. Such special evenings were part of the social fabric of a Parisian's life, and the performers listed were widely known in the city's cultural world. Most likely, some were Degas's friends, and one of them must have persuaded the artist to design this program.

***98. Hilaire Germain Edgar Degas**, French, 1834-1917. *Dancers in Rose*, ca. 1898. Pastel on paper, 33⅛x22⅞ in. (84.1x58.1 cm). Lower left: degas. Museum of Fine Arts, Boston, Seth K. Sweetser Fund. 20.164

***99. Hilaire Germain Edgar Degas**, French, 1834-1917. *Four Dancers*, ca. 1900. Pastel, 26x30½ in. (66x77.5 cm). Lower left: Degas. Private Collection

100. Jean-Louis Forain, French, 1852-1931. *A Masked Ball* (Un bal masqué), 1885-1890. Oil on canvas, 25½x36½ in. (64.8x92.7 cm). Lower right: j. l. forain. Private Foundation

***101. Jean-Louis Forain**, French, 1852-1931. *Foyer of the Opéra* (Foyer de l'Opéra), ca. 1880. Gouache, 8⅞x12¼ in. (22.5x31.1 cm). Upper left: l. Forain. Museum of Fine Arts, Boston, Lucy Dalbiac Luard Fund. 1971.306

***102. Jean-Louis Forain**, French, 1852-1931. *A Box at the Opéra* (Une loge à l'Opéra) ca. 1880. Gouache and oil on board, 12½x10¼ in. (31.8x26 cm). Lower right: forain. Fogg Art Mu-

seum, Harvard University, Bequest of Annie Swan Coburn. 1934.32

103. Alphonse Mucha, Moravian, worked in France, 1860-1939. *La dame aux camélias*, 1896. Poster for the Théâtre de la Renaissance; color lithograph, 82½x30 in. (210.8x76.2 cm). Museum of Fine Arts, Boston, Gift of Charles Sumner Bird. 1970.514

104. Pierre Auguste Renoir, French, 1841-1919. *A Box at the Opéra* (Une loge à l'Opéra), 1880. Oil on canvas, 39¹⁄₁₆x31¾ in. (99.2x80.6 cm). Upper left: Renoir. 80.; center left: Renoir. Sterling and Francine Clark Art Institute, Williamstown, Massachusetts. No. 594

105. Jan Toorop, Dutch, 1858-1928. *L'Oeuvre*, 1895. Poster for the play *Venise Sauvée* (Venice Preserved) by Thomas Otway, performed at the Théâtre de l'Oeuvre. Lithograph, proof before typographic text of program; image: 17½x11 in. (44.5x28 cm). Museum of Fine Arts, Boston, Lee M. Friedman Fund. 1990.255

106. Henri de Toulouse-Lautrec, French, 1864-1901. *The Loge with the Gilt Mask* (La loge au mascaron doré), 1893. Program for Le Théâtre Libre; color lithograph; 12⅛x9⁷⁄₁₆ in. (30.8x24 cm). Courtesy of the Boston Public Library, Print Department, Gift of Albert H. Wiggin

107. Henri de Toulouse-Lautrec, French, 1864-1901. *The Large Theater Box* (La grande loge), 1897. Color lithograph, 20½x15⁹⁄₁₆ in. (51.5x39.5 cm). Lower left: T-Lautrec/No. 7. Sterling and Francine Clark Art Institute, Williamstown, Massachusetts. No. 1962.118 (not illustrated)

In the tradition of Degas and Cassatt, Lautrec also enjoyed depicting spectators in theater boxes and, with wry humor, used his "friends" as members of the audience. The heavy-set, "upper-class" man seated in a box, unmindful of his neighbors, was Tom, a coachman for the Rothschilds, whom Lautrec knew from a bar. The woman in profile is identified as a one-eyed, former prostitute, who was the owner of a prominent lesbian bar (Stuckey, p. 273).

108. Félix Vallotton, Swiss, worked in France, 1865-1925. *La Pépinière*, 1893. Poster, color lithograph; image: 47⅝x35⁷⁄₁₆ in. (121x90 cm). The Metropolitan Museum of Art, Gift of Mrs. Bessie Potter Vonnoh. 41.12.32 (not illustrated)

If one could not afford a theater ticket, the next most popular and democratic pleasure centers were the music halls, where a viewer could inexpensively enjoy vaudeville or comedic performances. La Pépinière, on Rue de la Pépinière, was a gathering place for soldiers from nearby camps and domestic servants in the area. In this poster Vallotton has forcefully conveyed the boisterous participation of the audience, which was expected to voice its opinion of the musical revue.

109. Édouard Vuillard, French, 1868-1940. *An Enemy of the People* (Un ennemi du peuple), 1893. Program for the performance of the play by Henrik Ibsen at the Théâtre de l'Oeuvre; lithograph; image: 8¾x12⅛ in. (22.5x31 cm). Museum of Fine Arts, Boston, William A. Sargent Fund. 1988.397 (not illustrated)

The actor Aurélien Lugné-Poë founded his own theater, Théâtre de L'Oeuvre, in 1893, where Symbolist plays by Ibsen, Maeterlinck, Mallarmé, and Verlaine were performed. In this play by Ibsen, an idealistic doctor, a "whistle-blower" on pollution, became the enemy of the people when his suggestions met with resistance on economic grounds. The ambiguity and irony of the play are reflected in the program, in which Vuillard's black and white calligraphic design overshadows information about the play.

110. Édouard Vuillard, French, 1868-1940. *Design for a Program for the Théâtre Libre*, ca. 1891. Gouache, ink with brush and touches of graphite, 10⅜x8¼ in. (26.2x21 cm). Lower right, stamped: EV. Museum of Fine Arts, Boston, Gift of William Kelly Simpson. 1986.344 (not illustrated)

In operation from 1887 to 1894, the Théâtre Libre presented avant-garde realist plays by writers such as Zola, Tolstoy, and others. Many young artists produced program covers for the theater; this charming design by Vuillard, however, was never printed as a cover.

Le Chat Noir

111. Anonymous Artist, French, 19th century. *Ombres chinois*, ca. 1890-1900. Toy theater, color lithographs, 15¾x19⅞x5⅛ in. (40x50.5x13 cm). Jane Voorhees Zimmerli Art Museum, Rutgers, The State University of New Jersey, Museum Purchase. 1986.1309 (not illustrated)

112. George Auriol (Jean-Georges Huyot), French, 1863-1938. *Menu for the Chat Noir*, before 1895. Photorelief with stencil coloring, 13¾x9⅞ in. (35x25 cm). Worcester Art Museum, Worcester, Massachusetts, Eliza S. Paine Fund. 1990.29

113. **Emmanuel Caran d'Ache**, French, 1859-1909. *The Epic* (L'épopée). Study for a zinc cutout for *L'épopée*, 1888. India ink, 10¾ x 22⅝ in. (27.2 x 57.5 cm). Jane Voorhees Zimmerli Art Museum, Rutgers, The State University of New Jersey, Gift of Carleton A. Holstrom. 1986.0883

114. **Benjamin Jean Pierre Henri Rivière**, French, 1864-1951. *The Sky* (Le ciel). Photorelief with stencil coloring; in the music book *La tentation de Saint-Antoine*, Paris, E. Plon, Nourrit et Cie, 1887. Page: 10⅜ x 13¼ in. (26.5 x 33.8 cm). Jane Voorhees Zimmerli Art Museum, Rutgers, The State University of New Jersey, Norma B. Bartman Research Library Fund. 1986.1680

115. **Benjamin Jean Pierre Henri Rivière**, French, 1864-1951. *The Temptation of Saint Anthony* (La tentation de Saint-Antoine), 1887. Zinc cutout, 29½ x 16½ in. (75 x 42 cm). Jane Voorhees Zimmerli Art Museum, Rutgers, The State University of New Jersey, Gift of University College, New Brunswick Alumni Association. 1986.0081

116. **Benjamin Jean Pierre Henri Rivière**, French, 1864-1951. *Untitled* (Figures in boat). Zinc cutout, 12⅝ x 21⅝ in. (32 x 55 cm). Jane Voorhees Zimmerli Art Museum, Rutgers, The State University of New Jersey, David A. and Mildred H. Morse Art Acquisition Fund. 1987.0492 (not illustrated)

117. **Benjamin Jean Pierre Henri Rivière**, French, 1864-1951. *Untitled* (Cabaret scene). Zinc cutout, 16⅛ x 29⅛ in. (41 x 74 cm). Jane Voorhees Zimmerli Art Museum, Rutgers, The State University of New Jersey, David A. and Mildred H. Morse Art Acquisition Fund. 1987.0493 (not illustrated)

118. **Benjamin Jean Pierre Henri Rivière**, French, 1864-1951. *The Théâtre d'ombres at the Chat Noir Café*, ca. 1888. Pen and ink, and gouache, 8 x 7⅞ in. (20.5 x 20 cm). Jane Voorhees Zimmerli Art Museum, Rutgers, The State University of New Jersey, Mindy and Ramon Tublitz Purchase Fund. 1987.0194

119. **Benjamin Jean Pierre Henri Rivière**, French, 1864-1951. *Clairs de lune*, 1896. Poster for the *Théâtre du Chat Noir*; photorelief with hand-coloring in border, 22⅞ x 16½ in. (58.1 x 41.9 cm). Jane Voorhees Zimmerli Art Museum, Rutgers, The State University of New Jersey, David A. and Mildred H. Morse Art Acquisition Fund. 85.143.007 (not illustrated)

Rivière designed this poster with a margin of black cats for the shadow-theater programs; the text insert was changed for each new show. Clairs de lune, a play by Rivière with music and poetry by Georges Fragerolle, was offered for the first time at the theater of the Chat Noir, December 1896. It comprised six "tableaux" about nature.

120. **Théophile-Alexandre Steinlen**, Swiss, worked in France, 1859-1923. *Tour of the Chat Noir of Rodolphe Salis* (Tournée du Chat Noir de Rodolphe Salis), 1896. Poster, color lithograph, 53⅛ x 37¾ in. (135.9 x 95.9 cm). Jane Voorhees Zimmerli Art Museum, Rutgers, The State University of New Jersey, Gift of Susan Schimmel Goldstein. 77.050.003

Cafés, Cafés-Concerts, and Cabarets

121. **Anonymous Photographer**, French, 19th century. *Jardin Mabille*, 1870s. Photograph, albumen print; image: 8¼ x 6¾ in. (20.9 x 17.1 cm). Museum of Fine Arts, Boston, Charles Amos Cummings Fund. 1979.214

122. **Louis Anquetin**, French, 1861-1932. *The Dance at the Moulin Rouge* (La danse au Moulin Rouge), ca. 1893. Oil on canvas, 66⅛ x 79 in. (168 x 207 cm). Josefowitz Collection

*123. **Georges Barbier**, French, 1882-1932. *Fan*, 1912. Relief print with stencil coloring on paper with fourteen wood sticks, 9¾ x 13 in. (24.9 x 33.1 cm). Published by M. Spicq. The Wenham Museum, Wenham, Massachusetts. 40-292 (not illustrated)

Barbier designed this fan as an advertisement for the Restaurant Henry in Paris. The luscious arrangement of fruit along with a candelabra illustrates that food preparation for Parisian tables was considered an art form.

124. **Émile Bernard**, French, 1868-1941. *The Café* (Le café), 1885. Pen and ink, 10⅞ x 8¼ in. (27.5 x 21 cm). Lower right: Le café Bernard 85. Jane Voorhees Zimmerli Art Museum, Rutgers, The State University of New Jersey, Edward and Lois Grayson Purchase Fund. 1987.0439

125. **Émile Bernard**, French, 1868-1941. *The Brasserie* (La brasserie), ca. 1885-1886. Pen and ink, watercolor, 6⅜ x 6⅞ in. (16.1 x 17.4 cm). Lower center: la brasserie (with estate stamp). Jane Voorhees Zimmerli Art Museum, Rutgers, The State University of New Jersey, Edward and Lois Grayson Purchase Fund. 1987.0440 (not illustrated)

126. **Émile Bernard**, French, 1868-1941. *The Hovel* (Le bouge), ca. 1885-1886. Pen and ink, watercolor, 8⅝ x 4⅞ in. (22 x 12.5 cm). Lower center: le bouge (with estate stamp). Jane Voorhees Zimmerli Art Museum, Rutgers, The State University of New Jersey, Edward and Lois Grayson Purchase Fund. 1987.0441 (not illustrated)

The term le bouge implied that an establishment was an unregulated bordello, without government supervision. The well-lit and over-sized street number atop the doorway indicated a brothel. When Lautrec was living at a bordello, he would comment with great amusement about his address with a "very large street number."

127. **Émile Bernard**, French, 1868-1941. *The Grind* (Le turbin), ca. 1885-1886. Pen and ink, watercolor, 8½ x 5⅛ in. (21 x 13.2 cm). Upper right: le turbin (with estate stamp). Jane Voorhees Zimmerli Art Museum, Rutgers, The State University of New Jersey, Edward and Lois Grayson Purchase Fund. 1987.0438 (not illustrated)

Le turbin, meaning "grind," suggests the daily work or routine of a prostitute.

128. **Jules Chéret**, French, 1836-1932. *Frascati*, 1874. Poster, color lithograph, 44¾ x 62⅜ in. (113.7 x 158.7 cm). Jane Voorhees Zimmerli Art Museum, Rutgers, The State University of New Jersey, Class of 1937 Art Purchase Fund. 82.053.001

129. **Jules Chéret**, French, 1836-1932. *Ball at the Moulin Rouge* (Bal du Moulin Rouge), 1889. Poster, color lithograph, 24 x 16⅞ in. (61 x 42.8 cm). Jane Voorhees Zimmerli Art Museum, Rutgers, The State University of New Jersey, Museum Purchase. 74.016.001

130. **Jules Chéret**, French, 1836-1932. *Folies-Bergère — La Loïe Fuller*, 1893. Poster, color lithograph, 43⁵⁄₁₆ x 32¼ in. (110 x 82 cm). Barbara and Ralph Voorhees

131. **Hilaire Germain Edgar Degas**, French, 1834-1917. *"The Song of the Dog"* ("La chanson du chien"), 1876-1877. Lithograph; image: 14 x 9¹⁄₁₆ in. (35.5 x 23 cm). Museum of Fine Arts, Boston, Gift of W.G. Russell Allen. 54.996 (not illustrated)

By 1870 Thérésa was the "reigning queen" of the café-concert and well known for her classic performance of a song about a dog. Louisine Havemeyer, a friend of Degas and Mary Cassatt, wrote a memorable description of her act: "A woman stands upon the stage singing a popular song. . . . Her hands suggest the movement of a dog, and the gesture is done as only Degas could do it . . . she is conscious of her power over her audience, all this and much more shows clearly what a café-chantant is, what part it plays in Parisian life, the kind of creature it is that furnishes the amusement; and although you do not see them distinctly, you know immediately the class of pleasure seekers who are entertained by such a performance" (quoted in Reed and Shapiro, p. 75). Degas was one of those who enthusiastically visited these cafés-concerts, and as late as 1883 he was still commenting on Thérésa's abilities.

132. **Hilaire Germain Edgar Degas**, French, 1834-1917. *Mlle Bécat at the Café des Ambassadeurs*, 1877-1878. Lithograph; image: 8 x 7⅝ in. (20.4 x 19.4 cm). Lower left, in black chalk: Degas. Museum of Fine Arts, Boston, Bequest of W.G. Russell Allen. 60.258

133. **Hilaire Germain Edgar Degas**, French, 1834-1917. *The Siesta — Scene in a Brothel* (La sieste — scène de maison close), ca. 1878. Monotype; image: 8⅜ x 6⁵⁄₁₆ in. (21.5 x 16 cm). Museum of Fine Arts, Boston, Katherine E. Bullard Fund in Memory of Francis Bullard. 61.1215 (not illustrated)

This and other similar monotypes show prostitutes in poses of abandon, waiting for clients; the perpetual and boring routine dominates Degas's descriptions. Brothels and prostitutes were generally registered by the law, and both served as a major source of pleasure in the life of Parisian men and foreign visitors.

134. **Hilaire Germain Edgar Degas**, French, 1834-1917. *Two Women — Scene from a Brothel* (Deux femmes — Scène de maison close), ca. 1877-1879. Monotype; image: 8½ x 6¼ in. (21.5 x 16 cm). Museum of Fine Arts, Boston, Katherine E. Bullard Fund in Memory of Francis Bullard. 61.1214

135. **Hilaire Germain Edgar Degas**, French, 1834-1917. *The Private Dining Room* (Le cabinet particulier), ca. 1877-1879. Monotype; image: 6¼ x 8¹⁄₁₆ in. (16 x 21.5 cm). Museum of Fine Arts, Boston, Katherine E. Bullard Fund in Memory of Francis Bullard. 61.1212 (not illustrated)

In many large and fine restaurants, private rooms were set aside, with their own entrance, where a couple could dine and meet discreetly, away from the glances of the public.

136. **André Derain**, French, 1880-1954. *Outdoor Café on the Champs-Élysées*, ca. 1905. Watercolor, 17¼ x 21⅝ in. (44 x 55 cm). Lower right: Derain. Private Collection

*137. **Jean-Louis Forain**, French, 1852-1931. *Bar at the Folies-Bergère* (Le bar aux Folies-Bergère), 1878. Gouache, 12½ x 7¾ in. (31.8 x 19.7 cm). Lower right: A. Siri [sic] / bien cordialement / 8 Janvier 1878 / Forain [date may have been added later]. The Brooklyn Museum, Gift of Frank Bell Babbott. 20.667

*138. **Jean-Louis Forain**, French, 1852-1931. *The Absinthe Drinker*, ca. 1885. Oil on panel, 8 x 5⅛ in. (20.3 x 13 cm). Museum of Art, Rhode Island School of Design, Providence, Anonymous Gift. 60.024

139. **Eugène-Samuel Grasset**, Swiss, worked in France, 1841-1917. *The Morphine Addict* (La morphinomane). From *L'Album d'estampes originales de la Galerie Vollard*, 1897. Color lithograph; image: 16¾ x 12⅝ in. (42.5 x 32 cm). Jane Voorhees Zimmerli Art Museum, Rutgers, The State University of New Jersey, Friends Purchase Fund. 77.054.001

140. **Winslow Homer**, American, 1836-1910. *A Parisian Ball — Dancing at the Casino*. Published in *Harper's Weekly*, November 23, 1867. Wood engraving; image: 9¼ x 13¾ in. (23.4 x 35 cm). Museum of Fine Arts, Boston, Gift of Edward J. Holmes. 30.935 (not illustrated)

The Casino, located in Montmartre, was the winter home of the Jardin Mabille dance hall. The editor of Harper's Weekly *commented that "the Frenchman is preeminently a dancing animal" and that "our artist [Homer] . . . has caught Paris in the supreme crisis of its dancing frenzy." He perceptively noted that Louis Napoleon "takes care that uneasy Paris shall be so gorged with cheap bread and exhausted with pleasure that it may have neither the disposition nor the power to shake off the iron collar he has put on its neck . . . and [furthermore] a license, such as was never before conceded, is now allowed to the disheveled balls of Paris."*

141. **Winslow Homer**, American, 1836-1910. *A Parisian Ball — Dancing at the Mabille, Paris*. Published in *Harper's Weekly*, November 23, 1867. Wood engraving; image: 9⅛ x 13¾ in. (23.2 x 34.8 cm). Museum of Fine Arts, Boston, Gift of Edward J. Holmes. 30.934

*142. **Édouard Manet**, French, 1832-1883. *The Street Singer*, ca. 1862. Oil on canvas, 69 x 42¾ in. (175.2 x 108.5 cm). Lower left: ed. Manet. Museum of Fine Arts, Boston, Bequest of Sarah Choate Sears in Memory of her husband, Joshua Montgomery Sears. 66.304 (not illustrated)

According to Manet's friend Antonin Proust, the two men were walking in an area of torn-up streets (the result of Baron Haussmann's massive rebuilding of Paris), and saw "a woman coming out of a sleazy cabaret lifting up her skirt, holding a guitar." She was an itinerant singer who seemed to represent the wretched life of the street musicians. Manet was immediately attracted to her as a subject for a painting and asked the woman to pose but "she went off laughing." Eventually, his favorite model, Victorine Meurent, did stand in for the street singer (Manet, 1983, p. 106). The cherries that she puts to her mouth may suggest sexual activity or just poor luck (Herbert, p. 36). Although Paris was known for its strolling singers and musicians, Manet's painting reveals the poverty of those who were not the popular cabaret favorites but were, instead, displaced persons in a disrupted city.

143. **Édouard Manet**, French, 1832-1883. *At the Café* (Au café), 1874. Lithograph; image: 10⅜ x 13⅛ in. (26.2 x 33.4 cm). Museum of Fine Arts, Boston, Gift of W.G. Russell Allen. 27.1319

144. **Édouard Manet**, French, 1832-1883. *George Moore at the Café*, 1878 or 1879. Oil on canvas, 25¾ x 32 in. (65.4 x 81.3 cm). The Metropolitan Museum of Art, Gift of Mrs. Ralph J. Hines, 1955. 55.193

145. **Alfred Henry Maurer**, American, 1868-1932. *Le bal Bullier*, ca. 1904. Oil on canvas, 28⅝ x 36⅛ in. (73 x 92.7 cm). Lower right: Alfred H. Maurer. Smith College Museum of Art, Northampton, Massachusetts, Purchased, 1951. 1951:283

*146. **Emmanuel-Joseph-Raphaël Orazi**, Italian, active in Paris, 1860-1934. *Loie Fuller*. Poster for the Universal Exposition of 1900; color lithograph, 78½ x 25½ in. (199.4 x 64.8 cm). Harvard Theatre Collection. HTC ACC76-77.001

*147. **Pablo Picasso**, Spanish, worked in France, 1881-1973. *On Stage* (En scène), 1901. Pastel on brown paper prepared with gray ground, 19½ x 13⅛ in. (49.6 x 33.4 cm). Lower left: Picaso. Albright-Knox Art Gallery, Bequest of A. Conger Goodyear. 66:9.16 (see frontispiece)

*148. **Pablo Picasso**, Spanish, worked in France, 1881-1973. *Stuffed Shirts* (Les plastrons), 1901. Oil on panel, 5⅜ x 8⅞ in.

(13.6 x 22.5 cm). Upper left: PR Picasso. Museum of Fine Arts, Boston, Gift of Julia Appleton Bird. 1970.475

149. **Pablo Picasso**, Spanish, worked in France, 1881-1973. *Jardin [de] Paris*: Design for a Poster, 1901. Brush and ink, and watercolor, 25½ x 19½ in. (64.8 x 49.5 cm). The Metropolitan Museum of Art, Gift of Raymonde Paul, in memory of her brother, C. Michael Paul, 1982. 1982.179.17

*150. **Pablo Picasso**, Spanish, worked in France, 1881-1973. *The Diners* (Les soupeurs), 1901. Oil on cardboard, 18½ x 24½ in. (47 x 62.2 cm). Lower right: Picasso. Museum of Art, Rhode Island School of Design, Providence, Bequest of George Pierce Metcalf. 57.237

151. **Pablo Picasso**, Spanish, worked in France 1881-1973. *The Frugal Repast* (Le repas frugal), 1904. Etching; image: 18¼ x 15 in. (46.5 x 38 cm). Lower right: A Mlle Gatti / son admirateur / Picasso / 1905. Museum of Fine Arts, Boston, Ellen Frances Mason Fund. 34.577

152. **Pierre Auguste Renoir**, French, 1841-1919. *Dance at Bougival* (Bal à Bougival), 1883. Oil on canvas, 71⅝ x 38⅝ in. (181.8 x 98.1 cm). Lower right: Renoir. 83. Museum of Fine Arts, Boston, Picture Fund. 37.375

153. **Georges Rouault**, French, 1871-1958. *The Procuress*, 1906. Watercolor and pastel on cardboard, 12⅛ x 9½ in. (30.8 x 24.1 cm). The Museum of Modern Art, New York, Acquired through the Lillie P. Bliss Bequest. 503.41

154. **SEM (Georges Goursat)**, French, 1863-1934. *Maxim's*, ca. 1900. Color lithograph; image: 11⅝ x 18¼ in. (29.7 x 46.5 cm). Sterling and Francine Clark Art Institute, Williamstown, Massachusetts, Gift of Mrs. F. Hamilton Palmataire. 1963.214 (illustrated on page 33, fig. 3)

The cartoonist SEM frequented Maxim's and enjoyed the comfort, ambiance, and elegant society at the restaurant, where large amounts of money were spent. This lithograph was used to illustrate Maxim's menu. The Art Nouveau, or "Modern" style, which flourished around the turn of the century, could claim the daringly designed restaurant as well as the Métro entrances by Hector Guimard. The woman who strides determinedly into the dining room may have been a famous grande horizontale, who would have been welcome in the legendary Maxim's.

*155. **Théophile-Alexandre Steinlen**, Swiss, worked in France, 1859-1923. *A Chahuteuse at a Café-Concert*, 1893. Brush and ink, and charcoal over blue pencil, 17 x 12⅛ in. (43.3 x 30.9 cm). Lower left: Steinlen. The Metropolitan Museum of Art, Robert Lehman Collection, 1975. 1975.1.730

156. **Théophile-Alexandre Steinlen**, Swiss, worked in France, 1859-1923. *Yvette Guilbert — Aux Ambassadeurs*, 1894. Poster, color lithograph, 73⅛ x 31⅜ in. (186 x 79.7 cm). Museum of Fine Arts, Boston, Gift of Mr. and Mrs. Arthur Vershbow. 62.927 (not illustrated)

Yvette Guilbert preferred Steinlen's large poster of herself to the amusing caricatures that Toulouse-Lautrec created. Wearing her long, black gloves, Guilbert seems poised to step to the center stage as an applauding audience eagerly awaits her performance. The Ambassadeurs, which was transformed into a popular café-concert in 1867, opened onto a large pleasure garden that was strewn with lights. By 1893 it had acquired a removable roof that permitted performances on a regular basis without concern for the weather.

157. **Théophile-Alexandre Steinlen**, Swiss, worked in France, 1859-1923. *Fins de siècle: monologue par Aristide Bruant*, 1894-1895. Pen, brush and black ink, with colored crayon, 18¼ x 12⅛ in. (46 x 30.5 cm). Lower left: Steinlen. Arthur and Charlotte Vershbow, Boston

158. **Théophile-Alexandre Steinlen**, Swiss, worked in France, 1859-1923. *Yvette Guilbert*, 1896. Blue and black chalks with gray wash, 14³⁄₁₆ x 10¹³⁄₁₆ in. (36.1 x 27.5 cm). Lower left: St. 96. Sterling and Francine Clark Art Institute, Williamstown, Massachusetts. No. 1842

159. **Théophile-Alexandre Steinlen**, Swiss, worked in France, 1859-1923. *Design for a Music Program*, late 1890s. Pen, brush and black ink with colored crayon (verso: sketch of two women in graphite), 14¼ x 9⅞ in. (36 x 25 cm). Left center: Steinlen; bottom center, margin: Feuilles mortes — Chanson Cliché du Bleu. Private Collection

160. **Henri de Toulouse-Lautrec**, French, 1864-1901. *Moulin Rouge — La Goulue*, 1891. Poster, color lithograph, 75¾ x 47¾ in. (192.4 x 121.3 cm). Collection of Mr. and Mrs. Jack Rennert, New York

*161. **Henri de Toulouse-Lautrec**, French, 1864-1901. *At the Café La Mie*, 1891. Watercolor and gouache on paper mounted on

millboard mounted on panel, 20⅞ x 26¾ in. (53 x 67.8 cm). Upper right: T Lautrec. Museum of Fine Arts, Boston, S.A. Denio Collection, and General Income. 40.748

162. Henri de Toulouse-Lautrec, French, 1864-1901. *At the Moulin Rouge, the Goulue and Her Sister* (Au Moulin Rouge, la Goulue et sa soeur), 1892. Color lithograph, 18 x 13½ in. (46.2 x 34.7 cm). Lower left: T Lautrec. Sterling and Francine Clark Art Institute, Williamstown, Massachusetts. No. 1433 (not illustrated)

163. Henri de Toulouse-Lautrec, French, 1864-1901. *The Englishman at the Moulin Rouge* (L'anglais au Moulin Rouge), 1892. Color lithograph; image: 18⅞ x 14⅝ in. (48 x 37.3 cm). Lower left: T Lautrec no. 18. Museum of Fine Arts, Boston, Bequest of W.G. Russell Allen. 60.746 (not illustrated)

William Tom Warrener, an affluent Englishman, came to Paris as a young man to study art at the Académie Julian. In the early 1890s he met Toulouse-Lautrec, who represented him in this lithograph attempting to engage the attention of a young lady. By coloring Warrener plum (as if he were blushing all over), Lautrec removes him from the normal world and masks his lustful intentions. The lady's friend, seated beside her, glares at Warrener even though she knows full well that it was at these popular cafés where professional liaisons were made.

164. Henri de Toulouse-Lautrec, *Jane Avril*, 1893. From the portfolio *Le café concert*, 1893. Lithograph; image: 10⅜ x 8⅜ in. (26.5 x 21 cm). Museum of Fine Arts, Boston, Bequest of W.G. Russell Allen. 60.750

165. Henri de Toulouse-Lautrec, French, 1864-1901. *Loie Fuller*, 1893. Color lithograph, 14¾ x 10 in. (37.3 x 25.5 cm). Lower center: à Stern T-Lautrec. Courtesy of the Boston Public Library, Print Department, Gift of Albert H. Wiggin

166. Henri de Toulouse-Lautrec, French, 1864-1901. *Loie Fuller*, 1893. Color lithograph, 15 x 11 in. (38 x 28.1 cm). Museum of Fine Arts, Boston, Bequest of W.G. Russell Allen. 60.761

167. Henri de Toulouse-Lautrec, French, 1864-1901. *Divan Japonais*, 1893. Poster, color lithograph, 32 x 24½ in. (81.5 x 62.3 cm). Museum of Fine Arts, Boston, Lee M. Friedman Fund. 68.721 (not illustrated)

This poster was commissioned by Édouard Fournier, the owner of the Divan Japonais, who had decorated its interior with oriental silks and fans; even the waitresses wore kimonos. Curiously, the decor was more Chinese, although the name Divan Japonais was attached. The short-lived cabaret was made famous by Lautrec's striking poster. Seated in the audience are Jane Avril, in her traditionally large hat, and Édouard Dujardin, a music critic who also occasionally wrote about contemporary art. Although Yvette Guilbert's songs were the chief attraction of the cabaret, only her black gloves identify her in the background beyond the musicians. In her memoirs, Guilbert described the cramped quarters: "There was a platform set at the back of the hall, about a metre and a half from the floor, which obliged me to take care not to lift my arms unless it was absolutely necessary for then, my hands would hit the ceiling — a ceiling up to which the heat of the gas-lit footlights rose so fiercely that it was like putting one's head into a suffocating furnace!"

168. Henri de Toulouse-Lautrec, French, 1864-1901. *Jane Avril*, 1893. Poster, color lithograph, 50⅝ x 37 in. (128.8 x 94.1 cm). The Metropolitan Museum of Art, Harris Brisbane Dick Fund, 1932. 32.88.15

169. Henri de Toulouse-Lautrec, French, 1864-1901. *Aristide Bruant in His Cabaret* (Aristide Bruant, dans son cabaret), 1893. Poster, color lithograph; sight: 54¼ x 38 in. (137.8 x 96.5 cm). Museum of Fine Arts, Boston, Otis Norcross Fund. 56.1190

170. Henri de Toulouse-Lautrec, French, 1864-1901. *At the Ambassadeurs — Singer at the Café-concert* (Aux Ambassadeurs — chanteuse au café-concert), 1894. Color lithograph; image: 11¾ x 9⅝ in. (29.7 x 24.5 cm). Lower left: T-Lautrec. Museum of Fine Arts, Boston, Bequest of W.G. Russell Allen. 60.764 (not illustrated)

*171. Henri de Toulouse-Lautrec, French, 1864-1901 *Yvette Guilbert Taking a Curtain Call* (Yvette Guilbert saluant), 1894. Black crayon, watercolor, and oil with white heightening (upper right portion of sheet missing), 16⅜ x 9 in. (41 x 22.5 cm). Lower right: artist's monogram, stamped. Museum of Art, Rhode Island School of Design, Providence, Gift of Mrs. Murray S. Danforth. 35.540

*172. Henri de Toulouse-Lautrec, French, 1864-1901. Cover for the album *Yvette Guilbert*, 1894. Lithograph, 15¾ x 16⅝ in. (39.8 x 42.2 cm). Courtesy of the Boston Public Library, Print Department, Gift of Albert H. Wiggin (not illustrated)

This famous and bold jacket image designed by Lautrec for the Yvette Guilbert album depicts the singer's easily recognizable black gloves that drape, almost in animation, over her dressing table with a powder puff nearby.

*173. Henri de Toulouse-Lautrec, French, 1864-1901. *Yvette Guilbert Taking a Curtain Call*. In the album *Yvette Guilbert*, text by Gustave Geffroy, 1894. Book with lithographed cover printed in black and sixteen lithographs in green; page size: 15 x 15 in. (38.1 x 38.1 cm). Verso of flyleaf: 34 / Yvette Guilbert. Smith College Museum of Art, Northampton, Massachusetts, Gift of Selma Erving '27. 1972:50-109 (not illustrated)

Although Yvette Guilbert did not favor Lautrec's sharp characterizations, the deluxe limited edition of this book quickly became so popular in France and abroad that four years later, in 1898, a second series of ten lithographs was printed in London.

174. Henri de Toulouse-Lautrec, French, 1864-1901. *Woman Putting on Her Corset — Passing Conquest* (Femme en corset — Conquête de passage). From the portfolio *Elles*, 1896. Color lithograph, 20⅝ x 15¹⁵⁄₁₆ in. (52.5 x 40.5 cm). Courtesy of the Boston Public Library, Print Department, Gift of Albert H. Wiggin

175. Henri de Toulouse-Lautrec, French, 1864-1901. *Woman in Bed, Profile* (Femme au lit, profil). From the portfolio *Elles*, 1896. Color lithograph, 15⅞ x 20½ in. (40.3 x 52 cm). Museum of Fine Arts, Boston, Lee M. Friedman Fund. 68.556 (not illustrated)

Some cataloguers have proposed that the pair of women in this lithograph are Madame Baron, mistress of a maison close (brothel) in Montmartre, and her daughter, Paulette, called "Popo." Without this information, one could conclude that this is a domestic scene in which a mother attends her awakening daughter.

176. Henri de Toulouse-Lautrec, French, 1864-1901. *The Clowness at the Moulin Rouge* (La clownesse au Moulin Rouge), 1897. Color lithograph, 16⅛ x 12⅝ in. (40.9 x 32.1 cm). Lower right: T Lautrec / no. 20. Museum of Fine Arts, Boston, Bequest of W.G. Russell Allen. 60.767

177. Henri de Toulouse-Lautrec, French, 1864-1901. *Dancing at the Moulin Rouge* (La danse au Moulin Rouge), 1897. Color lithograph, 18½ x 14 in. (47 x 35.5 cm). Lower left: T Lautrec à Pellet. Sterling and Francine Clark Art Institute, Williamstown, Massachusetts. 62.119

178. Jacques Villon, French, 1875-1963. *The Cricket — American Bar* (Le Grillon — American Bar), 1899. Poster, color lithograph, 49 x 34⅝ in. (124.5 x 88 cm). The Museum of Modern Art, New York, Abby Aldrich Rockefeller Fund. 246.51

179. Jacques Villon, French, 1875-1963. *Dancer at the Moulin Rouge* (La danseuse au Moulin Rouge), 1899. Color lithograph, trial proof, 11¾ x 10 in. (29.8 x 25.4 cm). Courtesy of the Boston Public Library, Print Department (not illustrated)

180. Jacques Villon, French, 1875-1963. *Night Cabaret* (Cabaret de nuit), 1902. Etching printed in green, trial proof, hand-colored in gouache and charcoal; image: 19 x 15 in. (48.1 x 38.1 cm). Sterling and Francine Clark Art Institute, Williamstown, Massachusetts. No. 1970.9

181. Jacques Villon, French, 1875-1963. *Nevers in Paris* or *The Reveler* (Nevers à Paris ou Le Fétard), 1904. Color aquatint and drypoint; image: 13¾ x 17¾ in. (35 x 45.3 cm). Courtesy of the Boston Public Library, Print Department, Gift of Albert H. Wiggin (not illustrated)

Villon depicts a well-to-do high fonctionnaire *from the provinces who has traveled to Paris to enjoy the nighttime pleasures of a cabaret. The gentleman appears slightly dismayed, knowing he has the money to spend but concerned that he will be taken advantage of by an attentive* demi-mondaine.

Circuses and Fairs

182. Hilaire Germain Edgar Degas, French, 1834-1917. *At the Cirque Fernando* (Au Cirque Fernando), 1879. Lithograph, image: 4¹¹⁄₁₆ x 6⁵⁄₁₆ in. (11.9 x 16 cm). Museum of Fine Arts, Boston, Katherine E. Bullard Fund in Memory of Francis Bullard and proceeds from the sale of duplicate prints. 1983.311 (not illustrated)

183. Georges de Feure, French, 1868-1943. *Le Cirque Corvi*, ca. 1893. Gouache and watercolor over graphite, 15⁹⁄₁₆ x 15¹⁵⁄₁₆ in. (39.5 x 40.5 cm). Lower left: De Feure. Sterling and Francine Clark Art Institute, Williamstown, Massachusetts. No. 1648

184. Henri-Gabriel Ibels, French, 1867-1936. *At the Circus* (Au cirque), ca. 1893. Oil on panel, 12½ x 15¾ in. (31.7 x 40 cm). Lower right: H.G. Ibels. Private Collection

185. **Henri-Gabriel Ibels**, French, 1867-1936. *At the Circus* (Au cirque), 1893. From *L'Estampe originale*. Color lithograph, 19½ x 10¼ in. (49.5 x 26 cm). Jane Voorhees Zimmerli Art Museum, Rutgers, The State University of New Jersey, David A. and Mildred H. Morse Acquisition Fund. 80.012.001 (not illustrated)

186. **Henri-Gabriel Ibels**, French, 1867-1936. *Le grappin* and *L'affranchie*. Program for Le Théâtre Libre, 1892-1893. Color lithograph, 9½ x 12¾ in. (24 x 32.3 cm). Courtesy of the Boston Public Library, Print Department (not illustrated)

On an abbreviated stage, Ibels clearly conveys the informality and lack of lavish display of the forains, *itinerant circus performers, who set up temporary facilities throughout the city and provinces.*

187. **Henri-Gabriel Ibels**, French, 1867-1936. *Mirages*. Program for Le Théâtre Libre, 1892-1893. Color lithograph, 9⅜ x 12⅜ in. (23.7 x 31.4 cm). Courtesy of the Boston Public Library, Print Department (not illustrated)

Ibels was a member of the Nabi brotherhood, primarily interested in popular illustrations for journals, posters, sheet music, and theatrical programs. He designed eighty covers for the avant-garde theater group Le Théâtre Libre, which operated from 1887 to 1894. His clever integration of image and text and his use of flat, colorful figures, often in silhouette, produced lively compositions that did not detract from the advertisement of the content of the plays.

188. **Emmanuel-Joseph-Raphael Orazi**, Italian, active in Paris, 1860-1934. *The Hippodrome, Boulevard de Clichy* (L'Hippodrome, Brd de Clichy), ca. 1900. Poster, color lithograph, 88 x 59¹⁄₁₆ in. (226 x 150 cm). Jane Voorhees Zimmerli Art Museum, Rutgers, The State University of New Jersey, The Class of 1937 Art Purchase Fund. 84.023.003

189. **Pablo Picasso**, Spanish, worked in France, 1881-1973. *The Acrobats* (Les saltimbanques), 1905. Drypoint; image: 11¼ x 12⅞ in. (28.5 x 32.7 cm). The Museum of Modern Art, New York, Gift of Abby Aldrich Rockefeller. 502.40 (not illustrated)

*190. **Pablo Picasso**, Spanish, worked in France, 1881-1973. *Harlequin*, 1901. Oil on canvas, 32⅝ x 24⅛ in. (83 x 61.4 cm). Lower left: Picasso / 1901. The Metropolitan Museum of Art, Purchase, Mr. and Mrs. John L. Loeb Gift, 1960. 60.87

191. **Pablo Picasso**, Spanish, worked in France, 1881-1973. *The Two Acrobats* (Les deux saltimbanques), 1905. Drypoint; image: 4¾ x 3⅝ in. (12 x 9 cm). Lower right: Picasso. Museum of Fine Arts, Boston, Gift of Mrs. George Rowland in Honor of Miss Eleanor Sayre. 1980.622 (not illustrated)

192. **Pablo Picasso**, Spanish, worked in France, 1881-1973. *At the Circus* (Au cirque), 1905. Drypoint; image: 8⅝ x 5½ in. (22 x 14 cm). Museum of Fine Arts, Boston, Bequest of W.G. Russell Allen. 60.1234

193. **Pablo Picasso**, Spanish, worked in France, 1881-1973. *Harlequin with a Guitar*, 1916. Oil on wood, 8½ x 5½ in. (21.6 x 14 cm). Mr. and Mrs. Eugene V. Thaw

194. **Maurice Prendergast**, American, 1958-1924. *The Circus* (Le cirque), ca. 1902. Color monotype; image: 11 x 14¼ in. (28 x 36.2 cm). Museum of Fine Arts, Boston, Charles Henry Hayden Fund. 58.981

195. **Georges Rouault**, French, 1871-1958. *Circus Act*, 1905. Watercolor and pastel, charcoal, and brush and ink; image: 10¼ x 13½ in. (25.5 x 34.3 cm). The Museum of Modern Art, New York, The Joan and Lester Avnet Collection. 158.78

196. **John Singer Sargent**, American, 1856-1925. *Rehearsal of the Pasdeloup Orchestra at the Cirque d'Hiver*, 1876. Oil on canvas, 21¾ x 18¼ in. (55.2 x 46.3 cm). Lower right: rehearsal at the Cirque / d'Hiver / John S. Sargent. Museum of Fine Arts, Boston, Charles Henry Hayden Fund. 22.598

197. **James Jacques Joseph Tissot**, French, 1836-1902. *The Amateur Circus* (Les femmes de sport), 1883-1885. Oil on canvas, 58 x 40 in. (147.2 x 101.6 cm). Lower right: J.J. Tissot. Museum of Fine Arts, Boston, Juliana Cheney Edwards Collection. 58.45

198. **James Jacques Joseph Tissot**, French, 1836-1902. *The Ladies of the Chariots* (Ces dames de chars), 1883-1885. Oil on canvas, 57½ x 39¾ in. (146 x 101 cm). Lower right: J.J. Tissot. Museum of Art, Rhode Island School of Design, Providence, Gift of Walter Lowry. 58.186

*199. **Henri de Toulouse-Lautrec**, French, 1864-1901. *Woman on Trapeze*, ca. 1887-1888. Gouache on gray cardboard, 31½ x 23⅝ in. (80 x 60 cm). Upper right: H T Lautrec. Fogg Art Museum, Harvard University, Bequest of Annie Swan Coburn. 1934.34 (not illustrated)

It is known from records and photographs taken about 1890 that Lautrec was working on a mural-size painting of the Cirque Fer-

nando with an oversize clown, ringmaster, and probably other images. Some paintings and related drawings executed about 1887 may have been preparations for this huge canvas, which was eventually dismantled. It is possible that this large gouache of a solitary figure sitting on a trapeze was a study for Lautrec's ambitious project since its size is uncommon for its subject matter.

*200. **Henri de Toulouse-Lautrec**, French, 1864-1901. *The Salutation* (Le salut), 1899. Graphite, black chalk, colored chalk, and colored crayon, 14 x 10 in. (35.6 x 25.4 cm). Lower right: T-L monogram. Fogg Art Museum, Harvard University, Bequest of Frances L. Hofer. 1979.56

201. **Henri de Toulouse-Lautrec**, French, 1864-1901. *Woman Riding without Saddle* (Équestrienne, travail sans selle), 1899. Black charcoal and colored chalks with gray wash, 19¼ x 12⅛ in. (48.9 x 31.5 cm). Upper right, lower right, and lower left: T-L monogram. Museum of Art, Rhode Island School of Design, Providence, Gift of Mrs. Murray S. Danforth. 34.003 (not illustrated)

This drawing is one of a group that Lautrec executed while he was recovering in a sanatorium.

*202. **Henri de Toulouse-Lautrec**, French, 1864-1901. *The Spanish Step* (Le pas espagnol), 1899. Graphite, crayon, and pastel, 13¾ x 9⅞ in. (35 x 25 cm). Lower right: T-L monogram. The Metropolitan Museum of Art, Robert Lehman Collection, 1975. 1975.1.731

203. **Henri de Toulouse-Lautrec**, French, 1864-1901. *At the Circus: The Rehearsal* (Travail de répétition du panneau), 1899. Black and colored chalks, 14 x 10 in. (35.5 x 25.4 cm). Upper right: T-L monogram. Private Collection (not illustrated)

204. **Henri de Toulouse-Lautrec**, French, 1864-1901. *The Dog Trainer* (Dresseur de chiens), 1899. Black and colored chalks, 14 x 10 in. (35.5 x 25.4 cm). Lower right: T-L monogram. Sterling and Francine Clark Art Institute, Williamstown, Massachusetts. No. 1427 (not illustrated)

Books, Journals, and Ephemera (not illustrated)

205. **Camille Boignard**, French, 19th century. *Ticket for Bal des Quat'Z'Arts*, 1900. Photorelief, 6½ x 10 in. (16.5 x 25.4 cm). Jane Voorhees Zimmerli Art Museum, Rutgers, The State University of New Jersey, Museum Purchase. 1987.0409

The Quatre Arts ball was devised in 1892 by students at the École des Beaux-Arts to celebrate the four arts: painting, sculpture, architecture, and poetry (later replaced by printmaking). The first ball was an unpretentious event, but the following year a number of journalists, particularly the publisher of Le Courrier français, encouraged a costume parade. Several models wore revealing gowns of the "ancients," causing a great scandal that led to court action. The exaggerated excitement of the evening became more legend than reality, and as the news of the event calmed down and in subsequent years public opinion relaxed, the ball became an enjoyable tradition.

206. **Emmanuel Caran d'Ache**, French, 1859-1909. Cover for the journal *Paris Grand Prix*. Photorelief, 15 x 11½ in. (38.1 x 29.2 cm). Jane Voorhees Zimmerli Art Museum, Rutgers, The State University of New Jersey, Museum Purchase. 1989.1396

207. **Jules Chéret**, French, 1836-1932. *Tertulia*, 1872. Poster, color lithograph, 16 x 12¼ in. (40.6 x 31.1 cm). Jane Voorhees Zimmerli Art Museum, Rutgers, The State University of New Jersey, Lillian Lilien Memorial Fund. 1989.1341

208. **Jules Chéret**, French, 1836-1932. Cover for the book *Lulu, pantomine en une acte*, by Félicien Champsaur, 1888. Lithograph; page: 8½ x 6¼ in. (21.6 x 15.9 cm). Jane Voorhees Zimmerli Art Museum, Rutgers, The State University of New Jersey, Museum Purchase. 1988.0939

209. **Henry Frichet**, French, 19th century. *Le cirque et les forains*. Tours, A. Mame et fils, 1898. Book with illustrations by several hands, including E. Grandjean, M. Lang, H. Gerbault, et al. Page: 11 x 6 in. (27.9 x 15.3 cm). Laurence Senelick Collection

For this serious study of the circus, the delightful cover was stamped in gold. It reveals all the essential acts that were found in a popular circus arena as well as in popular country fairs.

210. **Jules Alexandre Grün**, French, 1868-1934. *Invitation to Élysée Montmartre*. Lithograph, 4¼ x 5½ in. (10.8 x 14 cm). Jane Voorhees Zimmerli Art Museum, Rutgers, The State University of New Jersey, Museum Purchase. 1987.0451

211. **Albert Guillaume**, French, 1873-1942. Cover for the journal *Au Quartier Latin*, 1895. Color lithograph, 17 x 13 in. (43.2 x 33 cm). Jane Voorhees Zimmerli Art Museum, Rutgers, The State University of New Jersey, Museum Purchase. 1989.1395

212. **Henri-Gabriel Ibels**, French, 1867-1936. *The Waltz of the Black Stockings* (La valse des bas noirs), ca. 1895. Music sheet, lithograph with stencil coloring, 10⅝ x 6⅞ in. (27 x 17.5 in.). Matthew Braddock

Ibels executed a pastel of a dancer dressed in yellow with black stockings (Zimmerli Art Museum). It was reproduced as a music sheet cover to illustrate a song that describes one man's love of such hosiery: "But when, on the next day, I saw my beauty in black stockings my heart caught fire" (Cate, ed., p. 154). At this time black stockings had sexual connotations and indicated that the wearer was available for favors.

213. **L. Lefèvre**, French, 19th century. Program for the Folies-Bergère, 1894. Color lithograph, 10½ x 14¾ in. (26.7 x 37.5 cm). Jane Voorhees Zimmerli Art Museum, Rutgers, The State University of New Jersey, Museum Purchase. 1987.0458

214. **Henry Somm**, French, 1844-1907. Invitation for the Bal des modèles at the Moulin Rouge for Monday, March 13, 1893. Lithograph, 7 x 14 in. (17.8 x 35.6 cm). Jane Voorhees Zimmerli Art Museum, Rutgers, The State University of New Jersey, Carleton A. Holstrom Art Purchase Fund. 1989.0491

215. **Pierre Vidal**, French, 1849-1929. Cover for the book *La vie de Montmartre*, by Georges Montorgueil, 1899. Color lithograph, proof before lettering, 11⅞ x 19¾ in. (30.3 x 50.3). The Metropolitan Museum of Art, The Elisha Whittelsey Collection, The Elisha Whittelsey Fund, 1954. 54.658.12

This amusing proof for a cover design epitomizes the lively reputation Paris enjoyed in the late nineteenth century. The jauntily dressed workers and dancers who float across the rooftops of Montmartre, home of many artists and writers, convey the possibilities of pleasure and fantasies that were available. On the skyline are the Moulin de la Galette windmill at left and, at the highest point in Paris, the unfinished church of the Sacré-Coeur, covered with scaffolding. Begun in 1875 as a penance for France's defeat in the Franco-Prussian War, the church was not completed until just before World War I.

Selected Bibliography

This bibliography should be used in conjunction with the references in the footnotes of the introduction and the essays. Abbreviations in the catalogue entries are cited in full here.

Abdy, Jane. *The French Poster: Chéret to Cappiello*. New York, 1969.

Adler, Kathleen. *Unknown Impressionists*. Oxford, 1988.

Barrows, Susanna. *Distorting Mirrors: Visions of the Crowd in Late Nineteenth-Century France*. Princeton, N.J., 1973.

Baudelaire, Charles. *Charles Baudelaire, the Painter of Modern Life*. Edited and translated by Jonathan Mayne. London, 1965.

Boyer, Patricia Eckert, ed. *The Nabis and the Parisian Avant-Garde*. New Brunswick, N.J., 1988.

Bransten, Ellen H. "The Significance of the Clown in Paintings by Daumier, Picasso and Rouault." *The Pacific Art Review* 3 (1944).

Castleman, Riva, and Wittrock, Wolfgang, eds. *Henri de Toulouse-Lautrec: Images of the 1890's*. New York, 1985.

Cate, Phillip Dennis. *The Eiffel Tower: A Tour de Force*. New York, 1989.

Cate, Phillip Dennis. *Émile Bernard (1868-1941): The Theme of Bordellos and Prostitutes in Turn-of-the-Century French Art*. New Brunswick, N.J., 1988.

Cate, Phillip Dennis, ed. *The Graphic Arts and French Society, 1871-1914*. New Brunswick, N.J., 1988.

Cate, Phillip Dennis, and Boyer, Patricia Eckert. *The Circle of Toulouse-Lautrec: An Exhibition of the Work of the Artist and of His Close Associates*. New Brunswick, N.J., 1986.

Clark, T.J. *The Painting of Modern Life: Paris in the Art of Manet and His Followers*. Princeton, N.J., 1984.

Conrad III, Barnaby. *Absinthe: History in a Bottle*. San Francisco, 1988.

Cooper, Douglas. *Picasso Theatre*. New York, 1968.

Dans les rues de Paris au temps des fiacres, by R. Coursaget, G. Chabance, G. Pillement, and L.-P. Fargue. Paris, 1950.

Degas. Exhibition organized by the Réunion des musées nationaux, Paris; National Gallery of Canada, Ottawa; The Metropolitan Museum of Art, New York. New York, 1988.

Evenson, Norma. *Paris: A Century of Change, 1878-1978*. New Haven, 1979.

Farwell, Beatrice. *The Cult of Images: Baudelaire and the 19th-Century Media Explosion*. Santa Barbara, 1977.

The Fine Arts Museums of San Francisco. *The New Painting: Impressionism, 1874-1886*. San Francisco, 1986.

Georgel, Chantal. *La rue*. Paris, 1986.

Grad, Bonnie L., and Riggs, Timothy A. *Visions of City and Country: Prints and Photographs of Nineteenth-Century France*. Worcester, Mass.: Worcester Art Museum, 1982.

Grand-Carteret, J. *Les moeurs et la caricature en France*. Paris, 1888.

Hare, Augustus J.C. *Paris*. London [1897].

Haskell, Francis. "The Sad Clown: Some Notes on a 19th Century Myth." In *French 19th Century Painting and Literature*, edited by Ulrich Finke. London, 1972.

Herbert, Robert L. *Impressionism: Art, Leisure, and Parisian Society*. New Haven, 1988.

Isaacson, Joel. *The Crisis of Impressionism, 1878-1882*. Ann Arbor, 1980.

Isaacson, Joel. "Impressionism and Journalistic Illustration." *Arts Magazine* 56 (June 1982).

Ives, Colta; Giambruni, Helen; and Newman, Sasha M. *Pierre Bonnard: The Graphic Art*. New York: The Metropolitan Museum of Art, 1989.

Kendall, Richard. *Degas: Images of Women*. Liverpool, 1989.

Mainardi, Patricia, ed. "Nineteenth-Century French Art Institutions." *Art Journal* 48, no. 1 (spring 1989).

Manet, 1832-1883. Exhibition organized by the Réunion des musées nationaux français, Paris, and the Metropolitan Museum of Art. New York, 1983.

Mayer, Frederick; Peck, F.W.; Olivares, Jose de; and Bar, Marius. *The Parisian Dream City*. A portfolio of photographic views of the World's Exposition in Paris. St. Louis, 1900.

Millman, Ian. *Georges de Feure*. [Tokyo?], 1990.

Milner, John. *The Studios of Paris, the Capital of Art in the Late Nineteenth Century*. New Haven, 1988.

Musée Carnavalet, Paris. *Les grands boulevards*. Paris, 1985.

Nochlin, Linda. "A Thoroughly Modern Masked Ball." *Art in America* 71 (November 1983).

Oberthur, Mariel. *Cafés and Cabarets of Montmartre*. Translated by Sheila Azoulai. Salt Lake City, 1984.

Perrot, Michelle. *A History of Private Life*, 4: *From the Fires of Revolution to the Great War*. Cambridge, Mass., 1990.

Philadelphia Museum of Art. *The Second Empire, 1852-1870: Art in France under Napoleon III*. Philadelphia, 1978.

Quantin, A. *L'Exposition du siècle*. Paris, 1900.

Rearick, Charles. *Pleasures of the Belle Epoque: Entertainment and Festivity in Turn-of-the-Century France*. New Haven, 1985.

Reed, Sue Welsh, and Shapiro, Barbara Stern. *Edgar Degas: The Painter as Printmaker*. Boston: Museum of Fine Arts, 1984.

Reff, Theodore. *Manet and Modern Paris*. Washington, D.C.: National Gallery of Art, 1982.

Renoir. Exhibition organized by the Arts Council of Great Britain, London; Réunion des musées nationaux, Paris; and Museum of Fine Arts, Boston. London, 1985.

Richardson, Joanna. *La vie parisienne, 1852-1870*. New York, 1971.

Royal Academy of Arts, London. *Post-Impressionism: Cross-Currents in European Painting*. London, 1979.

Rubin, William. *Picasso in the Collection of the Museum of Modern Art*. New York, 1972.

Rubin, William. "Shadows, Pantomimes and the Art of the Fin de Siècle." *Magazine of Art* 46, no. 3 (March 1953).

Rudorff, Raymond. *The Belle Epoque: Paris in the Nineties*. New York, 1972.

Russell, John. *Paris*. New York, 1983.

Sansom, William. *Proust*. London, 1973.

Segel, Harold B. *Turn-of-the-Century Cabaret*. New York, 1987.

Seigel, Jerrold. *Bohemian Paris: Culture, Politics, and the Boundaries of Bourgeois Life, 1830-1930*. New York, 1986.

Shattuck, Roger. *The Banquet Years: The Art in France, 1885-1918*. New York, 1958.

Silverman, Debora L. *Art Nouveau in Fin-de-Siècle France: Politics, Psychology, and Style*. Berkeley, 1989.

Steele, Valerie. *Paris Fashion: A Cultural History*. New York, 1988.

Stuckey, Charles F. *Toulouse-Lautrec: Paintings*. Chicago, 1979.

Thomson, Belinda. *The Post-Impressionists*. 2nd ed. New York, 1990.

Weber, Eugen. *France: Fin de Siècle*. Cambridge, Mass., 1986.

Welsh-Ovcharov, Bogomila. *Vincent van Gogh and the Birth of Cloisonism*. Toronto: Art Gallery of Ontario, 1981.

Wentworth, Michael. *James Tissot*. Oxford, 1984.

Wildenstein Gallery, New York. *Paris Cafés: Their Role in the Birth of Modern Art*. Text by Georges Bernier. New York, 1985.

Zeldin, Theodore. *France, 1848-1945*. 5 vols. Oxford, 1979-81.

Index of Artists

Numbers refer to those in the checklist. Italicized numbers indicate illustrated works.